MW01074231

Sound of the Border

Sound of the Border

MUSIC AND IDENTITY OF
KOREAN MINORITY IN CHINA

SUNHEE KOO

University of Hawai'i Press
Honolulu

26 25 24 23 22 21 6 5 4 3 2 1

Library of Congress Cataloging-in-Publication Data

Names: Koo, Sunhee, author.
Title: Sound of the border : music and identity of Korean minority
 in China / Sunhee Koo.
Other titles: Music and performing arts of Asia and the Pacific.
Description: Honolulu : University of Hawai'i Press, 2021. | Series: Music
 and performing arts of Asia and the Pacific | Includes bibliographical
 references and index.
Identifiers: LCCN 2020057438 | ISBN 9780824888275 (hardcover) | ISBN
 9780824889562 (adobe pdf) | ISBN 9780824889579 (epub) | ISBN
 9780824889586 (kindle edition)
Subjects: LCSH: Music—China—Yanbian Chaoxianzu Zizhizhou—History and
 criticism. | Chosŏnjok—Music—History and criticism. |
 Chosŏnjok—Ethnic identity.
Classification: LCC ML3746.7.Y3 K66 2021 | DDC 781.62/95705188—dc23
LC record available at https://lccn.loc.gov/2020057438

Cover photos: *(Front)* A signpost of a cabaret located on
Park Street, Yanji, China; *(Back)* Yanji Chaoxianzu
Arts Troupe building, Yanji, China. Photos by the author, 2005.

For Mom and Lina

CONTENTS

ACKNOWLEDGMENTS

I WANT to express my deep gratitude to those who guided me to begin and stick with my journey in this study on diasporic Koreans in China and their music and identity, which have been shaped straddling the Sino-Korean border over the span of more than a century. I thank Professor Emerita Adelaida Reyes for introducing me to migration studies and for her continued mentorship over nearly two decades; Professor Byong Won Lee, who led me to focus my scholarship on Korean music dispersed to various parts in Northeast Asia; and Professor Emerita Barbara Smith, Professor Emeritus Ricardo Trimillios, and Professor Jane Moulin, who reassured me of the joy of being an ethnomusicologist and the possibility of building an academic career beyond my comfort zone and wherever I am located. My deep and special thanks go to Professor Frederick Lau, to whom I am tremendously indebted in many ways: for this book, from start to end, he gave me endless support, inspiration, and motivation to come this far. Thanks, Fred!

I have been very fortunate to be surrounded by eminent scholars along the way. At my present institution, the University of Auckland, New Zealand, Professor Gregory Booth has always been a great mentor and a big supporter of my book project. He and his partner Alison's generous hospitality and loving friendship enabled me and my daughter, Lina, to find a home in Aotearoa. I wish to thank a number of my colleagues in Australasia who contributed to my research in a number of different ways, directly or indirectly, providing helpful feedback, encouragement, comfort, entertainment, and drinks, all of which were necessary and helped me stay on this project. They are, in no specific order, Professor Simon Holdaway; Professor Alan France; Professors Emeriti Julie Park, Harry Allen, Richard Moyle, and Ken Wells; Dr. Kirsten Zemke; Dr. Kooshna Gupta; Dr. Daniel Hernandez; Dr. Irene Hee-Seung Lee; Dr. Sung-Young Kim; Dr. Jihye Kim; Associate Professor Roald Maliangkay; Dr. Nicholas Malone; and

Associate Professor Ethan Cochrane. I especially thank Dr. Changzoo Song, the director of the University of Auckland's Korean studies program, who granted me generous access to a Korean studies grant for multiple years in completing this publication.

I also want to thank Professor Tongsoon Lee and my friend Dr. Heather Diamond, who read the earlier versions of my book manuscript and provided fruitful feedback in developing my research when I was a budding academic. I am hugely indebted to Mona-Lynn Courteau, who graciously dedicated much of her time reading, editing, and giving invaluable comments on the transformation and current version of the book manuscript. Wendell Ishii also contributed much to the formulation and writing of the drafts of my manuscript. I thank Seline McNamee and Timothy Mackrell for their technical support in improving the images used for this publication. At the University of Hawai'i Press, I was very fortunate to work with Executive Editor Masako Ikeda, who was so patient in guiding me and supporting various stages of my writing as she graciously coordinated reviews that provided invaluable information in revising and improving the contents and approaches of this book. Cheryl Loe, Lori Rider, and Amron Gravett did an amazing job in finalizing the production of this volume.

The individuals and institutes that contributed to this study are too numerous to mention by name. My thanks go first to the many Chaoxianzu individuals whom I met in Yanbian and Korea. As friends, teachers, and acquaintances, they shared insights into their music and communities. I was very privileged to hear their firsthand stories, which eventually came to constitute the main body of this study. I express my great appreciation to all of my informants whose names appear in the text and whose information builds upon my knowledge and understanding of Chaoxianzu music and identity. A number of individuals stand out for their special interest in and contributions to my research. Professor Kim Sŏngjun generally guided me through my field research in Yanbian. Professor Nam Hŭich'ŏl was extremely generous both with his time and in introducing me to acclaimed musicians. Without their coordination my fieldwork could not have proceeded smoothly. Pak Changsu also helped me tremendously by connecting me to Chaoxianzu musicians and enriching my research with his insights from a lifetime of service for the Chaoxianzu Music Organization. Numerous people shared their knowledge with me as academics and performers of Chaoxianzu and/or Korean music. I sincerely thank the professors and professor emeriti at Yanbian Arts School, including Kim Sŏngsam, Kim Chin, Cho Sunhŭi, Chang Iksŏn, Kim Yep'ung, Lee Hun, Sin Okpun, Pak Hakch'ŏl, Kim Tongsŏl, Chŏn Hwaja, Kim Sunhŭi, and Pak Ch'unhŭi, and those leading Chaoxianzu musicians in Yanbian such as An Kungmin, Pak Sesŏng, Hwang Ch'angju, An Kyerin, Lim Pongho, Kim Kyeok, Pak Wich'ŏl,

and Ch'oe Misŏn. I also thank the scholars in South Korea who helped me in invaluable ways. They are Professor Emeriti Kwŏn Osŏng, Lee Bo-Hyeong, and Chun In Pyong, and Professor Kim Illyun. I am also greatly indebted to Kim Ch'unhŭi, Kim Hun, and Kim Ch'anggŭn at the Yanbian Radio and Television Broadcasting Station, who supported me and my research with great care and concern. I also wish to express my deep gratitude to Drs. Rowan Pease and Haekyung Um, who encouraged and inspired me to take up my study of Yanbian and Chaoxianzu music and identity when I was a PhD student and before I left for the field. Without these people, this work could never have been completed.

I owe much gratitude to my family for always cheering me on and supporting me. My parents, whose infinite love and trust has accompanied me all along no matter what I have done and even in my mistakes, provided reasons for me to be in academia and progress within it. I thank my siblings, nieces, and nephew who have always been on my side even though they were not always sure what I was up to. Above all, my daughter, Lina Song, deserves my deepest appreciation and gratitude. She provided me with every single reason for me to live, sustain, and complete this work. While just her existence is already a huge inspiration and motivation for my life, she greatly supported me by encouraging me and reminding me to get back to work. Without her patience as well as her love, her cries, and her smiles, I would never have finished this book and would not be the person I am today. Thank you, Lina, and I love you so much!

This publication was supported by a generous grant from the Core University Program for Korean Studies through the Ministry of Education of the Republic of Korea and the Korean Studies Promotion Service of the Academy of Korean Studies (AKS-2017-OLU-2250001).

ROMANIZATION AND
OTHER CONVENTIONS

Between the two representative Korean romanization systems respectively adopted by native and foreign academics, I have chosen to adopt the McCune-Reischauer system with the following modifications. Authors' names are cited by the romanizations used in the original publications; if necessary the McCune-Reischauer version is provided in brackets in text and/or references (e.g., Chun, In Pyong [Chŏn, Inp'yŏng]). The place-names in North and South Korea are given based on the McCune-Reischauer transcription. However, the 2000 Revised Romanization spellings for the places in South Korea are provided in the glossary since they are the official spellings currently used by the South Korean government. Some well-known place-names, such as Seoul, are used in text as is without the provision of McCune-Reischauer romanization. All Chinese terms are romanized according to the pinyin system.

In referring collectively to my Korean Chinese informants in this book, I identify them as "Chaoxianzu" by adopting the official name of Koreans who moved to China before 1949. More than a few indigenous terms are provided in parentheses throughout the text. Chinese terms are distinguished from those of Koreans with the abbreviation Ch. (e.g., Ch. *guoyue*). When both Korean and Chinese terms are provided, Korean names always appear first, followed by Chinese names (e.g., the Yanbian Folk Arts Research Group [Yŏnbyŏn min'gan munye yŏn'gujo; Yanbian minjian wenyi yanjiuzu]). All non-English terms are italicized throughout, with the exception of proper nouns, titles of pieces, associations, government groups, and place-names. For the names of Korean Chinese people, I maintain their Korean names by reflecting the language in which they were read or introduced to me, for example, An Kungmin and An Kyerin instead of their Chinese pronunciations, An Guomin and An Jilin.

Introduction

Iɴ 2003 in Seoul, I often encountered Chaoxianzu who were working in restaurants and bars, on construction sites, or as housekeepers for South Korean families. Chaoxianzu refers to the Koreans who migrated to China between the late nineteenth and early twentieth centuries and their descendants. Following the establishment of the People's Republic of China (PRC) in 1949 as a nation of multiple nationalities, about two million Koreans were recognized as one of China's fifty-five ethnic minorities and given Chinese citizenship. The highest concentration of these Koreans has been in Yanbian Korean Autonomous Prefecture, or simply Yanbian (Yŏnbyŏn in Korean), located in the northeastern part of Jilin Province; its cities of Hunchun, Tumen, and Helong border on Russia and North Korea. Since the establishment of diplomatic relations between the PRC and South Korea in 1992, many Chaoxianzu have visited or remigrated to South Korea, for the economic opportunities offered by their ancestral home, as spouses, or as returning expatriates wishing to resettle or revive family relationships in South Korea after the long break in Sino–South Korean relations due to the Cold War and its subsequent impact on the political milieu of Northeast Asia during the latter half of the twentieth century.

Though some Chaoxianzu migrants to South Korea held college degrees earned in China and came with urban and professional backgrounds, many took the kind of low-wage jobs largely disdained by a majority of South Koreans with degrees and stable economic backgrounds. Their income as government employees in the 1990s in China—in professions such as teachers, musicians, or nurses—was far less than what they could earn in South Korea as restaurant or bar servers or as day workers. This, plus the discrepancies in currency values between different Asian countries in the late 1990s, incited more than a few migrants, including Chaoxianzu, to come to South Korea to serve as low-paid workers. There Chaoxianzu were treated similarly to other foreign

labor migrants despite their Korean ethnicity and language proficiency. Unlike the cases of North American or European expatriates whose English skills and Western education were privileged, a Chaoxianzu background was rarely viewed favorably in South Korea, especially in finding jobs where these Koreans could use their training in China or their professional aptitude. In South Korea, it is much easier for them to take unskilled low-wage jobs that still enable them to save some money to take back to China.

Amid the influx of Chaoxianzu migrants in and around Seoul, I met two musicians who were working toward their PhDs in Korean music at renowned South Korean universities. Prior to their move to South Korea, they taught Korean music at Yanbian Arts School (Yŏnbyŏn yesul hakkyo), the sole secondary and higher education institution for the music and arts of the Korean minority in China. These musicians proudly described the unique sound of the Korean music that had developed in China, compared with what they saw as the attributes of *kugak* (traditional Korean or national music), cultivated as South Korea's national heritage art. They stated that Korean music in China combined *chŏnt'ong* (old tradition) with *hyŏndaesŏng* (contemporary or modern characteristics). If South Korean *kugak* and North Korean *chuch'e ŭmak* (a post-1960s creation of North Korean national music based on *chuch'e sasang*—self-reliance—ideology) represent a contrast of maintained tradition versus progress, Chaoxianzu music fuses the merits of these two Korean musical streams, with the addition of Chinese influences. Having no previous experience of Chaoxianzu music—of which audiovisual recordings or literary documents were rarely available outside China at the time—I was not sure how to imagine the sound of the Korean music that these musicians were describing, nor was I fully convinced by their characterization of Chaoxianzu music as having more modern or contemporary components than *kugak,* some of which has also reflected a clear synthesis of traditional sounds with foreign, mostly Western, musical influences over the last two decades. Indeed, *kugak* musicians' keenness to contemporize the sound had noticeably increased, leading to a boom in *ch'angjak kugak* (creative *kugak*) or *p'yujŏn kugak* (fusion *kugak*) in South Korea. I started to ask myself a lot of questions. With the Chinese and North Korean socialist governments going in a similar direction with their communist spirit of cultural reformation, how did musical modernization in China differ from North Korea? And how, then, would Chaoxianzu music differ from the North Korean construction of national music? To what extent has Chaoxianzu music been able to maintain "Korean traditions" while at the same time modernizing them? Doesn't the idea of maintaining cultural traditions contradict the fundamental ideology of communist governments, which largely reject the legacy of feudalism and ethnocentrism that might lead to national factionalism, especially during the proletarian revolution? More fundamentally,

given the paradoxes of discursive modernity practiced in various parts of the world with a range of different interpretations, how do Chaoxianzu musicians make sense of the innate discrepancy between the modernity that they attribute to their music and the social reality that they experience as citizens of the PRC and as ethnic Koreans, shuttling back and forth between the economically reforming state in which they have long lived and their ancestral home, which since the 1990s has presented them with better financial opportunities? Inspired by these questions, I began my navigation of the Chaoxianzu community, its music, and its processes of identity construction.

In establishing a strong socialist state in 1949, the PRC instituted its minority nationality policy and assured all minorities within its borders of their right to perpetuate their own ethnic traditions and to have political autonomy under the jurisdiction of minority autonomous governments. The policy was never intended to offer independent empowerment separate from broader state directives. Minority cultural and political autonomy was only allowed within the frame of conforming to communist ideology and supporting the realization of a great socialist revolution in China. Therefore, in order to conform to the socialist cultural agenda, all minority nationalities had to reform their ethnic traditions and distinctive cultural practices. Symbolic and expressive cultures such as music and dance were no exception. In fact, they came in rather handy as mediums for spreading and reinforcing socialist didactics. Thus, Chinese minority nationality performing arts went through a series of reformations and constructions throughout the second half of the twentieth century, in conformance with the state's emphasis on social progress and proletarian identity.

As one of the PRC's minority nationalities, Koreans in China were thus required to be explicit about their cultural identity and construct ethnically distinctive music that would encapsulate their Korean and Chinese cultural backgrounds. Broadly speaking, Chaoxianzu music in China can be divided into three time periods: before and after the socialist revolution, and the post–Cultural Revolution reform era. If the Korean music prior to the revolution was largely a reflection of the folk and popular music brought from Korea as part of the cultural knowledge and memory of migrants, and later as musical recordings imported from the motherland, the Korean music since the revolution has largely been a product of diasporic construction aimed at expressing Korean (minority) identity and socialist citizenship. Traditional (Han) Chinese music and folk identity were dramatically reshaped over the twentieth century under such influences as nineteenth-century Western music idioms, early twentieth-century modernist ideology, and later the cultural progressiveness underpinning socialism, and Chaoxianzu music—as well as the musics of other ethnic minorities in China—followed a similar path. As described by the two Chaoxianzu musicians I encountered in Seoul, the creation and transformation of Korean music in the PRC is

characterized with its *hybridity*, combining ethnic cultural traditions with various foreign and Chinese cultural and ideological influences.

In the creation of Chaoxianzu music, Koreans in China not only relied on Korean music originally brought into China but also substantiated the content and practices of their traditional music cultures through active interaction with North Korea. Uniquely positioned between the PRC and North Korea, Chaoxianzu collaborated with and were assisted by North Korean artists to perpetuate and solidify a diasporic Korean identity. Later, when cultural interaction between the PRC and South Korea resumed along with the Open Door policy of Chinese reform government, Chaoxianzu realized that Korean performance cultures shaped under socialist governments were far different from what had been cultivated in the South. For that reason, since the 1990s, an increasing number of Chaoxianzu musicians have visited South Korea or have invited South Korean musicians to come to China to broaden and enrich the scope and practice of Chaoxianzu music. South Korean maintenance of older traditional Korean culture has thus become one of the strands feeding into Chaoxianzu's own musical creation.

As described above, not only has Chaoxianzu music been shaped by the context of migration and influenced by the cultural directives of the Chinese Communist Party (CCP), it manifests how its musicians and community have been responsive to internal as well as broader social transformation in Northeast Asia. Chaoxianzu music thus cannot be comprehended without taking into account the multitudes of social powers and shifting national and diplomatic relations, and how they influenced and were negotiated by musical agency, especially against state power and the role played by state institutions in the creation and cultivation of ethnic minority music in China. Moreover, despite the apparent and strong state cultural backdrops, Chaoxianzu's own creativity and cultural interpretation should not be overlooked since they also have "helped to redefine, or even subvert, the boundary of state ideology to create the artistic expressions that reflect their hybrid culture and multiple identities" (Um 2004b, 55).

Despite my keen interest in learning about Chaoxianzu music, my participant-observation research in the field did not unfold as smoothly as I had hoped when I first visited Yanbian in 2003 and in the following two years when I spent a longer period there as a researcher. Yanbian in the mid-2000s was affected by a new and fervent interest in financial opportunity and the accumulation of monetary wealth. With the PRC's reform government's implementation of market capitalism and private ownership into its socialist economic system, the impact of capitalism across China was swift. Now economic progress was sought after more than any of the other social, cultural, and political imperatives previously emphasized in China for the realization of social revolution.

In contrast with the emphasis on building the economy at both the state and individual levels, investment in arts and culture had not grown at a similar pace, although government patronage and the state's cultivation of arts and culture did continue. Due to rising inflation over the last twenty-five years since the start of the Age of Reform (1978–), the salaries that government-employed musicians and artists received in China were never sufficient and viewed as providing only partial financial security. Overall it was difficult to find live-music stages for Chaoxianzu *art* music, especially those open to public audiences who could buy tickets out of their own interest in the arts. Most of the production of Chaoxianzu art music continued to be narrowly confined to state institutions. Even so, spending more than six consecutive months in Yanji City, I was only able to see the Yanbian Song and Dance Troupe perform twice. With help of Kim Sŏngjun, then a professor in Chinese music history at Yanbian Arts School, I acquired invitation-only tickets distributed to people who were on a VIP list or related to the troupe. According to Kim, large state ensembles like the Yanbian Song and Dance Troupe or Yanji Chaoxianzu Arts Troupe rarely offered or advertised regular concert series for local audiences. Instead they performed at state- or municipal-level celebrations such as the Chinese New Year Festival or the Founding Day of Yanbian Korean Autonomous Prefecture. As in many other places in the world, the sustainability of arts and cultural troupes in China cannot depend on ticket sales, especially those large and small ensembles specializing in Chaoxianzu art music, for whose performances local audience attendance and patronage could hardly be expected. However, when rich patrons like local business organizations or companies were willing to sponsor performances by state ensembles, these were organized specifically for patrons and their guests on an invitation-only basis.

This situation of live-music production in Yanbian being so rare was very challenging for me, especially since, having a strong interest in Chaoxianzu instruments and instrumental pieces, my intention was to study a range of Chaoxianzu music. Chaoxianzu live performance opportunities for smaller-scale ensembles or individual recitals seemed to be slightly better than for the large ensembles, but event information was only shared among the circle of people who knew the musicians or sponsoring organizations. Thus all live-music performances that I was able to observe in Yanbian were presented by the Yanbian Song and Dance Troupe or by the Yanbian Arts School and produced by the Yanbian Radio and Television Broadcasting Station, where I was able to build some personal contacts and gain the privilege of attending studio recording sessions as their guest.

As the state institution dedicated to the teaching of Chaoxianzu music and arts, the Yanbian Arts School was the hub for the shaping of Chaoxianzu performing arts and its transmission to the next generation. By accessing the

school's teaching and learning resources, I collected both ethnographic and archival data on Chaoxianzu music. I spent a lot of time in the school's library, browsing and reading their collection on Chaoxianzu as well as North Korean music. I observed student music lessons, recitals, and seminars and interviewed and conversed with music staff and students. As part of my participant-observation research, I also took lessons in *so-haegŭm* (four-string spike fiddle invented in North Korea) with Pak Hakch'ŏl, who was then the sole instructor at the school for this instrument, which had been slowly gaining the musicians' favor over the *yŏnbyŏn'gŭm* (four-string spike fiddle invented in Yanbian; also called *illamgŭm*).

Overall, my research on Chaoxianzu music was inevitably confined to and shaped by the resources available through state and municipal institutions such as Chaoxianzu performance troupes, the music school, mass media, and musicians formerly and currently affiliated with those music-related government sectors.

In comparison with the art music scenes, Chaoxianzu popular music seems to be relatively more vibrant and widely consumed, with greater permeation into Chaoxianzu lives thanks to mass media and technology. Walking along Park Street (Kongwŏllo; Gongyuanlu) to People's Street (Inmillo; Renminlu) in a stretch from Yanbian University to the old market district in Yanji, I readily observed a proliferation of shops and street vendors carrying musical recordings produced by local, national, and foreign companies, which provided a good cross-section of local tastes. Amid Chaoxianzu, Chinese, and North and South Korean songs floating in the soundscape of Yanji's commercial hub, the current hits were K-pop songs from South Korea, like singer Chang Yunjŏng's 2004 hit "Ŏmŏna!" [Oh Dear!]. In China Chaoxianzu have been inclined toward the latest South Korean popular songs and idols since the 1990s (Pease 2006, 141–143). However, against the influx of South Korean, Chinese, and Western popular songs into Yanbian, Chaoxianzu as well as North Korean songs were also in steady demand (see chapter 6). The Korean music collection at the Yanji store of Xinhua Shudian (Xinhua Bookstore, the PRC's largest bookstore chain) was composed almost entirely of vocal music. The Chaoxianzu music offered there—in the form of VCDs, CDs, and cassette tapes—was produced by a single company, the Jilin Nationality Audio-Visual Publishing Company (JNAPC), also owned by the government.

Mixed in with the Chaoxianzu music collection were North Korean audio-visual recordings imported via the JNAPC. While South Korean music commodities were prioritized in Yanji's newly opened department stores and by street vendors dedicated to selling music, films, and TV dramas, the mixed offerings of Chaoxianzu and North Korean music at Xinhua Shudian is an obvious sign of the historical and continuing relationship between the Chaoxianzu community and North Korea.

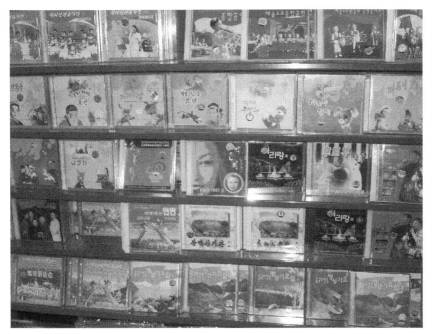

Figure 0.1 Korean music collection in Xinhua Bookstore, Yanji, China, 2005. Photo by author.

The state-run mass media organizations, such as the Yanbian Radio and Television Broadcasting Station, were surely essential in maintaining the vibrancy of Chaoxianzu music in terms of its production and dissemination. Chaoxianzu singers, whether specializing in traditional Korean genres such as *p'ansori* (traditional sung drama) or *minyo* (Korean folk songs) or in contemporary art songs or popular music, found more regular and frequent performance opportunities in the music programs featured on the television and radio stations, whereas Chaoxianzu instrumentalists were less frequently featured in the broadcast media, tending to appear as accompanists to Chaoxianzu singers wanting to feature traditional Korean or Chaoxianzu ethnic cultures. In general vocal music has been privileged in socialist states as a tool of political propaganda and still is today, albeit for differing reasons and with different effects (see chapter 6). As songs were commoditized and promoted through the government-sanctioned mass media and recording company, Chaoxianzu songs were disseminated to wide audiences in and outside of the Korean autonomous cities, counties, and towns.

Overall, researching Chaoxianzu music in China in the early twenty-first century was difficult and intensified by anxieties over lacking or discrepant data, which—even if available—were not easily accessed by a foreign scholar,

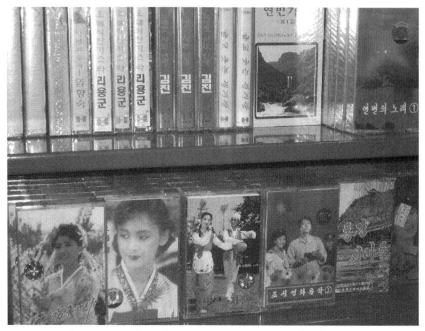

Figure 0.2 Chaoxianzu and North Korean cassette tapes displayed in Xinhua Bookstore, Yanji, China, 2005. Photo by author.

even a Korean one like me, due to a lack of social connections or simply the loss or poor status of music publications and archives. Nevertheless, I felt encouraged to persevere in my field research there by my encounters with people both in and outside the Chaoxianzu music scene. Whether these were brief meetings or relationships that extended over time, I learned much about Chaoxianzu music from the many people who shared their experience and viewpoint with me in affirming their distinctive cultural identity as diasporic Koreans, especially in terms of who they are and what they do as *Koreans in China,* individually and collectively, as distinct from other groups of Koreans and other Chinese nationalities.

Chaoxianzu, Migration, and Identity

As a native South Korean who has spent more than thirty years in the United States and New Zealand as an international student and then a transnational migrant who maintained close contact with the homeland, I have inevitably become conscious of and engaged with issues of identity, social categorization, and ethnic inequity. I became mesmerized by the complexity and politics of

identity of diasporic Koreans in China, who constantly have to physically, psychologically, and culturally configure themselves in their interactions with multiple states, including China, South Korea, and North Korea, where the lines between home, homeland, and host society can be very blurry indeed.

The term "diaspora" first appeared in the Greek translation of the Bible, from the root meaning to disperse, sow, or scatter. It was originally used in reference to the Greek colonization of Asia Minor and the Mediterranean in the Archaic period (800–600 BCE) and to the dispersal of the Jews and Armenians (Cohen 1997, 117). Its semantic terrain has greatly expanded over the last century to include a multitude of meanings covering a great variety of cases of dispersal observed at the global level, historically and in contemporary times. In her edited volume *Diasporas and Interculturalism in Asian Performing Arts* (2004), ethnomusicologist Haekyung Um (2004a, 2–4) summarizes various competing definitions of the term "diaspora" as suggested by a number of scholars including Tölölyan, Safran, Van Hear, Cohen, and Clifford, to name a few. Although not all definitions are a perfect fit for the case of Koreans in China, several of them confirm that the complexity that I observed with Chaoxianzu migrants prevails in many other diasporic groups. Chaoxianzu are a people resulting from historical movements of their ancestors, and many of them have continued to migrate within or beyond China. While Tölölyan's expansive definition of diaspora suggests that the term embraces various categories of people such as "immigrant, expatriate, refugee, guest-worker, exile community, overseas community, [and] ethnic community" (Tölölyan 1991, 4–5), Van Hear (1998, 6) emphasizes the movement of people and their persistent sociocultural exchange between the homeland and the new host as the features of diaspora. Based on these definitions, Chaoxianzu ticks off several types of diasporic groups—immigrant, expatriate, guest worker, exile community—while maintaining a more or less consistent connection with the North or South Korean homeland, by exchanging labor as well as cultural resources. Safran, on the other hand, suggests that the definition of modern diaspora extends to embrace expatriate minority communities that have certain features:

1) they, or their ancestors, have been dispersed from a specific original "center" to two or more "peripheral," or foreign, regions; 2) they retain a collective memory, vision, or myth about their original homeland—its physical location, history, and achievements; 3) they believe that they are not—and perhaps cannot be—fully accepted by their host society and therefore feel partly alienated and insulated from it; 4) they regard their ancestral homeland as their true, ideal home and as the place to which they or their descendants would (or should) eventually return—when conditions are appropriate; 5) they believe that they should, collectively,

be committed to the maintenance or restoration of their original home-land and to its safety and prosperity; and 6) they continue to relate, personally or vicariously, to that homeland in one way or another, and their ethnocommunal consciousness and solidarity are importantly defined by the existence of such a relationship. (Safran 1991, 83–84)

The first three features as well as the last at least apply to the Chaoxianzu experience, their movement, memory, perception, and recognition of who they are. Interestingly, in contrast to increasingly expansive definitions of diaspora, Clifford in particular distinguishes diaspora from immigrants:

Diasporic populations do not come from elsewhere in the same way that "immigrants" do. In assimilationist national ideologies such as those of the United States, immigrants may experience loss and nostalgia, but only en route to a whole new home in a new place. Such ideologies are designed to integrate immigrants, not people in diasporas. Whether the national narrative is one of common origins or of gathered populations, it cannot assimilate groups that maintain important allegiances and practical connections to a homeland or a dispersed community located elsewhere. Peoples whose sense of identity is centrally defined by collective histories of displacement and violent loss cannot be "cured" by merging into a new national community. (Clifford 1997, 250)

Here Clifford defines a diaspora as a group that maintains a strong connection with its own homeland or coethnic groups, and that shares collective histories of displacement and violent loss; immigrants, on the other hand, tend to merge into a new nation with some experience of loss and nostalgia. While Clifford distinguishes voluntary "immigrants" from diaspora by pointing out that the experiences of forced migration are essentially different from those of voluntary migration, he does not much address the fact that migration can never be complete but is always *in progress*. A diaspora can have roots in a community in forced exile while having become voluntary immigrants, subjectively shaping and reshaping their relationships with the homeland and/or host societies, which do not have to be a singular state (Reyes 2014). In the case of Chaoxianzu, the majority of early migrants may be seen as "diaspora" in Clifford's sense. However, those who took the "return migration" route to South Korea later for various practical as well as psychological reasons (Tsuda 2019) describe their migration with numerous unhappy stories, social alienations, and subsequent disappointments that hinder their assimilation at both systematic and psychological levels despite the fact that they have moved to (so to speak) their ancestral homeland (see chapter 7).

Given the myriad of cases of diaspora and thus competing conceptualizations of dispersed people in late modernity, Stuart Hall (1994) turns our attention to the construction and expression of diasporic identity in the context of migration. He argues that the cultural site of diasporas should be viewed as creative spaces where diasporic lifeways are hybridized, intentionally or not (Hall 1994; Um 2004a, 1)—just as the diasporic identity of Koreans in China is constructed as a syncretizing of influences from China, prepartition Korea, and the two ideologically split Koreas.

Yanbian is located in China's Northeast region bordering on Russia and Korea. Like many other frontier areas such as the U.S.-Mexico border, the Irish border, and the borders of eastern European nation-states, Yanbian was historically a geopolitical and cultural border zone where Chinese, Russian, and Japanese imperial powers confronted one another from the early twentieth century. Even today, it continues to be a cultural contact zone in which China, North Korea, and South Korea encounter and intersect with one another, each carrying its own version of the histories, cultures, positions, and understandings of the others. While the study of borders has emerged as a new topic in the social sciences over the last three decades, many studies use terms such as border, borderland, or border zone loosely, and different branches of scholarship take different approaches in exploring the topic:

> Over the last decade "borders" and "borderlands" have become increasingly ubiquitous terms in the work of a wide range of academics and intellectuals including journalists, poets, novelists, artists, educationalists, literary critics and social scientists. . . . But while this convergence of interest might indicate agreement about a topic of importance and significance, the terms are used in so many different ways as to suggest that it is not one topic but many. Social scientists occasionally claim precision, though even they employ a range of terms—border, borderland, border zone, boundary, frontier—which sometimes pass as synonyms and at other times identify quite different phenomena. (Donnan and Wilson 1999, 15)

Among many different ways to conceptualize and define it, border can at least mean a geopolitically drawn space where two or more different cultures, peoples, and ways of living make contact. Clifford (1997) describes this zone of contacts—"blocked and permitted, policed and transgressive"—as a "borderland" (8), while Renato Rosaldo states that a border or borderland is not necessarily a physically embodied line or space but can be socially and conceptually drawn, like those boundaries around sex, gender, class, race, nation, ethnicity, and age (Rosaldo 1993, 207). Donnan and Wilson argue, on the other hand,

that when borders are contacted, transcended, and challenged, they become creative spaces for making new definitions and identities:

> State borders in the world today not only mirror the changes that are affecting the institutions and policies of their states, but also point to transformations in the definitions of citizenship, sovereignty and national identity. It is our contention, moreover, that borders are not just symbols and locations of these changes. . . . Borders are also meaning-making and meaning-carrying entities, parts of cultural landscapes which often transcend the physical limits of the state and defy the power of state institutions. (Donnan and Wilson 1999, 4)

Based on Donnan and Wilson, a border or borderland is more than a transitional space or interface of different cultures; more importantly, it is a productive and creative place for shaping new culture and meanings out of and through those contacts and interfaces. Yanbian's geopolitical particularity as a borderland can be viewed as a significant factor that makes this place extraordinary as a culturally creative space in addition to the fact that it, historically having been a thinly populated area until the mid-nineteenth century, became filled with the waves of migrants who moved from inland China as well as foreign countries such as Korea, Japan, and Russia (see chapter 1). Resonating with Hall's (1994) previous characterization of the site of diasporas with almost inevitable yet meaningful hybridization of diasporic lifeways, Yanbian articulates its conduciveness to cultural creativity both as a borderland and a site of diasporas. Indeed, Chaoxianzu have been displaced into a geographical, social, and cultural border zone, in which as a diasporic agent they have had greater opportunities to perform their creativity and productivity in terms of who they are, what they construct, and how they want to establish relations with their host country, their ancestral homeland, and other countries.

As I looked into this area over multiple trips to Yanbian, I noticed that an essentialist view of Chaoxianzu music, characterized as a combination of tradition and modernity, prevailed throughout Yanbian and was almost uniformly cited by Chaoxianzu musicians and cultural officials alike in China. While such a narrative was certainly contestable, it also served as intellectual inspiration, guiding me and shaping my research as I investigated how and to what degree tradition and modernity are mixed into the sound of Chaoxianzu music, and in what way cultural hybridity or syncretism has become the most obvious characteristic of this diaspora.

When music and other cultural traditions are displaced into different locales, they come to carry different meanings and values for creators, performers, advocates, and audiences. More specifically, being part of a Korean

diaspora takes on different meanings and values from being Korean at home. In the context of displacement, not only is ethnic culture used as a means of marking one's own or one's group identity, it also provides a significant context for negotiating and shaping new meaning, that is, a unique diasporic identity as a group or individuals who went through particular experiences of migration (Hall 1994). Like many other diasporic groups, Koreans in China have altered, negotiated, or newly created their cultural identity as they have settled down in China and shaped themselves as one of the state's ethnic minorities. Koreans in China were once voluntary migrants who left Korea attracted by the economic opportunities that empty land in Northeast China represented. Some of them became exiles or forced migrants when the possibility of returning to South Korea was later cut off with the outbreak of the Cold War and the subsequent partitioning of the Korean Peninsula.[1]

Ethnomusicologist Adelaida Reyes (1999a) introduced the term "migrancy" to describe the phase of migration that engenders new cultural production. For her, migration is distinct from migrancy in that migration refers to "the movement of people, their goods and their ideas," while migrancy refers to "a state that grows out of and develops both as consequence of and as part of that movement. . . . Migrancy directs the observer's attention not just to where migrants have gone and where migrants have been but, perhaps more importantly, to the emotional, psychological, and *creative behaviors* that are the products of those moves" (206; italics added).

Reyes' conceptualization of and emphasis on "migrancy" point up several important aspects of performance cultures such as music and dance that are pertinent for the study of migration. As a manifestation of *creative behaviors*, performance culture is a window to the minds, emotions, and behaviors of the migrants, and thus it reflects the significant meanings of migration and the values of migrant lives, explicitly or implicitly, as an expressive art resulting from the movement of people and their settlement in a specific context (Reyes 1999a). Moreover, in investigating music as a salient example of what migrants do along with and as part of their migration, the types of displacement and its journey and experience of movement cannot be overlooked since they affect the overall lives of migrants (Reyes 1986, 1989, 1999a, 1999b; Baily 2005) and the relationships they form with their homeland, and their host society and its cultures. Um (2004a, 6) points out how different cases and conditions of migration lead to different shapings and revisions of ideas of the homeland and its traditions.

Migration encourages people to think about their belonging and recognize their relationship to other members of their social group with whom they interact in the new context. Therefore, the issue of self and the construction of identity are particularly pertinent to the study of migration. The pairing of identity and migration has grown since the introduction of the concept of "identity

crisis" by the well-known psychologist Erik Erikson, who himself was a migrant from Europe to the United States (Reyes 2014). Erikson (1963, 1968) initially coined this phrase in the context of developmental psychology to describe the stage of identity confusion experienced by people who are in the process of "finding themselves" and who haven't completed the job, ideally with confidence and certainty, before they enter adulthood. Later, historian Philip Gleason picked up Erikson's idea of "identity crisis" and applied it to his study on American identity, describing "identity crisis" in its modern sense as a condition that "seemed to grow out of the experience" of migration (Gleason 1980, 31; quoted in Reyes 2014, 111). Since then, identity has gained increasing attention in scholarly research as a significant social process that most migrants experience one way or another.

Fredrik Barth (1969) states that identity ascription is founded upon the perception of difference, and Reyes echoes and extends Barth in her assertion that "the perception of difference sets off the interplay between human actors who enact their differences and, in so doing, create a boundary between Self and Other, between belonging and non-belonging. The *Self* is thus defined through differentiation from an *Other,* in an *environment* or a *context* in which their perception of each other as different is articulated, communicated and enacted" (Reyes 2014, 106; italics in original). Displacement certainly heightens people's sense of the similarities and differences between "us" and "them." In this regard, migration triggers "identity" and the "identity-making" process, through which the old and new experiences of the migrants are negotiated, reconciled, and hybridized.

Identities are expressed differently in different contexts, more as a process of negotiation than a form of inheritance (Clifford 1997). In the case of Chaoxianzu, the perception of difference and the articulation of ethnic selves have been affected by both place and time, and by their shifting inter- and intra-ethnic relationships. As mentioned earlier, Korean migration to China began during the second half of the nineteenth century, at a time when the Sino-Korean border was not as firmly delineated as today. At that time, any non-Manchurians, including Koreans and Han Chinese alike, were considered to be new settlers and foreign to China's Northeast region. When the PRC was founded, Koreans were officially distinguished from the Han majority and other minority nationalities, and upon their acceptance of Chinese citizenship were recognized as a major demographic group in Yanbian. Chaoxianzu, as legal subjects of the PRC, have constructed themselves as both diasporic Koreans and a Chinese ethnic minority, distinct and distinguishing themselves from other ethnic groups in China and from Koreans in North and South Korea, as well as from other overseas Koreans. Given this complex registration of Chaoxianzu on both historical and contemporary sociocultural spectra, their "sense of self and belonging" has inevitably become plural, multiple, and

political, depending on each individual's imagination and reflection of their relationships to the state and the two ancestral nations.

Diasporic Agency

In general, music in twentieth-century China, especially work produced in the period between 1949 and 1980, has often been characterized as an art of collective production and as ideologically dictated rather than as an expression of individualism or creativity. However, as pointed out by Raymond Williams (1977), "hegemony" is not a static "structure" external to individuals but is rather "the whole lived social process" (109), and a "complex of experiences, relationships, and activities, with specific and changing pressures and limits. . . . It does not just passively exist as a form of dominance. It has continually to be renewed, recreated, defended, and modified. It is also continually resisted, limited, altered, challenged by pressures not at all its own" (112). The hegemonic arts, even when strongly oriented by a political entity for its own purposes, are not and should not be viewed as completely autonomous from the input of individuals, whether they represent an "articulate upper level of 'ideology'" or the "pressures and limits" of a "specific economic, political, and cultural system" (110) that they experience every day. The artistic or musical individuals shape the arts, a *social process,* though with different degrees of subjectivities, as producers, practitioners, and audiences. In Williams' sense, a hegemonic structure and the individuals operating within it are symbiotic rather than unilateral imposition characterized by domination and subjugation, although the power of individual agency might be different from that of social hegemony. Along the same lines, anthropologist Sherry Ortner (2006, 2) not only emphasizes the dialectics of social construction but also points out the permeable and flexible nature of social agents, describing ethnographic subjects as not "timeless and pristine objects, but . . . themselves products of the restless operation of both internal dynamics (mostly local power relations) and external forces (such as capitalism and colonialism) over time" (9). In both Williams' and Ortner's arguments, ethnographic subjects, including musicians, should be viewed as socially constructed and also actively constructing agents, especially those who occupy the social margins, such as immigrants and ethnic minorities.

To understand diasporic agency, Aihwa Ong's (1996) idea of "cultural citizenship" is also useful in the sense that citizenship is both a culturally shaping process and a process shaped by cultures, through which social agents make themselves over and are made "within webs of power linked to the nation-state and civil society" (738). Ong notes that becoming a citizen involves both state "governmentality" and individual subjectivity. Depending on who they are and how they are

constituted as cultural and social individuals, people, whether minorities or migrants, provide their own input into the process of transforming themselves or being transformed as citizens of a society. Informed by the aforementioned theories, this book illuminates Koreans in China as a group who were not merely responding to the PRC's cultural imperatives by reforming and reshaping their music and identity either as independent or institutional members; they were also actively engaging in the reformation process as they made themselves over culturally and were making themselves into subjects of the new Chinese nation-state.

About This Book

This book examines how political ideologies and music came together to produce and shape the distinctive social and cultural identity of diasporic Koreans in China, paying significant attention to the history of Korean migration to China, the formation of the Chaoxianzu community, and the diasporic agency—the individuality, creativity, and subjectivity—of Chaoxianzu musicians. In order to discuss this, I first delineate the history of Korean migration to China and how the Korean migrant community became a national minority upon the establishment of the PRC in 1949 (chapter 1). Historically, Yanbian was a politically and conceptually ambiguous region. The tension between the Qing (1644–1912) and Chosŏn (1392–1910) dynasties over territorial ownership provided considerable motivation for early Korean migration to that region; this tension continued through the twentieth century and persists even today, with the region politically and socially contingent as the PRC's northeastern border to the Russian Far East and Korea. Yanbian has continued to offer a unique environment in which Chinese, Chaoxianzu, North Koreans, and South Koreans can interact outside their nations' political divisions.

Chaoxianzu music, which I experienced in and outside of Yanbian, is distinctive not just as the sound of a diaspora but, perhaps more importantly, because it has been continuously situated within—yet simultaneously transcending—political and cultural boundaries in both historical and current times. Chapter 2 traces the history of Korean music in China, beginning with its initial introduction by migrants in the late nineteenth century and moving to the construction of Chaoxianzu music, a phenomenon that largely unfolded after the establishment of the PRC. This historical chapter aims to arm the reader with an understanding of the particular musical gestures and inclinations adopted by the Chaoxianzu musicians and cultural leaders who were actively engaged in the production of Korean minority music under the social and ideological milieu that emerged from the early 1950s. Chapters 3 to 7 present major ethnographic data, each chapter illuminating different phases and aspects of Chaoxianzu

music and the contributions made by Chaoxianzu musicians. The musicians featured are discussed in terms of how they have responded to national and local governments' cultural directives in generating their own creative input according to their own vision of what Chaoxianzu music is or should be. Chapter 3 examines the activities of Chaoxianzu intellectuals and musicians who were affiliated and worked with minority nationality performing arts organizations and educational institutions. Without strong or in-depth backgrounds in traditional Korean music, how did these Korean minority intellectuals and musicians engage with and create Chaoxianzu music as a demarcation of their community and ethnic identity, and why did they make these choices? This chapter presents a range of musical examples to analyze the ways in which Korean traditional music was combined with Han Chinese adaptations of Western and socialist practices while also promoting Korean folk cultures and worker identity. Chapter 4 focuses on Chaoxianzu *kayagŭm* (Korean zither with twelve to twenty-five strings) players affiliated with the Yanbian Arts School, the sole state school in the performing arts for Chaoxianzu youth, and how these musicians acted as important cultural agents in the development of Chaoxianzu *kayagŭm* music between the 1950s and 2000s. Chapter 5 introduces Chaoxianzu music troupes (i.e., the Yanbian Song and Dance Troupe and the Yanji Chaoxianzu Arts Troupe), some of their composers and musicians, and a range of their compositions and related philosophies. Analyzing these musicians' discourses about their music as well as about Chaoxianzu identity, I show how diasporic Korean musicians in China express their ethnic distinctiveness in their programming choices or in their projection of a particular musical language. Stylistic and compositional variables in Chaoxianzu music are closely related to individual musicians' own ideas about the Korean sounds and the underpinning ideologies of the different performing arts organizations with which Chaoxianzu composers are affiliated.

Chapter 6 is dedicated to Chaoxianzu singers whose songs were frequently broadcast by state media and produced into musical commodities by the Chaoxianzu recording company, JNAPC. Chaoxianzu songs have been widely circulated within and beyond the autonomous prefecture in mass media and micromedia formats, that is, television channels, radio stations, and cassettes, VCDs, and CDs. While pre-1980 Chaoxianzu songs were largely Korean folk songs and revolutionary propaganda songs, post-1980 Chaoxianzu songs have lyrics that convey daily lives, local places, romance, and nostalgia, topics the local audience can closely relate to. With a focus on Chaoxianzu songs composed for and consumed by locals, this chapter examines how Chaoxianzu identity is essentialized through sonic, lyrical, and visual representations.

The last chapter discusses how Chaoxianzu musicians move between China and Korea, transcending cultural borders by representing Chinese, North

Korean, and South Korean constructions of music. Since the early 1990s a massive return migration of Chaoxianzu to South Korea was primarily driven by economic and financial interest. However, more than a few Chaoxianzu music students and academics came to South Korea interested in learning Korean music cultivated in South Korea. These musicians not only reshape the musical landscape of both Chaoxianzu and South Koreans but also point to the irony of categorizing ethnic Koreans according to their different cultural and political backgrounds.

Finally, the book ends with reflections on Yanbian, at once having the largest concentration of Koreans in China and a geopolitical and symbolic borderland situated between China and the Koreas. Despite the ironies and disjunctures that Chaoxianzu have experienced both in Yanbian and Korea, this study shows how "diverse cultural repertoires" can be produced without "identity confusion" (Rosaldo 1993). Chaoxianzu musicians whom I met on this research journey were very clear about their distinct identity as Korean Chinese. At the same time, they acknowledged that they could flexibly shift between and beyond the state, national, and cultural borders. As noted by Rosaldo, "Creative processes of transculturation center themselves along literal and figurative borders where the 'person' is crisscrossed by multiple identities" (216). This study of diasporic Korean music in China illustrates how the cultural politics of diaspora suggests the possibility of diversification, reconfiguration, and the permeability of a nation and ethnicity as the people flexibly and pragmatically move across ideological and political boundaries. Using Chaoxianzu music as a case in point, I show that, against the institutional and hegemonic act of differentiating and categorizing national and ethnic members, human agents are never passive or uniform in constructing and expressing who they are and what they want to be. Rather, they creatively find ways to manifest their identity. This is exemplified in Chaoxianzu music in the form of hybrid cultural signs that Korean minority musicians in China have created, drawing from the cultural and social accessibility they enjoy across China and the two Koreas.

China's Northeastern Border and Korean Migration to China

O<small>F</small> all countries, China was the one with the largest number of transnational Korean residents until 2017.[1] Between the 1860s and the 1940s, about two million Koreans migrated to China in search of economic opportunity and political stability. Settling primarily in China's northeastern region in close proximity to northern Korea, the migrants were able to move back and forth between the two countries with little difficulty throughout the first half of the twentieth century. When Korea was liberated from Japanese colonial rule in 1945, a sizable number of Korean migrants chose to remain in China, for various practical reasons. Instead of returning to Korea, with its ominous signs of civil war, the majority of Koreans in China—who were tenant farmers or had peasant backgrounds—allied with the People's Liberation Army, which promised them landownership and political and cultural autonomy upon the victory of the Communist Revolution. When the Chinese Communist Party (CCP) took control of mainland China in 1949 and founded the People's Republic of China (PRC), Koreans there accepted the legal citizenship status offered by the new government, along with an official ethnic minority name, Chaoxianzu, and were granted the right to their own autonomous government over a territory designated as Yanbian Korean Autonomous Prefecture (see map 1.1).

Today, these early Korean immigrants are distinguished from North and South Koreans arriving later, especially since the establishment of diplomatic relations between the PRC and South Korea and the start of a major process of privatization of the PRC's state enterprises in the mid-1990s by Deng Xiaoping and his successors, who welcomed private and foreign investors.[2] Altogether, about 2.3 million Koreans are presently living in China, broadly affiliated with three different nation-states: China, North Korea, and South Korea.[3]

In this chapter, I delineate the history of Korean migration to China by exploring Northeast China as a geographic, political, and cultural borderland

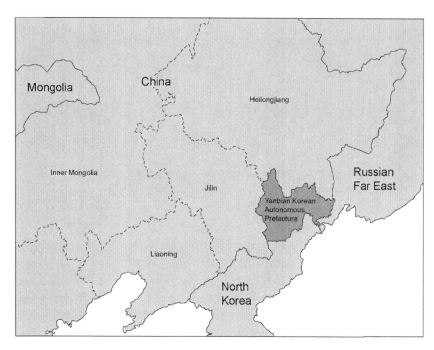

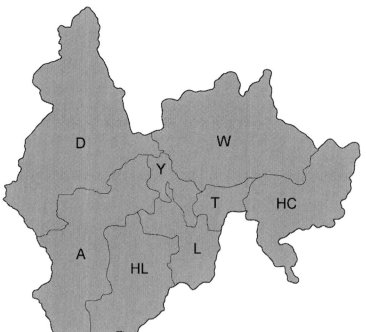

Map 1.1 Map of Yanbian, China (A: Antu; D: Dunhua; HC: Hunchun; HL: Helong; L: Longjing; T: Tumen; W: Wangqing; Y: Yanji)

and examining how these Korean migrants became one of the PRC's official ethnic minorities. While Yanbian has offered a unique sociocultural space for unofficial contact between North and South Koreans since the early 1990s, the region's liminality has far older origins. In fact, as China's northeastern frontier bordering the Russian Far East and Korea, it lured the early Korean migrants whose life in Korea had become difficult for various reasons. I explore the region's historical dynamics and political ambiguities in discussing why Koreans moved to and settled down in that region.

China's Northeast Border and Korean Migration

The greatest concentration of Koreans in China has been in the northeastern area formerly known as Manchuria, today consisting of the three provinces of Heilongjiang, Jilin, and Liaoning (see map 1.1) and collectively known as Dongbei Sansheng, or simply Dongbei. The eastern and southern edge of Dongbei borders Russia and North Korea. Jilin and Liaoning are adjacent to Hamgyŏng and P'yŏngan Provinces in North Korea (see map 1.2), whose border with China runs along two rivers, the Tumen and the Yalu. While the choice of this particular region for Korean settlement presumably was driven, at least in part, by its geographic proximity to Korea, geopolitical factors also came into play as the region was greatly affected by a series of political disputes and divergent power struggles that went along with the development of various nation-states in East Asia.

Koreans, who knew the area as Kando, may have viewed it as the least foreign part of China. Today's Northeast China was part of the territory of the two ancient Korean kingdoms of Koguryŏ (37 BC–AD 668) and Parhae (AD 619–926). Koguryŏ encompassed the southern parts of modern-day Jilin and Liaoning Provinces between the fourth and seventh centuries AD (C.-J. Lee 1986, 15). Parhae, whose territory was similar to that of Koguryŏ, also included Kando, the northern half of which, known as Pukkando, corresponds to the Yanbian Korean Autonomous Prefecture today. In contemporary China, Jiandao, the Chinese pronunciation for Kando, is little used, since the name is viewed as a reminder of Japanese rule over the area in the early twentieth century; instead the Chinese prefer to refer to the region as Yanbian. In contrast, Kando continues to appear in Korean popular and historical literature depicting Sino-Korean border dynamics as well as the lives of early twentieth-century Koreans in that region. Although a long time has passed since the rule of Koguryŏ and Parhae, some Koreans, especially those with nationalist views, continue to show great interest in the region, claiming a direct connection between those ancient kingdoms and contemporary Korea.

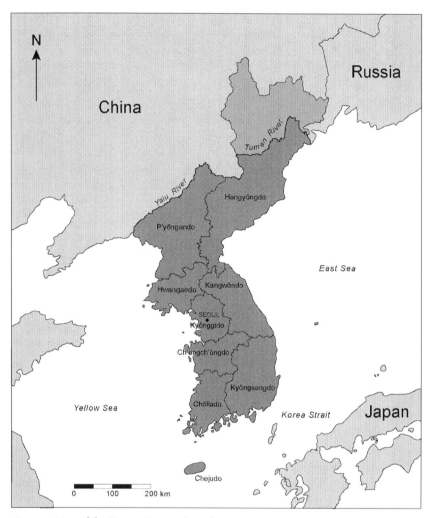

Map 1.2 Map of the Korean Peninsula and its provinces

The development of the Korean nationalists' view of Northeast China can be understood as influenced not only by the legacy of Korean history but also by the region's political ambiguity as a relatively recent addition to the Chinese territory, since the three northeastern provinces were not as rigidly established as in other parts of China and their borders only firmly demarcated in the first half of the twentieth century. These provinces were the territory of the Manchus and were not part of the territorial extent of the Chinese monarchy until the Manchus invaded Han China in 1644, ended the Ming dynasty (1368–1644), and replaced it with the Qing dynasty. Olivier (1993) explains that

Mukden (present-day Shenyang) was the original capital of the Manchus, but the new Qing dynasty transferred its court and offices to Beijing, then declared southern parts of the Northeast around Mukden as the sacred homeland of the Manchus and banned non-Manchus from settling in that region under its Fengjin (*Ponggŭm;* Seal and Prohibit) policy. Between 1653 and 1682, the Qing emperors built the Liutiaobian (Willow Palisades) to mark off their homeland, roughly corresponding to the area of Mukden. The Qing emperors' policies toward Northeast China left the region thinly populated for over two hundred years, and in some ways rendered it vulnerable to foreign hostility. While the Tumen and Yalu Rivers had served as the Qing-Chosŏn border since 1712, people living on the Chosŏn side frequently crossed them, sneaking into the area to live on and cultivate empty land, even though they ran the risk of being sent back to Korea if caught (Olivier 1993, 18). When the Russians moved to extend their power to the Far East, the Qing government lost control of some parts of thinly populated areas in Jilin and Heilongjiang in 1860. This loss incited the Chinese government to become more vigilant in guarding against further Russian expansion, eventually lifting the Fengjin policy in 1881 and accepting Han and Korean immigration to the region (Duara 2003).

Multiple etymologies and interpretations of Kando also resonate with the political controversies and hostilities surrounding the region. While the two Chinese characters 間島 have been regarded as the most convincing transcription for Kando, they simultaneously infer the dubious status of the region as a part of China, since the two characters together signify "in-between island." Whether that name was coined on the Korean or Chinese side, it signals the potential ambiguity in the region's political status. Another possible transcription of Kando is 墾島, which is pronounced Kando in Korean but Kendao in Chinese. The character *kan* (*ken;* 墾) means "to reclaim a wasteland," and *do* (*dao;* 島) is an island. From this, Kando is translated as "empty land to be cultivated." The last etymological hypothesis is that Kando is a mispronunciation of 江東, read as *kangdong* in Korean and *jiangdong* in Chinese, which means "east of the river" (Olivier 1993, 29). The region's affiliation with China was not clearly defined until the early twentieth century, and together with its contesting transcriptions *kando* evokes itself as a liminal space.

In 1905, after the Russo-Japanese War, Japan even adopted the argument that as northern Kando was once the territory of Koguryŏ and Parhae, it consequently belonged to Korea. Japan used this argument in pressuring the Qing government to legitimate the presence of the Japanese government in that region. Japan eventually invaded northern Kando in 1907, claiming in doing so that it intended to protect Koreans living in that area. However, Japan later sided with the Chinese by signing the Kando/Jiandao Convention in 1909, which affirmed the Tumen River as the official border between China and Korea. In

return for signing the convention, Japan gained the right to repair the railroad connecting Jilin, China, to Hoeryŏng, northern Korea, and the Japanese also convinced the Qing to open Longjing, Yanji, Helong, and Wangqing in Northeast China for trade (see map 1.1). Japan then established a Japanese consulate general in Longjing with branches in other cities (C.-J. Lee 1986, 17). While both North and South Korea have considered this region to be Chinese territory, dissatisfaction has lingered in the minds of some Koreans, who point to Japan's unfair treatment of Korea in its handling of the Kando/Jiandao Convention.

Whether or not Yanbian or Kando was historically Chinese or Korean territory, if the northeastern boundary had been firmly demarcated by the early twentieth century with no lingering disputes, the area would not have been so accessible and attractive for Korean migration and settlement. Indeed, Korean migration to Northeast China was driven and shaped by multiple factors: geopolitical history, physical and psychological proximity, and economic opportunity.

The earliest Korean settlers in Northeast China were poor farmers escaping severe famine in northern Korea in the 1860s. Successive groups followed to look for farmland, escape the Japanese colonial government, lead anti-Japanese movements, join Korean independence movements active in China, and, later, work in the industries that the Japanese developed in Manchuria. Among the drivers of Korean emigration were the sociopolitical complications that both China and Korea encountered around the turn of the twentieth century: the Qing government was experiencing the decline of its authority in China following the Boxer Rebellion (1899–1901); Russia launched hostile incursions into Manchuria and thus clashed with the Qing government; Japan exhibited naked colonial ambition toward Korea and Manchuria; and internal economic hardship caused by years of drought and famine forced Korean peasants to leave their native land (C.-J. Lee 1986, 1).

While the majority of present-day Chaoxianzu have been widely recognized as the descendants of Koreans who moved to China between the latter half of the nineteenth century and the first half of the twentieth century (C.-J. Lee 1986; Olivier 1993; Pease 2002; Duara 2003; H. Lee 2005; E. Han 2013), some historical records note that an earlier ethnic Korean community had existed in China from the ninth century. In *Ennin's Diary*, Ennin (AD 793–864), a Japanese Buddhist monk who made a pilgrimage to China in the ninth century, reported that Koreans were living close together in an ethnically concentrated area and were distinguished from other ethnic groups by their Buddhist ritual practices and the language they used in reciting Buddhist chant (Reischauer 1955, 152). He also writes that there was an Office in Charge of Korean Affairs that regulated the Korean population of the Wendeng area in the center of the Shandong Peninsula, China (Reischauer 1955, 123n383). While little detailed information is available on the lives of these early Koreans in China,

Table 1.1 Pre-1949 Korean Population of Northeast China

Year	Approx. Population
1876	1,000
1904	50,000
1907	77,000
1930	630,000
1945	2,150,000
1949	1,500,000*

Source: The data in the table is based on the information in H. Lee (2005, 9–11).
*After Korea was liberated from Japan in 1945, about seven hundred thousand Koreans residing in China returned to Korea.

another work written by a Chaoxianzu scholar, Ko Yŏnggil (2003), states that there were groups of Korean families—Ko and Pak—in Liaoning Province. The Ko family descended from the Koguryŏ people and lived in China from the time of the Tang dynasty (AD 618–907); the Pak family moved to China during the Ming and Qing dynasties (Ko 2003, 10–12). Geographically adjacent, there was vigorous cultural, political, and economic exchange between Korea and China from very early on. Beyond that, it is presumed that migration between the two states had been persistent even before a sizable number of Korean migrants settled in Northeast China in the latter half of the nineteenth century.

According to South Korean scholar Kwak Sŭngji (2013), among Chaoxianzu scholars two different perspectives compete in terms of the beginning of Korean migration in China. Some Chaoxianzu historians, especially those who are affiliated with Yanbian University, argue that the departure of Koreans for China could have begun around the end of the Ming dynasty or the beginning of the Qing dynasty. The other voice argues that since prior to the nineteenth century, Koreans in China were small in number and most had been fully assimilated into Chinese society, present-day Chaoxianzu should be viewed as distinct from those earlier Koreans in China (Kwak 2013, 28–29). A definite conclusion as to when Korean migration to China began is not easy to reach. However, the majority of present-day Chaoxianzu are descended from those Koreans who came to Northeast China between the late nineteenth and early twentieth centuries. Table 1.1 shows the gradual increase in the Korean population in China between 1875 and 1949. While Koreans in Northeast China numbered fewer than ten thousand immediately after the abolition of the Fengjin policy in 1881, their numbers increased rapidly throughout the early twentieth century (C.-J. Lee 1986, 16).

From the early 1930s, the number of Koreans in China increased markedly, with around three hundred thousand Koreans emigrating from central and southern Korea to take up cheap land offered by Japanese and Chinese companies to drive economic development in Manchukuo (1932–1945) (Pease 2002, 14; Duara 2003; Cathcart 2010, 28). While Manchuria was the region in Northeast China that the Qing dynasty designated as the homeland of the Manchus, Manchukuo was a puppet state that Japan set up after invading Northeast China and Inner Mongolia in 1931. Japan installed a pro-Japanese government with Puyi, the last Qing emperor, as the nominal regent and emperor of the state in 1932. With Japan's defeat in World War II in 1945, the Manchu government was dismantled. Japan's development of Manchukuo and its ambitions in continental Asia encouraged a large group of Koreans to relocate to northern Manchuria between 1932 and 1945; the majority of them were from the southern part of Korea. While many early Korean settlers in China came from northwestern Korean provinces such as Hamgyŏng and P'yŏngan and settled in the Yanbian area, these later migrants came from various other regions, settling farther north in China to avoid inter-Korean competition in Yanbian, which was already densely populated by earlier immigrants (C.-J. Lee 1986, 15–28). When the Japanese surrendered in 1945, a sizable Korean contingent returned to Korea, but those who wished to stay were allowed to do so and were eventually given Chinese citizenship (Cathcart 2010; Duara 2003; E. Han 2013; C.-J. Lee 1986; H. Lee 2005; Olivier 1993; Pease 2002).

Making *Minzu:* From the Chaoxian Dynasty to Chaoxianzu

The term *minzu,* commonly translated as "nationality," entered the national discourse during the Republic of China (1912–1949). The term originated in Meiji Japan (1868–1912), which had used it (*minzoku* in Japanese) to solidify the nation's unification for the first time after the fragmented feudal Edo period (1615–1868). Chinese Republicans, who feared the survival of China as an empire, began to identify it instead as a nation—"an ethnic group with common descent, territory, and culture, but which [is] also politically sovereign" (Harrell 2001, 29). While the idea of "nationality/nationalities" in a Western sense has implied a bounded territory, a specific state, or a particular citizenship, as it did in Japan, Chinese application of *minzu* was different in that it meant "culturally distinct groups," based on which all ethnic groups in China were respective *minzu* (Schein 2000, 81).

Historically, China's minority nationalities, particularly those in the border provinces, had some political and cultural independence—or at least autonomy—from the central authorities. However, such a liberal approach ran

contrary to the nation-building plan of Republican leaders such as Sun Yat-sen (Sun Zhongshan) and his Nationalist Party (Kungmindang; Guomingdang) members. They saw the ultimate unification of China as lying in the construction of a single cultural and political whole. Therefore, during the Republican era, the minority nationalities were encouraged to assimilate into the dominant Han culture. Non-Han place-names in the nationalities' areas were replaced with Han Chinese ones; becoming a Chinese national and adopting a Han last name was encouraged. The government supported the relocation of Han people to China's peripheral regions where the dominant population was its ethnic minorities (Schein 2000, 72). In contrast, the Communists, who in the early decades of the twentieth century had not yet risen to power, proposed that China be constituted of multiple states of different nationalities, promising them the right to establish their own national states separate from the Chinese government. This proposal, a kind of federal system, was approved at the first National People's Congress meeting held with the foundation of the Chinese Soviet Republic (Chungwa sobiet'ŭ kongwaguk; Zhonghua suwiai gongheguo), an independent republic that existed in Jiangxi Province, China, between 1931 and 1937 under the leadership of Mao Zedong and Zhu De. Although these Communist leaders later decided to grant degrees of autonomy rather than complete independence, from the early formation of the CCP it had a vision of embracing Chinese minority nationalities by giving them equal rights and designating areas where they were concentrated as their own autonomous areas (Kwak 2013, 229). The extent to which minority autonomy was allowed and protected was constrained by the CCP's heavy emphasis on building state unity alongside national diversity. Even so, the PRC proclaimed China a multination state whose unity would be created through "the reorganization of production and the standardization of social policy, not through the suppression of cultural differences" (Schein 2000, 72).

The PRC's minority nationality policy established in 1949 was a Chinese adaptation of Lenin's nationalization policy. However, the Chinese application of the concept of "nationality" was slightly different from that of the Soviet Union. While Soviet "nationalities" were prescribed with "different rights, privileges, and degrees of administrative autonomy" as part of a single unified nation-state (Schein 2000, 81), the Chinese did not implement any ranking system for its minority nationalities; instead, all nationalities were declared equally subordinate to the central state. Although four hundred different ethnic groups registered themselves to be identified as distinct, only fifty-five were officially recognized as minority nationalities by the late 1950s. In this regard, nationality categorization was a reductive process. As Schein (2000) points out, government "ethnologists did not consider this degree of plurality [hundreds of groups] to be ethnographically accurate, but rather a consequence of such

processes as historical splintering, migration, and political antagonism. A decision was made to override subjective identifications in favor of political exigencies and expert determination" (82).

For Koreans in Yanbian, the designation process was slightly different from other ethnic minorities in China, and perhaps politically more contentious, since they were relatively new migrants whose highest concentrations bordered their own or their ancestral homeland, that is, then North Korea. They also were politically ambiguous, having been the subjects of Korea and then Japan, and then as residents in China having been able to connect or maintain their connection with communist or democratic Korea. Although the CCP favored Koreans in Yanbian as a potential access point to the North Korean government, the relations between North Korea and Chaoxianzu could also be seen as contentious from a Chinese perspective due to the potential for shifts in diplomatic relations or future disputes in terms of Sino–North Korean frontiers. For the CCP, designating Koreans as a Chinese minority required a negotiation process among the party's non-Korean and Korean members. To a large extent, Koreans' acquisition of minority status was enabled due to diligent work on the part of Chu Tŏkhae (1911–1972), a recognized CCP member and prominent leader of Koreans in Northeast China. Chu saw Chinese citizenship as beneficial for Koreans living in China. Traveling back and forth between Beijing and Northeast China, he strove for Koreans to be designated as a Chinese nationality with the right to be ruled by their own autonomous government. Adam Cathcart states:

> As the civil war in Manchuria neared its conclusion in the frigid spring of 1948, the CCP sought to refine and justify its stance toward the Korean minority from the standpoint of theory. For this purpose, the Party convened meetings in Jilin city in February 1948. Chu Tŏk-hae participated actively, justifying the inclusion of Koreans as a minority (*shaoshuminzu* 少數民族) deserving of Chinese nationality, continually returning in his remarks to the role of Koreans in the anti-Japanese guerrilla resistance in Manchuria as justification. . . . Seemingly ignoring his history lessons, those convened in Jilin floated several theories under which the issue of the nationality of Koreans in China could be resolved. The idea of a "Theory of Multi-Nationality" for Koreans was advanced, but Chu found it unacceptable. His attitude was likewise hostile toward the "Three Nationality Theory," an idea that held that Koreans in Manchuria had "the Soviet Union as Proletarian Motherland, Korea as a Racial Motherland, and China as the Motherland of Liberation." To Chu's point of view, such a strata was far better than Koreans being considered aliens in China altogether, but hardly a tenable classification. . . . To his credit, Chu's emphatic support for unequivocal Chinese nationality for Koreans in the

Northeast would eventually place him squarely in the mainstream of CCP policy. (Cathcart 2010, 34)

Though the former status of Koreans as Japanese subjects raised concerns among some CCP leaders that Koreans would bring about the revival of Japanese imperialism in Northeast China, this did not prevent Chu from convincing the CCP in Beijing to designate Yanbian as a de facto autonomous area upon the founding of the PRC, including granting Koreans Chinese citizenship (Cathcart 2010, 36).

The CCP, on one hand, enlisted minority subjects, particularly intellectuals like Chairman Chu, to assist with the state's ultimate goal of smoothly transitioning to a socialist state. By recruiting minority leaders to its cause and adopting a friendly stance toward ethnicities other than Han Chinese, the CCP earned the broad support of the minority masses, who trusted their own local leaders, such as Chu Tŏkhae, more than they did representatives of the Chinese political party (Olivier 1993, 95). On the other hand, regardless of the degree of autonomy local governments hoped to achieve in their relations with the CCP, each was subordinate to the central government and largely directed by the CCP.

Yanbian Korean Autonomous Prefecture

The Chinese government founded the Yanbian Korean Autonomous Region (Yŏnbyŏn chosŏn minjok chach'igu; Yanbian chaoxian minzu zizhiqu) in 1952 and officially recognized ethnic Koreans as *Chaoxian minzu* (Chosŏn minjok), reflecting the name of the last dynasty of Korea—Chaoxian/Chosŏn. When the region was renamed Yanbian Korean Autonomous Prefecture (Yŏnbyŏn chosŏnjok chach'iju; Yanbian chaoxianzu zizhizhou) in 1955, "Chaoxianzu," a contraction of *Chaoxian minzu*, became the official designation for the Koreans in China (H. Lee 2005, 13). Since then, most Chaoxianzu have been concentrated in Yanbian.

Yanbian geographically borders China's Heilongjiang Province to the north, Russia's Maritime Province in Siberia to the east, and North Korea's North Hamgyŏng Province to the south. The region, covering 43,559 km^2, comprises the six cities of Yanji, Tumen, Longjing, Helong, Dunhua, and Hunchun, and the two counties of Wangqing and Antu (see table 1.2).[4] Of a total of about two million Chaoxianzu, roughly 40 percent live in Yanbian, which is under the jurisdiction of the Office of Frontier Affairs, headquartered in Yanji, the capital city of Yanbian.

Outside the Yanbian Korean Autonomous Prefecture, there are other Korean autonomous areas in China's northeastern provinces, including

Table 1.2 Demographics of Yanbian in 2001

	Size (Km²)	Total Population	Chaoxianzu	Chaoxianzu (%)
Yanji City	1,345	395,888	231,288	58.42
Tumen City	1,142	136,711	77,517	56.70
Longjing City	2,591	259,107	174,449	67.33
Helong City	5,069	222,327	121,677	54.73
Hunchun City	4,995	212,786	89,053	41.85
Dunhua City	11,962	482,424	21,670	4.49
Wangqing County	9,017	261,171	77,504	29.68
Antu County	7,438	217,444	46,938	21.59
Total	**43,559**	**2,187,858**	**840,096**	**38.40**

Sources: H. Lee (2005, 82); China Map Publication Company (2005, 46–53). Although this demographic information was based on 2001 statistics, the distribution ratio of Chaoxianzu population in Yanbian remains similar in the early 2010s. The total population of Chaoxianzu in Yanbian, however, had decreased to 820,000. See "Yŏnbyŏn chosŏnjok chach'iju in'gu" [Population in Yanbian Korean Autonomous Prefecture], *Yŏnbyŏn ilbo* [Yanbian Daily], 5 September 2018, http://www.iybrb.com/com/content/2018-05/09/55_307584.html.

Changbai Korean Autonomous County, forty-four Korean autonomous townships, and nine hundred Korean autonomous villages (Kwak 2013, 237).[5] The proportion of the population that is Korean in each autonomous region differs. In the villages, for example, Koreans generally make up over 90 percent of the total population, while in the townships the proportion tends to be lower (Pease 2002, 64n3). Chaoxianzu who live in regions with high concentrations of Koreans retain their ethnic culture to a greater extent than those who live in major cities amid non-Chaoxianzu populations, exhibiting a higher degree of assimilation with lower retention of ethnic culture and language (Pease 2002, 64). Through the 1980s and 1990s, most autonomous areas within Yanbian experienced a decrease in the Chaoxianzu population. Beginning in the 1980s, Chaoxianzu temporarily or permanently displaced their residential bases from Northeast China to larger industrial cities elsewhere in China or to South Korea or other parts of the world. They relocated for various reasons, including the desire for a better income, efforts to improve their children's education, or as a result of marrying non-Chaoxianzu, such as Han Chinese or South Koreans. While the Chaoxianzu population has decreased in the autonomous regions, it has increased in major cities in China, especially after the December 1978 Third Plenum of the Eleventh Central Committee of the Chinese Communist Party approved economic development as China's main political thrust (see table 1.3).

Part of the exodus can be explained by economically driven social reforms since the beginning of the 1980s leading the Chaoxianzu community to see the need for accumulation of wealth in order to sustain themselves in the new

Table 1.3 Population of Chaoxianzu in Large Cities in China Outside of Yanbian

City	1982	1990	2012
Beijing	3,906	7,689	93,450
Tianjin	816	1,788	45,600
Shanghai	462	734	70,300
Changchun	18,324	27,241	48,000
Shenyang	69,490	80,539	92,000
Harbin	30,514	36,562	30,000
Dalian	2,042	4,816	23,000

Sources: The table was drawn based on the information in H. Lee (2005, 19) and the 2012 demographic information released by the National Bureau of Statistics of China discussed in various documents found online. The numbers of Chaoxianzu in various cities in China have been further approximated by the author. See "Chagŭngsim nŏmch'inŭn haŏlbin chosŏnjok sahoe" [Social Assurance of Chaoxianzu Living in Harbin], *Yonhap News*, 14 September 2012, https://www.yna.co.kr/view/AKR20120914141600372; "Simyangsi chosŏnjogin'gu 92man yŏ myŏng" [Approximately 920,000 Chaoxianzu Living in Shenyang], *Yanbian Daily*, 22 April 2012, http://www.iybrb.com/soc/19.html; "Chosŏnjok isu—taeryŏn chosŏnjok, chunggungnae saeroun chosŏnjok kŏjujiro kakkwang" [Chaoxianzu Issue, Dalian Chaoxianzu, Growing Popularity of Dalian as a New Residential Place for Chaoxianzu], *GK munhwa tijain* [GK Culture Design], 2 October 2017, https://m.blog.naver.com/PostView.nhn?blogId=eyinekim &logNo=220931907580&proxyReferer=https%3A%2F%2Fwww.google.com%2F; "Chosŏnjok /punp'o chiyŏk" [Chaoxianzu Demography by Regions], *Namuwiki*, accessed 27 September 2019, https://namu.wiki/w/%EC%A1%B0%EC%84%A0%EC%A1%B1/%EB%B6%84%ED%8F%AC%20 %EC%A7%80%EC%97%AD.

market economy. Chaoxianzu from Yanbian left their autonomous areas to pursue job opportunities not only in China's industrial cities but also in foreign countries such as South Korea, Japan, Argentina, Brazil, Australia, New Zealand, and Pacific islands such as Guam and Saipan. Chaoxianzu who had relatives in South Korea could renew their family contacts. When China and South Korea established official diplomatic relations in 1992, a large number of Chaoxianzu flew to South Korea as nonprofessional or unskilled workers to take advantage of the better economic opportunities that the South could provide. Many Chaoxianzu migrants, having returned to their ethnic homeland, encountered social exclusion, mistreatment at work, and labor competition in the capitalist South (Song 2009, 2019), but this did not stop hundreds of thousands of Chaoxianzu from relocating to South Korea between the 1990s and 2018. South Korea's KOSIS (Korean Statistical Information Service) reports the Chaoxianzu population in South Korea as over 540,000 as of 2018.[6] Considering that these statistics are based only on Chaoxianzu over fifteen years old and legally residing in South Korea—including 19,500 Chaoxianzu who have acquired South Korean citizenship during the last five years (KOSIS 2018, 5)— if those who are minors, those who are illegally residing there, and those who

have naturalized as South Koreans between 1992 and 2013 are also taken into consideration, the total number of Chaoxianzu in South Korea is surely far higher.

On the other hand, the recent, economically driven redisplacement of Chaoxianzu within and outside China has led to a decrease in the Korean membership in its autonomous districts. Just between 2010 and 2016, the number of Chaoxianzu in Yanbian decreased from approximately 820,000 to 759,000, now accounting for less than 35 percent of 2,270,000, the total population in Yanbian, of which Han Chinese is the largest ethnic group at 59 percent (H. Chŏng 2018). This may place at risk the future maintenance of the legal ethnic minority status of Korean autonomous cities, counties, townships, and villages today, including Yanji, the capital city of Yanbian Korean Autonomous Prefecture.

In this chapter, I have introduced Korean migration to China and the settlement and formation of the Chaoxianzu community in and around China's northeastern border. While immigrants might have had a range of different reasons for migrating to that region, its geographic proximity to Korea and particular sociopolitical history were major factors for Koreans choosing to settle in that region with little sense of foreignness. While the economic opportunity presented by large expanses of uncultivated land was another motivation for Korean migration, in the latter half of the nineteenth century and the first half of the twentieth century, when the sovereignty and prosperity of the Korean Peninsula were unstable and eventually led to Japanese rule, for some Koreans Northeast China was also a place of resistance where they could politically act against Japan and still wield some agency. Crossing the Tumen and Yalu Rivers flowing between China and Korea with little difficulty, these Koreans carried not only their ambitions but also their culture—mostly nonmaterial aspects such as customs, behaviors, thoughts, and expressive arts. They began to create their new life as diasporic Koreans in China and a new culture for themselves by adapting the cultural knowledge and experience they brought from Korea to the new context they encountered in Northeast China.

Korean Music in China

IN THE PAST AND IN THE PRESENT DAY

WHAT has been the musical situation of Koreans in China since about two million Koreans migrated to China between the 1860s and 1940s, and then were designated as one of the PRC's minority nationalities in the middle of the twentieth century? In what ways has music been a significant part of Korean migration and reflected Korean migrant experiences in China? In this chapter, I provide a historical overview of Korean music in Northeast China, relying on ethnographic research as well as historical records in Korean and English that have been made accessible in post-1949 China. While I draw the reader's attention to a variety of musical spaces and activities in which Koreans engaged, a diachronic account of Korean immigrant music inevitably becomes discursive and inconsistent due in large part to the type of data available to a foreign researcher like me who visited Yanbian in the mid-2000s with little connection to Chaoxianzu or Chinese society. The majority of the written documents that I was able to access were published after 1949 or even after 1978 after the end of Cultural Revolution and seem to emphasize particular types and styles of music that have been cultivated in state schools and via performance troupes conforming to the Chinese government's ideological thrust as part of its efforts to construct a strong socialist nation-state. During the first three decades after the founding of the PRC, and to some extent today, any research published in China on the country's arts, including music, was profoundly influenced by revolutionary ideals and state imperatives; needless to say, the peak of this political pressure was during the period of the Cultural Revolution (1966–1976). In some ways, this could be seen as a shortcoming of my research, which largely draws on available publications, and yet can be complemented by ethnographic studies—by Chaoxianzu as well as by me and other foreign scholars—that contain the experiences and remembrances of the people who went through the period when Chaoxianzu music was not being actively recorded

and documented. While recognizing potential bias and discrepancies in the documentation and writing, this chapter aims to piece together a historical account of Korean music in China and provide a glimpse, through a musical lens, of the lives of the early Korean immigrants to China.

Before the Founding of the PRC

The majority of early Korean immigrants to China were tenant farmers involved in rice cultivation in Northeast China from the mid-nineteenth to the mid-twentieth centuries. Lee Byong Won, a Korean ethnomusicologist trained in North America, conducted a pioneering study on Korean music in Yanbian soon after the PRC proclaimed its program of economic reform in 1978. According to him, Korean music in Yanbian presented a rather narrow range of traditional music, especially when it came to the older, professional, sophisticated genres that have been acclaimed as Korean heritage cultures in South Korea in particular. Lee speculates that this was perhaps due to the immigrants' labor-intensive lives inhibiting them from cultivating a greater variety of Korean indigenous arts in China (B. W. Lee 1988a). His ideas were grounded in an economic and class-based view that took into consideration the economic-industrial context of the early Korean immigrants whereby the pursuit of a musical profession or patronage of the arts may have been out of reach, with most Korean farmers' immediate concerns centered on their social and economic sustenance in the context of new settlement. Whether or not the agrarian reality was a contributing factor in the relatively narrow range of traditional Korean music in China, it comes as little surprise that the immigrant musicscape has been different from the musicscape in the native context. Furthermore, more than 150 years of Korean migration to China would have been more than enough time for the establishment of a distinctive immigrant music, for the reinvention and negotiation of homeland music leading to a new diasporic manifestation of it. Considering that music is a social process, the immigrants' mode of living, living conditions, and sociopolitical reality in China must have affected their music. Whether Lee intended it or not, his report suggests the value of speculating on diasporic music as reflective of a social life that takes place in a particular context and time period and, in this case, of the sociocultural reality of Koreans in China.

Considering that nineteenth- and early twentieth-century Korean migration to China was initially shaped by the economic and industrial opportunities posed by Northeast China, these early Korean settlers in Yanbian might never have had the cultural capacity of Koreans at home in terms of access to opportunities such as musical aficionados, professional musicians, and socially

prestigious patrons of indigenous music and other arts. In contrast, Northeast China in the early twentieth century was rapidly transforming into a socially and culturally vibrant place where diverse racial, ethnic, and political groups intersected. Yanbian, where Koreans and Han Chinese later also encountered Japanese, Russian, and other foreign groups, was never immune to the larger sociopolitical transformations and cultural dynamics that emerged in early twentieth-century Northeast China.

From the point of view of Korean music scholarship, both the historical and contemporary Korean musicscape in Yanbian leave out a number of traditional music practices, such as *aak* (court ritual music), *chŏngak* (music of the aristocracy; Korean classical music), and *musok ŭmak* (shaman music), all of which used to be the domain of special groups of hereditary or government-enlisted musicians and were practiced in the Korean court or sponsored by the social aristocracy and bourgeoisie during the late Chosŏn dynasty (C. Chang 2009). Instead, different from that of Korea, the musicscape of Yanbian at the start of the twentieth century delineates a cultural crossroads where wider ranges of music from Korea, China, and the West were coming into contact.

The range of Korean immigrant music in Yanbian before the establishment of the PRC largely consisted of traditional Korean music—mostly *minsok ŭmak* or *minsogak* (folk music)—as well as Western classical music, marching band music, and early twentieth-century East Asian popular music. Various vocal music genres such as Korean *minyo* (regional and popular folk songs), *yuhaengga* (popular or commercial music), *ch'angga* (modern school songs; lit., singing songs), and *tongyo* (children's songs) seemed to be the most prevalent forms of everyday music practiced in immigrant households. Korean schools established in and around Yanbian supplied venues for musical performances.[1] Some professional vocal arts, such as *p'ansori* (solo narrative singing), *tan'ga* (a prelude to *p'ansori*; lit., short song), and *chapka* (folk songs by specialized singers; lit., miscellaneous songs), were introduced by community members as well as visiting artists trained in Korea, and numerous regional and cross-regional folk songs were brought in along with the larger body of immigrants. In terms of instrumental music, *nongak* (farmers' band music)[2] and *t'ungso* (long end-blown flute; Ch. *tongxiao*) music were the most noticeable types in the early Korean immigrant community in China (C. Chang 2009, 240; Pease 2015, 81). Apart from these two, it is hard to guess to what extent Korean ensemble or instrumental traditions were practiced in Yanbian, although some Chaoxianzu musicians remarked—corroborated by print sources—that there were a few resident artists who occasionally performed on traditional Korean instruments such as *kayagŭm* in the early part of the twentieth century (see, for example, K. Sin 2012, 2016b).

Despite the apparent decay and divergence of Korean music throughout the past century in China, written records describe music as one of the noticeable

cultural translocations of the Korean immigrant community in China from the beginning. It can be assumed that each individual emigrated carrying their own culture, memory, and knowledge as a member of a nation and region, but the details as to when and how particular music became part of Korean life in Yanbian and who was involved are scant, especially for the late nineteenth to early twentieth centuries. The majority of available records on this early period of Korean migration appear in the post-1949 publications put out by the Minority Nationality Social History Investigation Group, a national project (Ch. *minzu gongzuo*) conducted by the CCP in the 1950s to document a range of different ethnic groups and their cultural identities. Numerous minority nationalities were identified through self-registration and subsequent government classification, and the music and arts of all these nationalities throughout China began to be investigated. Subsequently, hundreds of Korean folk songs and other forms of cultural tradition were documented from the three northeastern provinces as part of the cultural heritage of the Korean minority, and a number of Chaoxianzu singers were recognized as important cultural carriers. This national project, however, focused largely on the folkloric arts (*mingan munye; minjian wenyi*), of which a large portion of the music was vocal and instrumental music that was considered an emblem of proletarian identity in post-1949 China.

Folk Songs

According to Rowan Pease, a British ethnomusicologist who conducted extensive research on Korean songs in Yanbian from the early 1990s, official government investigation into Korean folk songs first began in Yanbian in 1951, and the first song collection was published in 1954. Pease states that this earliest published collection of Korean music contained 49 folk songs, including "Ŏrang t'aryŏng" [Song of Ŏrang],[3] "Nanbongga" [Song of Mountain Peaks], and "Sijipsari" [Living with In-laws], but the actual volume was no longer accessible for detailed investigation in Yanbian by the 1990s (Pease 2002, 51). Instead, the earliest record of Korean folk songs that Pease was able to examine thoroughly was the 1959 *Chaoxianzu minjian wenyu diaocha baogao* [Korean Nationality Folk Arts Investigation Report], an unpublished document compiled by the Arts Sub-Group of the Jilin Province Minority Nationality Social History Investigation Group. The report was written in Chinese and provided an overview of a range of Korean folk arts including drama, visual arts, and handicrafts, as well as music. Pease found that this report did not seem widely known to Chaoxianzu scholars, and most of them speculated that its musical section must have been contributed by Li Hwanghun (1933–1990), a horn player with the Yanbian Song and Dance Troupe and a pioneer figure in Chaoxianzu

folk music research. Li was involved in a series of Korean folk music studies in Yanbian for several decades until the end of the 1980s (Pease 2002, 51). Pease shares her insights into the 1959 report:

> The author characterises the music of Yanbian as the music of poor immigrant workers, whose minds were not focused on love or scenery but on survival. There was little to attract the specialist musician to the area. Hence there were a great many folksongs, particularly work songs, while instrumental music was dominated by the cheap, easy to make *t'ungso* vertical bamboo flute, rather than the more sophisticated plucked half-tube *kayagŭm* zither. . . . [The report] describes only those instruments and ensembles found in the area, including *t'ungso, haegŭm* (two-stringed fiddle), *s[w]aenap* (shawm), *changgo* and *puk* (barrel drum), vocal genres such as folksongs and what he calls "narrative singing" (Ch. *shuochang*) forms, *p'ansori* and *tan'ga*. (Pease 2002, 51–52)

According to Pease, the 1959 report depicts the music of Koreans in Yanbian in a manner that resonates with the report's overall depiction of the lives of the early Koreans in China as peasants and workers. However, as previously pointed out, Koreans in Yanbian were in fact engaged in a rather wide range of music, and the practice of Korean folk songs in Yanbian needs to be taken as one of many kinds of music in which Koreans participated. That Chaoxianzu intellectuals documented Korean vocal music so comprehensively, especially its folkloric forms, is perhaps owing to the government's emphasis on and promotion of folk identities. It is difficult to know to what degree this Korean peasant identity was actually in evidence or politically constructed.

The first substantial publication on Korean vocal music was the 1963 *Chosŏnjok min'gan munye charyojip: min'ga p'yŏn* [Korean Folk Arts Material Collection: Folk Song Edition], released by the Yanbian Folk Arts Research Group (Yŏnbyŏn min'gan munye yŏn'gujo; Yanbian minjian wenyi yanjiuzu), a group mandated by the autonomous government and set up in 1961. The research group had collected over eight hundred Korean songs throughout Northeast China, of which 185 were published in the volume. They were transcribed using Western staff notation with the addition of symbols indicating various ornamentations employed in their performance. Interestingly, this publication seemed to leave out a range of *sinminyo* (new folk songs) that had emerged since the early twentieth century with the introduction of mass media and the rise of a commercial music industry in Korea (Pease 2002, 53).

Korean folk songs can be broadly classified into three categories: *t'osok* or *hyangt'o minyo* (regional or vernacular folk songs), *t'ongsok minyo* (popular pan-regional folk songs), and *sinminyo* (new folk songs). While all three *minyo*

types were brought to China, Chaoxianzu and North Korean music scholarship hardly distinguish *t'osok minyo* from *t'ongsok minyo*. Instead, they synthesize them both together under the label *chŏnt'ong minyo* (traditional folk songs). On the other hand, music scholarship on Chaoxianzu, North Korea, and South Korea all distinguish *sinminyo* from *chŏnt'ong minyo* (or from *t'osok* and *t'ongsok minyo* in the case of South Korea), acknowledging the commercial aspects and relatively recent development of *sinminyo*, whose composers and lyricists may be known, as opposed to the usual anonymity of *t'osok* and *t'ongsok minyo* (Yep'ung Kim 2004, 15).

Although *sinminyo* such as "Sin'gosan t'aryŏng" [Song for Sin'go Mountain] and "Arirang" [Song for Arirang] were documented in Yanbian, they were not always included in Chaoxianzu folk song publications, for example, the 1963 *Chosŏnjok min'gan munye charyojip: min'ga p'yŏn*. The reason perhaps lay in the fact that many *sinminyo* carried secular themes of love, despair, separation, and personal desire that were considered counterrevolutionary: "The editors wrote in their foreword that, as this was an internal document for study purposes, they had included songs with harmful contents with the aim of further understanding local custom; only the most vulgar songs were omitted" (Pease 2002, 53). Such a rationale for decisions about which Korean songs to include in the documentation of folkloric arts suggests that the editorial committee was conscious of the propriety of the songs in terms of the CCP's moral and ideological imperatives. Despite the significance of the *Chosŏnjok min'gan munye charyojip* as the first major publication of Korean folk songs in China, very few copies survived the Cultural Revolution, and I was not able to get access to one for this investigation.

The earliest folk song collection that I was able to closely examine was one published two decades later—the 1982 *Minyo kokchip* [Minyo Collection], which I stumbled across in a secondhand bookstore in Yanji's city center in 2005. Unlike the aforementioned document, this collection includes quite a number of *sinminyo* in addition to regional and popular folk songs, as well as longer vocal repertoires such as *kagok* (classical art songs), *chapka,* and *tan'ga*. Altogether the collection contains 520 songs transcribed in cypher notation with indications of lyrics, singers, and transcribers, as well as some anecdotes. In terms of the number of songs, the volume contained far more than the previous publications, and it certainly serves as an indicator of the presence of a wide range of Korean vocal music in China.

While *t'osok minyo*—folk songs from a specific region—seemed to be brought by migrants who had learned the music in their own community or village in Korea, the wide range of *t'ongsok minyo*—folk songs with nationwide circulation—as well as newly emerging popular songs must have been due to migrants' cross-regional knowledge, the contributions of professional performers,

and technical advancements that enabled the commodification of music. In fact, during the first part of the twentieth century, a number of Korean performance troupes toured Northeast China. After Japan invaded Manchuria in 1932, touring by Korean troupes further increased as greater numbers of Koreans moved from various parts of Korea to the regions that the Japanese government was developing in Manchuria. During that period, Korean *kisaeng* (female entertainers) were performing in local Korean restaurants, and a group of *p'ansori* artists even toured Northeast China presenting *p'ansori wanch'ang* or entire extended versions of *p'ansori* (Um 2013, 171). This perhaps explains why and how some professional vocal arts were found in China in addition to the broader repertoire sung by lay musicians (see Yep'ung Kim, 2004).

Instrumental Folk Music

Among a variety of traditional Korean music, *nongak* was one of the most visible types of ensemble music brought by the Korean immigrant community to China (C. Chang 2009; Pease 2015). *Nongak* was traditionally performed in the context of village purification and harvest rituals. It was performed by either farmers themselves or wandering minstrel troupes as a means of increasing the efficacy of the rituals or easing the fatigue of farmers working in the field. Almost all rural villages in Korea had their own *nongak* ensembles with their own regionally distinctive performance repertoires. Considering that rice cultivation was a primary industry among Koreans in China, it is not difficult to understand why Korean migrants to China brought *nongak* with them, and why this music was frequently performed by rural Chaoxianzu.

Among several *nongak* groups recognized in Northeast China, the Xincun Nongak Group (Sinch'on nogaktan) in Antu County is reported as having won first prize at the Minority Nationality Cultural Competition held at Xinjing in 1943 as part of the ten-year anniversary celebrations for the founding of Manchukuo.[4] The village of Xincun was newly established in 1938 by farmers mostly from Korea's southern Kyŏngsang Province (see map 1.2). The villagers purchased instruments and costumes from Seoul (then called Kyŏngsŏng) and also invited a teacher to come from Korea to China to teach them music (Chaoxianzu Music Organization 2005, 25). *T'ungso* music was also widely performed in rural Korean communities in China, where the majority of Koreans lived as farmers (C. Chang 2009; Pease 2015). Originally from China, the Korean *t'ungso* has been employed in both Korean classical music—namely, *aak* and *chŏngak*—and folk music—*minsogak*—traditions. However, today it is more known as an amateur's or farmer's instrument. The *t'ungso* as a folk/amateur instrument was most widely used in Korea's northern regions, now part of North Korea (or Democratic People's Republic of Korea—DPRK), and played

both as a solo and ensemble instrument. Perhaps it is because the majority of Chaoxianzu in Yanbian originally moved from northern Korea that the *t'ungso* has been played among Chaoxianzu farmers. Other than *nongak* and *t'ungso,* little information has been available depicting the status and details of traditional Korean instruments and instrumental music in China before the founding of the PRC (K. Sin 2012, 2016b).

Only a few individual musicians are thought to have had a specialization in traditional Korean instruments before 1949. For example, *20segi chungguk chosŏnjok ŭmak munhwa* [The Music Culture of the Chaoxianzu in the Twentieth Century], published by the Chaoxianzu Music Organization in 2005, and Sin Kwangho, a professor in Chaoxianzu singing and a musicologist in Yanbian, state that Sŏng Tŏksŏn (1863-1905), a descendant of Sŏng Hyŏn (1439-1504)—a famous scholar and musicologist from the early Chosŏn period and chief editor of *Akhakkwaebŏm* [Treatise of Korean Music], published in 1493—lived in Longjing in Yanbian and was an expert on the *kayagŭm* (twelve-string zither), *kŏmun'go* (six-string zither), and *yanggŭm* (hammered dulcimer) (K. Sin 2016b). Another musician, Pak Chŏngnyŏl (1920-1988), was known for her *kayagŭm pyŏngch'ang* (singing while accompanying herself on the *kayagŭm*). Formally trained in Korean music at a *kwŏnbŏn* (training school for *kisaeng,* female entertainers) in Korea, Pak moved to China in 1939, later teaching Korean folk song and *p'ansori* at Yanbian Arts School (Chaoxianzu Music Organization 2005, 26–28; for her biographical details, see chapter 6). She was known more for her vocal arts than for her *kayagŭm* playing. Others were known for singing *minyo* and *p'ansori* or for their ability to play *t'aryŏng* (a form of folk song) melodies on the *t'ungso* and *chŏttae* (long transverse flute, also called *taegŭm*) (Chaoxianzu Music Organization 2005, 26–28). Overall, in comparison with the prominent record on vocal music, information on the state of Korean instrumental music in the early part of the twentieth century is scant. This was one of the reasons the post-1949 Korean autonomous government paid attention to the development of Chaoxianzu instrumental music: to equip the Chaoxianzu community with a range of musical practices comparable to other ethnicities in China.

Popular Music

With the introduction of the gramophone in 1907 and the establishment of Kyŏngsŏng Radio Broadcasting Station in 1927, both foreign and indigenous music gradually became available for mass circulation and consumption in Korea. From the second decade of the twentieth century, Korean music, in the form of gramophone records, was already making its way to China and Japan as a transnational commodity (Atkins 2007; Koo 2010). However, the concept

and usage of "popular music" in Korea was still at its inception. There was a semantic overlap between *being popular* and *popular music,* allowing both artists and the music market to experiment with an emerging commercial sound by crossing *minyo* and *yuhaengga,* which are very different musics in terms of their origins, functions, and modes of production and dissemination.

Borrowing preexisting folk song melodies or featuring new melodies that resembled Korean folk songs in their use of anhemitonic pentatonic scales and traditional rhythmic cycles (*changdan*), *sinminyo* was perhaps the earliest type of vernacular popular music produced in Korea. It was new in terms of the various technologies and commercial elements involved, yet stylistically it more or less conformed to indigenous folk songs. Thus, *sinminyo* was "traditional" in sound but "new" in its means of production and circulation, conforming to the function and commercial characteristics of popular music as much as *yuhaengga* does. *Yuhaengga* was the Korean equivalent of the Chinese *liuxing gequ* 流行歌曲 and the Japanese *ryukoka* 流行歌, terms used for the new popular music in its respective contexts in early twentieth-century East Asia. The term *yuhaengga* denotes "trendy songs" or "songs in fashion" while embracing various tunes of foreign or indigenous origin. All foreign tunes were assigned new vernacular text for local consumption. Diverse styles of indigenous compositions were introduced as *yuhaengga* along with *sinminyo.* The emergence of popular music in Korea and its early conceptual and musical boundaries seem quite fluid, as has often been pointed out of popular music by scholars such as Keith Negus (1996) and Roy Shuker (2005): popular music "defies precise, straightforward definition" (Shuker 2005, 203), and its study has none of the discipline of similar existing studies of film yet is "broader and vaguer in scope and intentions" (Negus 1996, 5; quoted in Shuker 2005, 203). Even if *sinminyo* sounds were very different from those that today's audiences may imagine as typical of Korean popular music, *sinminyo* fulfilled the characteristics of commercial music in early twentieth-century Korea as a new, contemporary, and popular sound, and perhaps this is why *sinminyo* were largely left out of the early Korean folk song collections published in socialist China.[5]

While performance tours by popular singers were one of the primary means of spreading Korean songs to the diasporic community in China, the rise of the recording industry also contributed greatly to the transnational dissemination of Korean popular music in the early twentieth century. In the mid-1930s, Shenyang (Simyang) in Northeast China developed into a trading center for Korean cultural goods. Its Xita (Sŏt'ap) Street was decked out with numerous colorful posters of Korean singers with the Columbia, Victor, and Okeh record companies, and the air was filled with the sounds of Korean popular songs emanating from its music stores (Koo 2010, 15–16). Even today, Xita Street in Shenyang—the oldest "Koreatown" in the world and where both Chaoxianzu

and South Korean populations are found—continues to be a vibrant center of Korean culture in China (C. Sin 2011). Some representative hit Korean songs in Northeast China at the time were "T'ahyangsari" [Living Overseas], "Hwangsŏng yett'ŏ" [The Ruins of the Old Castle], "Hongdo ya uljimara" [Don't Cry, Hongdo], "Pulhyoja nŭn umnida" [Undutiful Son's Cry], "Tchillekkot" [Wild Rose], and "Nunmul chŏjŭn Tumangang" [Tumen River Drenched in Tears]. Among these, "Nunmul chŏjŭn Tumangang" is particularly associated with the region, since the lyrics speak of a couple's separation at the Tumen River, which forms the border between China and Korea. The song was composed by Yi Siu (1914–1974), who was inspired by the true story of a couple separated when the husband left his family to participate in the Korean independence movement in Northeast China and died after being arrested by the Japanese army. Yi heard the story when his troupe visited Longjing, where many diasporic Koreans lived at the time. Yi composed the song after his return to Korea, and it was recorded by Kim Chŏngku (1916–1998); it was well received both at home and in China (N. Kim 2010, 435–436). Popular songs—largely uniform in style—set to melancholy melodies with lyrics expressing nostalgia and longing for home and family held particular appeal for diasporic Koreans in China. Although gloomy and sentimental popular songs seemed to predominate throughout East Asia in the second and third decades of the twentieth century, songs that depicted homesickness, family separation, and sorrow due to displacement were particular to diasporic Korean communities as they were especially resonant with their life experiences (Koo and Sung 2016).

Western Music

As was the case in other parts of Asia, the influence and adaptation of Western music was pervasive in China, including Yanbian, around the turn of the twentieth century. First brought in with the European voyages of exploration and followed by Christian missionaries and the introduction of Western school systems, Western music gradually permeated indigenous life in East Asia, supplanting the old traditional sound. Christian hymns, military band music, European folk songs, locally composed Western-style songs, and a range of European classical instruments were gaining prominence, their sounds coming to be seen as those of advanced modern life and superior to those of local traditions.

One of the most important factors in the spread of Western music was the modern school, where music education was part of the school curriculum. Inspired by missionary schools, local governments and intellectuals established new schools in the early twentieth century and implemented Western music as part of the regular curriculum. "School song" (ch'angga) movements—centered

on the modern schools, especially those for children and youths—were put in place all over East Asia. These movements largely contributed to the wide dissemination and popularization of Western music across China, Japan, and Korea (Yoshihara 2007, 17–18). Another incentive for the spread of Western music was the rise of social movements. Emerging local intellectuals who received a modern school education valued the effectiveness and power of music in influencing the masses. Subsequently, music was used as a tool to accompany political or social movements to bring about social reform and revolution in East Asia.

In inland China, *geming gequ* (lit., revolutionary songs) were introduced to support the 1911 Xinhai Revolution, which led to the establishment of the Republic of China and the termination of the imperial Qing dynasty. The May Fourth Movement (1919–1922) was another significant social movement in the early decades of the twentieth century, sweeping all of China and awakening a national spirit emphasizing Chinese identity. As a social and intellectual movement, it incorporated literature and the arts as efficacious tools for spreading nationalism. Both the New Literature Movement and the Folk Song Campaign, which were part of the May Fourth Movement, called for social reform in a *Chinese way* (Manuel 1988, 225; I. Wong 1991, 41-42). In Korea, the March First Movement of 1919 was the equivalent of the May Fourth Movement in China. It instigated colonial anxiety and inspired Koreans to stand up against the Japanese colonial government. These movements both stirred up a sense of indigenous identity and the need for social reform to strengthen the nation's capacity to fight colonialism and foreign imperialism. Although music was not the spark for national and patriotic activism, it was certainly integrated into these social movements and played an important part in early twentieth-century transformations in China and Korea.

Due to the political multiplicity posed by Yanbian and its geographic proximity to Korea, numerous Korean nationalists and social leaders came to Yanbian to lead Korean independence movements around that area. These intellectuals formed Korean militia groups and established schools to educate Korean youths. As it had in inland China and in Korea proper, the cultivation and adaptation of Western music emerged in Yanbian centering on educational institutions, founded by Koreans and non-Koreans. Korean nationalists and intellectuals, American and European missionaries, and later the Japanese colonial government established Korean schools for the education of youth (C.-J. Lee 1986, 35–36).[6] All together about twenty-one primary and secondary Korean schools were established in Yanbian in the 1920s.[7] The majority of these institutions were concentrated in Longjing, then the center of Korean education and cultural activities.[8] The students attending those schools were not just the children of Korean immigrant families: also included were Korean families

from Russia and Korea who moved to Yanbian solely for the purpose of their children's education (H. Lee 2005, 38).

The overall curriculum at the Korean schools seems quite similar to what was taught in Korea around that time, including Korean history and culture, Western ideas, and arts classes such as music. However, one major difference between Korean schools in Yanbian and in Korea was that while the curriculum and content in the schools in Korea gradually came to be dictated by the Japanese colonial government after 1910, Korean immigrant youths in China had relative autonomy in choosing the school they wished to attend and could take into consideration each school's ideological and cultural orientations. The songs taught in Korean schools in China reflected such ideological veins. A range of different songs, from works by contemporary Korean and Japanese composers to rearrangements of Christian hymns, Western folk songs, and Japanese school songs, was taught in the schools (Chaoxianzu Music Organization 2005, 58–76).

Besides singing, almost all Korean schools in China are thought to have had brass band ensembles. The Western brass band was introduced in East Asia from the Western military system, whose marching bands so impressed East Asians when the European soldiers marched out from their battleships. Soon indigenous governments formed their own military bands as they went about reforming traditional military systems. Japan's first military band was formed in 1869 by the Satsuma clan, and then in 1871 the national military band was formed. In China, Yuan Shikai established the first Western-style Chinese military band in 1895, while the first military band in Korea dates to 1881. In East Asia, the military band not only functioned as a symbolic performance of social modernity and reform; it also provided a gateway for East Asians to experience Western ensemble music and instruments. The military bands are considered to be responsible for the introduction of both Western band music and Western orchestral instruments, as well as the piano, to late nineteenth-century Japan (Yoshihara 2007, 16).

From the introduction of Western military music in East Asia, the brass band was immediately popular and was quickly adopted as a youth activity in the modern schools. Yanbian also saw a booming of brass bands based at Korean schools. A number of Chaoxianzu musicians in their old age clearly remembered how brass band culture flourished in Yanbian before the end of World War II. Some of them mentioned that brass band music was in fact the first "musical sound" they remembered and were exposed to as young Chaoxianzu (Ch'a 2004, 50; Chaoxianzu Music Organization 2005, 64–65).[9]

Pease (2013) also confirms that Westernized music culture predominated in Yanbian before the founding of the PRC, a legacy of the Japanese invasion of Northeast China (1931–1945) and its modernizing agenda. According to her,

not only did many townships have their own brass bands—as well as pedal organs and accordions—but larger cities like Yanji had a professional choir and orchestra (89).

Although not in Yanji city, at least two representative Western symphonic orchestras were based in Northeast China, the Harbin Symphonic Orchestra and the Xinjing Symphonic Orchestra, with which a number of Koreans were affiliated as instrumentalists. As an orchestra based in the capital of Manchukuo, the Xinjing Symphonic Orchestra in particular included a number of outstanding musicians from Japan and Korea. Some of the Korean musicians later returned to Korea and became leading musicians in the postwar states of North and South Korea (Chaoxianzu Music Organization 2005, 83–93). Although neither orchestra was physically based in Yanbian, the existence of large-scale orchestras nearby suggests that the practice and performance of Western classical music was a recognizable part of Korean immigrant music in China. In fact, the majority of Chaoxianzu musicians who led the development of Korean minority music from the beginning of the 1950s had been previously trained in Western classical and band music (see chapters 4 and 5). These musicians did not know how to play traditional Korean instruments and had to learn to do so for the development process, and it is worth pondering whether their primary language in Western music might have underpinned their ideas in this undertaking. Whether deliberate or unintentional, bimusical backgrounds—or even trimusical, with the addition of the influence of Chinese music—have been a feature of Chaoxianzu musicians in post-1949 China. These musicians often characterize their musical uniqueness as a cultural fusion enabled by their access in Yanbian to Korean, Chinese, and Western musics.

The Rise of Communism and Music as Political Propaganda

Around the start of the twentieth century, Northeast China was already transformed into a place of political contradictions at the interface of the imperial Qing dynasty, Russia, and Japan, and later Korean nationalists and various Chinese political parties. Japan's colonial hostility toward Korea was a major trigger for Russia increasing its vigilance over its far eastern region. Soon after the Qing dynasty lost the First Sino-Japanese War (1894–1895), Russia invaded Manchuria in a bid to expand its own imperial power across Eurasia. With the building of the South Manchuria Railway, Mukden (today's Shenyang) became a Russian stronghold. As with other foreign powers that occupied parts of China, such as Portugal, the United Kingdom, the United States, France, and Japan, Russia demanded concessions along the railway. After the Japanese invasion of Korea, Korean nationalists moved to Manchuria and led the nation's

independence movement, forming anti-Japanese organizations in China; some of them took up arms, working hand in hand with Chinese Republicans to fight against the Japanese army, which had been stationed in Manchuria since the 1920s. In the meantime, a sizable number of activists in early twentieth-century China and Korea were fascinated by the success of the Bolshevik Revolution (1918) and later joined the CCP to fight for a proletarian revolution in Northeast Asia.

In this period, throughout all three East Asian countries, music was ideologically charged and used as a tool to propagate political messages, each political faction infusing it with its own ideological and political thrust. The Korean provisional government established in China in 1919 had its own propaganda teams (sŏnjŏndae); these traveled throughout China, performing music and dance for the Chinese and Korean publics as an appeal for Korean independence. The songs they performed often included lyrics describing the lives of soldiers, though not necessarily with strong political inclinations. Like other revolutionary songs that appeared in China around the same time, the songs of the Korean Liberation Army showed Western and Soviet influences in terms of their musical style. A large number of songs were written in duple meter and based on a four-bar line structure. Old folk tunes or tunes from well-known songs were rearranged with new texts to disseminate political messages and were used for mass singing (Chaoxianzu Music Organization 2005).

Soon after the establishment of the Republic of China in 1912, China faced internal turmoil. Political disputes between the Chinese Nationalist Party and the Chinese Communist Party (CCP) led to civil war (1927–1936; 1946–1949). Although the two parties did unite in the fight against Japanese invasion between 1937 and 1945, the Chinese Civil War then resumed and continued until 1949, when the CCP finally won and expelled the Nationalist government to Taiwan, restricting the latter's jurisdiction to several islands in the Taiwan Strait. Of the two political factions, the CCP was more appealing from a minority perspective since it promised a multinational China granting equal rights to ethnic minorities, for example, in the area of landownership. For this reason, the CCP gained the favor of the majority of Chaoxianzu, particularly those who had a peasant background but were unable to possess land as non-Chinese under the rule of the Qing and Republican governments.

The Korean militia (Chosŏn ŭiyonggun), established in 1938, allied with the CCP from 1941 and fought against Japan. When Japan surrendered in 1945, between five and seven hundred thousand Koreans returned to Korea, while a much larger group, about 1.5 million, remained in Northeast China.[10] By that time, quite a number of Koreans living in China were already second- or third-generation immigrants, and for these Koreans, Northeast China looked more promising than their ancestral home, which showed signs of breaking out in

civil war. Another reason for these Koreans to strongly ally with the CCP was their negative experience with the National Party, which, when it arrived in Yanbian in 1946, labeled Koreans as Japanese collaborators rather than as compatriots who had fought together with Chinese people for the nation's liberation (Cathcart 2010, 26). Whether legal or illegal migrants, the majority of Koreans in China were officially Japanese subjects until the end of World War II, and this provided the rationale for the National Party to accuse Koreans of being Japanese collaborators. This stance on the part of the National Party appealed to Han Chinese in Yanbian, who, as a proportionally smaller group than Koreans in that region, developed anti-Korean feelings around that time. In contrast, the CCP proposed to Koreans social reforms and support for the Korean language and culture. Although uncertainty and feelings of doubt toward the CCP were pervasive among Koreans in China at the time, the CCP's policy of land redistribution held inevitable appeal to Koreans in Yanbian, 90 percent of whom were farmers (Cathcart 2010, 32). In the ensuing years, 62,942 Korean youths joined the People's Liberation Army; in Yanbian alone, 34,855 Koreans had joined by 1948 (Chaoxianzu Music Organization 2005, 96).

Music and the performing arts were deployed by the Communist Party as well as by the Korean militia as an effective tool of political propaganda. According to Adam Cathcart (2010), who studied Chu Tŏkhae, the first governor of the Yanbian Korean Autonomous Prefecture and a Chaoxianzu Communist leader, one of more notable tools used to recruit Koreans to the CCP was the arts, which interested Chu and his friends: "Artistic activities among Koreans were a potent and prevalent means of justifying the seizure of political power from departing Japanese as well as the incoming Guomindang" (34). Chu and his compatriots recognized the power of arts as an important propaganda tool from the founding of the Korean militia; music and dance was integrated into political movements that Koreans led in China.

The Korean militia was established in 1938 in Hankou, now one of the three districts that make up modern-day Wuhan, the capital city of Hubei Province. From an initial ninety-seven members, it expanded gradually, and from August 1945 it deployed its troops to several different regions across China including Northeast China. Its fifth troop was based in Yanbian and suppressed rebels that were taking advantage of political and social confusion at the time (W. Chŏng 2014, 132, 141–153). After going through several reorganizations, from being independent to commissioned by the Chinese People's Liberation Army, it was finally integrated into the latter with the founding of the PRC, and thus during the Korean War, it supported the People's Army of North Korea.

According to Chŏng Wŏnsik, a member of the South Korean tribunal that visited China (Hanjung hangil yŏksa t'ambangdan) to investigate anti-Japanese movements and political activism among Koreans in China, on 13 October

1938, the founding of the Korean militia was celebrated at the Wuhan branch of the YMCA, where the militia members gave a music and dance performance; other groups also put on a range of performances such as the 3–8 Women's Choir, Hankou Supporter and Propaganda Team (Hank'ŏusi huwŏn sŏnjŏndaedae), Hankou Youth Resistance Association (Hank'ŏusi ch'ŏngnyŏn hangjŏn hyŏphoe), and a school group (tongjagun; lit., children's army) (W. Chŏng 2014, 133). Apart from such celebratory occasions, the Korean militia integrated music and dance into their military activities by assigning a propaganda team to each troop and actively deploying visual, literary, and expressive cultures in support of their battles.

Several sources on Chaoxianzu music (e.g., N. Kim 2010; Chaoxianzu Music Organization 2005) record that sŏnjŏndae had been a dominant part of performance scenes in Yanbian before 1949. Their membership included a significant number of Chaoxianzu musicians who later played key roles in the development of Korean minority music in China through the second half of the twentieth century. Sŏnjŏndae, which had both male and female members, performed a diverse range of music including songs with political messages, popular songs, Western art songs, minyo, and instrumental arrangements for Western classical instruments as well as brass band (Chaoxianzu Music Organization 2005, 96–119). During the Chinese Civil War, the most representative sŏnjŏndae was the Yanbian Culture and Arts Work Team (Yŏnbyŏn mun'gongdan; Yanbian wengongtuan), affiliated with the Yanbian Commissioner's Office of Nationality Affairs. This troupe was the predecessor organization of the Yanbian Song and Dance Troupe, which represented Yanbian and Chaoxianzu cultural identity in the post-1949 era. Like other military propaganda teams, the Yanbian Culture and Arts Work Team used mostly Western classical and band instruments and performed a variety of vocal, instrumental, dance, and theatrical works, some of which were embedded with socialist messages (Chaoxianzu Music Organization 2005, 101). For example, it staged its own original musical and theatrical productions in addition to conventional repertoires of popular folk songs and well-known foreign melodies. Original works included the marching band pieces "Sŭngni haengjin'gok" [Victory March] and "Inmin haebanggun haengjin'gok" [March of the People's Liberation Army], the musical theater productions Hyŏngmyŏng ŭl kkŭtkkaji chinhaengaja [Continue until the End of the Revolution] and Sŭngni ŭi taejin'gun [Victory Procession], and the vocal pieces "Sŭngni ŭi kippal" [Flag for Victory], "Ch'ŏngnyŏn haengjin'gok" [Youth March], "Rodongja haengjin'gok" [Proletarian March], and "Yŏsŏng haengjin'gok" [Women's March]. Chaoxianzu music produced and performed at the time reflected the support of the Korean community for Communist China, expressing a revolutionary and socialist spirit through songs highlighting

revolution, victory, liberation, and the struggles of socially marginalized groups such as youths, workers, and women. In 1948 the Yanbian Culture and Arts Work Team put together a brass band of 120 musicians and performed in celebration of the Communist liberation in Northeast China. In 2005 this was reported as having been the largest brass band arrangement in the history of Chaoxianzu music (Chaoxianzu Music Organization 2005, 121).

Among many Korean artists who were immersed in political activism and vigorously participated in both anti-Japanese and socialist movements in China, composer Chŏng Yulsŏng (1914–1976) might be the most notable figure. Nam Hŭich'ŏl, a Chaoxianzu musicologist at Yanbian Arts School, has pointed out that Ch'oe Ŭmp'a, possibly a violinist, predated Chŏng Yulsŏng as a Korean revolutionary composer active across China and the former Soviet Union, a musician whose life is largely unknown (Nam 2016). However, it has been clearly acknowledged by both Chinese and Chaoxianzu sources that Chŏng Yulsŏng, as a Korean musician, made major contributions to the Chinese Communist Revolution, along with Chinese musicians Nie Er (1912–1935) and Xian Xinghai (1905–1945). Chŏng Yulsŏng was born in Kwangju, Korea, during the Japanese occupation to intellectual, well-to-do, nationalist parents. Exposed to music from his early years, he grew up in Korea playing the piano and listening to music on the family gramophone. In 1933 he moved to Shanghai with his sister and was trained as an armed political leader at the Military School for Korean Revolutionary Army Executives (Chosŏn hyŏngmyŏnggunsa chŏngch'i kanbuhakkyo) in Nanjing. While leading the Korean independence movement in Nanjing and Shanghai, he continued his musical studies in voice, violin, composition, and piano. Later when he moved to Yan'an (Yenan) in Shaanxi Province and joined the CCP, he studied music at the Lu Xun Academy of the Arts (Luxun yishu xueyuan), a comprehensive literature and arts school founded by the CCP for the technical and ideological cultivation of anti-Japanese war cadres during the Second Sino-Japanese War (1937–1945).[11] As a member of the Eighth Route Army (P'allogun; Balujun), officially known as the Eighteenth Group Army of the National Revolutionary Army of the Republic of China and commanded by Chairman Mao Zedong and General Zhu De, Chŏng Yulsŏng composed "Yŏnansong" [Glory of Yan'an] and "P'allogun haengjin'gok" [March of the Eighth Route Army], both of which were widely sung by CCP members during the Revolution. The latter song was later renamed "Chungguk inmin haebanggunga" [Song of the Chinese People's Liberation Army] and designated as the anthem of the Chinese People's Liberation Army in 1988 (P. Ch'oe 2014, 185–186; Ye 2014). Chŏng Yulsŏng never lived as a Chaoxianzu but instead acquired Chinese nationality when he returned to China in 1950 from P'yŏngyang, where he had lived and served as a leading revolutionary artist for several years (Ye 2014). In the history of both Chinese and Chaoxianzu music,

he has been recorded as one of the most influential musicians, with many of his songs widely sung among the Chinese, Korean, and later North Korean armies in their respective revolutionary wars.

Dissemination of *sŏnjŏndae* propaganda music in this period was greatly facilitated by the broadcast media and publishing companies that were established in China. By 1949 the Korean mass media organizations operating in Yanbian were the Yanji Xinhua Broadcasting Station (Yŏn'gil sinhwa pangsongguk), opened in 1946; Mudanjiang Broadcasting Company (Moktan'gang pangsongguk), 1947; Yanbian Educational Press (Yŏnbyŏn kyoyuk ch'ulp'ansa), 1947; Yanji People's Bookstore (Yŏn'gil inmin sŏjŏm), 1946; Yanbian Mass Education Publishing Company (Yŏnbyŏn taejunggyoyuk inswaegongjang), 1948; and Cultural Centers in Yanji (Yŏn'girhyŏn inmin munhwawŏn) and Tumen (Tomunsi inmin munhwawŏn). Although it is difficult to encapsulate all the detailed activities that each organization conducted in relation to music in that period, performances of representative propaganda teams were recorded and broadcast by, for example, Yanji Xinhua Broadcasting Station. Although Yanbian was not as well developed as other industrial hubs in northern China, such as Changchun in the early 1940s, it did function as the hub for Korean affairs in politics, economics, culture, and education. Gradually a number of Korean performance troupes and propaganda teams active throughout Northeast China moved to Yanbian and merged into the Yanbian Culture and Arts Work Team, later renamed the Yanbian Song and Dance Troupe (Chaoxianzu Music Organization 2005).

Pre- and post-1949 music in China cannot be comprehended without understanding the cultural frame that Mao Zedong developed by adapting the socialist cultural ideal outlined by Marx, Lenin, and then Stalin to reflect his vision of a national culture for the new China. From the late 1930s through the early 1940s, Mao gave a series of talks on the ideals for literature and arts in China (Perris 1983). In particular, Mao's "Talks at the Yenan [Yan'an] Forum on Literature and Art" of 1942 was greatly influential in terms of the later construction of music, literature, and arts in post-1949 China (Mao 1967 [1942]). These talks, along with subsequent missives, set out his ideas on what literature and art should be in Communist China, and became official cultural policy upon the establishment of the new nation-state.

While stressing the need for the state to embrace ethnic and cultural plurality, Mao was greatly influenced by the socialist cultural ideals of Marx, Lenin, and Stalin. In his talks on literature and the arts, Mao rejected art forms associated with the social bourgeoisie, reflecting Lenin's and Stalin's views on European opera and esoteric art music (Perris 1983, 3). Instead he stated that the arts should serve the proletarian masses, which include peasants and soldiers, groups that Mao particularly emphasized as those audiences to whom music

creators should target their work. To do this, musicians should not only strive to understand the peasants and their cultural dispositions but also learn from them by spending extensive time and closely communicating with them. Moreover, in instructing artists to create arts for the common people, Mao highlighted that all arts should be of both aesthetic and political value. This indicates that Mao not only valued the arts in terms of their functional significance but also upheld aesthetic standards that should guide artists in producing high-quality work (Perris 1983).

In terms of music, Mao acknowledged the necessity of adapting foreign influences as well as the remnants of past societies (e.g., traditional or feudal China) into the creation of high-quality contemporary culture. He stated that the new culture in China should make use of foreign (Western) culture regardless of its origin or its ideological and cultural underpinnings while remaining grounded in national, revolutionary, and socialist ideas (Mao 1967 [1942]; Perris 1983). Even prior to his talks in 1942, Mao emphasized:

> To nourish her own culture China needs to assimilate a good deal of *foreign progressive culture,* not enough of which was done in the past. We should assimilate whatever is useful to us today not only from present-day socialist and new-democratic cultures but also from the *earlier cultures of other nations,* for example, the various capitalist countries in the Age of Enlightenment. . . . Similarly, in applying Marxism to China, Chinese communists must fully and properly integrate the universal truth of Marxism with the concrete practice of the Chinese Revolution. . . . Chinese culture should also have *its own form . . . national in form* and *new democratic* [i.e., *socialist*] *in content.* (Mao 1966 [1940], 380–381; italics added)

Taken together, Mao's talks published through the 1940s provide important frames and rationales for the construction and reformation of Chinese cultures at all levels and beyond their ethnic and national distinctions. The cultural framework "national in form and socialist in content" highlighted by Mao Zedong as well as his Soviet comrades, Lenin and Stalin, served as a de facto agenda for all revolutionary cultural construction in the Soviet Union and Northeast Asia where the victory of the Communist Revolution was envisioned. A draft of a public order released by the Yanbian Commissioner's Office in 1948 announced that the construction and perpetuation of Chaoxianzu culture and identity should be in line with the realization of the new China in *an ethnic way.* Koreans in Yanbian also constructed and reconstructed their arts and literature in adapting to Mao's guideline that all arts should serve the interests of the masses while representing socialist realism.

Korean Music in Post-1949 China

The founding of the People's Republic of China in 1949 and the designation of Koreans as one of the PRC's fifty-five minorities opened up a new epoch of the lives of diasporic Koreans in China. With the establishment of the Yanbian Korean Autonomous Prefecture, Chaoxianzu were given the right to develop their own political system, economy, culture, and education while maintaining their Korean language and traditional customs and practices (Pease 2002, 78).[12] Within this milieu friendly to the promotion of minority nationality identity, Chaoxianzu continued to maintain their own mass media and education systems, some of which predated the founding of the PRC and, in effect, were already intellectually and culturally shaping Korean migrant lives in Yanbian. From 1945 on, the spread of a Korean mass media and the formation of intellectual circles were a noticeable development in Yanbian. For example, the newspapers *Yanbian Daily* (*Yŏnbyŏn ilbo*) and *People's News* (*Inmin sinbo*) were published in Korean, the Yanbian Educational Press (Yŏnbyŏn kyoyuk ch'ulp'ansa) and Yanbian People's Press (Yŏnbyŏn inmin ch'ulp'ansa) published books in Korean, and the Yanji Broadcasting Station (Yŏngil pangsongguk) broadcasted extensively in Korean. Besides the mass media, a number of intellectuals and artists gathered in Yanbian and formed interest groups such as the Yanbian Society for the Literary Arts; the Yanbian Literary Artistic Circles Union, which published its own periodical, *Yanbian Literature and Art* (*Yŏnbyŏn munye*); and the Yanbian branch of the Chinese Writers' Association (Pease 2002, 78).

Korean musicians and artists gathered in Yanbian to begin crafting Korean culture in the new China and, following the principles outlined by Chairman Mao, endeavored to make their arts nationalistic, socialistic, progressive, international, and friendly to the masses. A number of Chaoxianzu performing arts groups, such as the Yanbian Song and Dance Troupe and the Yanbian Theater Troupe, represented Yanbian in promoting the Korean minority nationality identity through creative and expressive performance cultures. The Yanbian Song and Dance Troupe produced numerous new compositions and musical arrangements beginning in the early 1950s. Besides creating new repertoire, minority intellectuals and artists were sent to villages and towns in Northeast China with a mission to "excavate" (*palgul*) Korean folklore, including folk songs, dances, and musical instruments (Um 2013, 171).

Korean schools, which the Japanese government had closed down in the late 1930s, reopened in and around Yanbian. The first university for Korean students in China, Yanbian University, was established in 1949. Its students maintained close ties with schools in North Korea, especially Kim Ilsŏng

[Ilsung or Il Sung] University in P'yŏngyang, which to a great degree influenced curriculum development at Yanbian University and the ideological shaping of Chaoxianzu students, especially in its first decade. Yanbian Arts School, a conservatory for Korean minority performing arts, opened in Yanji on 5 October 1957 and began training Chaoxianzu students in music, dance, art, and literature. In its first year, the music department had students majoring in six different subjects: composition, *kayagŭm,* voice, violin, piano, and cello (T. Kim 1997, 3). Students learned *kayagŭm* and *minyo* from Chaoxianzu teachers based in Yanbian and from visiting instructors from North Korea through the 1950s (Pease 2016, 170). North Korean musicians such as Chi Mansu and Pang Ongnan stayed in Yanbian between 1959 and 1960 and taught Chaoxianzu students folk singing, *p'ansori,* and *kayagŭm* (Y. Cho 2002, 92). While North Korea supplied teaching and learning resource materials, which Chaoxianzu used to create a diasporic Korean music in China, Chaoxianzu musicians also traveled to North Korea to learn traditional Korean instruments, especially at P'yŏngyang College of Music and Dance. This heyday of minority culture between the 1950s and 1960s was not unique to Chaoxianzu: all minority nationalities in China at the time experienced a blossoming of broadcasting systems, film productions, sound recordings, and sheet music publishing with considerable state support—all controlled by the state, which had replaced the patronage system of social elites and bourgeoisie that had existed before the founding of the PRC (Manuel 1988, 229).

The Ministry of Culture inaugurated a massive program in order to stimulate broad interest in expressive arts and ensure wider circulation. For example, in 1954 the Yanbian People's Broadcasting Station (Yŏnbyŏn inmin pangsongguk) collected and recorded about one hundred pieces of Korean music from areas in Northeast China, including Mudanjiang, Shangzhi, Xinanzhen, and Harbin in Heilongjiang. In 1958 the autonomous government's propaganda department set up a Chaoxianzu *minyo* collection committee. In 1961 the state's cultural department established the Yanbian Folk Arts Research Group and directed it to research, collect, record, and transcribe Korean songs found in rural Chaoxianzu villages. As mentioned earlier, before the Cultural Revolution, about eight hundred Korean songs had been collected in Northeast China. These songs were then introduced to the general public through a series of publications. Forty-nine Chaoxianzu *minyo* were published by the Yanbian People's Press in 1954. The Yanbian Folk Arts Research Group also published a collection of songs in 1963 (Chaoxianzu Music Organization 2005, 139–141).[13] Under the stimulus of the new state, Korean music in China entered a new stage: it was developed, and flourished, as Chaoxianzu culture, although older traditional practices had to be given a new form and sound in order to fulfill the state's underpinning ideology, that of "national in form and socialist in content."

With the CCP promoting the production, research, and collection of folk musics throughout China as of the early 1950s, the Chaoxianzu autonomous government ordered Chaoxianzu musicians to concentrate on the performance of ethnically distinctive music by "excavating and collecting" (*palgul sujip*) Korean folk traditions from rural Chaoxianzu villages and "creating" (*ch'angjak*) new repertoires that would appeal to the Chaoxianzu masses. One type of Chaoxianzu music widely circulated was that of songs with didactic messages. The creation of didactic songs in a style considered friendly to the masses was, however, no longer new—neither in Yanbian nor in China in general—since Chairman Mao's cultural framework, which remained strongly in effect, sanctioned revolutionary propaganda songs only. For Chinese ethnic minorities, their music also had to be explicit about ethnic identity in its lyrical content and/or musical style. With this in mind, professional and amateur musicians in Yanbian composed a great number of Chaoxianzu songs as well as reworking traditional music with which Koreans were familiar. In these rearrangements of Korean folk songs they incorporated Western musical influences such as harmony, piano accompaniment, and bel canto voice. The newly composed songs were kept melodically simple so that anyone could easily sing along; Koreanness was articulated by adapting the pentatonic/tritonic scales of Korean *minyo* and representative traditional Korean rhythms to Western melodic, metrical, and stylistic frames.[14] In terms of subject matter, these songs celebrated the founding of the PRC, the Korean autonomous areas, communism and communist heroes, and proletarian identity.

Chaoxianzu artists created new theatrical productions inspired by and recycling old *p'ansori* and *ch'anggŭk* (an opera version of *p'ansori*) repertoire from the 1950s.[15] These Korean theatrical productions were undoubtedly favored in the socialist context because they entertained both the urban and rural Korean masses as artistic collages incorporating both regionally and nationally familiar music and story lines. Moreover, all *p'ansori* plots fundamentally articulated traditional morals and didactic messages directed at the masses. In Yanbian, traditional *p'ansori* and *ch'anggŭk* were both reworked to convey traditional moral values while drawing on socialist realism. These recreated Korean theatrical forms were presented as the arts of the new China, fulfilling Mao's dictum of "national in form and socialist in content." New pieces in short or long length were composed, such as "Punyŏ sangbong" [Union of Father and Daughter], created out of an excerpt from traditional *p'ansori, Simch'ŏngga* [Song of Simch'ŏng], which articulates the virtues of filial piety. Another new *p'ansori*-inspired piece, "Ttŏngme ŭi chŭngo" [Ttŏngme's Hatred], was composed by a Chaoxianzu composer, Chŏng Chinok (1926–1981), and was premiered in Yanbian in 1956. This composition depicted a young soldier, Ttŏngme, and his anti-capitalist patriotism while fighting in the Korean War, during which a

great number of Chaoxianzu youths died fighting for the socialist liberation of the Korean Peninsula. Besides *p'ansori,* a more elaborate form of musical theater, *ch'anggŭk,* was adapted and performed by a Chaoxianzu theatrical troupe, the Yanji New Ch'anggŭk Troupe (Yŏngilsi sinch'anggŭktan). This troupe produced a new theatrical work, *Hŭngbu wa nolbu* [Hŭngbu and Nolbu], based on another traditional *p'ansori,* as well as another new work, *Pulgŭn chame* [The Red Sisters], an adaptation of a Chinese drama from the northeastern region. The troupe also introduced a completely new theater production, *Haengbok* [Happiness], whose story line depicted the happy life of Chaoxianzu in socialist China (Um 2013, 172).

While overall the 1950s were a productive period for the construction of Chaoxianzu culture and identity in the new China, they were not entirely conducive to the celebration of minority heritage. There were instances when Chaoxianzu were discouraged from expressing and celebrating their ethnic heritage. The CCP revised its stance toward minority nationalities several times as it shifted its revolutionary strategies at the state level. In the late 1950s and the 1960s, some minority musicians and artists were accused of being ethnocentric by preferring traditional Korean music. The Hundred Flowers Campaign, conducted in 1956 and 1957, purported to celebrate the expression of hundreds of different ideas in China, but it soon became the Anti-Rightist Campaign serving as a mechanism to purge people critical of Mao's party line. This was succeeded by the Great Leap Forward, known as "three years of hardship," which caused a great famine leading to the loss of about twenty million lives between 1958 and 1962. During that time, ethnic diversity was no longer seen as something to be celebrated but rather as a nuisance obstructing the realization of state unity. The members of minority nationalities were instructed to achieve unity through cultural homogenization and participation in economic development. Subsequently, much of the culture of the ethnic minorities was clearly reformed during this period according to socialist agendas, most of which emphasized production, material well-being, progress, and revolution (Schein 2000, 86–87). Obviously, all these shifting ideologies and political impositions from the top must have been bewildering to ordinary people, regardless of whether they were members of the Han majority or of ethnic minorities; however, the sense of confusion and frustration must have particularly affected the social margins since a sizable number of Chaoxianzu decided to leave China and move to North Korea around that time.

Meanwhile, the Han Chinese population was steadily growing in Yanbian, and soon they outnumbered Koreans in some areas in the prefecture. To promote inter-ethnic unity, the CCP required that about 60 percent of cooperatives were to be formed of mixed nationalities. However, the reality was that Chaoxianzu and Han Chinese did not always get along. Some Chaoxianzu requested

single-nationality cooperatives, attracting harsh criticism from the central government and being accused of "'local nationalism' dangerous to the 'great collective family' in the anti-rightist backlash that followed" (Pease 2002, 79–80). Many Chaoxianzu musicians who were active in the development of diasporic Korean music were subsequently intimidated as they witnessed the fluctuation of minority nationality policy and their colleagues labeled as rightists.

Obviously, the first seventeen years of the PRC, before the outbreak of the Cultural Revolution, did not consistently ensure security in the perpetuation of minority nationality culture in China, since between socialism and the culturally essentialized nation, ethnic minorities in China had to accept the supremacy of the state ideology in order to avoid risking their lives, even in their autonomous regions. In this sense, in practice, the minority autonomous government was never allowed to pursue true autonomy. Nevertheless, the first decade of the PRC was greatly significant in the history of Chaoxianzu music, since it was the period when numerous traditional Korean music practices were promoted and reinterpreted as Chaoxianzu culture.

The Cultural Revolution

The Cultural Revolution launched by Mao Zedong was ostensibly intended to reconsolidate Chinese Communism by purging remnants of capitalist and feudal traditions from Chinese society. However, perhaps more fundamentally, this class struggle was about restoring Mao's power, which was weakened by the failure of the Great Leap Forward Movement, and eliminating his rivals within the CCP, who had become less supportive of his leadership. Mao branded his rivals as social revisionists who needed to be eliminated or reeducated. After all, the Cultural Revolution had been excessively violent and aggressively handled, persecuting and harming millions of civilians, including the killing of five hundred thousand to two million people, leaving China socially and culturally debilitated, and seizing up its economy to a significant degree.[16]

At the beginning of the Cultural Revolution, its attack on Chaoxianzu society was not as swift as that on Beijing. It was after Mao Yuanxin (also known as Li Shi) arrived in Yanbian at the end of 1966 and admonished Chu Tŏkhae for not vigorously imposing the Cultural Revolution there that Chaoxianzu were no longer safe from the political turmoil that was spreading across all of China. Chu Tŏkhae, the celebrated political leader and first chairman of the Chaoxianzu autonomous government, was criticized for his pro-nationality stance and accused of being a counterrevolutionary revisionist. While the outbreak of the Cultural Revolution, driven by the goal of restoring and consolidating Mao's power within the CCP, was largely disguised as a class struggle in the name of the proletariat revolution, it turned into an accusation of Korean nationhood

when it came to Yanbian and Chaoxianzu. Mao Yuanxin harshly criticized Chaoxianzu leaders and intellectuals of ethnic factionalism. Subsequently, 2,653 Chaoxianzu were recorded as having died as a result from violent persecution, suffering, or suicide to escape persecution and depression (Kwak 2013, 256–257).

Pease (2016) states that from the beginning, the CCP's aims with the Cultural Revolution in Yanbian were different from those in the central parts of China. Because the majority of Korean migrants had a peasant background, the class struggle was not a strong factor in Yanbian. At the same time traditional Korean cultural practices were weakened and intimidated due to Japan's efforts at eradicating them in Korea and to an extent in Northeast China. In Yanbian the CCP was most concerned about the potential loyalty of the Korean community, which was viewed as precarious due to North Korea's accessibility and geocultural proximity. Before the Cultural Revolution, Koreans in Yanbian could cross the Sino–North Korean border without difficulty, there were no restrictions on listening to North Korean radio and importing North Korean goods such as books and musical instruments, and a number of Chaoxianzu intellectuals were making substantial use of North Korean resources in constructing the Chaoxianzu cultural and educational landscape. Again, a number of Chaoxianzu intellectuals—including musicians—fled to North Korea during the brutal years of the Cultural Revolution. Especially in its first phase, North Korea was mistrusted and Kim Ilsŏng was denounced by Red Guards as a "fat revisionist" and "Korea's Khrushchev" (169, 170). Amid this political turmoil, even the Koreans' revolutionary history was revised to ensure that it contained no elements of Korean nationalism. The autonomy of language, education, and culture promised to ethnic nationalities in China was no longer foreseen in the China that was emerging (Kwak 2013, 258–260).

Oliver (1993) describes the revision of the state directives over its ethnic nationalities during the Cultural Revolution that emphasized blurring the differences between Han and non-Han groups by way of blending ethnically distinctive cultural practices with those of Han Chinese:

> The Cultural Revolution . . . denied the earlier achievements of the nationality policy and dismantled most of the nationality organizations in place at that time, at all levels and in all domains. It declared the nationality question solved and treated all non-Han as Han. It was no longer a question of autonomy, nationality characteristics, and special privileges. Rather, the goal became the complete assimilation of the non-Han minority nationalities into the mainstream of Han society. The Cultural Revolution affected all nationalities and all nationality areas, and the havoc it unleashed upon them made recovery slow and difficult after years of indescribable chaos. (Olivier 1993, 145–146)

During the early period of the Cultural Revolution from 1966 to 1971, Chaoxianzu endured the closure of ethnic schools, bans on ethnic cultural practices including music, and the purging of nationalists by divestiture and reeducation as proletarian workers. As early as July 1966 the Chaoxianzu Music Organization (the Yanbian branch of the Chinese Music Organization) was disbanded. Around the same time, the Yanbian Song and Dance Troupe was banned from performing ethnically explicit music. The Yanbian Arts School was closed as well, in 1969. Unlike under the revolutionary promise of the preceding years, Chaoxianzu ethnic culture was no longer a mark of virtue in China. In Beijing, Chairman Mao's last wife, Jiang Qing (1914–1991), who formed the Gang of Four, the ultraleftist group consisting of Jiang herself and her followers—Zhang Chunqiao, Yao Wenyuan, and Wang Hongwen—also devalued Korean culture and criticized it roundly:

> Jiang Qing and her acolytes branded Korean culture as unworthy of preservation. They claimed that Chaoxianzu culture only had a short history of about a hundred years. That was because, they argued, traditional Korean culture belonged to Korea and not China, and was, therefore, foreign to the Koreans of Northeast China. Local Koreans particularly cherished the more recent "Resistance culture" of the period of resistance against Japanese domination. That culture eulogized the virtues and achievements, and sang the praises, of the Korean resistance fighters. But Jiang Qing and her clique concluded that these Koreans fought for Korea and not directly for China and the local Koreans and that nothing was really worth preserving in such a culture. (Olivier 1993, 152)

The emerging new revolutionaries thus condemned those who defended Korean culture. Chaoxianzu musicians who had enjoyed the support and admiration of the national and autonomous government were now painted as enemies of the Great Proletarian Cultural Revolution and were expelled and sent to rural areas for reeducation. The performance of traditional music, dance, and theatrical works in Korean was banned, and wearing Korean costumes on stage or even advertising performing arts programs in Korean was prohibited (Olivier 1993, 153). All the effort put into researching and creating Chaoxianzu music in the pre–Cultural Revolution period was also completely recast as counterrevolutionary. As the citizens of a single state, all nationalities in China were instructed to consume six "model operas" and two ballets.[17] These eight model works were the only performing arts that any Chinese people were allowed to publicly and privately enjoy during the first three years of the Cultural Revolution. The Yanbian Song and Dance Troupe had to produce Korean versions of the model operas, which initially had been sung in Chinese, so that

Chaoxianzu could actually understand them (Chaoxianzu Music Organization 2005, 276–277; for the production of model operas in Yanbian, see Pease 2016). This severe ultraleftist policy of promoting a specific type of culture while at the same time suppressing the diverse nationality cultures was applied until September 1971 (Chaoxianzu Music Organization 2005, 277).

Another type of music propagated by the Gang of Four was the "quotation song" (ŏrok kayo): propaganda songs pieced together from quotations from talks given by Mao Zedong and Lin Biao (1907–1971).[18] These songs, sung while dancing, were designed as pledges of the people's loyalty to the two figures. During the early period of the Cultural Revolution, hundreds of such quotation songs were composed and sung by the Red Guard. The most representative song propagated by the Chaoxianzu Red Guard was "Yŏnbyŏn inmin mojusŏk ŭl noraehane" [The Yanbian People Praise Chairman Mao]. The Red Guard of Yanbian sang this song on its travels through China as a means of showing its loyalty and respect toward Mao Zedong.

The first five years of the Cultural Revolution were its extreme years—a period in which Mao Zedong and the ultraleftist Gang of Four aimed to control China at every level and completely dismantle nationality differences. The sudden death of Lin Biao and widespread criticism of the Gang of Four brought some relaxation of the policy. Mao realized the need for moderation in order not to annihilate the party and the country completely. Therefore, in 1971 he revised his policy, from one of complete destruction of nationality identities to one that adopted a positive approach toward the nationality question. While the general theme of the Great Proletarian Cultural Revolution was maintained, a little room was left for ethnic diversity.

From this time on, Chaoxianzu communities slowly resumed communication with North Korea (Pease 2016, 170). In 1972, Yanbian Arts School reopened, Chaoxianzu musicians who had been sent to rural villages for reeducation returned, and minyo and Chaoxianzu instruments slowly reappeared. Despite the gradual return of some Chaoxianzu music and cultural activities from 1971, however, until 1976 music and the arts in general remained dominated by the leftist ideal of constructing a unified Chinese proletarian culture (Chaoxianzu Music Organization 2005, 278; Pease 2016). Quotation songs continued to be the dominant musical genre. Chaoxianzu musicians, such as Cho Sunhŭi (1935–2006), arranged propaganda songs for Chaoxianzu kayagŭm and taught them at Yanbian Arts School as a replacement for ethnically distinctive repertoire. In 1973, influenced by the revolutionary spirit, the revolutionary opera Ryonggang-song [Eulogy to Dragon River] was adapted as a ch'anggŭk (Um 2013, 173; Pease 2016). For that to happen, a team of ten professionally trained creative workers—including composer Hŏ Wŏnsik (1935–2001), music theorist Chŏng Chun'gap (1941–1995), and cultural adviser Li Hwanghun—was formed to work on the

production of the opera by Yanbian Song and Dance Troupe. Altogether, it took almost two and a half years to complete the full orchestral scores and get them approved by the cultural office in Beijing (Pease 2016, 177–179). This Korean version of a model opera was infused with Koreanness through its incorporation of *p'ansori* modes and melodies and Korean instruments (Chaoxianzu Music Organization 2005, 278). Pease (2016) provides stylistic details of *Ryonggangsong,* which she calls *Song of the Dragon River,* in her article addressing this topic. With her ethnographic research and musical analysis, Pease provides an account of how this opera was produced by combining Korean, Chinese, and Western elements (see Pease 2016, 175–176). There she cites singer Chŏn Hwaja (b. 1943), who played the heroine, describing the detailed instruction that she received from the Beijing office on how to stylize and perform her role on stage. Under the slight relaxation of restrictions on minority ethnic music in China, An Kungmin (1931–2014), having served as the director and composer of the Yanbian Song and Dance Troupe, composed "P'ungnyŏn madi kippŭm" [Joy of a Full Harvest Year] for *changswaenap* (a long conical oboe; lit., long *swaenap*), inspired by the *minyo* "P'ungnyŏn'ga" [Full Harvest Song]. An recollects that given the revolutionary and political milieu at the time, this composition was a brave one since it made explicit reference to ethnic Koreanness by featuring Korean instruments and incorporating a Korean folk song melody and traditional rhythms.[19] Unlike *Ryonggangsong,* in which Korean elements were deliberately incorporated into the model opera format following specific directives from Beijing, smaller-scale works resulting from individual musicians' creativity, such as Cho Sunhŭi's *kayagŭm* music and An Kungmin's composition for *changswaenap,* during the Cultural Revolution may point to the ambivalent power dynamics between the state and individual musicians.

A new Chaoxianzu theatrical genre, *Yŏnbyŏn ch'angdam,* also emerged during the later phase of the Cultural Revolution. This was a storytelling genre created by a group of Chaoxianzu musicians who studied Han Chinese oral narrative arts in places such as Tianjin, Beijing, and Shanghai. *Yŏnbyŏn ch'angdam* made use of preexisting *minyo* melodies. A melody would be chosen as a theme and then variations applied to it for the entire drama, with varying texts set to them (N. Kim 2010, 395). Um Haekyung (2013) states that *Yŏnbyŏn ch'angdam* was based on at least three different contemporary music styles: the dramatic plots of the revolutionary operas, the performing styles of local Chinese narrative genres, and the *minyo* melodies of traditional Korean music dramas (173). It is hard to know how well this new genre was received in Yanbian at the time. What was clear was the effort of the Chaoxianzu community in creating Chaoxianzu theatrical works by fusing the characteristics of Korean music with those of Han Chinese traditions to make them acceptable to the regime. While Chaoxianzu music and musicians were eclipsed in the suppression of

minority nationality cultures during the first half of the Cultural Revolution, the second half provided a turning point for Chaoxianzu music in some ways. Unfavorable political conditions for minority nationality music incited Chaoxianzu musicians to come up with new musical forms that would be permitted for staging even during the harsh revolutionary period. Although Korean minority musicians had to negotiate their musical practice by being vigilant in terms of constraining ethnic elements or by combining them with the revolutionary model works or Han Chinese cultural practices, the flip side was the initiation of new forms of music by individual musicians trying to find a way of sustaining minority nationality cultures in China.

As Litzinger (2000) points out, "Mao Zedong's revolutionary rhetoric and practices of class struggle did not dictate every moment of this historical period, and his visions of development were often challenged at all levels of Chinese society" (10). The Cultural Revolution affected Chaoxianzu society and culture through intimidation while at the same time providing a new context in which Chaoxianzu identity was revisited and newly constructed. Korean scholar Kwak Sŭngji (2013) states that despite their status as a Chinese minority nationality, Koreans in China held a strong connection with North Korea and viewed themselves, to a degree, as North Korean nationals. In fact many Chaoxianzu were entitled to North Korean citizenship not only because they had families there but also because the majority, especially those living in and around Yanbian, had migrated from Hamgyŏng Province, now part of North Korea. For these Koreans, North Korea was the country of their motherland to which they felt connected and for which they developed a psychological and cultural sense of belonging as a Korean diaspora. This was one of the major concerns of Mao's party and the driver of its harsh treatment of Chaoxianzu to repress their Korean identity. During the Cultural Revolution, when Chaoxianzu were cut off from North Korea in terms of social and cultural interaction, Koreans in China began to recast themselves more unequivocally as Chinese citizens (256). Ironically, the policy of Han Chinese assimilation imposed by the Gang of Four on all minority nationalities in China in some ways created a backdrop against which a new Chaoxianzu identity could be constructed, as Chaoxianzu were forced to adapt to Han Chinese cultural citizenship. Through the ten years of unequal dialectics between state power and individual agency in China, Chaoxianzu and their cultural identity were inevitably reshaped. When the Cultural Revolution officially ended and the minority nationalities were given the freedom to revive their ethnic heritage and cultures, Chaoxianzu musicians' apprehension of Han cultural citizenship provided the ideas underpinning the crafting of Chaoxianzu cultural identity in the Age of Reform and taking center stage in defining and shaping discourse around the cultural identity of Koreans in China, distinct from those of North or South Korea.

Chaoxianzu Music in the Age of Reform

The Cultural Revolution ended in October 1976, one month after Mao's death. The PRC marched into a new era under the leadership of Deng Xiaoping (1904–1997). At the Third Plenum of the Eleventh Central Committee of the CCP in December 1978, Deng called for freedom of thought and the abandonment of ideological dogma; subsequently revolution and class struggle were replaced as China's chief political goals by the challenge of promoting economic reform and surplus accumulation. In this new Age of Reform, the degree of political conformity and the social background of cadres and common people in China were less emphasized than their economic competence (Olivier 1993, 175). Along with political and economic reform, cultural reform was also taking place all over China. In this new era, minority nationality musicians and artists saw their honor and status restored. They were again encouraged to express their ethnicity (Chaoxianzu Music Organization 2005, 296).

The political and economic reforms brought great changes to the lives of the Chinese people. China's rural areas lost many people as they migrated to newly emerging cities. Between 1982 and 1990, about ninety thousand Chaoxianzu relocated from the rural Jilin and Heilongjiang provinces to the growing cities of inland China, such as Beijing and Shanghai. Between 1990 and 1996, two hundred thousand Chaoxianzu moved to developing cities in China's coastal areas, such as Tianjin and Chengdu. Moreover, throughout the 1990s, many Chaoxianzu moved to foreign countries as temporary workers or through marriages to non-Chaoxianzu. Since the establishment of diplomatic relations between China and South Korea in 1992, a significant number of Chaoxianzu have visited South Korea as temporary migrant workers or have permanently moved there. Despite some discrepancies in population figures of Chaoxianzu in South Korea, four to five hundred thousand Chaoxianzu are living there (Kwak 2013, 11; also see chapter 1).[20] These out-migrations from China have resulted in the Chaoxianzu population in the autonomous regions shrinking dramatically over the past thirty years (Chaoxianzu Music Organization 2005, 298).

Anthology of Folk Music of the Chinese Peoples

Many records of folk and traditional music that were collected in the research boom of the 1950s and early 1960s did not survive the Cultural Revolution. With the changing political tide, a massive new campaign to document folk music around the country was launched in 1979. Chinese minority nationality folklore research was centered on the autonomous regions. As an outcome of the project, the multivolume *Zhongguo minzu minjian yinyue jicheng*

[Anthology of Folk Music of the Chinese Peoples] was published starting in 1995. Each volume dealt with a number of different provinces in China and included sections dealing with folk songs, instrumental folk music, operas, narrative singing, and other musical genres (on this project, see Jones 2003).

As part of this project, a local committee was formed in Yanbian to conduct research on surviving Chaoxianzu traditional music from three provinces in the Northeast, with both professional and amateur musicians participating in the work. Chaoxianzu songs, dramas, and instrumental repertoires were published in the volumes on Liaoning, Jilin, and Heilongjiang Provinces. All together 596 Chaoxianzu songs, 103 narrative works including *ch'anggŭk, p'ansori,* and *ch'angdam,* and 71 instrumental pieces were included in the anthology.[21] For this project, the term *minyo* seemed to be rather broadly defined since the folk song section included children's and revolutionary songs as well as Korean folk songs. Moreover, during the collection process, some repertoire was reconstructed or contrived specifically to swell the data. For example, a Chaoxianzu musician who was recorded playing "Yŏngsanhoesang" and "Sinawi," examples of traditional Korean instrumental music, admitted that he had not known or played these pieces before then. Although a large amount of Korean music was documented and published in the anthology, not all the repertoire collected represented living traditions (Chaoxianzu Music Organization 2005).

A New Age of Chaoxianzu Music

As Korean minority identity and Chaoxianzu music were revitalized in Yanbian, Chaoxianzu musicians, particularly those who were affiliated with Yanbian Arts School, published a series of music books to be used as teaching resources for Chaoxianzu students. Cho Sunhŭi, a *kayagŭm* teacher, had already been publishing books for her students before the end of the Cultural Revolution. Her series of pedagogical materials featured playing technique for the new Chaoxianzu twenty-three-string *kayagŭm,* new arrangements of *minyo* for *kayagŭm,* and transcriptions of traditional Korean repertoire such as *sanjo.* Her teacher, Kim Chin (1927–2006), who taught *kayagŭm* at the arts school for many years, also published *kayagŭm sanjo* transcriptions reflecting his studies in North Korea. If Cho was better known for her modern and innovative approach to traditional Korean instrumental music as well as her development of the Chaoxianzu *kayagŭm* and a repertoire for it, Kim Chin was acclaimed for introducing traditional Korean *kayagŭm* as part of Chaoxianzu music education in Yanbian.[22] Though a single instrumental genre, the transmission and maintenance of *kayagŭm sanjo* in Yanbian was to prove particularly meaningful since it later enabled Chaoxianzu musicians to argue for the embracing of authentic traditional Korean music as part of the diasporic musicscape in Yanbian (see chapter 4).

Besides the Chaoxianzu vocal music published in *Zhongguo minzu minjian yinyue jicheng*, a Chaoxianzu composer and music theorist, Chŏng Chun'gap, transcribed *p'ansori* sung by Pak Chŏngnyŏl (1920–1988) in 1989 and made these available to the students at Yanbian Arts School. Chŏn Hwaja and Kang Sinja (b. 1941), who were teaching Korean singing at the arts school, also published songbooks in 1995 for their students. Perhaps the content of their songbooks was not much different from the folk song repertoire found in North and South Korea. However, Chaoxianzu singing methods and performance practice have been uniquely developed in China as the diasporic singing of Korean songs (see chapter 6). The typically husky vocal production of Korean *p'ansori* artists became less prominent in Yanbian, with lighter voices and high vocal tessitura preferred. While traditional *p'ansori* and *minyo* singing in Korea were accompanied by the *puk* (Korean barrel drum) or other Korean percussion or melodic instruments, Chaoxianzu voice majors at Yanbian Arts School are often taught with a piano and a Korean percussion instrument, either *puk* or *changgo*. Through the 1990s and 2000s, the publication of Chaoxianzu music continued to increase. Since Yanbian Arts School has been almost the only institution for higher education in Chaoxianzu performing and creative arts, it is not an exaggeration to say that what has been available in the school has come to make up the body of representative works of Chaoxianzu music in Yanbian.

Outside the academic setting, Chaoxianzu performing arts organizations were revived and reformed. While the Yanbian Song and Dance Troupe continued to be the representative Chaoxianzu performing arts troupe, its selection of Chaoxianzu instruments was rather reduced in post–Cultural Revolution Yanbian in consideration of wider audience groups in the region. Instead, another Chaoxianzu music troupe, the Yanji Chaoxianzu Arts Troupe (Yŏngilsi Chosŏnjok Yesultan), was formed in the 1980s as an ensemble featuring Chaoxianzu instruments and the works of Chaoxianzu composers (see chapter 5).

Some of the musical development that the Chaoxianzu community had initiated before the outbreak of the Cultural Revolution was resumed in the 1980s. In 1983 the Center for the Reformation of Korean Music Instruments (Minjogakki kaehyŏk yŏn'guso), which had been established within Yanbian Arts School in 1964 by the Department of Culture under the Yanbian autonomous government, reopened as the Institute for Yanbian Chaoxianzu Musical Instruments (Yŏnbyŏn chosŏnjok chach'iju minjok akki yŏn'guso) while continuing to be located within Yanbian Arts School. Like the 1964 version, this institute was devoted to the development and manufacture of Chaoxianzu instruments (C. Chang 2009, 241). Pak Kŭumryong, Ch'oe Ch'unhwa, Kim Sŏngch'ŏl, Kim Sŏksan, and Sin Ryongch'un were employed as researchers under Chŏn Ŭnggwŏn (chair of the Department of Culture) and Chŏng Chun'gap (vice principal of

Yanbian Arts School). Chaoxianzu instruments such as *tanso* (short vertical flute) and *chŏttae* were made of synthetic resin and had metal keypads. Later, the materials were replaced with hardwood for better resonance and a softer sound (see chapter 3). The Chaoxianzu *yanggŭm* was redesigned and acclaimed for its louder and clearer sound. Researcher Pak Kŭumryong was later invited to South Korea's Center for Traditional Performing Arts in North Chŏlla Province to collaborate with South Korean instrument manufacturers to improve the sound production capacity of Korean traditional instruments (Chaoxianzu Music Organization 2005, 318–319).

Although Chaoxianzu instrument manufacturers endeavored to supply the local market, Chaoxianzu musicians resumed their interactions with artists in North Korea from the beginning of the Reform era. Throughout the 1980s, Chaoxianzu musicians visited North Korea to learn the new form of national music invented in North Korea in the 1960s and the 1970s reflecting Chairman Kim Ilsŏng's ideology of self-reliance (*chuch'e sasang*). Chaoxianzu musicians who studied in North Korea brought North Korean instruments and music back to Yanbian. Consequently, the North Korean influence on Chaoxianzu music again became prominent, although Chaoxianzu musicians argue that Chaoxianzu adapted North Korean music in their own way (see chapters 4 and 6).[23]

Alongside the predominance of North Korean music in Yanbian, in the mid-1980s Chaoxianzu musicians began to interact with South Korean musicians, a process that continues today. Accordingly, Chaoxianzu music diversified as music learning opportunities increased. Chaoxianzu musicians who are now instructors at Yanbian Arts School visited North or South Korea to study different forms of Korean music. For example, Kim Sunhŭi, who is currently teaching Chaoxianzu singing at Yanbian Arts School, studied *Kyŏnggi minyo* (a folk song style from central Korea) in South Korea in the late 1990s. Before she began to teach *Kyŏnggi minyo* at the arts school, only *sŏdo minyo* (from northwestern Korea—today in North Korea) and *namdo minyo* (from southwestern Korea—today in South Korea) had been taught. In contrast, Pak Ch'unhŭi, another instructor in Chaoxianzu voice at the arts school, is well known for her specialization in *chuch'e ch'angbŏp,* the self-reliance singing developed in North Korea, and has taught this style to numerous Chaoxianzu singers (see chapter 6).

The political relaxation and cultural liberalization of post–Cultural Revolution China did not always have positive effects on Chaoxianzu music. Government financial support for state or municipal performing arts organizations was no longer sufficient due to growing inflation in China. As China no longer eschews global capitalism, musicians who become financially insecure may leave the profession to pursue careers in other fields, for example, to open businesses or leave temporarily for South Korea to seek financial opportunity.[24] The changing social milieu brought uncertainty to Chaoxianzu music and has led it

to seek new forms of patronage complementary to or as a replacement for government sponsorship.

Popular Music

The development of popular music in China has followed quite a different path than in the other capitalist states in Northeast Asia. Only close to the beginning of the Age of Reform did popular music in the capitalist sense reappear in the PRC. Although popular music was introduced in China around the beginning of the twentieth century and blossomed during the century's second and third decades (centered on the city of Shanghai), it was completely banned when the CCP took over mainland China. While government propaganda songs continued to be produced by state-owned recording companies and circulated for mass consumption even in the post-Mao PRC, starting in the late 1970s Western and Chinese popular music were smuggled into the PRC and gradually affected the lives of mainland Chinese. Hong Kong and Taiwan were the two cultural springboards through which the mainland people experienced contemporary life outside the Communist regime, and cassettes and records of the *gangtai* pop produced in those places were brought into the PRC (Baranovitch 2003, 10). In particular, the impact of Taiwanese singer Teresa Teng (Ch. Deng Lijun, 1953–1995) was enormous. She reshaped the popular music scene in mainland China by exposing the people to Western and alternative Asian forms of modernity with her music. In his book, Moskowitz (2010) illustrates Teng's impact in mainland China through the voice of an informant:

> [The *gangtai* invasion] began with Teresa Teng and then with people like Fei Xiang, an American-born Chinese singer who also came to China in the 1980s. Before Teresa Teng no one listened to pop music. It was all revolutionary songs. It was Teng that ushered in love songs. Her stuff was really great because she sang about real life issues, not just about politics. . . . My mom loves Teresa Teng and all the other music from that era. My folks were in their twenties and thirties at that time, and that is the age when people usually listen to pop music, right? . . . If you had to choose one star and say "she is the absolute most important pop singer in the history of Chinese pop music" there is no doubt it would be Teresa Teng. (Moskowitz 2010, 19–20)

Many of the PRC's singers and songwriters who worked in Chinese popular music at the time of its reemergence in the 1980s unequivocally mentioned how influential Teng's music was in the PRC as well as on them in pursuing careers in the pop industry. Although Deng Xiaoping paved the way for capitalism with

his Open Door policy of 1978 and his 1979 call for "socialism with Chinese characteristics," pop was only consumed "half-openly." While people could legally buy or copy cassettes brought in from the outside, pop music was still not broadcast on state-controlled TV and radio. Eventually the PRC realized that it could no longer restrict the nation from accessing foreign popular music such as *gangtai* pop. Instead it shifted its focus to censorship. Favoring songs with moral messages, the PRC allowed some *gangtai* pop to be aired through Chinese mass media, while continuing to ban Western pop music and music videos from Europe and America, classifying them as too sexual and depraved. Despite the PRC launching its new era of reformation, in the eyes of the Communist government, sentimental songs about love and despair were detrimental and counterproductive, especially to the young Chinese whose hearts and minds were to be devoted to the nation (Moskowitz 2010). Just as the earlier Communist regime had labeled the Chinese popular music that had sprung up in Shanghai as deleterious and a bad influence, the reform government considered most popular music to be polluting, obscene, and morally decadent.

From 1986 the PRC began to release its own popular music, *tongsu yinyue,* which was supposed to be more grounded in local culture while highlighting Chineseness, whether the prospective consumers were of the Han majority or the minority nationalities. TV programs in the PRC were aired featuring Mandopop (popular songs in Mandarin) singing competitions. Chinese Central Television (CCTV) especially emphasized that music on Chinese television should carry on and develop traditional Chinese culture, as well as reflect the love of the people for the homeland and for their lives. Subsequently, the PRC promoted its own popular music—one that was filled with optimism and especially celebrating China's historical and racial superiority, local places, and landmarks, and the happy lives of all Chinese peoples—whether as part of the ethnic majority or a minority. This type of propagandistic framing of Chinese popular music has been well observed in the production of Chaoxianzu popular music since the 1990s.

The Jilin Nationality Audio-Visual Publishing Company (JNAPC; Killim minjok nogŭm nokhwa ch'ulp'ansa), Yanbian People's Radio Station (YBRS; Yŏnbyŏn inmin pangsongguk), and Yanbian Television Broadcasting (YBTV; Yŏnbyŏn TV pangsongguk) played major roles in producing and disseminating commercial Chaoxianzu songs.[25] In its similarity to much of the state-sanctioned popular music produced in the 1980s and 1990s for the Han or minority peoples, many Chaoxianzu popular songs, even throughout the 2000s, conformed to the *good* kind of popular music promoted by the PRC through its visual, textual, and sonic signifiers that highlight the pure, innocent, rural, and happy lives of Chinese minorities (Baranovitch 2001). Many Chaoxianzu songs in the media share certain commonalities in terms of topics, that is, pure or

innocent love, friendship, regional landmarks, family relationships, farming, and the hometown. Often, Chaoxianzu songs are visually supported with images that evoke the regional identity of Yanbian or of specific places where Chaoxianzu live (for more details, see chapter 6).

The pre-1949 music of Koreans in China was characterized by a musical diversity that was created out of musical translocation, the arrival of Western and popular music, and the appropriation of music as part of political propaganda. As Northeast China was inhabited by different ethnic groups who moved into the area with various aims and pursuits, the music of Chaoxianzu at that time could only be experienced by visiting the various musical domains in which Korean immigrants participated. In contrast, with the founding of the PRC, it was decreed that all music in China had to be ideologically correct and in support of the Chinese nation, be it the music of the Han majority or of ethnic minorities. Except during the period of Cultural Revolution that disrupted the cultivation of minority nationality culture and identity, this has oriented the development of Chaoxianzu music through today, though emphases have changed. Moreover, since the 1980s, changing social dynamics and diversification have put Chaoxianzu in the position of constantly having to negotiate and reflect upon their diasporic identity as they have accessed the very different manifestations of Korean culture associated with North and South Korea. The new cultural predicament for Chaoxianzu in the Age of Reform was then to demarcate and solidify diasporic Korean identity as distinct from those found in the two contrasting motherlands and reflect the Chinese cultural citizenship they acquired through multiple stages of political transformation and amendments to cultural policy over the decades.

The Construction of Chaoxianzu Musical Identity

Tradition is in practice the most evident expression of the dominant and hegemonic pressures and limits. It is always more than an inert historicized segment; indeed it is the most powerful practical means of incorporation. What we have to see is not just "a tradition" but a *selective tradition:* an intentionally selective version of a shaping past and a pre-shaped present, which is then powerfully operative in the process of social and cultural definition and identification.
—Raymond Williams, *Marxism and Literature*

In 1949 the Chinese People's Political Consultative Conference proclaimed the equality of all nationalities in China, decreed the establishment of autonomous territories and governments, and promised each nationality political representation according to the proportion of their population within and outside of their autonomous region. This proclamation of the minority nationality policy led to the establishment of the Yanbian Korean Autonomous Region on 3 September 1952 with Chu Tŏkhae as the first chairman of the Korean People's Government (Olivier 1993, 71–72). At the time of its founding, Yanbian's population was 854,000, of which Koreans numbered 530,000. The new Chinese government instructed local governments to support the development of political systems, economies, culture, and education for the minority nationalities, and guaranteed their rights to preserve each nationality language and ethnic custom or habit (Olivier 1993, 60; Pease 2002, 78; Cathcart 2010; Kwak 2013, 225–238).

This chapter traces the construction of Chaoxianzu music since the establishment of the PRC, focusing particularly on the activities of Chaoxianzu intellectuals and musicians who were affiliated and worked with the minority

nationality performing arts organizations and educational institutions, such as the Yanbian Song and Dance Troupe and Yanbian Arts School. In so doing, it demonstrates how ethnic traditional cultures were instrumentalized to demarcate and express the cultural autonomy and new citizenship of Koreans in post-1949 China while being recreated to conform to the CCP's cultural guideline based on Mao Zedong's doctrine of "national in form, socialist in content."

The Minority Nationality Cultural Project

In order to make the numerous ethnic groups in China more intelligible to the new state, a large-scale survey and research project on Chinese minority cultures was carried out all over China as a major government initiative, known as *minzu gongzuo,* initially between 1953 and 1957. Researchers and collectors were dispatched by the central government or locally selected:

> Following the call [of Mao Zedong], researchers "went down" to minority villages and lived with peasants for months, even years, in order to learn the local languages, collect folklore, and ultimately to decide who was who. . . . Their studies were tremendously detailed and included data on agriculture and land tenure patterns, significant sidelines and handicrafts, costumes and material culture, history and legends, kinship and social organization, marriage practices, ritual and festival activities, funeral practices, customary law, taboos, as well as the progress of land reform. (Schein 2000, 82–83)

Documenting minority culture and traditions had two facets: the research work would enable the central government to better know its minority subjects, while at the same time it would fulfill the goal of socializing China by means of promoting a proletarian identity, since rural, peasant, and folk cultures were considered "community culture[s] which tea[ch] the superiority of the group over the individual," according to a Marxist-Leninist view (Um 2013, 167). Privileging "community cultures" was particularly pervasive and sat at the heart of the socialist cultural agenda in the construction of post-1949 national music. A *folk/proletarian* identity was the state's major emphasis and an important communist rhetoric, an ideology that affected not only minority musics but also the development of a Chinese national music (Lau 1995/1996, 2007).

Although minority cultures were investigated on a large scale all over China, the mere preservation or transmission of traditions was not the ultimate goal of the government research. Rather, the information gathered was then applied to the project of reshaping all nationality cultures for the masses by

embedding them with communist ideology and in conformity with the cultural modernity modeled by the Han Chinese. In the context of Han Chinese music, musical modernity has been largely conceptualized through the adaptation of European musical practices such as "functional harmony, equal-tempered tuning, orchestral texture, solo virtuosity, sanitized timbre, standardized repertoire, professionalized performing groups, written notation, and so forth" (C.-F. Wong 2012, 41). As Wong Chuen-Fung (2012) points out in his article on Uyghur minority music, the construction of minority music and identity in China was based on an interplay between minority traditions and nineteenth-century European musical elements that had already influenced the modernization of Han Chinese music several decades before the Communist Revolution. The three broad cultural and political frames of modernization, socialist progressiveness, and minority nationalism together guided the construction of minority nationality music in post-1949 China.

Another underpinning directive that guided the construction of the cultural identities of Chinese minority nationalities was the state's "civilizing project," aiming to elevate "peripheral peoples' civilization to the level of the center [i.e., Han Chinese], or at least closer to that level" (Harrell 1995, 4). In this civilizing project were "identified certain premodern styles and genres as hopeful candidates from the array of regional and subcultural varieties to be transformed into a higher order of musical collectivity" (C.-F. Wong 2012, 41). It was in accordance with this minority "civilizing project" together with the idealization of a "modern" sound that the re-creation of minority traditional music was undertaken. Korean music in China was no exception, and it began to be reshaped extensively in conformance with the state's cultural and political imperatives.

The CCP strategically allied itself with the patriotic bourgeois nationalities and co-opted them into the new political system with the expectation that these minority individuals would cooperate and work with the new regime. The minority intellectuals were posted at "the local political, administrative, economic, education and cultural institutions of the new socialist state" (Olivier 1993, 69). They then set out to promote local proletarian cultures and reform them to conform to a socialist frame.

As intellectuals posted at cultural institutions, Chaoxianzu musicians with government-sponsored performing arts organizations such as the Yanbian Song and Dance Troupe played leading roles in the investigation and construction of Chaoxianzu music from the founding of the PRC. Mostly with backgrounds in European classical or Western band music practices rather than in traditional Korean music, the members of the Yanbian Song and Dance Troupe went to rural Chaoxianzu villages and investigated traditional Korean music. They collected folk songs, sought out traditional instruments and musical

practices, and designated community musicians (*mingan yein; minjian yiren*) as important cultural holders. This process was not exclusive to Chaoxianzu in Yanbian but was carried out for all nationalities in China. As Charlotte D'Evelyn (2014) states, "The PRC government has fostered a system in which 'model' musicians have been hand-picked from the countryside, recruited as musicians into state institutions, and later recognized as first-rank performers and composers" (92). Likewise, the Chaoxianzu community musicians were later deployed in various governmental performing arts organizations as well as in Chaoxianzu schools to serve as instructors and performers of Korean music.

Yanbian Song and Dance Troupe

The Yanbian Song and Dance Troupe was established through the merging of several volunteer-based Korean troupes acting as propaganda teams in Northeast China with governmental culture and arts work teams based in Yanbian.[1] The majority of these organizations featured ensembles composed of Western band and symphonic instruments. Although instrumental arrangements of some traditional Korean vocal music, such as *minyo,* were already part of their repertoire, traditional Korean instruments were only included after 1950 (see Chaoxianzu Music Organization 2005, 100–133). In order to start using Korean instruments in their performances, the troupe had to figure out where to obtain the instruments and then learn to play them from scratch from community musicians. The troupe's performances thus began to include both Korean instruments and the Western instruments in which they were specialized. The Yanbian Song and Dance Troupe's transformation into bimusicality in the 1950s signaled the beginning of Chaoxianzu music, and this later became an important characteristic of Korean music in China.

As early as 1951 the Yanbian Song and Dance Troupe presented its first performance with an ensemble entirely composed of Korean instruments. The troupe's clarinet player, Paek Munsun (1930–2014), played the *t'ungso;* cellist Kim Chŏngrok played the *p'iri;* violinists Ch'oe Sammyŏng (b. 1932), Sin Pyŏngsŏp, and Kim Chaech'ŏng (b. 1933) played the *haegŭm;* and An Kungmin played the *kayagŭm* (Chaoxianzu Music Organization 2005, 147). All of them learned the instruments quickly for that first performance. An Kungmin reminisced in 2005 that the instrument he played was not even a Korean *kayagŭm* but a thirteen-string Japanese *koto* he had found in Yanbian. Previously trained in the accordion and viola, he managed to play a simple tune on the instrument. Although the *kayagŭm* has become one of the most iconic Chaoxianzu instruments in Yanbian, in 1951 it was nearly unknown to Chaoxianzu musicians and was not publicly performed in the Chaoxianzu community. Musicians like An Kungmin who were working for government performance troupes have been

credited with introducing the *kayagŭm* as well as other Korean instruments to Yanbian—a task they accomplished in responding to government instructions.[2]

Kim Chin (1927–2007), another Yanbian Song and Dance Troupe member who participated in the construction of Chaoxianzu music from the early 1950s, states, "At the time of the communist liberation, Korean vocal music in Yanbian was doing okay, but besides the *t'ungso,* Korean instruments were hardly seen."[3] There were traditional instruments present in Yanbian, and Yanbian Song and Dance Troupe musicians tracked some down and learned to play them from community artists who knew how to play them but were not professional musicians or experts in any particular instrument. Little information has been available as to the details of those who had previously played or owned these instruments. Whether the practice of playing traditional instruments was strong or not, with the founding of the PRC, Chaoxianzu musicians had to conspicuously incorporate traditional Korean instruments into Yanbian Song and Dance Troupe performances as a means of marking their cultural identity and autonomous space.

As pointed out earlier, a major underpinning of the cultivation of national music and traditional instruments in China throughout the twentieth century was the reform of old heritage cultures in a modern and scientific way. Traditional East Asian music has been characterized as solo and small ensemble music that values each musician's skills in interpreting established melodic and rhythmic conventions and focuses on the linear progression of the music, to which each instrumentalist's unique melodic renditions contribute. The introduction of the large Western orchestra and its method of instrumentation brought in a new musical culture emphasizing harmonic progression and vertical sonority created out of homophonic movement. Gradually this Western musical culture overshadowed traditional East Asian ones and became idealized in terms of the sound, scale, and instrumentation of the ensemble, performance and compositional methods and practices, and the pedagogy and physical practicality of the instruments. As early as the 1920s, Chinese musicians adapted their traditional music to Western symphonic settings and created a modern Chinese orchestra out of the instruments of the *jiangnan sizhu* ensemble (lit., the silk and bamboo music from south of the Yangzi River—one of the Chinese string and wind music traditions associated with the city of Shanghai). In the process, traditional Chinese instruments were experimented with and reconstructed to equip them with physical and acoustic effects similar to European ones and thus render them conducive to the performance of modern Chinese pieces newly arranged or composed using Western heptatonic scales supported with the four-part harmony (Han and Gray 1979; Lau 2007). Albeit an invented tradition (Hobsbawm and Ranger 1983), the modern Chinese orchestra and the new compositions it inspired have become a national

emblem recognized in mainland China as well as in exile communities in Taiwan and Hong Kong.

Influenced by these earlier developments in Han Chinese music, Korean music in China was also reshaped to reflect both the aesthetics and practices of Western classical music. Rather than emphasizing musicians' internalization and then personalization of preexisting pieces that they learned by rote, as was the case in traditional East Asian music, the principles of fixed composition, notation, and authorship became the norm in the building and learning of musical repertoires. Though not many Chaoxianzu musicians at the time the autonomous government was founded were trained in the composition of symphonic pieces—either for Chaoxianzu or Western classical instruments—there were four musicians in Yanbian who today are recognized for their symphonic works: Hŏ Serok (1916–2000), Ko Chasŏng (1922–2006), Chŏng Chinok (1926–1981), and Ch'oe Sammyŏng (b. 1932). Another musician, Kim Chŏngp'yŏng (b. 1929), has also been known for his large-scale compositions. Rather than living in Yanbian, he taught composition at the Central Conservatory of Music in Beijing (Chaoxianzu Music Organization 2005, 180–181). Except for Chŏng Chinok and Ch'oe Sammyŏng, these composers mostly wrote works for Western classical instruments. Their manner of incorporating Korean or Chaoxianzu identity into their works was through the use of a range of Korean folk songs or other familiar melodies or by programming music to well-known Korean folk stories or images with whom Chaoxianzu people would identify. One approach popular with Chaoxianzu composers was to make new arrangements of existing folk songs, early twentieth-century compositions, or contemporary Chinese or Chaoxianzu propaganda songs. Rearranging well-known melodies enabled musicians to express proletarian, Korean, and modern or progressive identities depending on the melody they chose. Chaoxianzu compositions have been predominantly lively and upbeat, though occasionally including slow movements containing propagandist messages.

The most representative symphonic orchestra piece composed for Chaoxianzu instruments was Chŏng Chinok's *Ch'uŏk kwa hwanhŭi* [Memory and Joy], premiered in 1959 with An Kungmin conducting. Although precise details of the orchestration are lost, the piece was performed by fifty-five musicians on Chaoxianzu instruments, some of which had already been modified to be able to accommodate Western heptatonic scales and modulations. Incorporating traditional Korean rhythmic cycles, such as *chungmori* and *chajinmori,* as temporal frames, the piece combined Korean musical elements with Western compositional methods and orchestration. In 1960 this piece was remade into a *kayagŭm* concerto and performed with Kim Chin, who had just come back from North Korea after learning *kayagŭm sanjo* in P'yŏngyang, as the soloist. This work was acclaimed by the Chaoxianzu community. In arranging *Ch'uŏk*

kwa hwanhŭi for *kayagŭm,* Chŏng Chinok incorporated *kayagŭm sanjo* melodies drawn from the works of Yu Tonghyŏk and An Kiok, *sanjo* masters who had both taught Kim Chin in North Korea. Chŏng set "Ch'uŏk" [Memory] to the *chungmori* featured in Yu Tonghyŏk's *sanjo* and "Hwanhŭi" [Joy] to An Kiok's *chajinmori* (Chaoxianzu Music Organization 2005, 151–152). Both the symphonic and concerto versions of *Ch'uŏk kwa hwanhŭi* have been frequently referred to by Chaoxianzu musicians as the seminal grand symphonic work for the Korean ensemble in Yanbian.

From the beginning of the 1950s, minority nationality performance troupes participated frequently in competitions and events through which the various ethnic cultures were displayed. In 1953 a music competition was held in Shenyang among professional performing arts organizations based in Northeast China. At the competition, the Yanbian Song and Dance Troupe presented a newly composed song, "Ch'ŏnyŏ ŭi norae" [Song of a Lady], by Chŏng Chinok. It was accompanied by a fusion ensemble of Western classical instruments and two Korean instruments, *kayagŭm* and *t'ungso.* The performance was positively received by the Chaoxianzu community, with remarks on its successful juxtaposition of Western and Korean instruments (Chaoxianzu Music Organization 2005, 149).

Another well-known work of the Yanbian Song and Dance Troupe is the symphonic poem *Haeran'gang* [Haeran River], by Ch'oe Sammyŏng, who studied composition and traditional Korean vocal music such as *minyo* and *p'ansori* in North Korea from 1955 to 1959 and composed the work during his residence in P'yŏngyang. While this piece represents Ch'oe's depiction of a scene from *Simch'ŏnnga* [Song of Simch'ŏng], one of five core pieces of the *p'ansori* repertoire, the orchestration features largely Western classical instruments.

In the early 1960s a number of Chaoxianzu musicians composed new works for performance by the Korean ensemble of the Yanbian Song and Dance Troupe. In 1961 Pak U composed "P'ungsu" [Feng shui] for *so-p'iri* (small or soprano *p'iri*). In 1963 another musician, Pak Chisun, composed a new piece bearing the same name and featuring the same instrument. Both compositions were written for Korean instruments for both the solo part and the accompaniment instead of combining Korean and Western instruments. This reflects the steady establishment and increasing profile of the Chaoxianzu instrumental ensemble in Yanbian since its first appearance on stage in 1951. According to Chang Chinsŏk, who teaches music theory and composition at Yanbian Arts School, Chŏng Chinok, then the director of the Yanbian Song and Dance Troupe, even suggested that Chaoxianzu musicians form a group under the troupe devoted to the development of traditional Korean instruments to accommodate twelve-tone equal temperament so that they could be used to play a wider range of contemporary repertoire (241). Under this encouraging milieu of promoting Chaoxianzu music, the Yanbian Song and

Dance Troupe even abolished Western orchestral instruments completely in 1964 and moved to Korean instruments exclusively. As not all of the troupe's fifty instrumentalists at the time had been trained on Korean instruments, those that were trained in Western instruments switched to specialize in Korean ones (Chaoxianzu Music Organization 2005, 152–153). Chŏng Chinok's idea of setting up a professional team to develop specifically Chaoxianzu instruments out of traditional Korean ones was later carried out with the founding of the Center for the Reformation of Korean Music Instruments (Minjogakki kaehyŏk yŏn'guso) in 1964, although it was not established within the troupe but rather the Yanbian Arts School (C. Chang 2009, 241).

Yanbian Arts School

From the early 1950s, Korean preschools and community cultural centers were established in Yanbian, and it was often in those institutions that Chaoxianzu children and adults were exposed to Korean performing arts for the first time. By 1957 a number of vocational schools (*chungdŭng chŏnmun hakkyo; zhongdeng zhuanmen xuexiao*) including teachers' colleges were established for Chaoxianzu youths intending to specialize in Korean or Chinese languages, arts or music, public health, or agronomy (C.-J. Lee 1986, 72).[4] Between 1951 and 1953, the Yanbian Teachers' College accepted Korean students specializing in teaching music, dance, and fine arts and assigned them to work in Korean primary and middle schools. At the same time, a number of Chaoxianzu students began to study music and the arts in major higher education institutions across China.[5]

As one way of effectively establishing a selective tradition is to depend on formal institutions (Williams 1977, 117), the introduction and cultivation of Chaoxianzu music in China was reinforced through its implementation in school curricula at a range of different educational institutions. According to T. Kim (1992), Chaoxianzu primary and middle school students received instruction in various instruments, including Western stringed instruments and traditional Korean instruments, creating a pathway to later enrolling at Yanbian Arts School. Subsequently, if brass band music predominated in Yanbian into the early 1950s, the range of brass instruments that students could learn was greatly expanded with the establishment of Yanbian Arts School. Also, the participation of female students in ensemble music became increasingly noticeable. Music was also favored as an after-school activity (*kwaoe hwaltong*) at Chaoxianzu primary and middle schools in Yanbian, with participants in these programs competing with other nationality youths in interschool singing and instrument-playing competitions. From 1955 onward, the Yanbian People's Broadcasting Company ran its own boys' choir and band (*sonyŏn adongjo*) in order to produce and broadcast children's singing and music education

programs—a vibrant cultural phenomenon that was interrupted by the outbreak of the Cultural Revolution (T. Kim 1992, 60).

In 1957 Yanbian Arts School (Yŏnbyŏn yesul hakkyo) was established as the sole conservatory for the Korean minority nationality. Although the school was established specifically for Chaoxianzu students, it later accepted all nationalities. The year it opened in 1957, it admitted twenty-two students from various locations in Northeast China into a four-year music program. Their prior levels of education and musical exposure varied: some were middle- or high-school graduates while others were already professionals who were working as Song and Dance Troupe members or teaching students affiliated with primary or middle schools, and more than half had professional experience as performers or educators. Enrollments remained steady in the ensuing years: twenty-one students were admitted in 1958, seventeen in 1959, twenty-three in 1960, nine in 1961, ten in 1962, thirty in 1963, thirty-one in 1964, and thirty-one in 1965. After two years of intensive training, sixteen primary-school students were selected to continue for the six years of secondary education. Together, various levels of programs lasting three, four, or six years were offered by the arts school. Today the school covers middle school to tertiary education. It is also recognized as the College of Arts under Yanbian University and as such offers undergraduate and graduate programs (T. Kim 1992).

Yanbian Arts School offered programs in Western and Chaoxianzu music, as well as in dance, theater, and fine arts in both traditions. Certain majors, such as Korean music and theater, were limited to Chaoxianzu student enrollment only. Chaoxianzu students who enrolled in the Korean music program— the *minjok ŭmak* (lit., ethnic or nationality music; Ch. *minzu yinyue*)—at the arts school could major in a range of different Korean instruments (*minjok kiak; minzu qiyue*) and different styles of Korean singing (*minjok sŏngak; minzu shengyue*). When the school first opened the only Korean music classes available to Chaoxianzu students were in *kayagŭm* and folk song (T. Kim 1992. The range has now greatly expanded to include *haegŭm, p'iri, tanso, chŏttae/taegŭm, yanggŭm, swaenap, t'ungso*, Korean percussion instruments, and Korean vocal music in the styles of the northwestern, southwestern, and central provinces of South Korea as well as North Korean national singing, a style known as *chuch'e ch'angbŏp* (self-reliance singing).

In developing the Korean music program, the school invited musicians from North Korea to come as teachers. Between 1959 and 1960, North Korean *kayagŭm* master and instrumentalist Chi Mansu and singer Pang Ongnan taught at Yanbian Arts School as visiting faculty. From them all teachers and students at Yanbian Arts School learned to sing *minyo* and *p'ansori* (Y. Cho 2002; Pease 2013; K. Sin 2012, 2016b), and instrument majors also had to learn at least one Korean instrument. For example, violin majors learned the *haegŭm*,

clarinet majors learned *minyo* and *p'iri,* and piano majors learned *sogŭm* (short bamboo transverse flute). After less than a year studying these instruments, the students formed a Korean wind and string ensemble and were able to perform *Yŏngsan hoesang* (a suite of five to fifteen short pieces).[6] This piece was an odd representation of Chaoxianzu identity since it was a *chŏngak* (music of the aristocracy) associated with the male literary class in the late Chosŏn period, and its performance in China seemed quite unusual since such a class-oriented kind of music might contradict the socialism that underpinned the foundation of the PRC and the overall working-class background of the Chaoxianzu population who might have been unfamiliar with it. It is unclear whether the entire suite was performed, and if not, which sections were featured. South Korean scholar Cho Yumi (2002, 94) notes that the performance of *Yŏngsan hoesang* took place in 1959, the year Kim Chin performed for the orchestral arrangement of *kayagŭm sanjo* as the featured soloist. However, in conversation with Kim Chin in 2005, he recollected that his performance in 1959 was of traditional *sanjo* and the orchestrated version was a year later. Nevertheless, Cho's plausible statement raises the possibility that *Yŏngsan hoesang* might have been available in Yanbian from North Korean sources such as Chi Mansu and Pang Ongnan, who both apparently spent a year in Yanbian from February 1959 to February 1960 (K. Sin 2016b).

When Kim Chin and Ch'oe Sammyŏng returned to Yanbian after their studies in *kayagŭm* and composition in North Korea, they became the Korean music instructors at Yanbian Arts School. Kim Chin was assigned a high load of administrative work at the time, which according to Sin Kwangho (2016b, 139) prevented him from being a more vibrant performer, although when I interviewed Kim he gave a somewhat different reason for having deliberately withdrawn from his performance career (see chapter 4). In order to meet the demand stemming from increasingly diverse student interests, Pak U, a conductor and resident composer with the Yanbian Song and Dance Troupe, transferred to Yanbian Arts School as a music faculty member, as did Ch'oe Sundŏk, who had been teaching at Yanbian Teachers' College. In 1961, four years after the school opened, eight students were selected from the first and second group of graduates and hired as full-time instructors to address the shortage. With the addition of new staff, new courses in areas such as harmony and counterpoint, form and analysis, and orchestration were introduced (T. Kim 1992, 145–146).

Through the mid-1960s the construction and expression of Chaoxianzu cultural identity was the focus of heated discussion among Yanbian's Chaoxianzu artists, intellectuals, and community at large. Yanbian Arts School staff argued that the school's Korean music department should selectively adapt traditional Korean music by taking what they considered to be the essential components and leaving the unnecessary behind. In so doing, Korean music would

be recreated to serve contemporary people and their lives and the remnants of the old feudalist society would be cleansed. For the Western music majors, the school emphasized that the point of learning Western European music should be so that it could be used to benefit Korean music. In order to fulfill these aims, students in the Korean music department incorporated modern- and progressive-style pieces into their repertoire, while the Western music majors were expected to add to or adapt their repertoires to ensure that they had a strong Korean element. For example, Kim Chaech'ŏng's solo violin piece "Yŏnbyŏn mugok" [Yanbian Dance] became part of the core repertoire for violin students. A number of Korean *minyo* arranged for Western instruments were introduced (T. Kim 1992, 145–146).

In order to incorporate and express worker identity in their musical works, both staff and students at the arts school worked in the field closely interacting with rural people. As a result, many of the songs composed by students and staff featured Yanbian or Chaoxianzu identity incorporating themes of farming and agricultural work. Students performed this music for the rural population in Yanbian.

With the majority of Chaoxianzu musicians in China having either attended Yanbian Arts School or studied privately with its staff, it is clear that the school has played a vital role in the establishment and development of Chaoxianzu music in China. Since 1990, more than four hundred students have studied there. Besides its administrative body, the school comprises departments of composition, Western music, Korean music, music education, dance, fine arts, and theater, as well as an arts research institute and an institute for Yanbian Chaoxianzu musical instruments (T. Kim 1992, 142). The Yanbian Song and Dance Troupe brought Chaoxianzu music to audiences beyond its own community and across China through its performances, and Yanbian Arts School contributed to the establishment of Chaoxianzu music pedagogy and trained and supplied professional musicians and teachers.

The Development of Korean Instruments in China

With the numerous new Chaoxianzu compositions that featured both Western and Han Chinese national musical practices, traditional Korean instruments were reconsidered and modified in view of improving their sound and adapting them to make it easier for these works to be played on them. The majority of instruments used by Chaoxianzu musicians today are modified or recreated versions of traditional Korean instruments. In the process of Chaoxianzu developing their own versions of Korean instruments, they again modeled the instrumental reformation of Han Chinese people and later that of North Korea.

The North Korean influence on Chaoxianzu instruments was in terms of not only physical and practical modifications but also the timbre the instruments were to produce, performance practices, and compositions (C. Chang 2009, 242). Although South Korean performers of traditional music have also introduced modernized versions of Korean instruments and adapted them for the performance of new compositions written using Western music idioms, the use of traditional instruments continues to be prevalent and even predominate in the overall traditional music scene. In contrast, almost all Chaoxianzu musicians in Yanbian favor Korean instruments modified locally or borrowed from North Korea. The preservation of ancient musical forms "as is" has been less prominent in the context of diasporic Koreans in China.

Stringed Instruments: *Kayagŭm* and *Haegŭm*

The two representative Korean stringed instruments played in Yanbian since the early 1950s are the *kayagŭm* and *haegŭm*. A number of senior Chaoxianzu musicians who were active in the Yanbian area in the 1950s, like Kim Chin and An Kungmin, did not recall ever having encountered these instruments in Yanbian before 1950, although some Chaoxianzu literature notes that before the 1950s, there were former *kisaeng* and instrument aficionados in Yanbian who owned and were knowledgeable about traditional Korean instruments, including the *kayagŭm* and *haegŭm* (see Chaoxianzu Music Organization 2005; N. Kim 2010). Younger Chaoxianzu music scholars such as Lee Hun and Sin Kwangho also note that in 1937 and 1940, there were performances of *kayagŭm pyŏngch'ang* (a musician or group of musicians singing Korean folk songs with self-accompaniment on *kayagŭm*) in Jilin and Heilongjiang Provinces (H. Lee 2006, 95; K. Sin 2012, 304). They agreed that An Kungmin was the person who introduced the *kayagŭm* to the Chaoxianzu community in 1952. Soon after the Yanbian Song and Dance Troupe's 1951 Korean music ensemble performance, in which An played the *koto* as a stand-in for the *kayagŭm,* An was able to acquire two Korean *kayagŭm,* locating one in Hunchun in 1952 and another in Yanji in 1953. He went to a former *kisaeng* to learn to play: "Though An was the first person to introduce the *kayagŭm* to the Chaoxianzu community, I don't think comrade An learned the instrument intending to perform on it for audiences. He must have been looking for ways to establish Chaoxianzu performance culture, given his high-ranking position in the Song and Dance Troupe."[7]

An Kungmin took one of the two *kayagŭm* to Sin Hŏri, a piano manufacturer living in Harbin, in 1953. Using the instrument as a model, Sin built a new *kayagŭm*. According to An, the instrument manufacturer suggested that as the new *kayagŭm* unexpectedly came out a bit wide, he could make use of the extra space by adding an extra string, to which An agreed.[8] The thirteen-string

kayagŭm went on to replace the twelve-string traditional *kayagŭm* in Yanbian and is considered the first distinct instrument invented by Chaoxianzu in China. While other Chaoxianzu instruments were intentionally modified to accommodate new compositions, according to An the thirteen-string *kayagŭm* was an unintended and unplanned outcome, even though the musician and manufacturer were aware of the possibility of creating new Korean instruments, having seen previous redesigns of Chinese folk instruments. Later, Sin modified the instrument even further by replacing its silk strings with steel ones in order to enhance their durability and pitch stability.

The thirteen-string *kayagŭm*—with either silk strings or synthetic fiber strings covered with steel coil—has become the standard instrument on which Chaoxianzu musicians perform traditional pieces such as *minyo* arrangements or *sanjo*. Its introduction was followed in the 1960s by the fifteen- and eighteen-string *kayagŭm* in Yanbian. All of these versions—predecessors of the twenty-three-string Chaoxianzu *kayagŭm*, which has become the standard in Yanbian—had tuning pegs attached so that the steel strings could be tuned easily (see figure 3.1). In 1977 Cho Sunhŭi, a student of Kim Chin and *kayagŭm* player, developed a larger *kayagŭm* with twenty-three strings able to be used in performing new compositions built on heptatonic scales. She added five more strings onto the existing eighteen-string *kayagŭm*, extending its range to three octaves from lower G2 to higher A5. First manufactured in Beijing, the twenty-three-string *kayagŭm* was remanufactured in Yanbian in 1978 to correct problems the musicians noticed with the first version (K. Sin 2012, 307).

Figure 3.1 shows the twenty-three-string heptatonic *kayagŭm* that has been used widely in Yanbian since late 1977. In terms of its physical construction, the traditional method of securing the strings in a bundle was replaced with a built-in tuning box in which tuning pegs are hidden. While traditionally the musician sits on the floor cross-legged to play the instrument, the Chaoxianzu twenty-three-string *kayagŭm* is raised up on two wooden stands and played sitting on a chair. Due to the extent of the transformations in terms of acoustics, performance practice, and material and structural features, when the Chaoxianzu *kayagŭm* first appeared it attracted criticism from its own community as to whether it had deviated too far from the original Korean version on which it was based, especially in terms of its size and timbre (K. Sin 2012, 308). However, the majority of Chaoxianzu musicians attest to the impossibility of relying on the traditional twelve- or thirteen-string *kayagŭm* because these can only be tuned to a pentatonic scale.

Another stringed instrument widely played in Yanbian today is the *haegŭm*, a bowed lute widely known in Yanbian and North Korea as the *so-haegŭm* (small *haegŭm*). Like the *kayagŭm*, the *haegŭm* was introduced to Yanbian by

Figure 3.1 *(Top)* Chaoxianzu twenty-three-string heptatonic *kayagǔm;* *(Bottom)* Tuning pegs built into the Chaoxianzu *kayagǔm.* Photos by author.

the Yanbian Song and Dance Troupe at its first Korean ensemble performance in 1951. The troupe's string players had newly learned the instrument from an unidentified person in Longjing in 1950. However, the traditional Korean *haegŭm* of central Asian origin, which was brought to Korea via China in 1116 as a musical gift offered by Song dynasty emperor Huizong (or Hui-tsung, 1082–1135) was soon replaced with Chaoxianzu's own creation of a bowed lute, simply named as *yŏnbyŏngŭm* or *illamgŭm* (see figure 3.3). Later this Chaoxianzu-made instrument was gradually replaced by the instrument (called either *so-haegŭm* or *pukhan'gŭm*) manufactured and imported from North Korea (see figure 3.4).

While many versions of bowed lutes have been found in China (where it is known as *xiqin* or *huqin*), either as regional folk instruments or modern variations of the ancient Chinese court instrument, in Korea it has been maintained in the form of the *haegŭm,* where it was adopted for the nation's court and in indigenous folk music practices. Traditional Korean *haegŭm* is a two-string instrument held with the strings facing to one side. The instrument's bamboo bow, strung with horsehair, is locked between the two strings and travels sideways along the neck joining the sound box (see figure 3.2). Unlike Western bowed lutes, the *haegŭm* does not have a fingerboard, and it is also unlike Chinese bowed lutes since it does not rely on the fingertips stopping and sliding along the strings for pitch variation and portamentos. Instead, players produce pitch gradations and ornamentations by engaging and releasing their grip.

Yŏnbyŏngŭm as well as North Korean *so-haegŭm* performed by Chaoxianzu musicians differs from the traditional instrument maintained in South Korea today. Through the second half of the twentieth century, both Yanbian and North Korea developed their own spike fiddle by modifying the traditional *haegŭm*'s physical shape and materials and developing their own performance and pedagogical methods. While the two strings of the traditional Korean *haegŭm* are made of twisted silk cord, the spike fiddles used in Yanbian and North Korea today have four strings made of synthetic fiber or steel strings covered with metal coil. In terms of the instrument's mechanism and playing method, the Chaoxianzu version resembles those of Western bowed spike lutes. About the size of a violin, it is held vertically on a spike and played like a cello. Its bow is no longer locked between the strings but held completely separate from the body of the instrument. The bow, while still strung with horsehair, is now carved out of solid wood rather than the traditional bamboo. While the sound box of the Korean *haegŭm* is a hollow bamboo tube closed at one end with a circular disk of paulownia wood, with the Chaoxianzu *haegŭm* it is made of several hardwood pieces assembled like the body of a European stringed instrument.

As early as the 1950s, Chaoxianzu began to experiment with the construction of traditional Korean *haegŭm* in order to "modernize" it in terms of sound

Figure 3.2 The traditional Korean *haegŭm* that is most in use in South Korea. Photo by author.

and playing method. As a result, its sound box was enlarged and reshaped similar to that of Chinese *pipa* (four-string pear-shaped lute). In the mid-1960s the Chaoxianzu *haegŭm* was again modified to resemble the shape of the Korean *kayagŭm*. At this point the changes to the traditional *haegŭm* were substantial enough to warrant adopting a new name for it. Chaoxianzu musicians began to call it *illamgŭm* in recognition of Li Illam, who manufactured the instrument in the 1960s (S. Kim 2000, 43). Such a name, however, could be perceived as unacceptable in a communist context since it places the emphasis on the achievements of an individual figure. *Yŏnbyŏngŭm* (lit., Yanbian lute) was thus suggested as an alternative, but this name equally posed a problem in that it promotes Yanbian as the exclusive place of origin for the Chaoxianzu instrument. Nonetheless, both these names, as well as *haegŭm* and *so-haegŭm,* have since been used interchangeably in Yanbian.

In the 1960s the *haegŭm* manufactured by Li Illam was the most widely known Korean bowed lute in Yanbian. However, since the 1980s the North

Figure 3.3 *Yŏnbyŏngŭm* (or *illamgŭm*) manufactured in Yanbian, China. Photo by author.

Korean version of *haegŭm* has taken over. Chaoxianzu musicians began to view the North Korean instrument as superior in terms of sound and material quality, physical shape, and quality of workmanship. Along with the incorporation of North Korean compositions into the Chaoxianzu repertoire, the North Korean *haegŭm* has been adopted as a Chaoxianzu instrument and used in both solo and ensemble settings.

Manufactured much like the Western violin in terms of its possibilities for range and tuning, both the *yŏnbyŏngŭm* and North Korean *haegŭm* have been made in three different sizes to provide soprano, alto, and bass sounds, like in the case of the modern Chinese orchestra, where larger bowed lutes were newly created and added to the ensemble to enhance the bass line (Han and Gray 1979). Pedagogically, the *yŏnbyŏngŭm* adopted a European violin repertoire

Figure 3.4 North Korean *so-haegŭm* (*pukhan'gŭm*) manufactured in North Korea. Photo by author.

and etude books, while all its music—whether Korean or foreign in origin—is written using Western staff notation. The *yŏnbyŏngŭm* and the North Korean *haegŭm* are both tuned a full step lower than the Western violin (e.g., if the Western violin is tuned to E5, A4, D4, G3, the Chaoxianzu and North Korean *haegŭm* are tuned to D5, G4, C4, F3) in order to accommodate Korean compositions, the majority of which are in keys compatible with the Bb (B flat) scales in Western music.

While the *kayagŭm* and *haegŭm* have gone through an extensive reshaping process driven by an idealization of Western instruments, they are not seen as Western: most Chaoxianzu musicians I met unequivocally stated that the characteristic difference between Western and Korean music lies in performance

technique and stylization rather than in the science of the instruments themselves. For example, they tended to characterize Korean music as essentially *nonghyŏn*. Musicians in traditional Korean music employ *nonghyŏn*—or pitch variation—to embellish and stylize the melody, applying it to particular pitches in particular modes and to varying extents according to regional conventions or styles of music. In comparison with the extent of vibrato typically applied with Western stringed instruments—less than half a semitone—on Korean strings *nonghyŏn* can reach as wide as a tone and a half. Despite the prevalence of Western idioms in Chaoxianzu music, Chaoxianzu musicians argue that they pay close attention to the conventions of *nonghyŏn* in Korean music, and that is what makes their music Korean.

Wind Instruments: *T'ungso, Chŏttae, P'iri, Tanso*

Korean wind instruments were traditionally constructed for the pentatonic scale with little capability for modulation. In order to accommodate multiple keys and facilitate modulation, it was necessary to either redesign the instruments or add a metal key pad similar to that of the Western flute. The reshaping of traditional Korean winds was again inevitable in order to be able to use them to perform new compositions in ensembles including both foreign and Korean instruments. The first Korean wind instrument to be redesigned in Yanbian was the *t'ungso,* a vertical bamboo flute traditionally played solo or as part of a *t'ungso* ensemble in rural Korea. The prototype key of the instrument was A; as of 1953, it began to be manufactured in a number of different keys, including B, C, and F. *T'ungso* music was particularly prominent in the Yanbian area since it was strongly present in the northern part of Korea as a folk instrument of the rural peasantry. Considering that the majority of Korean migrants in Yanbian came from the northern Korean provinces of Hamgyŏng and P'yŏngan, the prominence of the *t'ungso* in Yanbian and vicinity was unsurprising. As the *t'ungso* was adapted by Chaoxianzu musicians in the Yanbian Song and Dance Troupe, its performance context and status shifted from that of rural amateur music to professionalized institutional music. As a Chaoxianzu instrument, the *t'ungso* has been taught to music-major students at Yanbian Arts School (Chaoxianzu Music Organization 2005).

While the Chaoxianzu Music Organization reports that the *t'ungso* was institutionalized, taught, and performed by professional musicians in Yanbian (2005), Rowan Pease, in her study on the state and status of the instrument (2015), states that among the traditional Korean instruments available in Northeast China, the *t'ungso* "generally slipped under the radar for political appropriation, because it sounded too 'earthy,' too close to the peasants. It continued to provide music to accompany drinking and dancing at parties,

untouched by official ideology" (81). During her ethnographic research on this instrument spanning over a decade, Pease traced the original, rural, amateur *t'ungso* music through Kim Ch'angnyŏng, whom she met in Yanji and also in Mijian village by the Tumen River, the latter designated as the "Land of the *T'ungso*" (81–82). However, the instrument's tradition preserved in Mijian was gradually transformed, perhaps not so much in terms of its sound but more its amateur status, as the region began to attract attention with the PRC's campaign to get the culture of Chaoxianzu, as one of its minority nationalities, added to UNESCO's list of intangible cultural heritage items as well as to China's own list, and Chaoxianzu rural villages began to be developed as attractions for both Chinese and South Korean tourists (Pease 2015, 81–82). While Pease argued that the instrument was exempted from institutionalization within Korean minority nationality performance troupes and schools due to its overly earthy sound and obvious association with the Korean peasantry, as the most overtly representative and perhaps most widely heard Korean farmers' instrument, the *t'ungso* was once part of institutionalized Chaoxianzu music scenes. Perhaps its amateur status—past and present—is what prevented it from becoming a major instrument of specialization for Chaoxianzu professional musicians.

Another Chaoxianzu wind instrument widely played in Yanbian today is the *chŏttae* (also called *taegŭm*), a long transverse flute made of bamboo cane. It is not known whether any Chaoxianzu musician played the *chŏttae* before the 1950s. Its introduction to the Chaoxianzu community has been credited to a visiting North Korean troupe in 1954. As with other Korean instruments, the traditional shape of the *chŏttae* was changed in Yanbian: to enable modulation, a metal key pad was attached; in addition, the bamboo cane was replaced with hardwood or synthetic resin to achieve a stronger sound. Though the synthetic resin instruments were praised for their durability, they proved less resonant than the hardwood ones, and since the 1980s the Chaoxianzu *chŏttae* has been made of hardwood.

While traditionally the *chŏttae* was made in two different lengths—a longer one for *chŏngak* (courtly and literary music) and a slightly shorter one for *minsogak* (folk music)[9]—Chaoxianzu *chŏttae* are made in three different sizes, for the purposes of harmonic sonority rather than according to type of music (figure 3.5).

The first Chaoxianzu musician recognized as specializing in *chŏttae* is Hŏ Kŭmnam, who performed on it with the Yanbian Song and Dance Troupe from 1955. How and in what way he learned to play the instrument is not clear, but what is clear is that he played both the traditional and redesigned *chŏttae* and *t'ungso*. A student of his, Kim Tongsŏl, who has taught the *chŏttae* at Yanbian Arts School for many years, recollected that his teacher was knowledgeable in

Figure 3.5 Chaoxianzu *chŏttae* in different sizes. Photo by author.

both Chaoxianzu pieces and traditional Korean ones like *chŏttae sanjo*. Since the *chŏttae* was only recreated in Yanbian from the early 1960s, Hŏ may have learned the traditional *chŏttae* and *sanjo* from North Korean musicians, either on visits to North Korea or from visiting artists in Yanbian. Kim Tongsŏl stated that as a student he only took up the new Chaoxianzu *chŏttae* during the period of the Cultural Revolution, and since then he and his colleagues have preferred it. As with other Korean instruments in Yanbian, much of the *chŏttae* repertoire performed by Chaoxianzu musicians today has been derived from North Korea, while older repertoire such as *sanjo* is seldom performed in Yanbian. The instrument used by Chaoxianzu musicians today is also not all that different from that of North Korea. Some musicians prefer to play *chŏttae* manufactured in North Korea, for reasons similar to those who prefer North Korean *haegŭm*—they are perceived as being crafted to a higher standard.

The traditional Korean *chŏttae* has a buzzy, airy sound due to a membrane-covered hole (*ch'ŏnggong*) that is there for that purpose. The Chaoxianzu *chŏttae* has eliminated this opening. Similar to North Korea, where after the war there was a directive in the construction of national music to change the coarse, rustic timbre of traditional Korean music to a smooth, silky, resonant, and clear tone quality, Chaoxianzu musicians found that maintaining the traditional timbre of Korean music, including that facilitated by the *chŏttae*'s membrane-covered opening, was seen as counterrevolutionary and as cultural retrogression, despite it being considered aesthetically pleasing from the point of view of South Korean musicians. Ironically, although Chaoxianzu musicians have legitimized certain changes in traditional instruments to achieve a modern and progressive sound, they also want to maintain a certain degree of traditional aesthetics. In the case of the *chŏttae*, they continue to produce an airy and rustic sound through hard blowing and the use of Korean vibrato (*yosŏng*).[10]

Similar to the *t'ungso* and *chŏttae*, other Chaoxianzu wind instruments, such as the *tanso* (a short bamboo vertical flute) and *p'iri* (a double-reed bamboo pipe), were redesigned in order to accommodate heptatonic scales and make modulation possible when playing modern compositions. Due to its small size,

the traditional *p'iri* (also called *so-p'iri* in Yanbian) was not made into a new instrument through the addition of a metal key pad. Instead, the instrument, which was originally in the key of E♭, was newly manufactured in additional keys, such as the key of G. Larger versions of the *p'iri*, the *chung-p'iri* (alto) and *tae-p'iri* (or *chŏ-p'iri*; bass), both including a metal key pad and made of hardwood, were manufactured to boost the alto and bass sound of Chaoxianzu ensembles.

As Raymond Williams (1977) states, what we see as *a tradition* is "an intentionally selective version of a shaping past and a pre-shaped present, which is then powerfully operative in the process of social and cultural definition and identification" (115). The construction of diasporic Korean music was, then, a way of shaping the present and future by selectively adapting and using musical *traditions* from a homeland. In shaping the present, the re-creation of traditions was inevitable since it had to also comply with the contemporary ideology that all music in China should be "national in form, socialist in content." While socialist cultural ideals and minority nationality policy were two important factors that drove the creation and re-creation of Korean cultures in China, Chaoxianzu musicians who had been primarily trained in Western or European music actively participated in the construction of Chaoxianzu music by reworking the traditional Korean sound and instruments so that they could establish Chaoxianzu music identity rooted in Korean tradition and expressing diasporic Korean experiences in China. That said, the construction of Chaoxianzu music in China not only articulates how Korean migrants founded their diasporic culture there by means of *selective traditions* and their reformation process; more importantly, it embodies the quest of *definition* and *identification* of those Koreans in becoming a PRC minority nationality by proactively adapting new musical language, that is, Korean traditional music in this case, following and conforming to the government cultural instructions, and recreating new music by synthesizing their new and old knowledge together.

The Chaoxianzu *Kayagŭm*

TRADITION FUSED WITH MODERNITY

WHILE traditional ethnic culture was used by the state as a means of marking and categorizing its minorities into a number of different *minzu,* no culture is ever static or able to be kept as fixed since those who practice it hold and shape a myriad of ideas and relationships in its respect. This chapter discusses how Chaoxianzu music—particularly *kayagŭm* music, considered the most representative Korean instrumental music in both diasporic and native contexts—was implemented and reshaped in China. This is approached through the stories of three Chaoxianzu musicians who have specialized in *kayagŭm* and their relationships to and interpretations of Chaoxianzu music. The stories of the three musicians that I present in this chapter demonstrate how each has exercised their individual agency in the making of Chaoxianzu music into what it is today. In this construction process, *a form of traditional culture,* that is, the *kayagŭm,* displaced to China, has gained significance in the lives of contemporary people who use the tradition as "a version of the past . . . to ratify the present and to indicate directions for the future [in] a selective tradition [that] is at once powerful and vulnerable" (Williams 1977, 116). In this way Chaoxianzu people have constructed their diasporic identity by using, reinventing, and reinterpreting their ethnic traditional cultures. Since the *kayagŭm* in China was only promoted as an important element of Chaoxianzu heritage after 1949 (see chapter 3), this chapter also shows that even if a tradition is not necessarily an old or long-standing one, it can become embedded within a relatively short period of time and in response to the needs of contemporary people (Hobsbawm and Ranger 1983, 1).

The three Chaoxianzu musicians I introduce in this chapter are Kim Chin (1926–2007), Cho Sunhŭi (1935–2006), and Kim Sŏngsam (b. 1955), all of whom were affiliated with Yanbian Arts School as Korean instrument instructors. Each is recognized as a pioneer, innovator, and transmitter of *kayagŭm*

music in China. While they represent three different stages in the formation of post-1949 Chaoxianzu music, they are interrelated as teachers and students. As individual musicians, their work exhibits their individual training, experience, vision, and interpretation of what diasporic Korean music is. As Timothy Rice (2003) notes, "The subject, self, or individual around whom musical ethnography might be centered is a thoroughly social and self-reflexive being" (157). Agreeing with Rice's view of the self as inherently social and that the self-reflexive project of self-identity in modernity is a social process, I propose that these individual Chaoxianzu musicians' *kayagŭm* music and their projection of identity should be viewed not merely as experiences distinctive to each musician but also as a social phenomenon resulting from their encounter with the world and interaction with others (Rice 2003; Bakhtin 1981). Chris Waterman (1991, 51) noted that the individual representation of cultural patterns is grounded in a flow of activity continually shaped by the actor's interpretations of and reactions to social constraints and incentives. As both creative and social subjects, these Chaoxianzu musicians responded with their music to the social constraints and changes they each encountered in their respective times.

Kim Chin and *Kayagŭm Sanjo* in Yanbian

Kim Chin was born in 1926 in Helong County in Yanbian. As a young musician, he played the violin and cello in the Yanbian Song and Dance Troupe. Until he was sent by the Korean autonomous government to North Korea to study a traditional Korean instrument, Kim knew little about traditional Korean music: "I studied the *kayagŭm* for the first time in P'yŏngyang. I was originally a violin player and was not interested in Korean music. But I knew I had a responsibility to learn a traditional Korean instrument since I was sent by the nation."[1] When he got to P'yŏngyang, North Korean officials recommended that he study *chŏttae,* but he decided to study *kayagŭm* instead as it seemed to him a more promising instrument since it was favored by Chairman Kim Ilsŏng and frequently performed in North Korea at the time (Yang 2001, 119). Kim's background as a string player may be another reason why he preferred the *kayagŭm* over the *chŏttae,* although he did not specifically express that to me. Instead, Kim Chin reminisced that the *kayagŭm* was so loved by Kim Ilsŏng that, in the early 1960s, the chairman even considered equipping every North Korean household with a *kayagŭm*—used for family education and entertainment—although his vision was never realized. During his four-year residence in North Korea, Kim Chin noted the high musical status of *sanjo* played on the *kayagŭm* as a solo instrumental music, as well as the general popularity of the instrument (Yang 2001, 121–122). Kim studied *kayagŭm sanjo* with An Kiok (1894–1974),

Kim Kwangjun, and Yu Tonghyŏk at P'yŏngyang College of Music and Dance. Of the three, he recollects having spent the most time with An Kiok and that his studies with An were centered around the *sanjo,* even though An himself had begun to compose new musical works for *kayagŭm* influenced by socialism and European compositions.

Kim Chin learned both An Kiok's own version of *sanjo* and those of An's teacher, Kim Ch'angjo (1856–1919), who is recognized as the founder of Korean *kayagŭm sanjo.* While Kim Ch'angjo can be credited with inventing *sanjo* as a musical form, its contents were actually derived from *sinawi* or *simbanggok* music, which was performed at shaman rituals in Korea's southwestern provinces (B.-H. Lee 2009, 4–5). *Sanjo* was created as a form of *kayagŭm* music through the compilation and organization of existing musical materials into a set of movements, later developing into a musical genre in which numerous versions of *kayagŭm sanjo,* as well as for other instruments, are found. Traditionally speaking, it takes years of learning and practice under multiple teachers to master the *kayagŭm* as well as such music as *sanjo,* which required musicians to develop the ability to create their own renditions of *sanjo* as well as advanced skills in elaboration (H. Kim 2009, 31–32). However, the transmission and practice of *sanjo* in contemporary South Korea and Yanbian are much different from those in the past. Even in South Korea, where the maintenance of tradition is much emphasized, personalization of *sanjo* has been little emphasized due to the introduction of the Intangible Cultural Property System (Muhyŏng munhwajaebŏp) and Western music influences (Killick 2017, 14–15).

Because Kim Chin was a student from China and would return there, his training on *kayagŭm sanjo* was accelerated and much more intensive than that of any other student at the school. Drawing on his musicianship as a Western string player, Kim Chin transcribed An's *sanjo* lessons onto Western staff notation, and An did not mind repeating passages multiple times during a lesson in order to help Kim with this task (Yang 2001, 121). Kim Chin would later publish *sanjo* by An Kiok and Kim Ch'angjo in Yanbian and use them in teaching his Chaoxianzu students (Howard et al. 2008, 10).

While Kim Chin had observed *kayagŭm sanjo* thriving in North Korea in the 1950s, the situation he encountered back in Yanbian was much different. He premiered his *kayagŭm sanjo* in 1959, and despite his own enthusiasm for his music, it did not elicit the excited reaction he had hoped for by the Chaoxianzu community. Disappointed, he did not perform *sanjo* again for years. Instead, he devoted himself to teaching *kayagŭm* as a member of the music faculty at Yanbian Arts School.

Kim Chin speculated that the Chaoxianzu community's unfavorable reception of his *sanjo* in the late 1950s probably was because the sound of the traditional *kayagŭm* was too soft to be performed in front of a large audience that

Figure 4.1 Kim Chin's 1985 *Kayagŭm Sanjo Method,* including his transcriptions of *sanjo* by An Kiok. Photo by author.

had become accustomed to the vigorously paced and modern musical sounds promoted by the PRC, to which *sanjo* obviously did not conform. *Sanjo* might also have been relatively foreign to Koreans in China due to the genre's relatively short history, even though its components were old and might have sounded familiar to those who had experienced *simbanggok* or *sinawi,* most likely in southwestern Korea since neither seemed to be strongly practiced in Yanbian, if at all. In addition, when *sanjo* was first introduced in late nineteenth-century Korea, its popularity was more or less centered in Korea's Chŏlla, Ch'ungch'ŏng, and Kyŏngsang Provinces in the south (B.-H. Lee 1972), but not in the northern provinces such as Hamgyŏng, P'yŏngan, or Hwanghae, from where the majority of the early Korean immigrants to China originated. Although some renowned *kayagŭm sanjo* masters moved to North Korea before and during the Korean War and subsequently made this art known to those living in the North, Korean migrants in China would less likely be familiar with the sound of *sanjo.*

The lack of art music such as *sanjo* in early Chaoxianzu life in China can also be explained by the fact that the practice and consumption of art music, which requires professional musicians and financial patronage, might not have been facilitated among Chaoxianzu. Given that the early Korean immigrants to China were mostly poor peasants or people escaping the economic and political

hardships that afflicted Korea in the late nineteenth and early twentieth centuries, they would have spent much of their time in their rice fields or at least been busy with making a living elsewhere. They would have had neither the time nor the economic stability to cultivate highly professionalized musical arts from Korea such as *sanjo* (B. Lee 1988a; Koo 2007, 35).

In addition, from the early 1950s the Chaoxianzu community was much exposed to socialist musical innovations, typified by propaganda songs and programmatic instrumental pieces with a dramatic pace (Lau 1995/1996). *Sanjo* fell into a rather contrasting sound category since it progresses sedately from very slow to faster sections and is thematically abstract rather than programmatic. Its historical background also contradicts socialist ideology since its musicians were often patronized by the nobility, who greatly valued esoteric professionalism in individual musicians. Lastly, over the four years Kim Chin spent away in North Korea, the political milieu in China had changed dramatically. The CCP's ambitious launching of the Hundred Flowers Campaign (1956–1957) opened the floodgates to criticism of the CCP. The critiques so overwhelmed the party leader that he then decided to eradicate his opponents to reconsolidate his power. Mao labeled them as political rightists, among them many minority nationality leaders, whom he blamed for strengthening minority nationalism and thus inhibiting state unity.

Sanjo, as a Korean genre, was thus not the most likely candidate for a national musical style, as promoted by the PRC, to propagate the state ideology of proletarian identity. Given that the PRC's general understanding of all cultures was that they must fundamentally conform to state ideology by serving the masses, the Chaoxianzu community and its musicians would not have been likely to favor *sanjo*, especially in public settings, all the less so due to its having experienced the Anti-Rightist Movement (1957–1959) and the purging of nationalists by the late 1950s.

In 1960, a year after Kim Chin's *sanjo* premiere in Yanbian, Chŏng Chinok, the Yanbian Song and Dance Troupe's resident composer, invited Kim to perform as a *kayagŭm* soloist for "Ch'uŏk kwa hwanhŭi" [Memory and Joy],[2] a *kayagŭm* concerto that Chŏng created by adapting and rearranging the melodies of *kayagŭm sanjo* (Chaoxianzu Music Organization 2005, 180). Though Kim Chin performed as the soloist, he recalled that he did not much like the concerto format whereby the traditional *sanjo* was rearranged with orchestral accompaniment, even though the orchestral version was better received than his performance of traditional *sanjo* had been: "I only like the sound of *sanjo* when performed in a traditional way." The survival of *sanjo* in Yanbian would perhaps have been impossible had it not been incorporated into the pedagogical repertoire for *kayagŭm* students at Yanbian Arts School, especially considering that there was little emphasis on traditional Korean music repertoires in

Yanbian at the time, with the exception of various instrumental arrangements of popular and regional folk songs in which Western and Korean instruments and musical languages were fused together. Yet Kim Chin's *kayagŭm sanjo* later came to be considered by the Chaoxianzu musical community as the most ancient and traditional example of Korean music, a powerful symbol of an authentic Korean cultural heritage that Chaoxianzu have maintained and cultivated as diasporic Koreans.

While the impact of *kayagŭm sanjo* in Yanbian has been as a pedagogical repertoire rather than as a major genre performed outside the academy, Kim Chin explained that even as instructional material, *sanjo* had to be adapted to the conservatory curriculum. Knowing that the traditional way of learning *sanjo* is by rote, that its performance involves some degrees of improvisation, and that it emphasizes the personalization of sound after many years of learning with different teachers, just how traditional Kim's teaching was in China, and to what extent he encouraged each student to make interjections and improvisations based on their own understanding of the music, would be interesting questions to explore. Based on my conversation with him, I sensed that Kim Chin was well aware of the traditional performance practice of *sanjo* as well as *kayagŭm*. However, he clearly stated that the musical reality he had to consider as a Chaoxianzu musician was different from the native musical context in South Korea, where the preservation of traditional culture, including its performance practices, is emphasized in order to perpetuate national heritage and cultures, as contrasted with many new, foreign-driven, and contemporary musical sounds. For example, in teaching the instrument to Chaoxianzu youth, Kim Chin developed his own method of transmitting *sanjo* that relied on his own transcriptions. In a diasporic music context where particular holders of culture, such as *sanjo* masters, are often absent or inaccessible, it is necessary for musicians to find alternative means of transmitting musical practice. In this regard, Kim Chin, who studied *sanjo* with the authoritative masters in North Korea, was the first to introduce the tradition to the Chaoxianzu community, and he altered the traditional mode of teaching by implementing his transcriptions in Western staff notation, a format on which Chaoxianzu students could rely. The adoption of a form of notation was necessary for Kim himself in learning the *kayagŭm* since he was not trained in a traditional Korean instrument and had to return to Yanbian after a relatively short period of study in North Korea. In addition, Kim Chin's musicianship and background in Western classical instruments led him to incorporate the Western mode of learning music into his own *kayagŭm* pedagogy.

In addition, the *sanjo* notations Kim Chin used in his teaching did not include the *chinyangjo*, the first—and slowest—movement of traditional *sanjo*; instead, they start with the second movement, the *chungmori*. Although South

Korean scholar Hwang Chunyŏn and colleagues have found that a number of *sanjo* transcriptions published in Yanbian include the *chinyangjo* of *sanjo* masters such as Kim Ch'angjo, An Kiok, Ch'oe Oksam, Kim Kwangjun, and Chi Mansu (Hwang et al. 2002, 43–53),[3] when I reviewed the Yanbian Arts School's library archive, most *kayagŭm* collections—those used by Kim Chin, Cho Sunhŭi, and their students—left out the first movement. While I cannot definitively confirm to what extent *chinyangjo* was emphasized in *kayagŭm* teaching in Yanbian, all three musicians featured in this chapter—Kim Chin, Cho Sunhŭi, and Kim Sŏngsam—stated unequivocally that it was the least favored of the movements and was infrequently performed in Yanbian as the opening of *sanjo* due to its character being just "too" slow-moving.

One might take the point of view that Korean music in China has deviated from the traditional performance practices emphasized at home in terms of mode of transmission by rote and personalization of the music, yet these changes confirm that Korean music could not remain the same in the diaspora since the cultural context is different.[4] More fundamentally, no tradition is static or archaic; instead, it is revamped in the present to meet the needs of contemporary people who want to see and feel they have *traditions*. In this sense, the existence of adjustments and change in traditional music to serve current needs is natural rather than extraordinary.

Ethnomusicologist Lee Byong Won states that when he met Kim Chin in the early 1980s, Kim did not sound confident about his music at all and recommended other *kayagŭm* musicians for Lee to observe rather than himself.[5] Perhaps the poor public reception of Kim's *sanjo* in 1959 discouraged him as a *kayagŭm* performer, or perhaps he lost his confidence during the Cultural Revolution when the practice of ethnic minority music was largely viewed as an act of national separatism or as counterrevolutionary. However, when I interviewed him in 2005, Kim Chin appeared to have regained his confidence: he was enthusiastic about being an authority of *kayagŭm sanjo* in China and referred to himself as one of those rare cases who carried "tradition" to China as a Chaoxianzu artist. Part of this pride certainly had to do with the attention he has received from South Korea since the early 1990s, where he was recognized as the authentic transmitter of both An Kiok's and Kim Ch'angjo's *sanjo*.

Knowing about Kim Chin's life and his experience as a Chaoxianzu musician, how can we explain the sustenance of *kayagŭm sanjo* in Yanbian today despite the community and state's low interest in and support for this music for decades after he tried to introduce it there? The story of Kim Chin reveals the possibility of *irony* and *subversion* emerging from prolonged tension and dynamics between the state and creative individuals: as a minority cultural agent, Kim Chin had a significant impact, managing to maintain, practice, and favor a particular ethnic and *traditional* music culture—in this case, *kayagŭm*

sanjo—against an unfavorable government backdrop, "the dominant and hegemonic pressures and limits" (Williams 1977, 115) that the Chaoxianzu community faced and had to comply with in China. Under the changed sociocultural dynamics of the mid-2000s, the status and evaluation of Kim Chin and his music were completely flipped as foreign countries gaining access to the PRC translated into a rise in interest in ancient Chinese cultures, and China itself began to recognize the value of its traditional cultures for the growth of its financial and symbolic power in the age of globalization. Kim Chin was able to see his *sanjo* finally taking root in China nearly four decades after his first performance in Yanbian.

Cho Sunhŭi and the Modernization of the Korean *Kayagŭm* and Its Music

Kim Chin's significance as a Chaoxianzu musician lies in his carrying of Korean cultural tradition to China. Cho Sunhŭi, for her part, has been known more for her innovative *kayagŭm* works. She first began to learn *kayagŭm* from Kim Chin while he was in Yanbian during a school break at P'yŏngyang College of Music and Dance; she then continued with Chi Mansu, a North Korean *kayagŭm* teacher visiting Yanbian Arts School. Cho was one of the first *kayagŭm* students to graduate from Yanbian Arts School, in 1960, and she became a *kayagŭm* instructor at her alma mater after being recommended by Chi Mansu. While her *kayagŭm* training at the arts school focused on *sanjo* and Korean folk songs, Cho expressed to me that she had always thought of creating more virtuoso pieces for the instrument, comparable to similar works for Western classical instruments.[6]

As early as the beginning of the 1960s, Cho pondered increasing the prominence of the *kayagŭm* in Chaoxianzu orchestras, which at the time combined Korean instruments with Western ones. The disruption caused by the Cultural Revolution provided an immediate impetus for her to challenge the traditional *kayagŭm* and its music. According to Cho, "I had no music to teach when the Arts School reopened in 1972 in the midst of Cultural Revolution. At that time, people said, 'don't play *sanjo*,' 'don't play Korean folksongs,' . . . So we had to make new music to teach the instrument." Subsequently, she started to arrange revolutionary songs for the *kayagŭm* and compose new *kayagŭm* music. She did all her transcriptions using Western staff notation with the addition of symbols she created herself to indicate strong vibrato, pitch gliding or bending, harmonics, and newly adopted techniques such as glissandos and double-stops.

Cho Sunhŭi's *kayagŭm* books exemplify her efforts at incorporating arrangements of diverse music for the instrument into her teaching at the arts school. She published pedagogical books on the *kayagŭm,* including etudes,

Figure 4.2 Cho Sunhŭi's 1991 *kayagŭm sanjo* editions of works by (left to right) An Kiok, Ch'oe Oksam, Kim Kwangjun, Chŏng Namhŭi, Chi Mansu, and Yu Tonghyŏk. Photo by author.

methods for new techniques, collections of her own arrangements of traditional Korean folk songs, and arrangements of Chinese and Chaoxianzu contemporary songs, the majority of which were revolutionary songs, especially before the early 1980s, when the new reform era revived the cultural autonomy of Chinese minority nationalities. For example, Cho Sunhŭi's 1976 publication includes *kayagŭm* arrangements of one Korean folk song, four Chaoxianzu and Chinese revolutionary songs, and Chinese *guzheng* music; by contrast, her 1982 book includes *kayagŭm* arrangements of quite a few Korean folk songs, early twentieth-century Korean popular songs, contemporary Chaoxianzu songs, and *p'ansori* excerpts—but interestingly, no revolutionary songs. In 1978, a little more than a year after the end of the Cultural Revolution, Cho published *kayagŭm* method books and *sanjo* notation. Whereas Kim Chin's *sanjo* publications were dedicated to nearly complete versions of *sanjo* by An Kiok and Kim Ch'angjo,[7] Cho Sunhŭi's 1978 *sanjo* book was a compilation of excerpts from the works of various *sanjo* masters who lived in North Korea. Her publications in the mid-1980s are predominantly of compositions by North Koreans and Cho's own arrangements of North Korean pieces, whereas in the early 1990s Cho published a series of her own *sanjo* transcriptions from her studies with master musicians in North Korea until they passed away (see figure 4.2). As in the case of Kim Chin, who experienced a rise in the status of *sanjo* in Yanbian beginning in the 1990s, the published collections of her *kayagŭm* pieces might also reflect

how musicians and their choice of performance repertoire respond to the shifting political and social contexts of their times.

Each of Cho's 1991 publications is devoted to a different musician associated with *kayagŭm sanjo,* all based in North Korea since the partitioning of the Korean Peninsula. These editions also reflect her interest in modern *kayagŭm* music since most of them contained new compositions by each featured musician. Unlike Kim Chin, whose teaching of *sanjo* remained faithful to what he learned from his teacher, for Cho Sunhŭi the transmission of a particular school of *sanjo* or of complete versions of compositions seemed to be of less interest. Instead, in her publications, specific movements of each musician's *sanjo* are included as featured pieces so that her students can selectively learn and perform them.

Cho Sunhŭi has also been credited with introducing and establishing the twenty-three-string heptatonic *kayagŭm* in Yanbian. After An Kungmin's thirteen-string *kayagŭm,* Chaoxianzu musicians invented the fifteen-string *kayagŭm* and used it until the mid-1970s. As Cho experimented with new repertoire, she felt that making changes to the mechanisms of the traditional instruments was necessary. Cho advocated the reinvention of the *kayagŭm* in the hope of promoting it as a virtuoso solo instrument. In addition to adding strings, in order to increase its volume, she and other Chaoxianzu musicians experimented with attaching to it an electronic amplifier, later abandoned for a simple microphone due to the noise it made (S. Cho 2000, 39).

These modifications did not escape criticism:

> Some people say the reinvention of the *kayagŭm* took it too far from its ethnic heritage. Well, I say back to them that the reinvented *kayagŭm* is, of course, not the traditional *kayagŭm,* but it does not leave tradition behind wholesale; it remains grounded in tradition but reformed with the addition of new mechanisms. It has been my belief that the instrument should be reformed while not losing the tradition.

It is hard to pinpoint to what extent tradition was kept or replaced with Cho Sunhŭi's music and the advent of the new instruments. Cho's interpretation of "tradition" may have been different from that of others, but she was at least conscious of the criticisms raised concerning her work. She states:

> There should be a balance between old tradition and modernity. In other words, music [her version of music] cannot be entirely ancient nor be entirely new. If there is a section in a traditional style, then there should be a section in a new style. I frequently include both a prelude and a postlude in my works and use them as a way to create balance in my work by juxtaposing old and new techniques.

Figure 4.3 Korean folk song "Yangsando"

In order to create a balance between tradition and change, Cho ensured contrasting sections in her music. If the main body of a work was written in a style that recalled a more traditional sound, she highlighted new techniques in her preludes and postludes, and vice versa. For example, although no specific tempo indication is specified in her collections, her arrangement of the well-known Korean folk song "Yangsando" (figure 4.3) opens with a short dramatic section where new techniques such as glissandos and double-stops are highlighted (see figure 4.4, mm. 1–4).

In explaining her *kayagŭm* music, Cho relates that she was inspired by performance techniques on foreign instruments, such as the Chinese *guzheng, pipa,* and *yangqin,* as well as the Western harp, and incorporated these into her own performances. Where the Korean *kayagŭm* is traditionally plucked with the right hand while the left hand is responsible for intonation, pitch bending/gliding, and vibrato, Cho Sunhŭi adopted the *guzheng*'s modern development of using both hands for plucking: while the right hand is responsible for melodic progression, the left hand accompanies it with harmonic clusters and stops. Also, she uses arpeggios and glissandos learned from the Western harp as well as *pipa* strumming (S. Cho 2000, 38). The following transcriptions (figure 4.4) show how Cho Sunhŭi created a new *kayagŭm* piece by combining the folk song "Yangsando" with new musical idioms.

Cho's "Yangsando" begins with a broken chord, followed by octave double-stops delineating the melody in a flexible tempo. A short prelude (mm. 1–4) and two extra measures establishing the *semach'i* rhythm (mm. 5–6) precede the main part of "Yangsando" (starting from m. 7).

Figure 4.4 Cho Sunhŭi's "Yangsando," arranged for Chaoxianzu *kayagŭm* (author's transcription based on Cho Sunŭi's original manuscript)

Figure 4.4 (*continued*)

In the body of the piece, Cho marks certain notes as requiring vibrato (e.g., mm. 8, 12, and 13). While the traditional texture of Korean music is monophony (for solo music) or heterophony (for ensemble or orchestral music), in Cho's version of "Yangsando" the melody is occasionally harmonized with the addition of notes on the major third, perfect fourth, and octave. The simple folk tune is embellished with auxiliary notes. While the right hand plays the melody, the left hand provides harmonic support or adds vibrato. The piece's ending features a broken chord and double-stops (with the addition of a fermata), recalling its beginning.

As mentioned, Chaoxianzu compositions frequently include preludes and postludes whose tempi and musical content contrast with those of the main work. This compositional practice is often used in modern Chinese and North Korean music as well. Whether this convention was created by Cho or not, she clearly indicated that she wanted to develop new *kayagŭm* music to suit the contemporary setting. With this goal in mind, Cho introduced new performance techniques to the *kayagŭm* and expanded the instrument's repertoire with numerous arrangements of Chinese and Korean songs and adaptations of North Korean instrumental pieces.

The phenomenon of introducing modern compositions to traditional instruments has not been limited in China to Chaoxianzu music, as demonstrated by the government's promotion and implementation of Chinese folk instruments, such as the *dizi, erhu,* and *pipa,* into Han Chinese music conservatory curricula. Consequently, the traditional folk or people's music (Ch. *minjian yinyue*) of the Han Chinese became highly professionalized, developing into a music whose technical demands are largely unattainable by the amateur musician who sits outside the conservatory setting (Lau 1995/1996). Cho Sunhŭi was inspired and legitimized by the state's support of culture, which encouraged the reinvention of traditional music and instruments and the incorporation of new techniques in the development of contemporary national music. Although not identical to the case of development of state national music, Cho Sunhŭi's initiative in instrument reformation and her emphasis on technical development were definitely grounded in the state's progressive ideology, which was a powerful *shaping force* and provided an *operative context* for the construction of a national music in China at the time of Cho Sunhŭi's career as a musician and teacher. However, Cho also never forgot her traditional ethnic culture, even if her music was influenced by modern Chinese national music and North Korean compositions. In her *kayagŭm* music, she conveys her vision of what Chaoxianzu *kayagŭm* music can be, one that synthesizes a range of musical elements available to diasporic Koreans in Yanbian and a set of experiences with traditional Korean music gained across China and North Korea.

Kim Sŏngsam and Projecting Yanbian Color into the Chaoxianzu *Kayagŭm*

Kim Sŏngsam is recognized as the third-generation authority in Chaoxianzu *kayagŭm* music, after Kim Chin and Cho Sunhŭi, who respectively represent the first and second stages of the cultivation of *kayagŭm* music in Yanbian. Kim Sŏngsam studied the *kayagŭm* with Cho, and he collaborated with her to modernize the instrument through the development of the twenty-three-string heptatonic *kayagŭm* in Yanbian. With the PRC's enactment of its Intangible Cultural Heritage Law in 2011, some aspects of Chaoxianzu traditional cultural heritage, including in the areas of music, dance, wedding customs, and traditional dress, did get recognized by the PRC as part of China's national intangible cultural assets deserving of state and provincial support in order that they may be protected from complete disappearance (Y. Kim 2012). Subsequently, Chaoxianzu *kayagŭm* music was recognized as national intangible cultural property of China, along with the Korean folk song "Arirang" and *p'ansori* singing, and Kim Sŏngsam was officially designated as a transmitter of Chaoxianzu *kayagŭm* music in China.

However, although Kim Sŏngsam's *kayagŭm* music—as Chaoxianzu music cultivated in China—is distinguished from what South Korean cultural nationalists argue is the authentic practice of Korean *kayagŭm*, the PRC's recognition of traditional Korean performing arts as part of its own national cultural property and its ongoing efforts to get them registered on UNESCO's list of intangible cultural heritage items touched off heated debate over Chinese versus South Korean claims to Korean cultural assets. The pinnacle of the debate was in 2009 when the Chinese government got *nongak* added to UNESCO's list of intangible cultural heritage items as "Farmers' Dance of China's Korean Ethnic Group." The South Korean side of the debate claimed that the authenticity of ancient traditional Korean music lies in its identification, maintenance, and practice in South Korea.

While evaluating Chaoxianzu music in terms of its authenticity, especially from the point of view of trying to determine to what extent Chaoxianzu construction of Korean music conformed to South Korea's imagination of traditional Korean music, is potentially pejorative and depreciating of the cultural creativity of the diaspora, the PRC's institution of its Intangible Cultural Heritage Law and recognition of Chaoxianzu *kayagŭm* music and Kim Sŏngsam (as a key tradition bearer) as important state cultural heritages and assets ensured the transmission of Chaoxianzu *kayagŭm* music in China, as compared to the previous decade, when Yanbian Arts School had seen a drastic decline in the number of students majoring in Chaoxianzu music, both in singing and instruments (Y. Kim 2012; Indŏk Kim 2012; K. Sin 2012, 318).

Kim Sŏngsam was born and raised in Yanbian and started to learn and play the saxophone as a band member in middle school. Later he switched to trumpet with the intention of becoming a member of a symphony orchestra. However, when he entered Yanbian Arts School in 1973, he found himself recommended for a major in *kayagŭm*, an instrument he had never considered pursuing. It is not so clear how much of his own will was reflected in Kim's majoring in the instrument, or how strongly or why the school wanted him to become a *kayagŭm* student. However, studying *kayagŭm* with Cho Sunhŭi, Kim gradually fell in love with it. Upon graduating from the arts school in 1976, he was appointed as a *kayagŭm* instructor there, as had happened previously to his teacher, Cho. Working within a post–Cultural Revolution state milieu where the focus was on rejuvenating cultural diversity and minority identity, Kim Sŏngsam toured China numerous times starting in 1979 performing his *kayagŭm* music to audiences nationwide. Recognized as a fine *kayagŭm* player, he was invited to work with Han Chinese musicians who were interested in a variety of zithers, including the Chinese *guzheng* and the Korean *kayagŭm*. As a resident musician at Shanghai Music Conservatory, Kim Sŏngsam studied and collaborated with colleagues who were experts in

Chinese zither and instrument reformation. His experience with Chinese *guzheng* and its modern repertoire has greatly influenced his life as a performer and instructor of Chaoxianzu *kayagŭm* back in Yanbian (Indŏk Kim 2012).

As pointed out earlier regarding the musical work of Cho Sunhŭi, in the 1980s Chaoxianzu musicians actively worked with North Korean musicians in order to revitalize their Korean music in the post–Cultural Revolution period. Throughout the 1970s, North Koreans had reformed their national music, inventing new instruments and creating virtuoso pieces according to directives from chairmen Kim Ilsŏng and Kim Chŏngil (B. Lee 1988b). Progressive Chaoxianzu musicians such as Cho Sunhŭi were happy to find models (and thus legitimization) for their new music in similar innovations in North Korea. However, one ramification of actively resuming collaboration with North Korea was the domination of North Korean repertoires in Yanbian, which led to young Chaoxianzu musicians considering how to distinguish themselves as diasporic Koreans in China amid the influx of foreign and intra-ethnic cultural imports.

According to Kim Sŏngsam, "North Korean music sounds too modernistic. They got rid of too many of the traditional flavors [techniques]. . . . Instead of performing North Korean music as is, I arrange it to make it less modernistic and appeal to *our* audience [emphasis added]."[8] Kim Sŏngsam's perception of North Korean music is different from that of Cho Sunhŭi. While Cho was conscious of some traditionalists' criticism that her innovations in Chaoxianzu music deviated too far from Korean tradition, she said that she was happy to validate her own efforts at modernization by noting similar transformations that North Korea had made throughout the 1970s and 1980s. In contrast Kim Sŏngsam was concerned by the downplaying of traditional characteristics in North Korean music and as such was equally problematic in his consideration of which Korean music was to be practiced in China.

The majority of North Korean music performed in Yanbian today came out of a massive reconstruction of national music in North Korea throughout the 1970s, according to the dictates of the self-reliance ideology promulgated by Kim Ilsŏng and then substantially developed by his son, Kim Chŏngil. Self-reliance music is the fundamental underscoring of modernity, the revolutionary spirit, North Korean identity, and the value of creative *arrangements* of music, recycling old or preexisting musical materials. More specifically, it is largely characterized by the substantial reconceptualization and reconfiguration of traditional Korean instruments into distinctively North Korean forms—combining them with Western instruments to create a grandiose national orchestra—and the development of the self-reliance singing method, which became the prototype of North Korean singing and vocal production. Besides emphasizing a strong North Korean identity in recreating instrumental and vocal music, the ideology was greatly influential in every aspect of North

Korean music making, including music education, performance pedagogy, and compositional styles (Hwang et al. 2002, 24, 30). The thrust was stronger to develop a distinctively North Korean music than it was to maintain ancient traditional performance culture. In the process, certain traditional Korean aesthetics, such as *nonghyŏn* (vibrato) or more broadly *sigimsae* (pitch ornamentations through the bending, raising, and lowering of pitches), were de-emphasized; instead, the major consideration was to create a smooth, soft, silky, refined melodic line that the two Kims dictated that all North Korean music should project.

Considering the fact that even Cho Sunhŭi—the most modernist and innovative figure in Chaoxianzu *kayagŭm*—maintained varying degrees of vibrato as well as some gliding and bending of notes in her music, Kim Sŏngsam's dissatisfaction with the North Korean performance style and his desire to rework North Korean compositions as a Chaoxianzu musician are easily understood. In fact, a great number of Chaoxianzu musicians have freely rearranged North Korean compositions as they have incorporated them into their performance repertoires.

It is hard to determine if Chaoxianzu, in their openness to rearranging North Korean music, took their cues from North Korea or from China, since in China, musical rearrangements have also been accepted as a way of creating art for contemporary audiences. Chaoxianzu, North Korean, and Chinese musicians have long practiced the recycling of preexisting compositions with minor or even major alterations. However, the fact that Chaoxianzu have been able to make their own mark on North Korean music in their re-creation of it for the diasporic Korean community has enabled Chaoxianzu to insist that their music is distinct from that of North Korea even if the compositions originally came from there.

In particular, musicians like Kim Sŏngsam argue that Chaoxianzu musicians, in their work with North Korean music, strive to strike a balance between traditional Korean and progressive sounds. To achieve this, one technique that Kim favors is to restore *sigimsae,* and particularly *nonghyŏn,* which was downplayed in the performance of new national music in North Korea.[9] By adding a slow section when he arranges a North Korean piece, Kim highlights particular notes with different gradations of *nonghyŏn,* which he believes to be the most fundamental characteristic of traditional Korean music, the element by which the music's modes and regional affiliations are distinguished.

Besides the established Chaoxianzu practice of reworking North Korean music based on their own vision of how Chaoxianzu music should sound, Kim Sŏngsam's *kayagŭm* music shows that Chaoxianzu music is not confined to the North Korean repertoire; in fact, it has encompassed a range of different musics of Korean and non-Korean origin, unlike the case of North Korea, where the

state only allows for its own version of national music. Kim said that he bases his *kayagŭm* arrangements of Chinese, Japanese, South Korean, and Yanbian music on his own ideas about what would fit in with and appeal to his own students as well as the Chaoxianzu community at large.[10] On 21 June 2005 I attended the graduation recital of Ch'oe Misŏn, one of Kim Sŏngsam's students at Yanbian Arts School. Ch'oe had studied the *kayagŭm* there since 1990, and upon graduation she was invited to join the school's *kayagŭm* faculty. The concert featured eleven *kayagŭm* pieces, of which eight were originally North Korean compositions, some of them altered by her teacher Kim. Besides those, the program included "Chimhyangmoo" (or Ch'imhyangmu; Dance in the Perfume of Aloes), a modern *kayagŭm* piece composed by South Korean *kayagŭm* master Hwang Byungki in 1974. Ch'oe also performed a *kayagŭm* arrangement of a Chinese *guzheng* piece, "Liuyanghe" [Liuyang River], and of the Korean folk song "Yangsando." In addition to two more pieces—one composed by An Kungmin, and the other Kim Sŏngsam's arrangement of the Japanese folk song "Sakura" [Cherry Blossoms]—her original program included a movement from traditional Korean *sanjo,* but for some reason it was not performed.

The duration of each piece was relatively short; tempos were fast, except for "Chimhyangmoo." Two different *kayagŭm* were used: one with thirteen strings (for "Chimhyangmoo" only) and the other with twenty-three (for the rest of the program). The *kayagŭm* was accompanied by *changgo*. Instead of sitting on the floor, both instrumentalists sat on chairs during the recital. All the pieces were either modern compositions or rearrangements of preexisting tunes done using Western compositional methods. Clearly the performance enacted on stage reflected how the sound of Korean music and its instrumental practices have been reshaped as a diasporic practice through adapting and favoring new ideas in terms of performance repertoire, setting, and musical practices. According to Kim Sŏngsam, the repertoire performed at the recital is widely taught at Yanbian Arts School.[11] Given that Chaoxianzu musicians have selectively yet extensively incorporated Korean cultures in the construction and promotion of their own music in China while also reshaping it with the addition of new musical idioms learned from Chinese and Western music, how can we characterize Chaoxianzu music as its own genre or style of music, distinct from the two Koreas? Does it really contain sonic characteristics discernible as unique to Chaoxianzu music? If so, what are they? Or is it a myth that only exists in the minds of Chaoxianzu musicians who imagine their music as different from that of the two Koreas or of China's other nationalities? In 2005 Kim Sŏngsam, then chair of Korean music at Yanbian Arts School, shared his view on what Chaoxianzu music is and should be, in an effort to help me solve the endless riddles I had. In his mind, in general it has a "Yanbian color" (*yŏnbyŏn saekch'ae* or *saekkal*), an essence that is the result of an amalgamation of various musical and cultural

elements from China and the two Koreas. As Chaoxianzu musicians have striven for a musical progressiveness that also emphasizes a Korean identity, they have created music clearly distinctive to themselves.[12]

One might critique this explanation offered by Kim Sŏngsam as abstract, lacking in concrete evidence, or avoiding specifying distinct features. Yet Kim's assertion of a "Yanbian color" is clearly grounded in his projection of the collective history and migrant experiences of Koreans in China in constructing their cultural identity, privileging Yanbian as the creative center of Chaoxianzu culture. Although the multiple and transgressive nature of identity delegitimizes simple and essentialized views of ethnic identity and glosses over the multiple inputs of numerous individuals, whether these inputs were seen as more or less prominent, Kim Sŏngsam's "Yanbian color" could be perceived more as an assertion than a fact, a projection rather than a definitive view by a diasporic musician who has devoted his lifetime to learning, performing, teaching, and promoting *kayagŭm* music as a Chaoxianzu musician in China: "As a Yanbian musician, I hope we can create our own music by using North Korea's development of national music and South Korea's maintenance of traditions, with the addition of Chinese characteristics."[13] Kim not only delineates his idea of Chaoxianzu music as grounded in the cultural hybridity of the people who collectively reside in that border region but also calls attention to the importance of the diasporic and musical agency of Chaoxianzu who have attained degrees of fluidity, accessibility, and autonomy in the production of specific cultures.

Individual Creativity and Interpretation of Tradition

These three case studies of *kayagŭm* musicians exemplify how each one's attitudes toward traditional Korean culture and interpretations of Chaoxianzu music are manifested in their music. Kim Chin, a first-generation Chaoxianzu musician, brought the *kayagŭm sanjo* tradition to China, whereas Cho Sunhŭi introduced new compositions and techniques to Chaoxianzu *kayagŭm* music. Her work was shaped by not only her own creative drive but also the social constraints of her time, for example, the Cultural Revolution. The value of her work was validated by similar progressive music developed in China and North Korea. Even so, Cho never totally abandoned the traditional Korean music practices used in the past or maintained in South Korea. Thus, she intended to create a middle ground fusing and balancing old and new practices. For his part, Kim Chin, as a musician and teacher of Chaoxianzu *kayagŭm* music, insisted on the importance of traditional-sounding *sanjo* in Yanbian. His self-esteem as a conservative musician was lifted after he began to be

recognized by South Korean scholars and musicians as an important transmitter of *sanjo* traditions in the 1990s. Around the same time, China began to reconsider the value of its own ancient and diverse cultural heritages and their capacity to contribute to the growth of the state at a global level. Given these social dynamics, Chaoxianzu musicians recognized the merits of including both tradition and modernity in their diasporic cultural identity.

Kim Chin and Cho Sunhŭi represent the respective polarities of tradition and modernity in ethnic music—associating themselves with North and South Korea—while Kim Sŏngsam argues for a Chaoxianzu music that must be unique to Chaoxianzu. The increasing cultural contacts cultivated by China since the 1980s seem to have affected the younger generation of Chaoxianzu musicians, like Kim Sŏngsam, who want to clearly distinguish their music from that of North and South Korea by its Chinese influence. Kim further insists that the combination of Korean and Chinese influences is not enough to characterize Chaoxianzu music. He argues instead for a "Yanbian color" that can only be expressed by Chaoxianzu musicians, whose music reflects and embodies their locational and diasporic particularity, the unique experience of all three cultures, and efforts to express a Chaoxianzu identity.

As seen through the stories of these three musicians, each one's creative interpretation and unique attitude toward what diasporic Korean music in China is has played a major role in transforming Chaoxianzu *kayagŭm* music into what it is today. With all three having been leading figures in the music education of young Chaoxianzu in Yanbian, these musicians can even be broadly read as fundamental to the construction and development of Chaoxianzu music in Yanbian over the last sixty years. While they all obviously grounded their music in Korean tradition, each took it in different directions according to their own view and creative impulses. In this case, a tradition is clearly "more than an inert historicized segment; indeed it is the most powerful practical means of incorporation . . . [which is] powerfully operative in the process of social and cultural definition and identification" (Williams 1977, 115).

The implementation of the minority nationality policy in China after 1949 was a double-edged sword in the sense that the state offered its minorities the right to maintain and perpetuate their own cultural traditions and practices, yet in so doing it presupposed ethnic homogeneity within each group whose members had in fact formed a wide variety of relationships with the nation, culture, and ethnicity. From the official perspective, everyone within a given *minzu* category was considered linguistically, historically, culturally, and ethnically homogeneous. This assumption is challenged by the reality of Chaoxianzu as active agents in incorporating, reproducing, and defining their cultural identity by instrumentalizing their traditional cultures (Ortner 1984, 148; Lau 1995/1996, 133). Thus the distinctive ways in which these three

kayagŭm musicians define and demarcate Chaoxianzu music destabilize the state's concept of ethnicity as well as nation. In fact, Korean identity in general is complex and permeable such that it confounds any official categorization, as is demonstrated by the Chaoxianzu musicians who participate in its construction through their own interpretation of diasporic Korean music, claiming an "in-between" positionality vis-à-vis state and nation, old and new, and tradition and modernity.

Musical Signs and Essentializing Chaoxianzuness

Because people commonly hear particular styles of music
played by particular individuals or social groups or in
particular regions, music typically serves as a powerful
index for these types of identity.
—Thomas Turino, *Music as Social Life*

In post-1949 China, the government has not only been the major patron of the arts but has also dictated every realm of the arts, from production to consumption. From the founding of the PRC through the beginning of the twenty-first century, many of the larger performance troupes in China were affiliated with the state or local government. In China the government-sponsored troupes and affiliated musicians had enjoyed relatively high job security with regular salaries. This security, however, gradually weakened and became less meaningful as government patronage struggled to keep up with rising economic inflation and could no longer provide a salary that would permit its employees to rely solely on their profession for their livelihoods. While in Yanbian around the beginning of the 2000s, some Chaoxianzu musicians left or took a break from their jobs, or they abandoned their music careers entirely to seek better opportunities for income offered elsewhere in and outside China, renowned musicians continued with the major government-sponsored troupes such as the Yanbian Song and Dance Troupe, Yanji Chaoxianzu Arts Troupe, or Yanbian Arts School.

In this chapter I introduce four Chaoxianzu composers who have represented Yanbian and Korean minority music in China in the second half of the twentieth century. All were affiliated with government-sponsored professional music troupes that openly emphasized the cultivation and expression of Korean

minority nationality identity. All musicians in China, whether affiliated with a government troupe or not, are expected to comply with the state's cultural mandate, especially those who reach larger audiences with their live performances or the audiovisual commodities they produce with the support of state-owned troupes or the media. Through the stories of Chaoxianzu musicians who have worked for state-owned troupes, I show how diverse musical representations of Korean minority identity have been produced and contested in Yanbian as an embodiment of Chaoxianzu identity. In so doing, I point to both individual creativity and the dialectics of state institutions and musical agency that together have shaped Chaoxianzu music in the Age of Reform.

Musical Signs and Identity

In exploring the relationship between musical representation and identity, ethnomusicologists have found the semiotic theory of Charles Sanders Peirce useful (Reyes 2014; Rice 2007; Turino 1999). Peirce's model is grounded in the belief that all words in language are signs, and the various ways in which linguistic signs and meanings are related to each other lead to different effects in the minds of sign perceivers. Although music and language are essentially different types of communication, Peirce's linguistic model has been instrumental in attempts to explain musical semiosis (Turino 2008, 6), especially considering that music as a form of expressive sign often enthralls people by evoking a range of psychological as well as physical reactions, such as weeping or grooving to the beat. These communications are conditioned by the context in which each sign is experienced by a person, who then remembers and subsequently connects it with a particular meaning or another sign based on their own experience (Turino 2008).

Peirce's sign process can be represented by a triangular relationship created between the sign, the object, and the effects. The process of communication starts with a *sign* (or a sign vehicle), which evokes a particular *meaning* or *object* that the sign stands for in one's mind. The types of chains linking the sign and the object result in different *effects* (interpretants) in the sign perceiver's mind. Also, three different concepts illustrate the various ways in which a sign is related to a meaning/object: icon (pictorial resemblance), index (experiential knowledge), and symbol (social agreement). Among these, it is the iconic and indexical signs that are most prevalent in the field of music. If a person hears a sound and connects it to something that they feel resembles it, an indexical sign is generated that is grounded in the experiential knowledge of the sign perceiver. When, where, and how people have experienced a musical sign in the past are the keys to determining what the sign is and stands for in one's mind.

In this way, people come to associate a particular sound or style of music with a particular individual or social group who performs, practices, and consumes that music within a particular region, state, or institution. This is how music as an indexical sign marks one's individual or social identities (Turino 2008, 8).

Such a chain created between the indexical sign and the object is then conventionalized through ritualized practice or repeated experiences—in Turino's terms, "co-occurrences" over a lifetime (Turino 1999, 227; Reyes 2014). As people experience the same sign multiple times in the same context or in similar ones, the sign-object chain is perceived as nearly absolute, true, factual information. However, any sign can gain new meanings over time and thus come to stand for something else in someone else's mind, especially when the context of the sign changes or shifts (Turino 1999, 229). This points to the importance of subjectivity and multiplicity of meaning to the indexical sign, since the sign can communicate with thousands of people in thousands of different ways. Moreover, the fluidity and permeability of a (musical) sign and of object/meaning chains confirms that any sign can be constructed to mean one thing or another by people who intend to convey a specific meaning to other people who are assumed to have similar experiences and thus will comprehend the sign similarly.

Understanding the link between the sign and the dissemination of meaning, Stuart Hall's (1980) discussion of encoding/decoding in mass media discourses can also be useful. He argues that a sign, which can be verbal or nonverbal, is constructed in a highly intentional manner directed at conveying particular messages to an audience (the sign perceivers or interpreters), whose social knowledge is assumed to be appropriate for understanding the sign message. Hall calls this process of communication *production,* the point where encoding, the construction of a message, begins. Although Hall's discussion is confined to examples of communication in mass media, he articulates the complex, highly intentional, and human-oriented process of communication. While both Hall and Turino emphasize the significant role played by *social knowledge* in the minds of both the sign producers and perceivers in the creation and interpretation of signs, Turino further points to *strategic essentialism* as important in the politics of social knowledge since, for both producers and interpreters, sign communication involves a process of essentialization according to their own subjective experiences and imagination. In particular, when a sign stands for a group's or an individual's identity, despite the fluid nature of identity, a sign of identity is constructed that communicates through strategic essentialism, which reduces a complex composition of selves to "a few emphasized aspects that are projected as fundamental and immutable" (Turino 2008, 104).[1]

I found that the operation of musical sign and social knowledge as well as the notion of strategic essentialism useful in understanding what the Chaoxianzu

community has done in order to express and construct its ethnic particularity by way of music as a Korean diasporic group in China. The community's musicians have instrumentalized certain traditional Korean musical elements as signs that convey their cultural identity, while reworking them to represent both Korean and Chinese identity by way of infusing Korean music with Chinese cultural influences (see chapter 3). Chaoxianzu in China are not alone in this process: a number of other diasporic groups have similarly constructed their diasporic music through a process of self-essentialization by accessing traditional music as the sign of ethnic identity. Frederick Lau (2001) has shown how Teochew Chinese in Thailand have constructed their identity by maintaining *uncontested ideas* of what comprises Teochewness and Chineseness. He argues that identity is *fluid* and *situational,* yet "the essential self—fixed and uncontested assumptions that informs and grounds an individual's sense of being—is a pre-condition and an indispensable ingredient for the invention, construction, negotiation, and transformation of identity" (38). In the performance of the *essential self,* forms of expressive culture such as music and dance are instrumental since they are *discursive representations* related to a person or a group, while the performative and symbolic nature of expressive cultural forms invites new meanings and significations.

The communication and effect (interpretant) of each musical sign-object chain varies depending on individually attributed significances and meanings. At the same time, these discursive representations evoke sentiments or act as reminders of experiences that the sign perceivers can easily relate to. Primarily focusing on four prominent composers for the Yanbian Song and Dance Troupe and the Yanji Chaoxianzu Arts Troupe, I discuss how Chaoxianzu identity is essentialized in the realm of music, and then reinforced through the practice and promotion of these discursive musical signs. Essentialism is a feature of various aspects of Chaoxianzu music and culture, sometimes in the form of *strategic essentialism,* whereby Chaoxianzu identities are reduced to a set of musical expressions, idioms, and materials that are selected to highlight Koreanness, and other times as *essentialization of the self,* whereby characteristics of both individual identities and the Chaoxianzu community as a whole are collectively imagined and presupposed. Yet the overall process and result of creating Chaoxianzu music by way of imagining an essential Chaoxianzu identity, in turn, demonstrates the constructive and permeable nature of identity.

The Yanbian Song and Dance Troupe and Its Musicians

The predecessor of the Yanbian Song and Dance Troupe (Yŏnbyŏn kamudan) was the Yanbian Culture and Arts Work Team (Yŏnbyŏn mun'gongdan)

under the Yanbian Commissioner's Office, Nationality Affairs Section, established in 1947. Most active pre-PRC Korean performing arts troupes in China were propaganda teams placed under volunteer troops such as the Korean militia based in Northeast China; the Yanbian Song and Dance Troupe was the result of a 1956 merger of the Yanbian Culture and Arts Work Team with several propaganda teams around Northeast China (Chaoxianzu Music Organization 2005). Between the late 1940s and the early 1980s, twelve professional Chaoxianzu performing arts troupes were established in Northeast China under government sponsorship.[2] Among them, the Yanbian Song and Dance Troupe is the largest and longest lived. Understandably, in an organization with a military pedigree, the troupe's early performance repertoire consisted of marching in a revolutionary spirit in addition to numbers based on folk songs. The instruments were mostly Western and included brass, accordion, and strings. The troupe performed musical plays, dances, choral pieces, and songs including folk songs, art songs, and contemporary popular and propaganda songs, as well as orchestral works. As already mentioned, the troupe's traditional Korean music before 1950 was mostly confined to instrumental or vocal arrangements of folk song melodies presented in the style of Western music (H. Lee 2005, 69–71).

Beginning in the early 1950s, the troupe made an effort to develop Chaoxianzu music to represent the Chaoxianzu community's Korean cultural heritage by adopting and reworking traditional Korean instruments (see chapter 3). In 1958 it created a separate orchestra of traditional Korean instruments and had this orchestra perform on its own or together with Western instruments. In 1964, several years before the start of the Cultural Revolution, the Yanbian Song and Dance Troupe even replaced all Western instrumental parts with parts for traditional Korean instruments or Chaoxianzu-modified versions of those instruments (K. Sin 2012, 306). With the advent of the Cultural Revolution, the Yanbian Song and Dance Troupe was again transformed to employ predominantly Western classical instruments, and that has been the troupe's format ever since (Chaoxianzu Music Organization 2005).[3]

An Kungmin (1931–2014)

An Kungmin, renowned as a representative Chaoxianzu composer, has served as a musician, director, and composer for the Yanbian Song and Dance Troupe since 1951. He grew up in farming villages in Heilongjiang Province in Northeast China (Ch'a 2004, 49). Self-taught on the accordion, viola, and organ, An came to Yanbian to join the Yanbian Song and Dance Troupe, where he was able to mature musically. Except for a one-year leave to study conducting in Beijing, he has spent more than half a century in Yanbian. His musical activities,

however, have not been confined to the Chaoxianzu community or to the Yanbian Song and Dance Troupe. He has conducted various orchestras in Beijing, Changchun, and Shanghai playing a wide range of music from symphonic works of European and Chinese composers, opera, and dance drama to film and television soundtracks. As a leading Chaoxianzu musician, An has received numerous awards from state, provincial, and prefectural governments. He has written art songs, popular songs, symphonic pieces, solo instrumental music, small ensemble music, and dance music (Ch'a 2004, 50). Some of his acclaimed works include the opera *Arirang* (1989), the *kayagŭm* suite *Simch'ŏng* (1983), and the symphony *Naŭi saldŏn kohyang ŭn* [My Hometown Where I Lived] (1998).

Overall, An Kungmin's compositions have featured Western instruments more than traditional Korean instruments or Chaoxianzu-modified versions of these. *Arirang* was one of the great compositions frequently performed by the Yanbian Song and Dance Troupe, for which An Kungmin collaborated with three other renowned Chaoxianzu composers: Ch'oe Ch'anggyu (b. 1935), Ch'oe Sammyŏng (b. 1932), and Hŏ Wŏnsik (1935–2001). All four were members of the Yanbian Song and Dance Troupe's creative team and had backgrounds in Western music. *Arirang* was composed in a fashion similar to a Western opera in terms of orchestration and musical form: it included arias, duets, and chorus, and the songs were lyrical but also included sections of recitative. *Arirang* is a tragic love story between the male and female protagonists, Rirang and Ayŏng. Similar to many other such stories, Rirang and Ayŏng's love is opposed by Ayŏng's stubborn father, who pushes her to marry a high official instead. The libretto is set in feudal Korea where Confucianism and class difference become the main obstacles for the young lovers. While the opera's story and music closely follow the conventions of Western opera, its title is the name of a famous Korean folk song, "Arirang." This song's melody, arranged in a manner closely resembling European music, is used to introduce the opera as a means of evoking traditional Korea and Korean culture. Apart from the title, the language of the libretto, and the minor incorporation of Korean traditional rhythms, *Arirang* differs little from a European opera. Through the 1980s the Yanbian Song and Dance Troupe performed predominantly with Western orchestral instruments, and An's as well as other resident composers' works of the troupe were mostly orchestrated for the Western symphonic orchestra. Although much of An's compositional language conforms to that of Western classical music, he incorporates vivid musical signs that communicate Korean identity. As discussed in chapter 3, An showed leadership and interest in the cultivation of Chaoxianzu instruments as early as 1951. He first introduced the *kayagŭm* in Yanbian and promoted it as an iconic Chaoxianzu instrument in China. Using his experience and knowledge of the *kayagŭm,* he later composed

Simch'ŏng, a solo suite for *kayagŭm* with Western orchestral accompaniment, in 1983. The suite was inspired by *Simch'ŏngga* [Song of Simch'ŏng], which recounts a well-known Korean folktale about a girl called Simch'ŏng and is one of the five core pieces of the *p'ansori* repertoire. An's *Simch'ŏng* consists of four movements, each named for an element of the story of Simch'ŏng. The first movement, "Tohwadong," is named after the village where Simch'ŏng and her blind father live; the second, "Indangsu," is named after the sea where Simch'ŏng sacrifices her life to recover her father's vision; the third, "Maenginyŏn," depicts the palace banquet for blind people hosted by Queen Simch'ŏng, after the ocean god took mercy on her and resurrected her; and the last, "Punyŏsangbong," describes the scene where Simch'ŏng is reunited with her father.[4] For the underlying rhythms of the first, second, and last movements, An incorporates the Korean rhythmic cycles *chungmori, chajinmori,* and *chungjungmori,* respectively. In the third piece, he simply indicates the tempo as "slow" and does not ground it in a Korean rhythm. *Simch'ŏng* was not only written for the Korean *kayagŭm* as the featured solo instrument, it also incorporated traditional Korean rhythms and the well-known story from a famous *p'ansori* episode. An clearly ethnicized the music by incorporating explicit markers of Korean identity into it.

Despite An's engagement with the *kayagŭm,* the composer states that before the 1970s, he did not much consider combining Chaoxianzu instruments with a Western orchestra in his music. In the early 1970s he attended a North Korean performance in Yanbian of an orchestra that employed both Korean and Western instruments. Inspired, he composed "P'ungnyŏn tŭn kippŭm" [Joy of a Full Harvest Year] in 1973 for solo *changswaenap* and Western orchestra.[5] The *changswaenap* is a longer version of the traditional *swaenap* (also called *nallari* or *t'aep'yŏngso*). Like other Korean wind instruments adapted in China and North Korea, the *swaenap* was redesigned: it was given metal keys for easier modulation and lengthened for a wider range of pitches. Noting that the *swaenap* is an important melodic instrument in *nongak,* An, in order to compose this piece, studied *nongak* from a book published in North Korea, selecting *swaenap* melodies to use as thematic motifs. He originally incorporated the Korean folk song "P'ungnyŏn'ga" [Song of a Full Harvest Year], but he later took it out again because it would sound too ethnic in the political climate of the early 1970s. Instead, he used a pentatonic scale and Korean rhythms to express Chaoxianzu identity. Even though the incorporation of ethnic musical idioms was highly restricted during the Cultural Revolution, he asserted that his use of Korean rhythms and instrument did not demarcate Chaoxianzu identity any less than did his other pieces, like *Simch'ŏng,* created in the 1980s as part of the resurgence of interest in minority nationality cultures in China. If so, some of An's compositions, such as "P'ungnyŏn tŭn kippŭm," was a result not only of

the composer doing his job as the director of the performance troupe representing Yanbian but also of how a musician can interject his own subjectivity into his music as a creative agent: even during the Cultural Revolution, when the expression of Chinese minority identity was largely discouraged, An composed music that featured Korean music elements, which he rarely did before. Another work that An Kungmin wrote for a Chaoxianzu instrument was "Kŭnenori" [Play on the Swing] in 1981. This piece was written for the middle-range *chŏttae* accompanied by a small Western ensemble including violin, cello, viola, and electronic instruments. An also composed numerous art and popular songs as well as pieces for Western orchestra. In the case of his Western orchestral works, he adapts well-known tunes from Korean songs such as "Naŭi saldŏn kohyang ŭn" [My Hometown Where I Lived] as the main thematic motifs.[6] For his voice compositions, he uses texts that include words or place-names familiar to Chaoxianzu. For example, some of his lyrics depict Yanbian or Yanji, or landmarks such as Changbai Mountain or the Tumen River. Whether or not An's primary inclination in terms of his compositional idioms was toward Western conventions, as the leading musician of the Chaoxianzu community, he introduced a range of music that features Korean, or more specifically Chaoxianzu, identity by incorporating Korean folktales, folk melodies and rhythms, and using traditional Korean instruments.

When I interviewed An in 2005, he stated that he intentionally selects themes and musical idioms that can express Chaoxianzu ethnicity, although he does not always feel that he needs to create music that is explicitly Korean. His compositions may automatically be interpreted as ethnically demarcated even when he did not intend them that way. An states: "Sometimes I create my music to explicitly convey Chaoxianzu identity, but at other times my music is perceived as the sound of Chaoxianzu whether I deliberately aim to express this identity or not." This illustrates that music as an expressive art and vehicle for communication can be consciously constructed to convey particular meanings, yet at the same time can be interpreted in multiple ways by the audiences/sign perceivers whose understandings are based on their own comprehension of the world. The performativity of An's music itself shows that various possibilities of meanings sprout up in the process of musical communication beyond the original intention of the composer.

Pak Sesŏng (b. 1956)

Pak Sesŏng, the director of the Yanbian Song and Dance Troupe in 2005, is considered as part of a younger generation of composers than An Kungmin. Pak Sesŏng majored in violin at Yanbian Arts School and then studied composition at Shenyang Music Conservatory. Like many earlier composers in the

Yanbian Song and Dance Troupe, he started with the troupe as a violin player. As an instrumentalist, he composed *Nagaja, Nagaja* [Go Forward, Go Forward], a symphonic work, in collaboration with An Kungmin in 1982. After studying and teaching composition at Shenyang Music Conservatory, he returned to Yanbian and rejoined the Yanbian Song and Dance Troupe as its assistant director. He has served as director of the troupe since 1999.[7] As a musician whose profession was established after the end of the Cultural Revolution, his musical expressions of Korean identity in some ways contrast those found with An Kungmin and this generation.

Pak Sesŏng was forthright about having been influenced by European composers of the romantic era, such as Beethoven and Tchaikovsky, in his compositions. As well, Pak was indebted to Béla Bartók for his understanding and employment of harmonic dissonances such as the diminished fifth or augmented fourth as well as the mixed use of major and minor triads. However, in employing such European music idioms, Pak ascribes them with new meanings: "The diminished fifth and augmented fourth are my favorite intervals. At the beginning of my violin concerto, I introduce a diminished fifth followed by an augmented fourth. With the first theme that follows, I depict our [Chaoxianzu] ancestors' lament to society, 'What a difficult world it is!'"

Pak explains that he intended to express "*han*" at the beginning of his violin concerto *Changbaek hon* [Changbai Soul]. *Han* is often translated in English as grudgingness, resentment, bitterness, or anger. Generally viewed as a mixture of sorrow and regret, it has been internalized by modern Koreans as part of the national ethos. While it is hard to trace exactly when Koreans started to project themselves as a people with *han* and whether the concept was an ancient or relatively recent addition to Korean culture, it was in the twentieth century that *han*—originally a description of the psychological state resulting from individual experience of suffering—began to be invoked as a psychological attribute of Koreans and as portraying them collectively as a suffering or oppressed people (Willoughby 2000, 18–19; Sasse 1991). Such views may have stemmed from various historical incidents. Of these, the one that has been most directly expressed in discourse has been the loss of sovereignty following Japan's colonization of Korea. However, neither historical suffering nor oppression are experiences exclusive to Koreans; when looking at it at the global level, various nations have suffered from imperial domination or internal class struggle (Sasse 1991). According to Werner Sasse, *han* as a Korean term was not frequently used until the middle of the twentieth century. He speculates that its popular usage today is perhaps specific to South Korea but not so much to North Korea. Especially, the concept of *han* snowballed in the latter half of the twentieth century as South Korean elites and nationalists strove to find *real Korean culture*. While Sasse convincingly delineates how *han* might have

gained currency as a collective ethos of Korea from a term used to describe individual psychological states, more particularly those of women who suffered under the Confucian social system, he acknowledged that there is no way to trace when it first emerged in the Korean language.

While it is certainly doubtful as to when and how frequently and widely *han* became part of Chaoxianzu narratives, Pak Sesŏng states that he views his ancestors as people who suffered hard times both before and after their migration to China, that is, in both their native and displaced environments. Knowing that the majority of Chaoxianzu had a peasant background and that they left their native home for the chance at a better life, Pak's characterization of the Chaoxianzu ethos as *han* is never absurd. That *han* can be projected into Chaoxianzu society and its ethos is all the more conceivable considering the degrees of political turbulence through which the Chaoxianzu community has lived with the CCP's various amendments of its minority nationality policies. In the violin concerto, Pak musically expresses an essentialized view of Chaoxianzu as people of *han* by employing dissonant harmonies as the violin enters—even as he acknowledges relying on Western idioms instead of traditional Korean ones in composing the concerto overall.

Along with his use of dissonance to evoke Chaoxianzu, in *Changbaek hon* Pak assigns an ethnically significant descriptive title to his music. Changbaek (Ch. Changbai) is the Korean pronunciation of the Chinese name of a mountain on the border between China and North Korea. The Korean name for this mountain is Paektu, whose western half is part of Yanbian while the eastern half is in North Korea. Koreans consider this mountain as a mystical and holy place, and historically, border disputes between China and Korea have centered on claims to it. Pak emphasizes that Korean as well as Chaoxianzu identity is strongly evoked in the work because of its title—its program—and it is not necessary to paint a more explicit picture by means of clearer sonic markers such as Korean folk melodies or rhythms. In this way he crafts his music to convey Chaoxianzu ethnicity highly effectively.

Figure 5.1 is an excerpt from *Changbaek hon*. Pak's evocation of Chaoxianzu *han* can be clearly discerned in his heavy use of dissonances and chromaticism with the entrance of the solo violin.

While with *Changbaek hon* Pak might have been influenced by the program music of nineteenth-century Western classical composers, embedding programs or adding descriptive titles to music is also a centuries-old practice in Chinese music. As Frederick Lau (1995/1996) states, "As the notion of absolute music rarely exists in Chinese music, titles and programs have become crucial hints for most Chinese audiences to understand the meaning of the music or, simply, what the music is about" (139). In his discussion of solo *dizi* music in post-1949 PRC, Lau argues that one of the means used by *dizi*

composers to satisfy official directives to present only traditional and ideologically correct music is to add programs or descriptive titles: "*Dizi* composers can simply attach a title to any composition in order to establish the meaning for the music, as long as it is in tune with the political climate of the time" (139). Whether influenced by nineteenth-century Western compositions

Figure 5.1 Pak Sesŏng's *Changbaek hon*, composed in 1987 (author's transcription based on Pak Sesŏng's original manuscript)

Figure 5.1 (*continued*)

or ancient Chinese music practices, Pak makes use of descriptive titles to express Chaoxianzu identity.

Changbai Mountain appears in the title of at least two of Pak's compositions: his violin concerto, *Changbaek hon,* and his 1992 symphonic work, *Sin'gihan changbaeksan* [Mystical Changbai Mountain]. While the mountain is politically

significant in that it is claimed by both China and Korea and is a source of dispute, it is overlaid with an additional layer of significance in the case of Chaoxianzu since it is not only Korea's holy mountain but also a symbol of Yanbian. Another way of reading Pak's poetic titles is that references to the mountain convey meaning to not only Chaoxianzu but also non-Chaoxianzu nationalities residing in Yanbian. Considering that the Yanbian Song and Dance Troupe aims to represent all of Yanbian's Chinese nationalities, not just Chaoxianzu, Changbai Mountain is an astute choice of local landmark to represent both regional Yanbian and ethnic Korean identity. In addition to this reference to the mountain in the title of his violin concerto, Pak strives to portray the harsh lives that Koreans led before and after migrating to China as well as their post-migration experience of becoming Chaoxianzu. While Pak essentializes Chaoxianzu according to his image of the collective experience of the hard life of diasporic Koreans, leaving out a distinctive sonic marker of Korean identity opens up a wider range of interpretations of the music by Korean and non-Korean audiences alike.

My examination of An Kungmin and Pak Sesŏng, as composers from the Yanbian Song and Dance Troupe, reveals that Chaoxianzu ethnicity is not musically imagined and expressed in a uniform manner. Chaoxianzu composers musically evoke Chaoxianzu through the use of signs that mark ethnicity in various ways. Some use traditional folk music materials to express ethnicity explicitly; others take a more subtle approach by attaching nonmusical, yet ethnically evocative, stories or images to their composition. However, in both cases musicians rely on the effects of an indexical sign that invites the sign perceivers, which is the audience in this musical communication, to the imaginary of collective nationhood or ethnicity. Korean folk song melodies signify Korean ethnicity by evoking individual experiences of widely circulated sounds known to the nation or diasporic community members, whereas new compositions convey their national or ethnic connection with the aid of nonmusical signs that speak to the sign perceivers by evoking emotion, story lines, or landmarks that are considered to be collectively shared. Also, while both composers make clear that they intend to express Chaoxianzu identity through their music, An Kungmin sticks more closely to Western tonal conventions than Pak Sesŏng does with his harmonic dissonances. The ways in which the Yanbian Song and Dance Troupe has created and performed Chaoxianzu music exemplifies how ethnic identities may be essentialized through discursive sonic and cultural representations according to individual or group ideas about their ethnicity and how it can be expressed (Lau 2001; Turino 2008). Also, in the case of this troupe, how each musician or group of musicians expresses ethnic identity has a political dimension since the troupe is sponsored and controlled by the state and by the local autonomous government, whose directives individual musicians are compelled to comply with in creative ways.

The Yanji Chaoxianzu Arts Troupe

The Yanji Chaoxianzu Arts Troupe (Yŏn'gil-si chosŏnjok yesultan) was established in 1981 from the merger of the Yanji City Culture and Arts Work Team (Yŏngil-si mun'gongdan) and the Yanbian Chaoxianzu Narrative Arts Company (Yŏnbyŏn chosŏnjok chach'iju kuyŏndan). The organization comprises a creative team, orchestra, choir, dance team, and stage design crew, as well as administrative offices. The Yanji Chaoxianzu Arts Troupe specializes in traditional Korean performing arts, strengthening their role in the lives of contemporary people by researching, transmitting, performing, and developing Chaoxianzu performing arts (Chaoxianzu Music Organization, 2005).

While within the Yanbian Song and Dance Troupe the boundaries between Western and Chaoxianzu music were not rigidly drawn—its early members, in fact, had multiple performance duties, alternating between Western and Chaoxianzu instruments—the Yanji Chaoxianzu Arts Troupe emphasizes its distinctiveness as a troupe that values Korean tradition through the presentation and development of Chaoxianzu music.[8] This organizational ideology reflects the social and cultural milieu in post–Cultural Revolution China, this troupe having been established in a climate of resurging interest in minority nationality identities in China and efforts to recuperate them.

With the establishment of the Yanji Chaoxianzu Arts Troupe, a number of Yanbian Song and Dance Troupe musicians transferred to the new troupe to dedicate themselves to traditional Korean and Chaoxianzu instruments.[9] Its orchestra consisted of *tanso, chŏttae, p'iri, swaenap, kayagŭm, haegŭm, changgo,* and *puk*, as well as *ongryugŭm* (North Korean trapezoid harp-zither with thirty-three to thirty-seven strings).[10] Some instruments, such as *chŏttae, p'iri,* and *haegŭm,* were represented in three different sizes for high, middle, and low pitch ranges. Some Western instruments were also present, such as double bass, guitar, harp, and electronic synthesizer (Chaoxianzu Music Organization 2005, 312). The inclusion of non-Korean instruments reinforces the fact that the troupe was also influenced by Western musical elements, particularly homophonic texture. Similar in format to the modern Chinese orchestra (Han and Gray 1979; Lau 2007), the ensemble played arranged parts and was led by a conductor. The sound of this ensemble hardly conforms to the old aesthetics of traditional Korean music, whose texture is characterized by heterophony with each instrument following a distinctive linear progression. Rather, the Yanji Chaoxianzu Arts Troupe demonstrated innovation in terms of musical instruments, format, and texture, despite the troupe's claim that it is about the promotion of traditional music.

Contrary to the Yanbian Song and Dance Troupe, the Yanji Chaoxianzu Arts Troupe incorporated vivid, well-known markers of Korean identity by

relying on a traditional repertoire or traditional melodies, though reworking them in a rather modern and contemporary way. Its creative team mostly rearranged Korean folk songs to be performed by various vocal and instrumental ensembles. For example, excerpts of Korean *p'ansori*—which is traditionally performed by one singer and one *puk* accompanist—were performed by a number of women singing and dancing. *Tradition* in the context of the Yanji Chaoxianzu Arts Troupe clearly is expressed in the form of Chaoxianzu's own contemporary interpretations and practices.

An Kyerin (b. 1939)

An Kyerin is one of the founding members of the Yanji Chaoxianzu Arts Troupe. After majoring in composition at the Jilin Conservatory of Music, he served in the Yanbian Song and Dance Troupe as an instrumentalist, and in the Yanbian Mass Arts Center (Yŏnbyŏn kunjung yesulgwan) as a music editor and reporter. In 1979 he and his colleagues founded the Yanbian Chaoxianzu Narrative Arts Company, for which he was conductor and composer. Later, when the Narrative Arts Company was merged into the Yanji Chaoxianzu Arts Troupe, An remained as a composer and director until his retirement in 1999. Beginning during the Cultural Revolution, four Chaoxianzu musicians—Kim Namho, Ch'oe Subong, Hŏ Posŏn, and Kim P'ilchun—together invented a new Chaoxianzu narrative genre, *Yŏnbyŏn ch'angdam* (Yanbian sung narratives), modeled after a Chinese narrative art form, *shuochang* (or *jiang chang*), and combining it with the dramatic plot of the "model" revolutionary operas and traditional Korean musical dramas. An Kyerin was also one of the early musical contributors to the invention and enactment of the *Yŏnbyŏn ch'angdam* and other narrative art forms. According to An, Chaoxianzu performing arts are too simple as just forms of song and dance. Even if Koreans had *p'ansori* as a representative traditional drama, An felt that not only is mastering *p'ansori* not easy, it was also ethnically too distinctive for performance during the Cultural Revolution. To be able to perform a Chaoxianzu sung narrative drama during the Cultural Revolution was a primary motivation for him and his colleagues to create *Yŏnbyŏn ch'angdam*. Thus, toward the end of the Cultural Revolution, he and his colleagues visited various regions of China, such as Tianjin, Beijing, and Shanghai, to observe regional operas and their narrative art forms. From this field trip he realized that every traditional opera in China was imbued with regionalism. Therefore, a new Chaoxianzu art could only be established if it reflected a regional [Yanbian Korean] identity.[11]

Haekyung Um (2013) notes that for very early *ch'angdam* works, for example, excerpts from the revolutionary Chinese operas such as *Dujuanshan* [Tugyŏnsan; Cuckoo Mountain] and *Zhiqu weihushan* [Chich'wi wihosan;

Taking Tiger Mountain by Strategy] were rearranged and sung in Korean. These pieces were premiered in Yanbian in 1974 and 1975, respectively (Um 2013, 173; N. Kim 2010, 387–389). Later *Yŏnbyŏn ch'angdam* gradually branched out to include such themes and topics as "recent historical events, heroic figures, domestic affairs, love stories, social critique and satire, all of which remained faithful to socialist realism and proletarian romanticism" (Um 2013, 174).

An Kyerin was the music director for the *ch'angdam* "Paekkyeyŏn esŏŭi hoesa" [Contemplation from Hundred Chicken Feast], a reworking of an excerpt from *Zhiqu weihushan*.[12] An also created music for other *ch'angdams* such as "Kisŭp" [Sudden Attack] and "Sinch'ulgwimol" [Swift Appearance and Disappearance] (N. Kim 2010, 389), and the invention of *Yŏnbyŏn ch'angdam* indeed led to the birth of additional forms of narrative arts such as *pukt'aryŏng* (drum songs), *p'yŏnggo yŏkkŭm* (hand drum narrative medley), and *norae yŏkkŭm* (song medley). All of these works are vocal narratives. Their stories are relayed with recurring folk songs, especially at the beginning and the end of each narration. While *Yŏnbyŏn ch'angdam* is the largest-scale narrative art form, its music was composed in similar fashion to smaller-scale sung narratives that drew on well-known Korean folk songs. The *ch'angdam* was built upon mostly one folk song, "Sutchap'uri" [Solving Numbers], each song in the *Yŏnbyŏn ch'angdam* a variation of "Sutchap'uri" as a melodic model and accompanied by both traditional Korean as well as Western electronic instruments.

In terms of the musical component of *Yŏnbyŏn ch'angdam,* An Kyerin expressed his view that Chaoxianzu narrative work should be based on Korean folk song melodies widely known to the Chaoxianzu community, and that each scene and verse should begin and end with the same melody or variations thereof, as is the case in Chinese narrative arts. In introducing and establishing new narrative arts that were grounded in both Korean folk song and Chinese traditional narrative arts, An and his colleagues wanted to enrich Chaoxianzu performance culture, which in their view lacks an easily accessible theatrical form that Chaoxianzu masses could enjoy. An states that he wants his musical creation to be specific to Chaoxianzu as well as to the region in which they live, just as its Chinese counterpart does.

Hwang Ch'angju (b. 1949)

Hwang Ch'angju takes a different approach to the expression of Chaoxianzu identity in his work. In 2005 Hwang, then director of the Yanji Chaoxianzu Arts Troupe, emphasized to me his preference for traditional Korean rhythms and melodies and Chaoxianzu instruments in his music. Hwang's way of manifesting Chaoxianzu identity reflects his musical background: his experience as a *kayagŭm* player and as a Chaoxianzu musician in Yanbian. Hwang studied,

and then taught, *kayagŭm* at Yanbian Arts School until he left for Shenyang Music Conservatory to study composition. After graduating, he returned to Yanji and became director of the Yanji Chaoxianzu Arts Troupe (Kim and Kim 1998, 441).

As mentioned earlier, the Chaoxianzu musicians I met in Yanji in the years between 2003 and 2005 demonstrated quite a range of different interpretations and modes of expressing Chaoxianzu identity. In their music, each one's imaginings of the *self,* their diasporic community, and their ethnicity were encapsulated and embodied through the sonic, emotional, visual, and literary elements that constitute music making. Obviously, *strategic essentialism* (1993)—mentioned in the discussion of Turino's (2008) musical semiosis in an earlier section of this chapter—is observed as a major tactic of Chaoxianzu composers. In the case of Hwang Ch'angju, Chaoxianzu music is imagined as associated with racial Koreanness, which is pointed to as essential to the enactment of Chaoxianzu identity.

He referred to an occasion when he had to hire a non-Chaoxianzu percussionist to play the *salp'uri* rhythm,[13] and that person was unable to master or evoke its unique flavors. Non-Korean musicians are most likely lacking exposure to Korean music, and that is why their comprehension of Korean rhythm was not as satisfactory as that of some ethnic Koreans whose musical training and/or cultural upbringing were centered on Korean music cultures. Hwang stated that when he conducted the Shenyang Symphony playing one of his own compositions, he had to simplify the Korean rhythms because the majority of non-Korean musicians were not able to convey the particular rhythmic effect he intended. While the composer pointed out that Korean music is characterized by its *changdan* and *nonghyŏn*, as well as by the prevalence of the interval of the fourth and the use of the pentatonic scale that is pervasive in both Chaoxianzu and Chinese music, he also raised the point that although non-Chaoxianzu audiences might show a level of interest in more traditional forms of Korean music such as *sanjo,* in his view *sanjo* is too intricate and sophisticated to be fully appreciated by general audiences in Yanbian.[14] Therefore, in his compositions Hwang adapts *sanjo* by arranging it to be simpler and more exciting to render it easier for his listeners to access and appreciate it. Such statements of Hwang's illustrate that he is defining and shaping Chaoxianzu music according to his own imagining and vision of what Chaoxianzu music is and should be, while also considering the wide range of audiences for his music in China, which include both Chaoxianzu and non-Chaoxianzu. Ironically, despite Hwang's emphasis on and valuing of the aesthetics of traditional Korean music and the use of Chaoxianzu or Korean instruments, both his compositions and his compositional methods reveal a solid mix of Korean and Western musical elements as the composer not only acknowledges incorporating Western

functional harmony into his compositions but normalizes this practice in Chaoxianzu music:

> The fundamentals of harmony are based in Western harmony. Some Chaoxianzu musicians argue for the need to create chords and apply harmony in a specifically Chaoxianzu way. But I think that this kind of innovation would still end up being a derivation of Western harmony. Moreover, an absolute theory for Chaoxianzu harmony does not exist. That's why I think it's fine for me to use Western music theory and harmonic principles as a basis for my compositions.

Figure 5.2 is an excerpt from Hwang Ch'angju's 2004 composition *Nalchomboso* [Please Look at Me]. In this work, Hwang's main melodic theme was borrowed from a well-known Korean folk song, "Miryang arirang" (see figure 5.3).

After a short introduction, the first section begins with the melody of "Miryang arirang," whose opening lyric, "Nalchomboso," Hwang used as the title of the composition. The overall form is a rondo: ABA'CdA.[15] In each section, the main melody deviates in various ways. Sections B, C, and d contrast with section A, where the main theme stands out clearly.

As can be seen in figure 5.2, the work is based on the tonal theory of common practice. He frequently uses common harmonic progressions such as V–I or I–IV–V–I. The composer views the augmented fourth as one of the distinguishing characteristics of Korean music, and in this example he adds it to a basic triad, as in E♭ G B♭ + (A). For the orchestration, Hwang utilizes Chaoxianzu instruments, which feature Western equal temperament and twelve-tone capacity, allowing for modulation, plus the North Korean *ongryugŭm,* Western electronic synthesizer, and traditional Korean percussion instruments. Inspired by the popularity of *samullori* (also spelled as *samul nori*) in South Korea,[16] Hwang has favored percussive sounds in his music since the early 1990s. While the majority of the instruments are Chaoxianzu inventions, Hwang obviously makes use of non-Chaoxianzu ones, including the *ongryugŭm.*

Table 5.1 shows the instrumentation used for *Nalchomboso.* It is adapted to Western three- and four-part harmony. For example, the four different sizes of the Chaoxianzu *haegŭm* parallel the set of bowed lutes found in the Western orchestra—violin 1/violin 2, viola, cello, and bass. However, although Hwang's instrumentation looks similar to the conventional Western orchestral one, the composer argues that Western instruments cannot deliver the same "flavor" as the Chaoxianzu/Korean instruments, and without this flavor the essence of Chaoxianzu music cannot be captured.

Figure 5.2 Hwang Ch'angju's *Nalchomboso*, composed in 2004 (author's transcription based on Hwang Ch'angju's original manuscript)

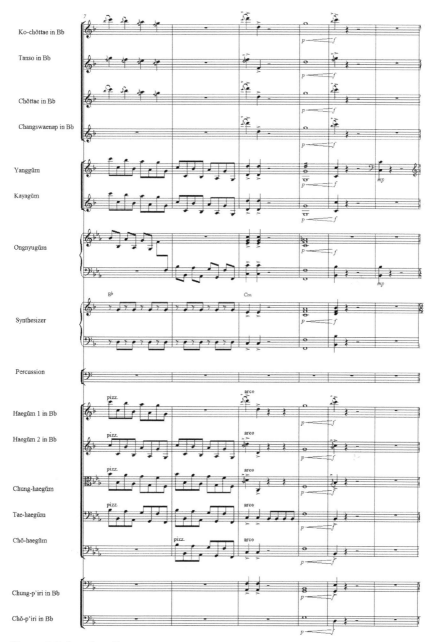

Figure 5.2 *(continued)*

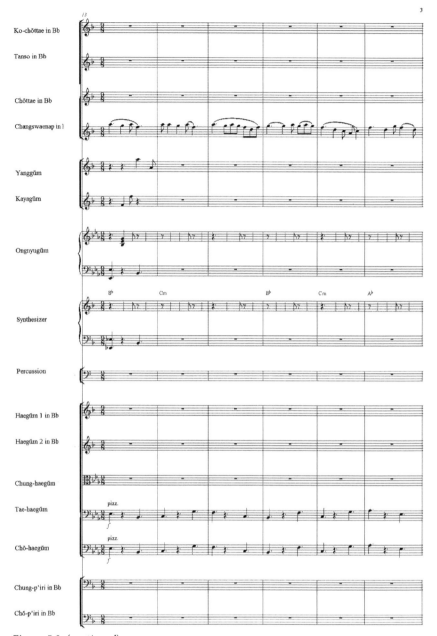

Figure 5.2 (*continued*)

Figure 5.3 Korean folk song "Milyang Arirang"

It seems that Hwang imagines the essence of Chaoxianzu music as lying in the use of Chaoxianzu or Korean instruments and of specific cultural and traditional rhythmic characteristics. Although a contradiction exists between his essentializing discourse and the music he actually composes, which in fact combines Western musical elements with Chaoxianzu and North and South Korean ones and is firmly based in Western functional harmony, considering the fact that musical "synthesis" has been profound in Chaoxianzu music from the beginning of its construction in the 1950s, the use of Western functional harmony and other foreign compositional mediums might not be viewed as completely foreign or non-Korean in Hwang's construction of a Chaoxianzu sound.

While government-sponsored performing arts organizations continue to be a primary context in which Chaoxianzu music has been constructed, ethnicity is expressed in multiple ways in the music they perform according to the approaches of the various composers. In the case of the Yanbian Song and Dance Troupe's composers An Kungmin and Pak Sesŏng, Western instruments are emphasized, with Korean instruments used only to create specific ethnically marked sound effects within the ensemble or as solo instruments over a Western orchestra. Not infrequently, this troupe's repertoire incorporates well-known folk song melodies and traditional Korean rhythms as markers of ethnic identity. By evoking sentiments or iconic images that are signs of Korean identity or experience, composers strive to convey Chaoxianzu identity. However, the troupe's two composers contrast each other in terms of their harmonic language: while An Kungmin's compositions rest on rather straightforward Western tonality, Pak Sesŏng's works feature chord progressions that extend beyond those usually used in traditional tonal harmony in evoking Koreanness.

The Yanji Chaoxianzu Arts Troupe's composers, in contrast, demonstrate a more nationalistic approach to expressing ethnicity. For example, Hwang Ch'angju aims to express Chaoxianzu ethnic identity through the use of traditional Korean instruments and Chaoxianzu and North Korean adaptations of

Table 5.1 Instrumentation for *Nalchomboso*

Classification	Instrument	Register
Wind	*koŭm-chŏttae*	high
	chŏttae	medium
	tanso	high
	swaenap	high
	chung-p'iri	medium
	chŏ-p'iri	low
Zither	*yanggŭm*	
	kayagŭm	
	ongryugŭm	
Keyboard	*electronic synthesizer*	
Percussion	*The samullori ensemble: changgo, puk,*	
	kkwaenggwari, ching; triangle	
Strings	*haegŭm 1*	high
	haegŭm 2	medium
	chung-haegŭm	medium-low
	tae-haegŭm	low
	chŏ-haegŭm	very low

these. Increasing cultural exchange between Chaoxianzu and both North and South Korea has enabled the composer to access the musics of both, each emanating from distinct music cultures that have arisen to represent the different Koreas. Hwang incorporates North Korea's newly invented national instruments while also taking into consideration the popularity of South Korea's folk percussion tradition in composing his music. In contrast, senior composer An Kyerin endeavored to create Chaoxianzu narrative art inspired by regional operatic traditions of the Han Chinese. However, instead of merely inventing a new narrative art comparable to that of the Han Chinese, which was missing in his community, An's vision with the creation of *Yŏnbyŏn ch'angdam* was to construct a narrative art that encapsulates the distinctive identity of Chaoxianzu in Yanbian as most Chinese regional operas do.

All the composers discussed in this chapter have worked to conform to the state's racial discourse through which the distinctive heritages of its minority nationalities are constructed. By supplying music that includes specific signs of Korean or Chaoxianzu identity, they demarcate Chaoxianzu cultural space as minority nationality composers as well as employees of government-sponsored institutions. However, it is also clear that signs of Korean identity in music can also be constructed purely discursively, which may render them in ambiguous

and contradictory ways. Pak Sesŏng's violin concerto is a case in point: although Pak insists that he expresses the collective psyche of Chaoxianzu with his music, his use of dissonance to evoke the idea of *han* does not have an immediate semantic referentiality on which music audiences would agree. As illustrated through the range of different techniques Chaoxianzu composers use in expressing ethnicity, audience subjectivity also invites a range of very different interpretations of the sign in the minds of sign perceivers. Thus, this examination of works by several Chaoxianzu composers reveals a musical construction of ethnicity that is not homogeneous but rather the result of individualized processes of essentialization as a means of constructing both self- and collective identity.

Using ethnographic data collected in Yanbian, this chapter has illustrated how Chaoxianzu music becomes a discursive sign and a creative space through which Chaoxianzu identity is constructed, expressed, and also essentialized. Although it is impossible to pinpoint and examine every single way that Chaoxianzu music is individually perceived and interpreted, it is possible to show that Chaoxianzu music making reflects a dialectic process between individuals and government institutions that together lead and shape the construction of Chaoxianzu music into an entity with its own distinctive style, whether it relies upon discursive signs or upon imaginings of an *essential self.*

Chaoxianzu Vocal Music

ITS DEVELOPMENT AND DISSEMINATION

Identity is not as transparent or unproblematic as we think.
Perhaps instead of thinking of identity as an already
accomplished fact, which the new cultural practices then
represent, we should think, instead, of identity as a
"production" which is never complete, always in process,
and always constituted within, not outside, representation.
—Stuart Hall, *Cultural Identity and Diaspora*

This chapter discusses Chaoxianzu vocal music—both traditional Korean and popular songs—and explores how they were developed into unique sound representations of diasporic Koreans in China. In the context of Chaoxianzu vocal music, the boundary between traditional Korean and contemporary Chaoxianzu singing is not always rigidly drawn since many singers perform a range of songs that fall into different genre categories. For example, a Chaoxianzu singer, despite specializing in a particular style of northwestern or southwestern folk song singing in Korea, is likely to maintain a very wide vocal repertoire as they often sing for multinational and multicultural audiences in China. Consequently, their vocal style has been developed to accommodate a range of different songs, deviating from the traditional ideal for Korean folk songs. Therefore, what Chaoxianzu vocal music is perhaps has less to do with the various genres with which singers are associated and more to do with a locally developed style of singing, whether for performing northwestern or southwestern Korean folk songs, traditional Korean music, or Chaoxianzu popular songs.

Also missing in Chaoxianzu vocal music is a strong sense of separation between classical art songs and popular songs, especially in terms of the performance repertoire of Chaoxianzu singers. Since both the broadcast media and

the recording industry have been largely, if not entirely, controlled by the government, Chaoxianzu popular songs (*chosŏnjok taejunggayo*) created out of commercial interest since the Age of Reform (1978–) have much in common with older propaganda songs for mass singing or minority art songs in terms of content and musical styles, even if commercial songs can be distinguished by their prevalent themes revolving around love and mundane life, which gradually superseded the songs of state propaganda. In Yanbian, any songs widely loved by Chaoxianzu are often lumped together into a single category: Chaoxianzu or Yanbian songs. In the following section, I first discuss the development of a Chaoxianzu style of singing in Korean folk songs and traditional vocal genres such as *p'ansori*; second, I look at the derivation of Chaoxianzu popular songs in Yanbian (*Yŏnbyŏn kayo* or *Yŏnbyŏn norae*) whose development has been quite different from the popular music of capitalist societies; and finally, I explore some sonic, emotional, and lyrical characteristics of contemporary Chaoxianzu songs and address the impact of *hallyu* (Korean wave) on Chaoxianzu music and community today.

The Construction and Development of Chaoxianzu Vocal Technique

Like the development of Chaoxianzu instrumental music (see chapters 3, 4, and 5) in Yanbian, the cultivation of Chaoxianzu vocal music has largely centered on the educational and professional minority nationality performing arts institutions such as the Yanbian Arts School, Yanbian Song and Dance Troupe, Yanbian Theater Troupe, and Yanji Chaoxianzu Arts Troupe. Considering that it is Yanbian Arts School graduates who became the main singers for the Yanbian Song and Dance Troupe and the Yanbian Theater Troupe, their training at Yanbian Arts School was crucial. At Yanbian Arts School, voice majors are divided into two different groups: those who major in *misŏng* (Ch. *meisheng;* bel canto singing) and those who major in *minsŏng* (Ch. *minsheng;* ethnic singing). While *misŏng* majors are trained in Western bel canto singing cultivated in European countries such as Italy, Germany, and even Russia and perform Western as well as indigenous classical art songs and excerpts from operas (O. Sin 2012), *minsŏng* majors are trained in Korean *p'ansori* and/or various regional folk song singing styles representing the northwestern (Sŏdo), central (Kyŏnggi), and southwestern (Namdo) provinces of the Korean Peninsula.

The particular traditions of Korean vocal music taught at Yanbian Arts School were the result of the resources that were musically available to the diasporic community in China. The early *minsŏng* majors at the arts school were taught by Sin Okhwa (1919–2014), Pak Chŏngryŏl (1920–1988), Kim Munja

(1908–1967), and Li Kŭmdŏk (b. 1922), all of whom were professionally trained in *kwŏnbŏn*, schools for *kisaeng* in Korea, before migrating to Yanbian (K. Sin 2016a, 320–321). There were other *minsŏng* teachers who were male, such as U Chegang (1899–1981) and Cho Chongju (1914–1993), who trained Chaoxianzu singers based in the Yanbian Song and Dance Troupe. However, U and Cho were different from the Yanbian Arts School teachers since they were never professionally trained in Korean singing but rather were farmers whose talent and performance skills in a range of Korean folk and traditional songs were recognized as a result of the effort to discover and promote bearers of nationality folklore (*min'gan yein; minjian yiren*) at the time of the founding of the PRC. While Pak, Sin, Kim, and Li all taught Chaoxianzu students at Yanbian Arts School, after a few years Li moved on to the Yanbian Song and Dance Troupe (K. Sin 2016a, 322). Obviously, in the early development of Chaoxianzu singing, female teachers were predominant, especially those associated with traditional Korean voice, due to their professional training in *kwŏnbŏn*. Regarding the gender imbalance in Chaoxianzu music, Pease (2013) explains that while both men and women enjoy singing as amusement, when it comes to professional singing, men are more engaged with Western and popular music and women with traditional singing (183).

Sin Okhwa was known for her expertise in northwestern (*sŏdo sori* or *sŏdo minyo*) as well as southwestern folk song singing (*namdo sori* or *namdo minyo*), whereas Pak specialized in the southwestern style. *Chosŏn minjok ŭmakka sajŏn* (Dictionary of Korean Musicians), published in Yanbian in 1998, refers to Pak Chŏngryŏl as "one of the inventors of the Chaoxianzu voice; she made a major contribution to the cultivation of the second generation of Chaoxianzu singers of ethnic voice" (Kim and Kim 1998, 269; my translation). As described in the dictionary, the Korean music teachers at the time of the founding of Yanbian Arts School are considered to be the first generation of Chaoxianzu musicians, the one that founded Chaoxianzu music in China. Such a statement implies that Chaoxianzu musicians distinguish *Chaoxianzu music* from the more expansive category of Korean music. It also implies that the institution of Korean minority nationality arts in Yanbian Arts School as well as the state performance troupes specializing in Chaoxianzu performance culture represents the inception of Chaoxianzu music tradition in China. While those early teachers at the arts school, trained in Korea, were the bearers of Korean traditional music and were viewed as the inventors/creators of Chaoxianzu music, those who studied Korean music under this first generation were viewed as the developers of Chaoxianzu music, making changes to what they had learned by degrees, especially in terms of vocal projection and performance practice. They did this out of a desire to create a unique Chaoxianzu sound appealing to their own audiences in China and representing their diasporic identity, while also ensuring compatibility with the musical styles of other nationalities in China.

According to Sin Kwangho, who himself is a Chaoxianzu singer and *minsŏng* teacher at Yanbian Arts School, the formation and development of Chaoxianzu voice can be divided into three different periods associated with vocal production styles applied in singing Korean folk songs, including *p'ansori.* He defines the first period from 1860 to 1979, during which Korean voice relied on *chinsŏng* (lit., natural or true voice) with a range falling in the capacity of natural sound of human beings; the second from 1980 to 1989, when Chaoxianzu singers incorporated *kasŏng* (lit., artificial or falsetto voice) into Korean folk song singing; and the last since 1990 with *chinsŏng* reemphasized and developed by Chaoxianzu singers as a distinctive Chaoxianzu style of *chinsŏng.* According to Sin, unlike the development of Chaoxianzu instrumental music in Yanbian, whereby traditional Korean instruments were modified away from the shape of their South Korean prototypes to render them friendly to a wider and more contemporary repertoire and to performance alongside non-Korean instruments (see chapters 3 and 4), the cultivation of Chaoxianzu vocal music with a unique Chaoxianzu vocal sound happened much later, since the traditional *chinsŏng* voice taught by the *kwŏnbŏn*-trained teachers mentioned above dominated Chaoxianzu singing until the end of the 1970s (K. Sin 2016a).

While Sin Kwangho credits his teacher, Chŏn Hwaja, as the initiator of the unique Chaoxianzu way of singing, *honsŏng ch'angbŏp,* the hybridization of *chinsŏng* and *kasŏng* that emerged after 1979 and characterized the second phase of the development of the Chaoxianzu voice, Chŏn Hwaja told me that she began developing *honsŏng ch'angbŏp* much earlier, when she started experimenting with the mixed-voice method as a student at Yanbian Arts School.[1]

Chŏn Hwaja (b. 1943)

Chŏn Hwaja became a Korean voice instructor at Yanbian Arts School upon her graduation in 1963. Chŏn studied with Kim Munja, Sin Okhwa, and Pak Chŏngryŏl. From Kim Munja, Chŏn learned the northwestern folk song style and *chŏngak,* including *kagok* (song cycles) and *sijo* (poem recitation). According to Chŏn, Korean voice majors at Yanbian Arts School were mostly taught in a group setting, the way folk songs were traditionally taught in Korea, from the school's establishment in 1957 until the late 1960s.

As pointed out earlier, Chŏn as well as other Chaoxianzu singers distinguish between the two different types of voices: *chinsŏng* and *kasŏng. Chinsŏng* is vocal projection by use of the natural range of the human voice, while *kasŏng* is the artificially projected voice from beyond one's own natural range, although the sound can be as rich as the natural voice through the use of various different vocal resonances. The closest equivalent to *kasŏng* in English is perhaps falsetto, since in Korean traditional vocal music, *kasŏng* refers to an extremely

Figure 6.1 Sound wave representations of three singers: one Chaoxianzu (top), one North Korean (middle), and one South Korean (bottom). Music sources drawn from *Hwang Yŏngae, Changbaek ŭi p'okp'osu ya* [Waterfall of Changbai Mountain], published by Jilin Nationality Audio-Visual Publishing Company, ISBN 7-88356-095-6, video compact disc; *Bukhan Arirang* [North Korean Arirang], published by Synnara Music NSSRCD-011, compact disc; and *Seven Great Artists Singing Kyŏnggi Folk Songs,* published by Silla Music, SUC-1766, compact disc.

high, delicate, and tender voice. However, if falsetto has been associated with male singers in Western European music, *kasŏng* in Korean music is found in both the male and female vocal arts, also referred to as *sech'ŏng* or *sokch'ŏng*.[2]

Figure 6.1 exemplifies three distinctive ways of articulating and projecting the folk song "Milyang Arirang" by the voices of Chaoxianzu, North Korean, and South Korean singers, and it intends to provide a sound wave comparison of their distinctive voices projected. The wave captures the sound texture and movement of the first two syllables, *"nal-chom,"* of the first phrase of the song "Nalchomboso" [Please Look at Me]. While the North Korean graphic (middle) exhibits a more tender and soft texture, the Chaoxianzu (top) and South Korean (bottom) voices are relatively rougher and denser. The South Korean voice imposes a stronger accent on the first syllable, *nal,* and tends to drag the progression from the first syllable to the next, whereas the Chaoxianzu singer elongates the second syllable, *chom.* The pitch progression of the Chaoxianzu singer, however, takes place as quickly as that of the North Korean singer. In terms of sound texture, the South Korean voice seems to be the roughest.

Even if Chaoxianzu singers sang Korean folk songs using only *chinsŏng* at the time of the establishment of Chaoxianzu vocal music in China (Chŏn 1999, 30; K. Sin 2016a, 319), Chŏn and her contemporaries felt the need to change the traditional Korean voice style in order to make Chaoxianzu vocal music more friendly to the ears of general audiences in China as well as of those of the Chaoxianzu community, who are not always inclined to the strong texture of *chinsŏng* (Chŏn 1999, 30). Instead of simply repeating the old traditional way of singing, Chŏn incorporated Western bel canto voice and sang Korean folk

songs alternating between both singing methods, according to the range of the song. Chŏn introduced this vocal technique as early as 1965 (31).

In her article "Minjok sŏngak kwa sori hullyŏn" [Chaoxianzu Voice and Vocal Training], Chŏn provides a fuller description of what she thinks Chaoxianzu singing should be:

> The Chaoxianzu voice should be fundamentally based on the natural/ pure voice of Korean traditional singing. Also, it has to adopt meritorious aspects of Western vocal production, such as manipulating various resonances according to registers, for example, the head voice for high-range pitches, the nose and throat voice for mid-range pitches, and the throat and chest voice for low-range pitches. By fusing these various resonant voices with the natural/pure voice of the Korean tradition, a perfect, beautiful sound is created. By using the mixed-voice method [*honsŏng ch'angbŏp*] we reduce the thickness and heaviness of the natural voice, and successfully achieve a light, silky, clear, and rich sound. . . . This kind of sound is ideal for traditional Korean songs. It can also be used in singing a wider range of songs such as contemporary and popular Chaoxianzu songs and Chinese and other minority nationality folk songs practiced in China. (Chŏn 1998, 39; my translation)

Chŏn's ideal of achieving a light, silky, and clear sound for graceful singing, however, contradicts the aesthetics of traditional Korean folk song singing. While singing styles vary from region to region, Korean folk song singing is, in general, often characterized by an unrefined, thick, and coarse or husky sound quality. In extreme cases of overuse of the natural voice, singers have broken their vocal cords by not lowering the larynx while holding pressure inside it. A well-known maxim of Korean music is that one can be a true master of singing only after repeatedly breaking and healing the vocal cords, which renders them coarser and huskier. The characteristic sound of Korean traditional singing is best observed in the folk song and *p'ansori* singing found in the southwestern part of Korea. South Korea–born and U.S.-based scholar Chan E. Park, who actively performs and teaches *p'ansori,* articulates fundamental differences with Western bel canto in projecting Korean *sori* (voice or singing)—in her case, *p'ansori* singing:

> A trained *p'ansori* voice is typically husky, resonating with *ki* (strength) and subtle expressiveness simultaneously. Bel canto (Italian, "beautiful singing") in comparison is characterized by tonal beauty, pure line, and clarity of enunciation, using abdominal respiration with a deflated diaphragm that in turn presses on the internal organs. *P'ansori* is characterized

by its own tonal aesthetics; it is said to resonate in the lower abdomen but with a different manner of respiration, resonation, projection, articulation, and aesthetic orientation. What is considered proper in bel canto is avoided in *p'ansori:* the pure line position of the larynx, diaphragmatic contraction, and abdominal pressure. Generally, the voice, departing the larynx, becomes amplified as it passes through the pharynx. In Western operatic singing, tonal depth is enhanced by the mechanical function of the larynx and the alteration of the shape of the resonator termed "covering," by the sensation of additional spaciousness in the pharynx, and by a high velum, a low tongue, and a lowered larynx. While it is undesirable in Western opera to have the vocal folds "adducted or approximated prior to phonation," *p'ansori* uses the increased pressure on the larynx resulting from not lowering it, and it is mostly the larynx that amplifies and resonates, creating pharyngeal tension that characterizes the voice as hard-pressed and husky. (Park 2003, 157)

Although Park describes the science of Korean *sori* in the specific context of *p'ansori* singing rather than region-specific practices of Korean folk song singing, *p'ansori* singing in Yanbian is also underpinned by the use of multiple resonances according to various registers that the singers have to encompass. Chŏn Hwaja and her colleague Kang Sinja (b. 1941) have respectively founded the vocal pedagogy of Korean folk song (*sŏdo sori* in particular) and *p'ansori* as teachers at Yanbian Arts School. Yet as second-generation Chaoxianzu singers their ways of teaching and performing Korean voice are quite different from what has been emphasized as an "authentic" traditional Korean vocal sound in South Korea. The changes in Korean folk song and *p'ansori* singing styles and techniques in Yanbian as presented by Chŏn and Kang conform to what Kim Namho, a Chaoxianzu music scholar, points to as the preferred sound of Chaoxianzu audiences: "The typical husky *p'ansori* voice is not appreciated by most contemporary Chinese-Korean audiences" (Um 2013, 174). Instead, the use of lighter voices with high vocal registers for Korean vocal music—like *p'ansori* and Korean folk songs—is prominent in Chaoxianzu singers in Yanbian. This change in Korean vocal production illustrates a reshaping of the aesthetics of Korean music by diasporic Koreans in China who have devised their own approach to vocal production keeping in mind what they imagine will appeal to their various audiences and their community.

Chŏn reports that musicians in China, and in the Chaoxianzu community in particular, view traditional Korean ways of using the voice as unscientific and harmful to the voice, and thus deserving of revision. Another reason why Chŏn and her colleagues deviated from traditional singing was more practical: since most professional Chaoxianzu singers have to sing a wide range of

songs—foreign, Chinese, North and South Korean, and Chaoxianzu in origin—in a variety of musical contexts in China, it is necessary for them to be equipped with an adaptable voice. Also, according to Chŏn, at about the same time as a particularly Chaoxianzu singing technique was developing, North Korea was reshaping its way of singing Korean folk songs by repressing the husky and coarse voice quality in favor of a light and clear vocal production in a high register. In the North, even *p'ansori* songs have been sung in this clearer and lighter voice since the 1960s (Sangu Han 1989, 113). Subsequently, Chaoxianzu musicians in Yanbian were influenced by the musical reformation undertaken in North Korea (Chŏn 1999, 31).

Over her forty-five years of teaching at Yanbian Arts School, Chŏn Hwaja incorporated the songs of other Chinese nationalities into her teaching. From 1978 to 1980 she studied at the Shanghai Conservatory of Music as an ethnic voice major, studying the folk songs and singing methods of the Han and other nationalities. Upon her return to Yanbian Arts School, she started including folk songs of other minority nationalities and the Han Chinese in her teaching repertoire. Chŏn stresses that she did teach a mixture of repertoire, including traditional Korean, Chinese, and contemporary and popular Chaoxianzu songs. The ability to cross over cultural boundaries is what Chŏn hoped to develop in her students; in her view, that skill is what will make Chaoxianzu singers unique.

Chŏn Hwaja's vision of Chaoxianzu singing not only points to the multiple influences that have become ingredients for the development of Chaoxianzu voice unique to the sound of diasporic Koreans in China but also highlights the flexibility of diasporic cultural agents who intend for their music to be defined "not by essence or purity, but by the recognition of a necessary heterogeneity and diversity" (Hall 1994, 235). As Stuart Hall states, *diasporic identities* are constantly "producing and reproducing themselves anew, through transformation and difference" and defined by their "hybridity" (235). Based on this view, the cultural boundary of the Korean diaspora in China seems only artificially drawn, and yet its hybridity in fact articulates both the contact and transcendence that the migrant community has experienced as a diasporic group and how those diasporic cultural agents view and imagine who they are and what their cultural identity is (Hall 1994, 237; Ang 2003).

Kang Sinja (b. 1941)

Kang Sinja represents another pole of Chaoxianzu vocal music at Yanbian Arts School. Like Chŏn Hwaja, she became a Korean voice teacher in 1961 after graduating from the arts school. During her studies she had focused on southwestern-style folk singing and *p'ansori* with Pak Chŏngryŏl and Sin Okhwa and

northwestern-style folk singing with U Ongnan (1937–2005), who was born in North Korea's North Hamgyŏng Province and whose family moved to Yanbian when she was three. After several years of teaching at the arts school, Kang left the school in the mid-1960s to serve as a professional singer and voice coach for the Jilin Nationality Cultural Work Team and Yanbian Chaoxianzu Arts Troupe. After two years of study at the Central Music Conservatory in Beijing, she returned to Yanbian Arts School in 1987 and has taught there since. While Chŏn Hwaja is known primarily for her northwestern folk songs, Kang is known for her specialization in southwestern folk songs and *p'ansori*. Kang often visited South Korea from the late 1980s to enhance her knowledge of traditional Korean *p'ansori* and southwestern singing, even if back in Yanbian she teaches *p'ansori* differently from the way it is done in South Korea (O. Sin 2012, 157–158).

As mentioned in the previous section, the *p'ansori* practiced in South Korea is sung predominantly using the *chinsŏng* voice with its natural range and its timbre, characterized, in the context of *p'ansori* singing, by a coarse, husky, and even broken quality of sound. It is performed with *puk* accompaniment, with the *puk* player occasionally adding *ch'uimsae* (cries of encouragement for the *p'ansori* singer, which can also come from the audience) in order to stimulate the singer or induce a more dramatic presentation. In the case of traditional *p'ansori,* the musical choreography between the singer and drum player relies on their musical intimacy, cultivated through the experience of performing together and understanding each other's musicality. The *p'ansori* that I observed in Yanbian with Kang's students was often accompanied by the piano together with a *puk* or *changgo*. Unlike Sin Kwangho's (2016a) description of Kang's voice as relying on the use of *chinsŏng* and contrasting with Chŏn's *honsŏng ch'angbŏp*, to my view the way *p'ansori* is taught and performed in Yanbian is quite different from the rough sound emphasized and idealized in *p'ansori* singing in the traditional music context in South Korea. Just as voice projection was emphasized in the case of Chaoxianzu folk song singing, Chaoxianzu *p'ansori* singing was rendered in a hybridized voice including *chinsŏng* and *kasŏng*, somewhat softened and less intense in comparison with that of traditional *p'ansori* as practiced by musicians in South Korea. Overall, *p'ansori* singing in Yanbian has also been reshaped in terms of timbre, melodies, and performance practices if it is compared with the sound idealized in Korea historically. The *p'ansori* songs performed by Chaoxianzu students at Yanbian Arts School work well with the harmonic accompaniment provided by the piano or by an ensemble of mixed Western and Chaoxianzu instruments.

As pointed out earlier, hybridity or a hybridized identity of a diaspora do "not only recognize differences within the subject, fracturing and complicating holistic notions of identity," but perhaps more importantly "address connections

between subjects by recognizing affiliations, cross-pollinations, echoes, and repetitions, thereby unseating difference from a position of absolute privilege" (Felski 1997, 12). While adapting traditional Korean arts to the manifestation of Chaoxianzu identity, teaching and performing Korean folk songs or *p'ansori* in the traditional way is less relevant in the context of Yanbian where the concept of preserving "tradition" is not as privileged as the state's emphasis on the construction of minority nationality music and identity. As long as Chaoxianzu music is largely grounded in or connected with Korean cultural practices, it could perhaps articulate the Chaoxianzu difference of diaspora. However, what makes the cultural *hybridity* of diasporas even more complicated is that it can be in an endless state of metamorphosis and has potential to carry numerous similar or different styles of a culture, mixing in the ingredients to different degrees.

Another Chaoxianzu singer, Kim Sunhŭi, a student of Chŏn Hwaja and then a faculty member in ethnic voice at Yanbian Arts School, states:

> The voice of Chaoxianzu singers, like that of Teacher Chŏn, can be characterized as a fusion of northwestern Korean folk song singing, Chinese folk song singing, and the North Korean way of singing. However, after several visits to South Korea since the late 1980s, Chŏn seemed to highlight traditional Korean aspects in her voice. Still, the reason why Chŏn has been described as the representative voice of Chaoxianzu ethnic music lies in the fact that her voice cannot be classified as within any single tradition.[3]

While Kim Sunhŭi characterizes her teacher's voice as "ambiguous," labeling it as a Yanbian- or Chaoxianzu-style voice (*Yŏnbyŏn ch'angbŏp; Yanbian changfa*) that is the result of the synthesis of Chŏn's training in Korean traditional, Chinese, and North Korean music, the very essence of this Yanbian style lies in its hybridity and thus stylistic ambiguity that is different from any of the three musical cultures. While a common discourse among Chaoxianzu musicians is to attribute their ethnic identity to their cultural and geopolitical particularity—being located at the intersection of China, North Korea, and South Korea—what they often misunderstand is that the characteristics of their music are not the result of this particularity but rather of Chaoxianzu musicians' own will to create a unique voice that would represent their community by fulfilling their own vision of what the Chaoxianzu voice should be. Most musicians I met in Yanbian find that the Korean traditional musical aesthetics as preserved in the South Korean sound are not only old-fashioned but also unfamiliar to the ears of Chaoxianzu as well as multinational audiences in China, and that North Korean singing sounds too artificial and therefore very unnatural.

The younger faculty at Yanbian Arts School, after studying mostly with Chŏn Hwaja and Kang Sinja, have gone on to specialize in different singing styles in their postgraduate studies in and outside of Yanbian. For example, Pak Ch'unhŭi and Sin Kwangho studied in North Korea in the 1990s and specialized in North Korea's nationally endorsed vocal style, *chuch'e ch'angbŏp* or *chuch'e sori*. Kim Sunhŭi went to South Korea to study traditional Korean folk songs, where she learned *Kyŏnggi minyo* (folk songs from central Korea). Pak Ch'unhŭi and Kim Sunhŭi both explain that their singing skills and knowledge of particular North or South Korean singing techniques were enhanced after studying in native contexts. However, both of them expressed the need for mediating what they learned in North and South Korea when they teach Chaoxianzu students. Kim Sunhŭi says that the way she learned folk songs during her stay in South Korea was a bit problematic since the teachers in South Korea who repeat the traditional methods of voice training do not consider the science of using one's voice. Similarly, Pak states that North Korean–style singing sounds too high, clear, and artificial to appeal to Chaoxianzu audiences, and therefore it needs to be modified.[4] The vocal instructors at Yanbian Arts School have unequivocally stated that they hold aesthetic standards for Chaoxianzu singing and its sound. While none of the musicians fully unpacked what the standard of Yanbian voice actually is, they each seem to hold ideas about what it should sound like. The Chaoxianzu voice is, then, a sonic construction resulting from a fusion of traditional Korean music with various other cultural influences, a process by which Chaoxianzu musicians developed their own aesthetic standard, mediating the different ingredients and incorporating them to varying degrees to reflect their vision and imagining of the sound that represents themselves and their diasporic community in China. Yanbian or Chaoxianzu music thus cannot be identified with either of the two Koreas or with China—or perhaps it can be identified with all three by way of its hybridity and stylistic ambiguity.

Chaoxianzu Mass Media and Yanbian Songs

While government-sponsored music troupes have represented Yanbian and the Chaoxianzu community by mostly presenting live music to local and national audiences, Chaoxianzu songs have been more broadly disseminated on television and the radio or in the form of cassettes, CDs, and VCDs produced by minority nationality recording companies. Even before 1949, the broadcast media was already established in Yanbian, making Korean music widely available to its diaspora in Northeast China. The radio broadcasters Yanji Xinhua Broadcasting Station and Mudanjiang Broadcasting Company were airing songs imported from Korea as well as locally produced (Chaoxianzu Music

Organization 2005, 76–80). Although a lack of detailed information on the history and music programs of these stations in pre-PRC Yanbian render it difficult to gain much insight into the early mediascape and soundscape of Chaoxianzu life in China, there is no doubt that these local radio stations were a major disseminator of both popular and political propaganda songs, especially during World War II (1939–1945) and the Chinese Civil War era (1927–1950).

Today the largest and oldest Chaoxianzu mass media establishment in Yanbian is the Yanbian Radio and Television Broadcasting Station (Yŏnbyŏn najio TV pangsongguk; hereafter YBTV), established in 1977. Of its three television channels, YBTV 1 features programming specifically aimed at the Chaoxianzu community. Broadcasting for eighteen hours a day and 40 percent in Korean, its programming includes news, music and entertainment, dramas, and documentaries. The YBTV website clearly states that the station aims to promote and perpetuate Chaoxianzu diasporic cultural identity to national and international audiences who access its programs online or via satellite outside Yanbian.[5] While special programs broadcast on holidays such as Chinese New Year and the Founding Anniversary of Yanbian feature some large-scale and elaborate ensemble music—performed by the Yanbian Song and Dance Troupe, the Yanji Chaoxianzu Arts Troupe, or YBTV's in-house orchestra—its regular music programs usually focus on Chaoxianzu songs. Chaoxianzu songs old and new are broadcast at least twice a day, every day, on the program *Maeju ilga* [Weekly Songs] or on the much longer weekly program *T'oyo mudae* [Saturday Stage] (Pease 2002, 196). Occasionally, these programs include footage taken from South Korean television programs, such as *Kayo mudae* [Song Stage] or *Yŏllin ŭmakhoe* [Open Concert], which feature a variety of traditional, classical art, and popular songs appealing to an older audience.

Just as YBTV has made Chaoxianzu music performances accessible via satellite to Chaoxianzu around China, the Jilin Nationality Audio-Visual Publishing Company (JNAPC), established in 1984, has made it available in recorded form, circulating it on cassette, CD, DVD, and VCD both within and outside of Yanbian. Of the few recording companies focusing on Chaoxianzu music, JNAPC is the largest. It releases full-length albums by Chaoxianzu artists as well as singles and compilations. Located in the same building as YBTV, JNAPC has also released some of the television music programming content in DVD and VCD format. Between 2000 and 2005, JNAPC's musical releases were most commonly in VCD or DVD format and mostly featured music videos as well as YBTV footage from its regular or special programming. As a government-sponsored media publishing company, JNAPC has also released educational films for Chaoxianzu children, promotional films on Chaoxianzu and Yanbian as the Korean autonomous prefecture, and annual recordings of the Chinese New Year Evening Performance Festival (Ŭmnyŏksŏl munyeyahoe) in Yanbian. The company has also

imported North Korean audio and video recordings and made them available for the Chaoxianzu community to purchase. With their focus on Chaoxianzu music, YBTV and JNAPC have been key supporters and promoters of Chaoxianzu artists, making their music available to audiences around China.

In Yanbian, Chaoxianzu songs are often unproblematically referred to as "Yanbian songs" (*Yŏnbyŏn norae* or *kayo; Yanbian geyao*) even if they do not make any direct reference to Yanbian or were in fact produced elsewhere. Chaoxianzu songs are quite varied in terms of musical content, function, origin, and style. They broadly encompass everything composed and sung by Chaoxianzu, from propaganda songs and revolutionary songs to folk songs, art songs, children's songs, and commercial popular songs. Even if Chaoxianzu songs are frequently featured in the local media, they might not sound so "popular" or "trendy" to audiences either in or outside of Yanbian or China, especially younger people who are accustomed to the more dynamic styles of mainstream or global pop songs. Even within Yanbian, an increasing number of Chaoxianzu youths have been inclined to listen to popular music produced in South Korea and/or China and have little interest in locally produced songs or Chaoxianzu artists (Pease 2006). Perhaps the category of "Chaoxianzu song" can only be defined loosely. Although the majority of locally produced songs are performed in Korean, some are in Chinese, and some may feature lyrics or music written by non-Chaoxianzu. The local broadcast media—mainly YBTV and JNAPC—are the main institutions in charge of their promotion, production, and dissemination, under the assumption that the main consumers of these songs are Chaoxianzu both in Yanbian and farther afield.

Popular music in Yanbian as well as in China in the 2000s must be understood differently from popular music in most capitalist societies. Popular music, in a commercial sense, emerged and flourished in China in the early twentieth century. After 1949, Chinese vocal music was dominated by government-promoted propaganda songs. Various styles of popular music filtered into China via illegal trade routes from Hong Kong, Taiwan, and the West through the 1980s (Pease 2006). A legal market for popular music was only reestablished in China with the Age of Reform (Manuel 1988, 232). Accordingly, the production of commercial music—whether for minority nationality or Han Chinese audiences—only began in the 1980s. Even then, the majority of popular music in this period had to conform to government guidelines in terms of its content and style.

Over the last thirty years, the political content that prevailed in earlier Chaoxianzu vocal music has decreased, with lyrical songs evoking regional landmarks or local scenery rising in popularity. Popular music generally oriented for mass consumption is framed through numerous distinctive subcategories such as rock, hip-hop, ballads, and R&B (Shuker 2005, 204–205). Chaoxianzu popular songs, however, at least until ca. 2005, lacked a wide range of stylistic

diversity, and they were not always commercially oriented. Most of these songs were lumped together under one umbrella category, that of Chaoxianzu (popular) songs, or *Chosŏnjok norae* or *Yŏnbyŏn kayo*. In the following section, I show how different styles of singing and distinctive singers are identified under the rubric of Chaoxianzu songs.

Chaoxianzu Songs in Folk or Traditional Style: Pak Ch'unhŭi (b. 1963)

Pak Ch'unhŭi is one of Yanbian's widely recognized singers, frequently appearing on YBTV music programs throughout the 2000s. Pak is particularly known for performing Korean folk songs. After majoring in Korean voice at Yanbian Arts School, she went to North Korea in the 1990s and studied self-reliance singing. Since her return, she has taught Korean voice at her alma mater. In 2002 Pak released a solo VCD album through JNAPC featuring songs composed by Chaoxianzu musicians, Korean folk songs, a North Korean film song, and a Chinese folk song. She is accompanied by a mixed orchestra of Chaoxianzu, Western, and electronic instruments.

Except for one song of Chinese origin, in her videos for this album she vividly marks her Chaoxianzu identity by wearing traditional Korean dress (*hanbok*), singing in Korean, and featuring frequent city views of Yanji. For example, her song "Changbaek sŏnnyŏ" [Nymphs of Changbai Mountain], a pentatonic song composed by Pang Yongch'ŏl (1940–1997), a Chaoxianzu composer, depicts the nymphs of Changbai Mountain. Like Pak Sesŏng's aforementioned violin concerto, *Changbaek hon,* this song features the mountain venerated by Koreans as a mystical holy place (see chapter 5). Another noticeable marker of ethnicity in "Changbaek sŏnnyŏ" is the *kayagŭm* accompaniment. When fused with the sounds of Western and electronic instruments, the *kayagŭm* seems to be incorporated to mark Chaoxianzu identity by both its sonic association and its role as a visual signifier of Korean cultural identity.

Popular Songs by *Kasu* Kim Sŏngsam (1971–2006)

Also frequently featured on YBTV are songs in the style of South Korean *t'ŭrot'ŭ* (trot) songs.[6] *T'ŭrot'ŭ,* a genre that is popular and widely consumed in South Korea, is reminiscent of the sound of early twentieth-century Korean popular music. It is characterized by duple meter, the pentatonic scale, and a particular style of vibrato and pitch bending. Of those songs labeled as Yanbian or Chaoxianzu songs in China, those resembling South Korean *t'ŭrot'ŭ* songs are perhaps the most commercially oriented. *Kasu* Kim Sŏngsam[7] was well known from the early 1990s as a Chaoxianzu popular singer of *t'ŭrot'ŭ* and *palladŭ* (ballad) songs.[8] Although he died in a motorcycle accident in 2006, his

songs continue to be popular among his fans in Yanbian. His two records are the best-selling Chaoxianzu albums ever released by JNAPC. Unlike earlier singers who sang Korean folk songs as well as contemporary songs of various origins, Kim rarely performed any other type of song apart from popular songs. One of his 1990s hits, "T'ahyang ŭi pom" [Spring in a Foreign Land], tells of a man's inability to return to his homeland, where his wife awaits his return:

> When spring arrives, even the swallows return home
> Although I yearn to go, I cannot
> Who would understand my heartbreak?
> Birds, flying behind the clouds, please deliver me from my sorrow
>
> [I] promised my wife I would return in the spring
> My heart aches because I can't keep my word
> Who would listen to this sad song from a foreign land?
> Climbing mountains and crossing fields
> Please bring this song to my beloved
> <div align="right">(Lyrics by Wŏn Ho; music by Wŏn Hoyŏn and Ch'oe Siryŏl)[9]</div>

The text certainly resonates with feelings of nostalgia widely felt among Chaoxianzu as a diasporic community. Kim sings the song dressed in a three-piece suit, accompanied by a mix of Western and electronic instruments, to an effect similar to that of Japanese *enka,* as Christine Yano describes it:

> To the Japanese public, enka sounds timelessly old, although it is still actively created and consumed. The erasure of passing time is in fact part of its attraction. A 1993 hit is deliberately contrived to be easily mistaken for a 1953 one, and for the duration of the song, the forty-year gap is neatly erased. What helps to achieve this timelessness are not only the sounds and the images of enka but also—and most important—its sentiment. (Yano 2002, 3)

Yano also emphasizes that *enka* engages Japanese audiences by offering an "imaginary" of communal brokenheartedness. Like *enka, kasu* Kim Sŏngsam as well as other Chaoxianzu *t'ŭrot'ŭ* singers transport Yanbian audiences to the Korea of the early twentieth century, the period when the style emerged and also when a large number of Korean ancestors migrated from Korea to China.

Lyrical Songs by Yeppŭnidŭl (Pretty Girls)

In 2002 JNAPC released the eponymous album *Yeppŭnidŭl* [Pretty Girls]. The group consists of five young female singers, all of whom are Chaoxianzu majoring in Korean voice at Yanbian Arts School. Like the majority of albums

released by JNAPC, the contents were compiled from YBTV music programs, such as *T'oyo mudae* and *Ŭmnyŏksŏl munyeyahoe*. The songs contained on the album are a mix of Korean folk songs, Chaoxianzu compositions, and arrangements of South Korean children's songs. Some are sung solo or as duets, others by the whole group.

"Toltari" [Stone Bridge], one of the songs on the 2002 album, was sung by two Yeppŭnidŭl members not so different from the average city girl in her early twenties. The song was written by a Chaoxianzu lyricist and composer. The text is lyrical and expresses nostalgia for a hometown left behind for city life. Yanbian is dominated by mountains and crisscrossed by the Tumen River and its tributaries, and the scenery featured in the video, a rural village surrounded by mountains—through which the two singers playfully stroll—is typical of many Chaoxianzu villages outside Yanji City. The imagery evoked in the song's text is relatable to many Chaoxianzu, old and young, as so many of them have a rural village background.

> There's a stone bridge leading to my mountain village
> Fresh water flows under that bridge
> There's a stone bridge at the entrance to my mountain village
> [I] caught a passing bus and found myself far from home
> Walking the street bright with neon lights,
> [I] miss that stone bridge in the mountains
> Last night, I saw it in my dreams, the stone bridge near my mother's house
> There's a stone bridge at the entrance to my mountain village
> Fresh water flows under that bridge
>
> (Lyrics by Sŏk Hwa; music by Ko Ch'angmo)

Besides the Korean folk songs on *Yeppŭnidŭl*, which give the singers the chance to showcase their training in Korean voice, the album contains smooth easy-listening tunes by Chaoxianzu composers with lyrical texts expressing nostalgia for rural Chaoxianzu village life. While *kasu* Kim Sŏngsam's song discussed above depicts diasporic nostalgia for the homeland, the nostalgia portrayed by *Yeppŭnidŭl* is rather a contemporary urban nostalgia for rurality. This type of easy-listening lyrical song is frequently featured on YBTV. Four of the sixteen songs on *Yeppŭnidŭl* depict Chaoxianzu women as pure, merry, devoted, and sincere. The members of Yeppŭnidŭl exude innocence rather than sex appeal. With its five young singers choreographed to evoke culturally idealized images of Chaoxianzu women, this album holds appeal for female audiences who might be of a similar age to or older than these women.

Constituted of visual, textual, and sonic signifiers, Chaoxianzu songs portray Chaoxianzu identity in multiple ways. While it is hard to pin down a specific range of stylistic diversity that defines Chaoxianzu songs, their lyrics

frequently feature topics such as migration, regional landmarks, family relationships and separation, farming, and hometowns—motifs that Chaoxianzu audiences can easily relate to. Pak Ch'unhŭi expresses her Chaoxianzu identity by cultivating a specific vocal style with the support of traditionally and regionally sourced visual, sonic, and lyrical signifiers; *kasu* Kim Sŏngsam's singing evokes the sentiments of Chaoxianzu audiences who, as a Korean diasporic group, share a collective memory. While Pak and Kim might appeal to older Chaoxianzu audiences, Yeppŭnidŭl seems to target a younger, gendered audience by portraying idealized images of Chaoxianzu women and evoking a peaceful, rural village life that many Chaoxianzu share as memories from childhood and miss in their city lives.

According to Lim Pongho, head producer at JNAPC in 2005, the major consumers of Chaoxianzu songs are presumed to be middle-aged and older and living far from cosmopolitan cities like Yanji.[10] This is consistent with my own interview-based conclusion that many teenage and college-age students tend to emphasize their cosmopolitan identity over a local Chaoxianzu identity in their preference for mainstream Chinese or foreign popular music. Other informants between thirty and forty years old said that they consumed both transnational and locally produced popular music. Based on my recent Internet research, Chaoxianzu songs are consumed online by people living in China or elsewhere in the world via personal or broadcasting company websites. While it is difficult to determine to what extent and by whom Chaoxianzu songs are consumed, this evidence suggests that Chaoxianzu music enjoys ongoing popularity despite it not being clear who its online consumers are. It is not rare for Chaoxianzu recordings to include North or South Korean popular songs or traditional folk songs. Although YBTV 1 occasionally broadcasts music footage produced in South Korea, Kim Hun, a recording engineer at YBTV 1, emphasized the need to remake South Korean songs using Chaoxianzu singers as he feels these songs are thus rendered more appealing to Chaoxianzu audiences.[11] Interestingly, in addition to YBTV's mission of promoting and serving the Chaoxianzu community and the Yanbian Korean Autonomous Prefecture, the station seems to perpetuate and reinforce an essentialized Chaoxianzu identity, focusing on supporting Chaoxianzu singers who sing Chaoxianzu songs. Most (though not all) of the songs broadcast are composed by Chaoxianzu musicians who are commercially driven or responding to popular singers' requests for new songs to perform.

Hallyu, the Korean Wave, and Chaoxianzu Songs

Despite the steady consumption of Chaoxianzu songs in and outside of Yanbian, especially among middle-aged to senior Chaoxianzu, the market for

Chaoxianzu songs—and thus the viability of their production—is relatively small and inevitably limited compared with that of Chinese or South Korean mainstream popular music. The penetration of *hallyu,* or the "Korean wave"— that is, the boom in popularity of South Korean cultural products—once it began, was swift, profound, and permeating in China in general and among Chaoxianzu communities in particular. Since the beginning of the 1990s, not only were the Chaoxianzu people seduced by South Korean goods and consumables, but the South Korean influence also affected the family system, citizenship, and sense of social belonging in sparking a sizable number of Chaoxianzu to move to South Korea, some permanently, and others eventually returning to Yanbian hoping to enrich their lives there by deploying the various forms of capital they had attained while away.

Predominant discourses on *hallyu* have centered on the circulation and consumption of Korean popular culture among Chinese young people, who are attracted to South Korean TV dramas, popular music, idols, fashion, beauty products, cosmetic surgeries, and even lifestyles. Koichi Iwabuchi explains the transnational consumption and global popularity of cultural commodities as due to them being "culturally odorless" (2002, 27). However, given that twenty years of *hallyu* in China has given way to *panhallyu,* or anti-Korean sentiment, stirred up by Sino-Korean political issues—even leading to the enactment of *hanhallyŏng,* the banning of Korean consumables—the status of Korean consumables and its consuming context, whether it is in China or not, has never been culturally odorless. Rather than viewing *hallyu* as exclusively about the consumption of cultural goods flown from South Korea or a sign of South Korean success in the Chinese market, I prefer to frame *hallyu* as a cross-cultural exchange, a vibrant cultural platform where both Chinese and Korean experiences, ideas, and cultural practices play a role, while shaping socially and culturally flexible agency across the two states.

The influence of *hallyu* and its ramifications specifically in terms of Chaoxianzu occurred at a more profound level, bringing changes to the social relations and structure of Chaoxianzu communities. Focusing on a case of a Chaoxianzu musician who is musically active across China and South Korea, I aim to demonstrate how *hallyu* has not been confined to the consumption of South Korean cultural products as a dominant cultural wave but rather has created a social platform allowing Chaoxianzu to proactively mobilize as cultural agents through their access to both China and South Korea in post–economic reform China.

From 1992, Chaoxianzu youth developed a strong inclination toward trendy South Korean and Han Chinese hip-hop, rap, and dance music (Pease 2006, 142–143). These young Chaoxianzu not only listened to South Korean music; they also internalized clothing styles and foods that symbolized South

Korean youth, showing little interest in local culture or in fostering it as their identity. Throughout the early 2000s, a large number of Chaoxianzu youths in Yanbian experienced family separation when many of their parents left for South Korea in search of better financial opportunities. While their inclination toward South Korean popular culture perhaps reflects how they felt about the faraway place their parents went to, this connection is also exacerbated by the relatively high financial support provided to them by their parents, which enabled them to access rather pricey technological and material culture sent to them from South Korea or locally available in Yanbian.

With *hallyu* dominating the scene and the market for local songs declining, some Chaoxianzu musicians moved to South Korea foreseeing the possibility of landing contracts with South Korean music production companies. An example is Jin Yuenu, who built her musical career in South Korea as a Chaoxianzu singer and frequently performs in Seoul, Yanbian, and major Chinese cities today. Jin studied Korean voice at Yanbian Arts School and then served as a Korean folk song singer with the Yanbian Song and Dance Troupe and the Beijing Central Nationality Song and Dance Troupe. Invited by a South Korean music production company, Jin Yuenu moved to South Korea in 2000, where she debuted as a *t'ŭrot'ŭ* singer. Since then, she has appeared on major South Korean music television programs such as *Kayo mudae* and *Yŏllin ŭmakhoe*, where she sang her biggest hit, "Pukkyŏng Agassi" [Beijing Girl], bilingually in Mandarin Chinese and Korean.

While her familiarity with Korean folk song and her popular singing style as a Chaoxianzu singer enabled her to relocate to South Korea, where a similar style is also popular, as a Chaoxianzu singer who is active in both China and South Korea, she is in demand back in Yanbian, where the local production of Chaoxianzu songs has been gradually affected by the domination of South Korean songs. Perceived as a Chaoxianzu singer who successfully made her name across China and South Korea, Jin Yuenu is warmly welcomed in Yanbian today. The cultural trajectories traced by the movement of Korean popular songs and musicians between China and Korea are manifestations of a multilateral flow of cultural influence generated by human agency as well as the advancement of modern technologies.

As Mark Russell (2008) pointed out in his book, "The trouble with talking about a 'Korean Wave' is that it does not really explain anything. Korean pop culture crosses many media, demographics, and regions, and it means very different things to different people. . . . 'Korean Wave' is a black box, a magical answer that explains everything and nothing" (213). Although Russell investigates *hallyu* as a phenomenon of Korean pop culture, his articulation of its polysemy is not so different from the penetration of South Korean influences into the lives of a range of different people including Koreans, Chaoxianzu, and

Chinese. In focusing on the case of the Chaoxianzu community, I have sought to tease out the multiple facets of *hallyu* and South Korean influence in Yanbian. It is no longer adequate to view South Korean culture in the transnational space as the unilateral flow of South Korean products passively consumed by local agents. Instead, inspired by *hallyu* and seizing opportunities to go to South Korea, Chaoxianzu have been actively participating in the shaping of *hallyu* through their own cultural background, experiences, and ambitions. Among the various discourses in the scrutinization of *hallyu,* where nationalist, cultural, and structural theories and economic and industrial perspectives intersect, I think *hallyu* can also be viewed as a shaping context for new human relations, and for cultural interaction and collaborations to take place. From this perspective, *hallyu* is no longer the mere inflow of the made-in-Korea but rather a cultural crossroads where *han* (韓) and *han* (漢) experiences can meet and intersect.

Using ethnographic data and commercial recordings collected in Yanbian, this chapter has illustrated how Chaoxianzu vocal music becomes a discursive yet creative space through which Chaoxianzu identity is constructed, expressed, and negotiated. The most prominent feature of Chaoxianzu vocal music is its flexibility and permeable boundary, with traditional Korean voice as well as popular music reshaped as the sound of diasporic Koreans in China, and Chaoxianzu songs produced in a range of vocal genres and styles that convey Koreanness in a variety of different ways. Despite the influence of *hallyu,* in a way a hegemonic cultural influence on Chaoxianzu popular songs, Chaoxianzu musicians subversively instrumentalize it to help *Yŏnbyŏn kayo* or Chaoxianzu popular songs to continue in China, and to be located in South Korea. "Cultural identity" is conceptualized in at least two distinctive ways: a collectiveness based upon the imagination of "a shared history and ancestry in common," and the difference/otherness that constitutes "what we really are" or "what we have become" (Hall 1994, 225). This chapter's discussion on Chaoxianzu vocal music shows that both concepts prevail and are played out within and beyond Yanbian in an effort to create and perpetuate cultural representations that are distinctive to diasporic Koreans in China. While the hybridity and syncretism that characterize the Chaoxianzu voice in singing traditional Korean songs delineate how Chaoxianzu singers and music educators distinguish their identity as a hybridized vocal style that is different from either of the two Koreas, the discursive signs and styles of Chaoxianzu songs, in representing a variety of different practices lumped together as "Chaoxianzu" or "Yanbian" songs, point to how fragile such an imagined community can be (Anderson 1983; Hall 1994). Furthermore, due to South Korean *hallyu,* the production and consumption of Chaoxianzu songs might seem under threat in Yanbian. The case of Jin Yuenu and the continuing national and transnational consumption of Chaoxianzu

songs show that Chaoxianzu are proactive and never passive agents who are assured of who they are and what they want to be and do. For all these outcomes, Chaoxianzu vocal music ironically has been both essentialized and dis-essentialized while exemplifying the very complexity and characteristics of *diasporic cultural identity* that is "never complete, always in process, and always constituted within, not outside, representation" (Hall 1994, 222).

Returning to a Home Never Lived In?

CHAOXIANZU MUSICIANS IN SOUTH KOREA

> Diasporic music-making can be understood in the
> ordinariness of creative production, as musicians working
> as individual agents in their everyday environments,
> making musical choices that suit them and their audiences.
> In moving beyond simple understandings of hybridity as
> musical cultures in contact that result in "new" musical
> expressions we move towards *politically articulated readings*
> of social relations and creative processes.
>
> —Tina K. Ramnarine, *Musical Performance in the Diaspora*

Since the establishment of diplomatic relations between South Korea and China in 1992, a large number of Chaoxianzu have visited South Korea, many as nonprofessional migrant workers. Their daily lives in South Korea have been a complex intersection of nationhood, citizenship, ethnicity, and class as they encounter people with whom they share ethnicity yet are culturally and socially different. Not infrequently these Chaoxianzu express that they feel unwelcome and alienated in the South due to their Chinese background and lower-class associations (Song 2019). South Koreans' prejudice toward Chaoxianzu is partly a reaction to the complex sense of belonging with which Chaoxianzu have been inculcated as citizens, nation, and diaspora: they are state subjects of the PRC, they are low-wage migrant workers in South Korea; they have been culturally interactive with North Korea, and the majority of their ancestors came from what is today North Korea, even if it was over a hundred years ago, before the peninsula was partitioned.

Despite the prejudice, along with Chaoxianzu economic migrants, a number of Chaoxianzu musicians have come to South Korea to pursue musical or nonmusical careers. It is not hard to encounter Chaoxianzu musicians

affiliated with renowned music schools in the South as resident artists, instructors, and graduate students (see introduction). Unlike the case of low-wage labor migrants, for Chaoxianzu artists a Chinese background may be a privileging factor since it can be a career-building opportunity. A number of progressive South Korean musicians have shown an interest in Chaoxianzu music, perceiving it as a potential source of inspiration for the development of traditional Korean music in the South and one that, relative to the South, had emphasized the preservation and maintenance of ancient practices until the 1990s. The welcoming of Chaoxianzu musicians into local South Korean music scenes is evidence that essentialist notions of cultural boundaries, despite being imaginary, can easily be transcended and even manipulated by people who seek to produce themselves as similar to or different from others, although musical individuals as social agents are never completely free from the wider power structure. In this case, collaborations between Chaoxianzu and South Korean musicians are infused with the nuances and inferences of a power imbalance that often places Chaoxianzu musicians in the situation of needing to reconstruct and negotiate their identity in accordance with the interests and expectations of the host society. This chapter focuses on the music and careers of several Chaoxianzu musicians who undertook return migration to South Korea.[1] I show how Chaoxianzu diasporic identity both privileges and restricts Chaoxianzu musicians' creativity and career development. While diasporic identity is a significant source of cultural capital for Chaoxianzu musicians who can promote themselves as being knowledgeable in Chinese, Korean, and Chaoxianzu music, the other side of the coin is that this very syncretism robs a cultural construction of its authenticity, automatically blurring the boundaries of musical roots and even discounting the notion of a diasporic music culture itself as a *unique construction*. From the conservative cultural standpoint of South Korea, the difference in diasporic Chaoxianzu music lies in that it is new and not in a *pure* or *authentic* form that can be embraced as *traditional* Korean music, which is most often translated as Korean heritage culture and is a national emblem of South Korea. Chaoxianzu music, influenced by and sharing elements with musics of China and North Korea in terms of style, repertoire, and material aspects, is often confusingly lumped together with North Korean music in the South today and perceived as representing the sounds of Others. The following vignette describes how two groups of ethnic Koreans and their cultural constructions encounter one another in a musical space and contest the different ideologies and social realities that have underpinned the music of Koreans who have been separated into bounded entities from the outbreak of the Cold War through today. And it simultaneously raises questions about the social inequities and power dynamics that are played out among

the different groups of Koreans, all affected by the political and social transformations of East Asia over the last seventy years.

Being and Representing the Other in South Korea

On 23 June 2011 the Sŏngnam (Seongnam) Municipal Troupe of Korean Traditional Performing Arts (hereafter, Sŏngnam Municipal Troupe) gave its twenty-eighth concert, titled *Hana toenŭn kyŏre ŭi ŭmak* [Unifying Korean National Music]. In South Korea the month of June is designated as commemoration for the nation's patriots and veterans. As many government troupes in South Korea do in June, the Sŏngnam Municipal Troupe dedicated its regular concert series to remembering national heroes and honoring their patriotism and sacrifice. As stated in the concert program, "This performance is put together to bless the people who died protecting their nation and to express compassion for the ten million families separated between the two Koreas . . . wishing for the nation's reunion and unification in the near future" (my translation). In order to commemorate war victims and underline the tragedy of partition, for this concert the focus was to showcase musical works from both North and South Korea. In the program, Ch'oe Sangwa, guest director of the troupe, noted,

> Today's concert intends to draw a comparison between the various musical forms of North and South Korea. . . . Over the last sixty years, each Korea has developed its own version of *chŏnt'ong ŭmak* [traditional or national music].[2] While South Korea has endeavored to preserve the performance practices of traditional Korea under the growing influx of Western music . . . instead of transmitting the old tradition as is, North Korea has newly created its own national music by inventing new instruments and developing a new vocal style with a bright and clear sound color. (my translation)

As Ch'oe describes it, since partition, Korea's two political poles have promoted different musical sounds as national emblems. Thus, the event's enactment of Korean unification was indeed a presentation of different constructions of Korean music from the North and the South. The concert featured six soloists performing North and South Korean music, accompanied by a modern Korean ensemble modeled after a Western symphony orchestra and made up of mostly traditional instruments. The concert program began with a North Korean symphonic piece, *Arirang*, a composition featuring the well-known Korean folk song "Kyŏnggi Arirang" as its main melodic theme.[3] Originally composed for Western orchestra, for this occasion it was rearranged by Pak Wich'ŏl, a Chaoxianzu

composer, for traditional Korean instruments. After opening with "Arirang," individual concertos featuring the *taegŭm, ongryugŭm, changswaenap,* and *modŭmbuk* (a set of single-headed drums, newly invented in South Korea) were performed. The final two selections were presented by solo vocalists whose performances contrasted the husky, raspy sound of Korean *p'ansori* with the clear, bright, refined sound of North Korean self-reliance singing.

While South Korean musicians Yi Yŏngŭn, Yi Yŏnghun, Pak Yŏngjin, and Min Ŭn'gyŏng performed *taegŭm, changswaenap, modŭmbuk,* and newly composed *p'ansori* songs, respectively, two Chaoxianzu musicians, Kim Kyeok and Kim Ŭnhŭi, performed on the *ongryugŭm* and sang folk songs and vocal compositions from the North in self-reliance voice. Of the twelve works performed, six were arranged by Pak Wich'ŏl. Despite the fact that a number of North Korean migrant musicians have been active in South Korea, none of them were invited to perform. Instead, the concert—symbolically unifying the two contrasting Koreas—was enabled through the collaboration of Chaoxianzu and South Korean musicians. In addition, the provenance of neither the North Korean music or its performers was mentioned in the program, nor was any reference made to Chaoxianzu music or the role of Chaoxianzu in facilitating the performance. As I pointed out in previous chapters, diasporic Korean musicians in China have constructed their own cultural identities distinct from those of North and South Koreans and have assertively promoted their cultural difference as characterized by its hybridity with Chinese influences. For the Sŏngnam Municipal Troupe's concert, an apparently pan-Korean music program focused on the enactment of the two polarized Koreas, a conceptualization that excluded the provenance and distinct identity of the Chaoxianzu musicians who participated in the concert. Indeed, the diasporic music and musicianship of Koreans abroad has been seldom discussed in the literature on Korean music. Most literature on Chaoxianzu music has been published by Chaoxianzu scholars based in the PRC; scholars from North or South Korea have scarcely acknowledged the subject in their writings and have excluded it from historical or contemporary surveys of Korean music.[4] Moreover, South Korean music scholarship has often presumed Chaoxianzu music to be almost identical to that of North Korea. It is not very plausible that the Chaoxianzu community was influenced by North Korea in musically constructing its diasporic Korean identity in China. Yet, for the Sŏngnam Municipal Troupe's performance in 2011, Pak Wich'ŏl, a Chaoxianzu musician, facilitated the production of North Korean and South Korean sounds—but not Chaoxianzu ones—with his arrangements for the orchestra and solo musicians. What, then, are the implications of such a performance for Chaoxianzu music? Is there an apparent power imbalance and social domination and discrimination played out by South Korean hegemony? How to interpret the

concert's paradoxes and contradictions and the narratives in its representation of wider Korea? What kinds of social information are revealed if we treat this performance as a cultural text and attempt to understand what is inferred both in and beyond the text? Ato Quayson (2003) suggests that "a form of close reading of literature"—which he calls "calibrations"—offers "what lies beyond it [literature] a way of understanding structures of transformation, process, and contradiction that inform both literature and society" (xi). Inspired by Quayson's idea of calibrations, ethnomusicologist Tina K. Ramnarine (2007) revisited her own ethnographic work on musical performances of the Caribbean diaspora in Britain and proposed that Quayson's literary theory can be useful for the analysis of musical performance, particularly in "multicultural contexts" like Britain (4). As she argued, "Calibration is not about homologies between the aesthetic and the social. A significant dimension of a calibrated reading is that it highlights the disjunctures between representations and realities" (6). Disjunctures and contradictions are both salient in the construction of and discourses around diasporic ethnicity. Since diaspora cannot be conceptualized as separate from "ethnicity," it also significantly "involves 'race' discourse and minority status" (Eriksen 2002, 4). Although Ramnarine's diasporic model cannot be directly applied to Chaoxianzu in South Korea in that South Korea is not a multiracial state, her adaptation of Quayson's close reading can be relevant in analyzing the contradictions observed at the Sŏngnam concert, "the disjunctures between representations and realities." Despite its program and its nontextual discourses that excluded the role and the distinctive identity of Chaoxianzu musicians, a close reading of the performance also allows for the potential subversion of the event through which a diasporic group can challenge a hegemonic construction of Korean ethnicity that is limited to two culturally polarized groups of Koreans, pointing instead to a power imbalance within the wider Korean community that excludes and marginalizes the diasporic group as a social minority.

Returning Home and Hierarchical Nationhood

Since the early 1990s, many Chaoxianzu have visited or moved to South Korea as *coethnic return migrants,* the term here referring to diasporic Koreans who came back to South Korea after having lived abroad for generations (Tsuda 2009a, 1). Even if they are ethnic Koreans, in official contexts they are distinguished from the South Korean majority in terms of their legal rights and social classifications (Tsuda 2019). Since the majority of Chaoxianzu migrants have come for the economic opportunities their ancestral home might offer them, South Koreans often view them as foreign labor migrants. "Return migration" is a paradoxical term since migrants, especially second generation or later, may

not view their move to the place of their ethnic origin as a "return" or a "home-coming" since they never actually "left" or had a "home" there in the first place. For this reason, I presume that not all Chaoxianzu—or, indeed, South Koreans—perceive the relocation of Chaoxianzu to South Korea as "return migration." Despite this contradiction, the term is used here to describe the joining, rejoining, and growing presence of Chaoxianzu who have moved to South Korea as emergent members of society.

Currently, more than 540,000 Chaoxianzu reside in South Korea as migrant workers, students, or spouses of South Koreans (KOSIS 2018). As Takeyuki Tsuda argues in his editor's introduction to *Diasporic Homecomings,* a major driver in many return migration cases is the economic benefit that accrues to diasporic descendants when they move from developing countries to the developed homeland that their ancestors left long ago. While they are similarly attracted by the immigration and social policies of the home that favor its diasporic returnees, many also decide to return due to the ethnic ties and nostalgia that diasporic groups hold for their ancestral lands. Nevertheless, the migrants' cultural and social relationship with their ethnic homeland may be completely secondhand, considering that in many cases most or all of their lives have been spent away from their ancestors' homeland (Tsuda 2009a, 3). In a more recent work, "Korean Diasporic Returns" (2019), Tsuda further states that while diasporic people's return to the homeland is primarily driven by economic and instrumental reasons and less by ethnic affinity per se, considerable variation in these motives for return also deserves attention: "Some are unskilled labor migrants seeking higher wages and better economic livelihoods in their homelands, while others are taking advantage of professional and educational opportunities in their countries of origin or are simply tourists and visitors" (8). This indicates that diasporic return as well as overall migration is never simple or straightforward, but complex and problematic in that it is characterized by "a tension" between centrifugal and centripetal forces (Tsuda 2009a, 11; 2019, 7). Therefore, upon migration, many coethnic returnees experience a psychological ambivalence that moves between a sense of brotherhood and foreignness, even if their migration results in practical and economic gain (Song 2009, 299; Tsuda 2009b, 31). In the case of Chaoxianzu who become return migrants, their "return" to their ancestral origins is a politically complicated act given the present reality of partition. The majority of Chaoxianzu whom I met in Yanbian and in South Korea had ancestral hometowns in northern provinces that are now part of North Korea. It is hard to discern the principal motivation in each case of Chaoxianzu return migration. However, the decision is often closely related to individual family backgrounds and the imagined nation that encompasses both Koreas, and more fundamentally, to practical issues for the Chaoxianzu community in postrevolutionary China.

The PRC's economically driven social reforms of the 1980s led the Chao-xianzu community to see the need for wealth accumulation in order to sustain themselves in the new market economy. When South Korea became accessible with the establishment of diplomatic relations with China, a large number of Chaoxianzu migrated there as nonprofessional or unskilled workers in search of better economic opportunities. The experience of return migrants is often negative, and the chances of this are even greater if they arrive as unskilled workers (Tsuda 2009a, 3), especially in a place like South Korea, where the state has strongly pursued economic and industrial ascendancy and social modern-ization. Chaoxianzu migrants expected their ethnic affinity to make for an easier or smoother integration than other migrants, and many were disap-pointed by the social exclusion, mistreatment at work, and competition for jobs they faced in the capitalist South. In addition, the South Korean government's differential treatment of coethnic return migrants as compared to South Korean citizens has exacerbated their alienation.

Sociologists Dong-Hoon Seol and John Skrentny (2009) state that "[South] Korea has recognized these immigrants as members of the Korean nation but has assigned them a subaltern position. In Korea, as in other states with ethnic return migrants, the co-ethnic newcomers are lesser members, part of a growing elabo-ration of what we call here 'hierarchical nationhood'" (149). Seol and Skrentny characterize "hierarchical nationhood" as having two important dimensions:

First is a *legal* dimension, where the state draws lines between the core, top-tier members and other co-nationals by offering the latter varying opportunities for citizenship, residence visas and work permits. Second is a *social* dimension, where top-tier members draw lines informally, prac-ticing various types of discrimination against co-nationals even while recognizing their kinship. Together, these two dimensions may result in a distinctively difficult experience of integration for individuals who have expectations of full acceptance. (Seol and Skrentny 2009, 152; italics in the original)

Applying Seol and Skrentny's framework, South Korea's reception of its coethnic return migrants articulates the privilege of South Koreans as primary citizens in discriminating against coethnics in terms of equal opportunities and citizenship rights. While I do not mean to portray Chaoxianzu return migrants as collectively passive and powerless as opposed to active social actors, the South Korean government's unequal treatment of its coethnic return migrants has contributed to the circulation and perpetuation of social preju-dice toward Chaoxianzu by imposing legal constraints on them, practiced at an institutional level.

The Overseas Koreans Act—revised several times between 1997 and 2010—has been particularly tailored to differentiate Chaoxianzu and Korean Russians from other coethnic returnees, restricting their visits to South Korea, limiting their voting rights (*ch'amjŏnggwŏn*), and banning them from government employment (Park and Chang 2005).[5] South Korea's rationale for this differentiation of Chaoxianzu and Korean Russians reflects the legacy of the Cold War's ideological disputes in which the South took part against former Communist states. Such government-sanctioned othering has powered the nationwide circulation and production of negative discourses and images of Chaoxianzu, especially since the majority of the Chaoxianzu in South Korea have been non-professional workers, including a large number of undocumented workers, serving in "3-D" (dirty, difficult, and dangerous) jobs disdained by the majority of South Koreans. It is not unusual for popular media, such as television programs and feature films, to overtly depict and ridicule Chaoxianzu as primitive, deceptive, premodern, violent, and disloyal to South Korea. Given the institutional realities and the forces of social alienation working against Chaoxianzu, how then shall we understand the welcoming of Chaoxianzu musicians into South Korean music scenes and the politics of agency that these musicians perform as they work and build their careers in the South?

Three Chaoxianzu Musicians in South Korea as Cases in Point

Timothy Rice (2003) suggests two directions for the study of music "in a complex, modern, and dynamic world" (151). He emphasizes that the study of music should occur with a focus on the relationships between individual musicians or small groups of musicians who are connected in "a moment in time and place by shared beliefs, social status, behaviors, tastes, and experiences of the world," as well as via understanding the ideas and behaviors of these individuals in relation to a context—in Rice's words, the "modern world system"—that rewrites and problematizes "cultures and societies as 'traditionally understood'" (152). Agreeing with Rice, I contend that it is impossible to understand the people involved in musical activities, as well as the sounds, behaviors, and conceptualization of the music they produce, without taking into account the particular time and context in which they find themselves and to which they respond. Music is, in that sense, a social behavior and construction, and what musicians do in the modern world inevitably points out the various contradictions, encounters, and challenges that are nested in their society and that affect all musicians who are members of that society. Moreover, music and what musicians do not only rewrites and problematizes "cultures and societies" understood in the traditional sense; it also shapes present and future understandings of contemporary

cultures and societies as forms of embodiment. By engaging in the ethnographic study of Chaoxianzu musicians in South Korea and paying attention to the three important dimensions of musical experience—place, time, and metaphors (Rice 2003, 151)—I illustrate how the particular experiences of Chaoxianzu musicians in South Korea are shaped by their shifting location and moment of migration, as well as the musical meanings they participate in constructing, all of which are tied to the contradictions and paradoxes that these musicians encounter in the South.

The three musicians I profile here are Pak Wich'ŏl, Kim Kyeok, and Kim Ŭnhŭi, all of whom were involved with the Sŏngnam Municipal Troupe concert. All were born and raised in the Yanbian Korean Autonomous Prefecture. Pak Wich'ŏl and Kim Kyeok worked in Yanbian as professional musicians after graduating from Yanbian Arts School. A later graduate of the same school, Kim Ŭnhŭi moved to South Korea to continue her studies. All three musicians came to South Korea in the early 2000s and have since been affiliated with South Korean universities as teachers and a student.

Pak Wich'ŏl

Pak Wich'ŏl, a theory and composition teacher at Yanbian Arts School, was invited to South Korea in 1998 by Pusan (Busan) University, some of whose staff he had met in Yanbian.[6] Upon learning that the school was interested in the Chaoxianzu practice of Korean music, Pak decided to pursue graduate studies in Korean music there, where he received an MA in Korean music composition in 2001 and a PhD in Korean musicology in 2010. While working on his doctorate, two of Pak's compositions, "P'yŏnghwa wa sangsaeng ŭl wihan non'gaesong" [Songs for Peace and Coexistence] and "Kŭrium" [Yearning], won prizes in 2004 and 2005, respectively, at the *Kungnip kŭkchang ch'angjak kongmo* [National Theater's Competition for Creative Korean Compositions], sponsored by the National Theater of Korea. These compositions were recognized as outstanding examples of *ch'angjak kugak* (new or creative Korean music), and his music has since been performed by a number of major orchestras, including the Sŏngnam and Ansan Municipal Troupes, the National Orchestra of Korea, and fusion music ensembles such as Chocolate and Chung-Ang Gayastra.[7] He is also frequently asked by these ensembles to arrange a variety of music for them. In Pak's case, degrees in Korean music, social networks he built in South Korea, and the musicianship he acquired in China together facilitated the building of his career, against a background of explicit interest on the part of South Korean musicians in Korean music in China.

Beginning in the 1980s, and more prominently in the 1990s, some traditional musicians in South Korea grew concerned about the diminishing appeal

of traditional music to contemporary audiences accustomed to the sounds of Western classical music and popular songs. Influenced by the examples of Japan and China, an increasing number of modern Korean orchestras were established under municipal or provincial government sponsorship. Young musicians trained in traditional Korean music also directed their efforts toward creating new music compatible with the emerging global world music scene of the 1990s. Subsequently, ensembles of various instrumentations and sizes were formed, and new repertoire was increasingly in demand for these ensembles to perform.

One of the well-known examples that led the movement of popularizing and contemporizing traditional Korean music was Chung-Ang University's Korean Music Department (now the College of Traditional Korean Music). Kim Illyun, professor in traditional Korean music at Chung-Ang University and director of Gayastra, for which Pak Wich'ŏl has composed works, remarks in the liner notes of her group's first album, *Beautiful Departure: The Present* (2009): "Our ensemble intends to contribute to the spread of traditional Korean music by fitting it in with the contemporary setting. . . . With new interpretations of what *kayagŭm* music is and approaching Korean traditions in various ways, we seek to bring creative dynamics to our music and thus suggest the sound of the present" (4). This album includes Pak Wich'ŏl's composition "Mŏnhunnal" [Remote Future], a programmatic piece based on South Korean poet Ch'ŏn Aeok's work of the same name. The piece was written for eight twenty-five-string heptatonic *kayagŭm* and several percussion instruments.[8] Besides appearing on the album, the piece was performed at the group's inaugural concert in 2007. The use of this piece is evidence that Pak's music conforms to a new direction in *kayagŭm* music as envisioned by Kim Illyun in South Korea, as the leader of Gayastra and a renowned *kayagŭm* player and Korean music educator.

Pak's "Mŏnhunnal" does not feature much in terms of the traditional Korean music aesthetics practiced in South Korea, such as a heterophonic ensemble texture, *nonghyŏn* and *sigimsae*, and *changdan*. Instead, the percussion and the focus on a simple diatonic melody are reminiscent of easy listening, a genre that in South Korea is perceived as light music, with its soft and lyrical character. The crescendo and lingering sound of the cymbals add dramatic effect to the melodic simplicity of "Mŏnhunnal." According to Pak, this piece exemplifies his favorite style of composition for Korean instruments— one featuring a single melody with one or two instrumental parts in counterpoint, with percussion accompaniment.[9] The easy-listening style of Pak's music is typical of Chung-Ang Gayastra's repertoire—for example, arrangements of Gounod's "Ave Maria" and "Habanera" from Bizet's *Carmen,* and even of popular songs such as Michael Jackson's "Billie Jean" and "You Are Not Alone." They also frequently perform arrangements of popular film music.

The movement to popularize and contemporize traditional music in South Korea was not just a recent phenomenon. It began as a variety of experiments starting in the 1960s, although its popularity and wide recognition emerged with the boom of fusion *kugak* beginning from the early 1990s. In the case of Chaoxianzu construction of diasporic Korean music in China, *mass*-friendly sound has been a de facto rule and profoundly underpinned the shaping of Chaoxianzu music identity due to the socialist cultural policy that guided the reformation of traditional Korean music throughout the second half of the twentieth century (see chapter 3). Pak explains that, unlike South Korean composers who specialized in traditional Korean or Western classical music, all Chaoxianzu composers in China were expected to integrate their ethnic heritage into their music composition process. Consequently, most Chaoxianzu composers are familiar with techniques they can use to fuse traditional Korean musical elements with Western musical idioms and compositional methods in expressing their Korean identity (see chapter 5). Moreover, Chaoxianzu composers in China are often inclined to recycle popular tunes familiar to the masses in their new works. As part of their cultural milieu in China, Pak states that from the start, Chaoxianzu composition students are trained to be bi- or multimusical by studying Korean, Western, and Chinese instruments and compositional methods, and to feel comfortable when these musical idioms are synthesized in their music and musicianship.

On the other hand, not all Chaoxianzu musicians prefer to compose works for traditional Korean instruments or choose to be explicit about their Korean background. However, even those who solely employ Western classical instruments and create works in a highly Western compositional style often ascribe meanings to their music or program it with stories or concepts that signify diasporic Korean experiences in China or discourses familiar to Koreans in general (Koo 2008). Considering the fact that many Chaoxianzu composers have studied at Yanbian Arts School, whose institutional focus has been to educate Korean minority nationality youths in their own distinctive visual and performing arts cultures, the Chaoxianzu composers described by Pak could very well have been greatly affected by the ideologies in evidence at that institution. According to what Pak related in an interview, his musicianship was strongly established in China and he was able to apply it to accommodate the needs of South Korean musicians and groups. Though he focused on traditional folk song analysis in his graduate studies in South Korea, he made little reference to the effect these studies have had on his compositional skills or philosophy. Instead, he emphasized that what he could contribute to the emerging movement in new Korean music was made possible by his training in China.

At one point during his interview, he related, a bit reluctantly, that he receives far more requests to arrange musical pieces than commissions or

recitals of his own compositions. He also expressed his discouragement at not having been offered a full-time academic position in the South despite frequent collaboration and service. It is difficult to attribute his getting more arrangement requests than commissioned work to his ethnic status in South Korea since the availability of compositional commissions is often insufficient for South Korean composers as well. Similarly, finding a full-time academic position in the South has been equally difficult for South Korean musicians and scholars, although the matter of equal opportunity and wage exploitation can be an issue when a job does become available. While the number of Pak's part-time instructorships in South Korea and the frequent calls for his music are indicative of the valuing of his work in South Korea, his cultural capital does not seem to neatly translate into financial security. Even so, he would rather stay in the South than go back to China in the immediate future due to family and practical considerations. His family is now accustomed to living in the South since they have been there since the early 2000s, and he sees the South as presenting more opportunities than Yanbian for him to work as a composer and for his music to be played in professional venues. Whether or not he is fully satisfied with his professional life since his return migration to South Korea, it is clear that Pak has contributed to a newly flourishing South Korean traditional music scene. He has introduced methods of fusing Korean and Western compositional idioms and effectively combining traditional Korean and non-Korean instruments, and he has supplied South Korean musicians with a great number and vast range of works, including his own compositions, arrangements of *sanjo,* concertos for various Korean instruments, orchestrations of traditional or contemporary vocal pieces, and adaptations of Western instrumental works for ensembles including traditional Korean as well as Western instruments. In supplying these works, Pak's training in China as a Korean minority nationality composer was crucial.

Kim Kyeok

Another Chaoxianzu musician who has been very active in South Korea is Kim Kyeok, an adjunct professor in Korean *kayagŭm* at Chung-Ang University since 2003. As an instrumentalist, Kim also specializes in North Korean *ongryugŭm,* on which she performed for the Sŏngnam concert in June 2011. Kim moved to South Korea in 2001 and has since taught *kayagŭm* to young South Korean students. After two years in Pusan teaching traditional *kayagŭm* and the *sanjo* that she learned in China, she was invited to Chung-Ang University as a resident artist specializing in the twenty-five-string heptatonic *kayagŭm.* Although her primary training in Yanbian was in the traditional twelve- or thirteen-string *kayagŭm* under Kim Chin (introduced in chapters 3 and 4), Kim Kyeok

also learned the twenty-three-string Chaoxianzu *kayagŭm* and was exposed to the twenty-one-string North Korean *kayagŭm* in Yanbian.[10] Although her move to South Korea was due to an interest there in her as a student of Kim Chin's and in her teacher's *sanjo* music, her skill in heptatonic *kayagŭm* ended up garnering more attention than her primary training in the traditional instrument.[11]

In the 1980s and 1990s, as various forms of traditional Korean ensembles sought to expand the range of their performance repertoire, the technical and practical limitations of Korean instruments became an important issue. South Korean musicians began to seek ways to modify traditional instruments so that they could be effectively played along with the equal-tempered instruments of the West with which they were often juxtaposed. Also, as had happened with traditional ensembles in China and Japan, new ensembles of traditional Korean instruments were modeled after the Western symphonic orchestra in terms of both format and performance practice. While several precedents from China and Japan might have motivated the birth of these orchestras and suggested a need for instrumental modification, South Korean composer and scholar Chun In Pyong (Chŏn Inp'yŏng) remarks that changes made to Korean instruments by Chaoxianzu musicians in China were in fact effected to provide a more compatible point of reference for South Korean musicians wanting to develop a new sound in terms of tuning, timbre, and level of acoustics through the modernization of Korean instruments.[12] Although such modification had been attempted several times by progressive South Korean music scholars and composers since 1964, none of these had been widely or consistently adopted. According to Chun In Pyong, the modern *kayagŭm* began to be positively viewed by South Korean musicians in the mid-1980s when the instrument was featured in "Pada" [Sea], an original composition by a South Korean composer, Yi Sŏngch'ŏn (1936–2003), while the drive to create a new *kayagŭm* in South Korea in some ways derived some of its momentum from the popularity of *samullori,* whose introduction in 1978 and ensuing success at the national and international levels showed how traditional Korean music can be adapted as a contemporary music culture gaining the support of modern audiences (Chun 2000/2001, 400–401). With Chaoxianzu-modified instruments and grand orchestra setting predating developments in South Korea, when South Korean musicians gained access to Chaoxianzu music in the early 1990s, it provided a useful reference point for those seeking to modify South Korean instruments.

As with Pak Wich'ŏl, Kim's relocation to South Korea coincided with an increasing interest on the part of South Korean musicians in developing pedagogy for the new twenty-five-string *kayagŭm* adopted by modern South Korean orchestras and fusion ensembles. From the 1990s, this *kayagŭm* gradually replaced the traditional one in the performance of new compositions due to its

ability to accommodate a range of scales to better acoustical effect. In what ways the Chaoxianzu and the new South Korean *kayagŭm* were similar in terms of manufacturing details is another matter. It was the fact that Chaoxianzu musicians had already made great progress in terms of the pedagogical and technical development of a heptatonic *kayagŭm* that enabled Kim Kyeok to establish herself as a teacher of the new *kayagŭm* in South Korea.

In Yanbian, Kim Kyeok was best known for having studied *kayagŭm* under Kim Chin, renowned for his work in traditional *šanjo* in Yanbian (see chapter 4). Prior to her arrival in Pusan, she envisioned that she would teach her mentor's *kayagŭm sanjo* to South Korean musicians. However, she soon realized that the demand for her as a musician and teacher in South Korea would rest primarily on her ability to play the twenty-three-string Chaoxianzu heptatonic *kayagŭm*. Accepting a teaching position at Chung-Ang University, Kim Kyeok moved to Ansŏng (Anseong) and taught students the twenty-five-string heptatonic *kayagŭm* created in South Korea. Like some *kayagŭm* musicians in Yanbian discussed in chapter 4, she emphasized to me that in teaching, she uses her own arrangements of well-known Korean folk songs and North Korean pieces. Kim states, "I prefer to use preexisting melodies or folk songs in my music, but instead of teaching or performing them as is, I always add my own cadenzas so that I can highlight the virtuosity of *kayagŭm* players."

Similar to Pak Wich'ŏl, Kim's preference for recycling existing melodies echoes the general Chinese socialist cultural ideal that any music in China should easily connect with lay audiences who might not have much musical background or a formal understanding of music. Also, highlighting the solo instrumentalist's skills by embedding cadenzas is widely found in both Chinese and Chaoxianzu music, as the Chinese and Chaoxianzu do not mind altering their national music to incorporate European compositional forms and practices. Kim's pedagogical emphasis also echoes what other Chaoxianzu *kayagŭm* teachers such as Cho Sunhŭi and Kim Sŏngsam in Yanbian pointed out (see chapter 4). She stated that her major pedagogical thrust with her South Korean students on the twenty-five-string *kayagŭm* is the mastery of finger technique through practice with etude books, a pedagogical principle used for most European stringed instruments. Kim notes with pride that her students have found jobs with national and provincial government-sponsored orchestras based on techniques developed under her instruction.

Like Pak Wich'ŏl, Kim's performance ideology and pedagogical method reflect her musical training in China, more specifically at Yanbian Arts School, where the institutional ideology is grounded in the creation of arts in the service of the masses and in the proactive adaptation of foreign idioms for the development of native traditions. While her musical knowledge and experience with Chaoxianzu music in Yanbian paved the way for her to become a

distinguished musician and specialist in the new *kayagŭm* in South Korea, the artist herself had to be flexible with her own interests and change her principal instrument in establishing her music career in the South. Despite Kim's initial vision of becoming a teacher in traditional *kayagŭm* in South Korea as a disciple of Kim Chin, she changed her expectations and accepted teaching the twenty-five-string *kayagŭm,* in contrast to South Korean musicians who view their strength as lying in the older Korean instrumental practices. By leaning on her experience in China with the Chaoxianzu *kayagŭm* as well as the North Korean *ongryugŭm,* Kim has promoted herself as a unique musician who can contribute to the development of the new South Korean *kayagŭm* by offering her experience with North Korean music, which has been scarcely accessible to South Korean musicians and audiences.

Kim Ŭnhŭi

Kim Ŭnhŭi, who represented North Korean singing at the 2011 Sŏngnam Municipal Concert with one Korean folk song and two North Korean compositions, came to South Korea in 2001 to enhance her skills in Korean folk song singing. While majoring in Korean voice at Yanbian Arts School, she became interested in Chinese opera and studied it on several visits to Beijing. In South Korea she has devoted herself to *sŏdo sori* studying with master singers and even earning the gold medal at the national *sŏdo sori* competition in 2003. Although the aesthetic foundations of North Korean self-reliance singing lie in *sŏdo sori*—a relatively bright, smooth, and more nasal vocal production compared to other regional singing styles of Korea, such as *p'ansori*—North Korean self-reliance singing privileges a much more refined and resonant sound than does traditional *sŏdo sori* singing. Nevertheless, Kim Ŭnhŭi is often represented as an expert in North Korean self-reliance singing, with her expertise as a *sŏdo sori* singer going unacknowledged.

Kim has performed in South Korea as both a solo vocalist and a member of Arirang Nang-Nang, a Chaoxianzu music group of seven female musicians. Just as Kim was introduced at the Sŏngnam concert as a singer of North Korean self-reliance singing, Arirang Nang-Nang is marketed as a group specializing in North Korean rather than Chaoxianzu music. According to the cover of their album, "This group is composed of young female musicians from Yanbian, China, playing North Korean instruments and singing" (2005). However, a closer look at the instruments held by the musicians in the cover photo reveals that they are of Chinese, South Korean, Yanbian, North Korean, and Western origin. In addition, the album features a collection of versions of the folk song "Arirang" found in various regions throughout Korea, with the addition of entirely new pieces also titled "Arirang" composed in North Korea and

Yanbian. Neither the repertoire featured on the album nor the instruments used quite match how this group is represented on the jacket. Instead, the group synthesizes various musical elements, including some from the West, associated with different groups of Koreans. Besides problematizing the depiction of Kim Ŭnhŭi and Arirang Nang-Nang as representing North Korean music, I want to also briefly touch upon what makes these artists so flexible with respect to the boundaries between the multiple musical constructions that emerged in contemporary South Korea.

In a feature in *Jilin Newspaper* on Kim Ŭnhŭi and her recent solo album, *Kasiri* [Leaving], produced in South Korea, it was reported that Kim stylized her song "Sup" [Forest] by using her *sŏdo sori* voice at the beginning and then finishing in bel canto style. Pointing to Kim's training in Chinese, traditional Korean, and North Korean singing, the article praised her in stating that "having such flexibility in moving between multiple styles of singing is rare, but Kim Ŭnhŭi does it." Although the article attributed this flexibility of vocal production specifically to Kim Ŭnhŭi's individual musical gifts, her ability to move between different singing styles is in fact due to her training as a Chaoxianzu singer in China, as renowned Chaoxianzu vocal teacher Chŏn Hwaja pointed out (see chapter 6). Ironically, Kim Ŭnhŭi herself asserts that she does not want to be identified as a singer of one particular style: "I wish I could sing a song that does not sound alien to any Asian people; [I want to sing] songs that are grounded in tradition but that carry the sentiments of all [Asian] people."[13] Whether or not Kim Ŭnhŭi imagines Asia as having generalized psychological or musical traits, she clearly expresses her vision of singing as not confined to her ethnicity but rather intended to reach an audience beyond Koreans.

Like the aforementioned Chaoxianzu musicians who participated in the Sŏngnam concert, Kim Ŭnhŭi is another example of those Chaoxianzu musicians in the South whose artistic strength there is their ability to fuse traditional Korean music with Western or nontraditional musical influences and thus transcend the boundaries of Korean versus non-Korean music. What enables this musician to do that is her versatility with various vocal styles across different regions and cultures and, even more importantly, her musicianship and training as a Chaoxianzu singer to sing for her own community and for non-Koreans in China.

In understanding the metaphor of the three Chaoxianzu musicians at the June 2011 Sŏngnam concert, and more broadly the reality and representation of Chaoxianzu return migrants in South Korea, we can come back to Tina K. Ramnarine's argument and her application of Ato Quayson's calibrated reading to her study of performances and cultural displays of the Caribbean diaspora in Britain. Ramnarine (2007) argues that calibrated readings "confront us with issues of comparison, and with the disjunctures between social reality, representation and translation" (5), all of which are relevant to the debates

and shared struggles among ethnomusicologists who produce and at the same time interpret ethnographic text. While each Chaoxianzu musician's story demonstrates how variations between different groups of Koreans are carved into musicians' own imaginations and expressions of identity, the representation of Korean culture at the Sŏngnam concert ignores such subjectivities by treating Chaoxianzu as representatives of North Korea while erasing their collaboration with South Korean musicians in enacting the national music of the South. Taken as a whole, the concert illustrates the disjuncture between how different groups of musicians are outwardly represented and the reality behind this. As Ramnarine (2007) points out, "Administering musical ethnicity . . . highlights agents and agency in the politics and performance of diaspora and in establishing power relations" (5). The concept of "administering" ethnicity is intertwined with how the social practice and performance of ethnicity is closely linked with the power and institutional structures that impose and govern the conception of ethnicity, especially in the case of diaspora. Although the Chaoxianzu I describe in this chapter are return migrants, their diasporic status is always a key aspect of the power relations to which they are subject in the South, as if they did not share ethnicity with South Koreans.

Subversion and Power Dynamics

If the imposition by the South Korean government of a hierarchical categorization of the nation's coethnics represents a hegemonic view of top-tier members of society who aim to maintain and affirm their superior positions by measuring other coethnic members based on an economic scale derived from capitalist social interests (Seol and Skrentny 2009), the embracing and incorporation of Chaoxianzu musicians into South Korean music scenes shows how musical performance can provide a space where social discrimination is ironized, contested, and belied. Martin Stokes (1994) stated that "performance does not simply convey cultural messages already 'known.' On the contrary, it reorganizes and manipulates everyday experiences of social reality, blurs, elides, ironizes and sometimes subverts commonsense categories and markers" (97). Similarly the musical collaboration between South Korean and Chaoxianzu musicians points out that economically or industrially based modernity allows for only a partial understanding of the encounters of modern citizens in the social complexity of the contemporary world. Viewed from South Korea's economic and industrial point of view, Chaoxianzu might seem socially behind or even premodern. However, the desire in South Korea to learn and accommodate Chaoxianzu music not only illustrates the value of cultural idiosyncrasy in the creative arts but also suggests how the contemporary world is constituted of

multiple modernities articulated by "a multiplicity of cultural programs . . . carried forward by specific social actors" (Eisenstadt 2000, 1–2).

Obviously, the migration of Chaoxianzu musicians to South Korea coincided with an emerging concern on the part of South Korean musicians who saw a market and venues for new interpretations of traditional Korean music. With South Korean music, a strong emphasis has been placed on the construction of national music, idealizing the preservation and maintenance of traditional cultures passed down from the previous century. At the same time, progressive and practical voices among the musicians have resisted the narrow approach of traditional Korean music. These musicians were interested in incorporating nontraditional and non-Korean music practices into the performance of traditional Korean music and reshape its sound to reduce the distance between the musicians' practice of tradition and their audiences' preferences, which were greatly influenced by Western cultural hegemony throughout the twentieth century. Such movements among South Korean musicians in the 1980s, and more prominently in the 1990s and early 2000s, allowed the incorporation of diasporic Korean music and musicians in South Korea.

One notable social connection observed with the aforementioned Chaoxianzu musicians was with South Korea's Chung-Ang University, whose College of Korean Music has been known for its emphasis on progressive ideology and experimentation in new sounds for traditional Korean music. This college was directed by Pak Pŏmhun, who has long been a professor of Korean music and served as the university's chancellor in the early 2000s. As a composer, he introduced numerous new works for traditional Korean instruments and ensembles, and in the early 1990s he created a pan–East Asian orchestra, Orchestra Asia, including instruments from Japan, China, and Korea (Chun 2000/2001, 400, 416). In line with Pak's interests, the school's Korean music staff has collaborated with Chaoxianzu musicians since the 1990s. The reason Chaoxianzu musicians were invited to participate in the June Sŏngnam concert perhaps has something to do with the fact that all three have been affiliated with Chung-Ang University as instructors or graduate students, and the resident and guest directors of the Sŏngnam concert, Han Sangil and Ch'oe Sangwa, are an alumnus and a current professor there, respectively. Obviously, the social capital that the Chaoxianzu musicians acquired in South Korea has contributed to their professional lives by increasing their performance or work opportunities.

Given that agency is never evenly distributed among social actors, Chaoxianzu musicians in South Korea visibly have more agency than their fellow non-musician Chaoxianzu migrants, since the musicians came to the South with education and musical professions that they developed in China. Even after their return migration to South Korea, these musicians' graduate degrees from

South Korean universities, experiences of teaching in academic institutions, and professional relationships developed with South Korean musicians further enhance their agency. Nevertheless, considering that all the Chaoxianzu musicians I met in the South said that their initial motivation to come to South Korea was to learn the traditional music that they perceive as having been well preserved there, the integration of Chaoxianzu musicians takes place to a large extent within a specific, limited segment of the South Korean music scene. Despite these musicians' interest and training in traditional Korean music, their cultural otherness seems to be the primary reason for their recognition by South Korean musicians who seek foreign and nontraditional musicians' input into the development of a new sound in traditional Korean music. This is somewhat analogous to the way that foreign and Chaoxianzu labor migrants have been welcomed into South Korea in order to fill "3-D" jobs that cannot be staffed domestically. In this sense, the musical experiences of Chaoxianzu musicians in the South have not been entirely independent of the power dynamics at work there in supplying the musical needs of their South Korean hosts.

Beyond the Performance Stage

Observing the Sŏngnam Municipal Troupe's concert in 2011, I had several questions regarding the meaning and identity of the Chaoxianzu musicians who were invited to the event to engage in both North and South Korean music. The questions that troubled me most were why they were invited to represent the music of North Korea instead of actual North Koreans who were readily available in South Korea, and why they were not invited to represent Chaoxianzu music. From the South Korean perspective, the differences between North Korean and Chaoxianzu music and the issue of who is to represent the sound of North Korea might have been less significant than the drive to articulate two contrasting Koreas, thereby reiterating and confirming the distinct cultural and national identity of the South. In fulfilling this nationalistic aim, Chaoxianzu musicians were accessible as colleagues who had previously experienced and continue to maintain their knowledge about the music of the North. However, these musicians' performances were about more than the mere representation of the North or an enactment of bringing the two Koreas together. By hybridizing and moving flexibly between the two political poles, Chaoxianzu musicians blur and rearticulate the social or cultural boundaries imagined among different groups of Koreans.

The Sŏngnam concert thus exemplifies "the metaphor of calibration," which Ramnarine (2007) states "is the emphasis on things not fitting, on adjustments in the musical and social worlds, and on the contradictions between discourses . . .

[and] leaves a space for confronting the discomforts of diaspora as it converges with racism, discrimination, violence and inequality" (6). In reading the Sŏngnam concert it is revealed how the disjunctures, social inequality, and discrimination that are behind and part of contemporary Korean music scenes were carved into the representations projected by the event. There, the semantic metamorphosis of Chaoxianzu music problematizes and challenges the essentialist construction of Korean music as to what is and what is not included in that construction.

Pak Wich'ŏl has contributed to South Korean music through his compositional skill and experience with a range of orchestras including both Korean and foreign instruments; for her part, Kim Kyeok has trained musicians who can perform the new and emerging South Korean repertoire, while as a performer she has presented both North Korean and Chaoxianzu music to South Korean audiences. Similarly, Kim Ŭnhŭi enables South Korean audiences to experience North Korean culture with her singing, but her voice in fact encapsulates her multifaceted training in Chinese, Chaoxianzu, North Korean, and South Korean music, and the singer hopes her appeal extends to much broader audience groups beyond Korea. Whether through their anonymous musical collaborations with South Korean musicians, their supplying of musical arrangements rather than commissioned compositions, or their identification as North Korean musicians rather than Chaoxianzu, the key for these musicians' career-building capacity in South Korea is indeed their diasporic cultural identity. This identity is what enabled them to transcend and move between cultural and ethnic boundaries in the creation of music that can easily communicate with mass audiences.

The two major ideas deployed in the essentialization of North and South Korean music are innovation and the preservation of tradition. The work of Chaoxianzu musicians disturbs this bipartite division of Korea by suggesting a third space in between or beyond the two Koreas, one where creative diasporic subjects mediate and reconfigure what has been imagined as the sonic representation of the North and South. The performativity and flexible identity of diasporic Korean musicians are clear indications of how constructive, fluid, and permeable *ethnically labeled* music can be, unlike the simplistic discourse of cultural essentialism.

Conclusion

> Our everyday lives are crisscrossed by border zones, pockets,
> and eruptions of all kinds. Social borders frequently become
> salient around such lines as sexual orientation, gender, class,
> race, ethnicity, nationality, age, politics, dress, food, or taste.
> Along with "our" supposedly transparent cultural selves,
> such borderlands should be regarded not as analytically
> empty transitional zones but as sites of creative cultural
> production that require investigation.
> —Renato Rosaldo, *Culture and Truth*

THROUGHOUT this book, I attempted to reveal the construction of cultural particularity and identity of Chaoxianzu people, against two important state backdrops, that is, socialism and the minority nationality policy. Two Chaoxianzu musicians whom I met in Seoul in the early 2000s summarized their music as modernity and ethnic tradition in comparison with South Korea's musical conservatism and North Korea's cultural progressiveness (see introduction). They were probably correct that older forms of ethnic culture have been better preserved in South Korea, owing to the nation's cultural policy in part, and also to the form of nationalism that emerged in the post–Korean War era. Koreans in China and North Korea have, however, chosen to deviate from the older forms of Korean music as they created their own unique forms of national music in response to Communist imperatives that legitimized cultural development and adaptation. Nevertheless, given that Koreans in China had to also negotiate terrains of pan-Chinese homogenization and state-defined edicts concerning ethnic minorities, Chaoxianzu musicians have vigorously performed their agency in creating their own music that captures Chaoxianzu's unique experience as diasporic Koreans in China and reflects ongoing and emergent

relationships with both North and South Korea. Sometimes, ethnicity had to yield to citizenship, while at other times citizenship could embrace ethnicity.

Inspired by the discourse of Chaoxianzu music, a fusion of tradition with modernity, my study began as a desire to identify Chaoxianzu music as to what it is and locate its boundaries. What I have found, however, was not so much a category of sound nor a straightforward definition of what it is but rather how it has been the merger of creativity and flexibility of the people who intend to create their own ethnic music manifesting both Korean and Chinese identity. In characterizing their music, Chaoxianzu musicians often position it as in between the poles of South Korean tradition and North Korean modernization, and simultaneously distance their diasporic identity from both Koreas by way of their Chineseness. Such characterizations can perhaps never sufficiently account for the complex politics of diasporic Korean music in China whereby Chaoxianzu music and musicians constantly position and reposition themselves as both respecting and transcending the boundaries of Korean music. After drawing the musicscapes of Northeast China before and after the establishment of the PRC, with specific focus on the status of Korean music (see chapter 2), I have shown the types of musical construction carried out since the establishment of the PRC in demarcating Korean community and ethnic identity in the region against state imperatives, that is, the creation of a distinctive Chinese minority nationality culture (see chapter 3). Even so, Chaoxianzu were never completely controlled by state power. Ethnic music in China is also constructed and perpetuated through the efforts of individual musicians who have responded to the national and local governments' cultural policies with their creative input (chapters 4, 5, and 6).

I also demonstrated how these diasporic musicians injected into their work their own vision and philosophy of what Chaoxianzu music should be. In terms of finding an ethnically Chaoxianzu voice, the faculty at Yanbian Arts School have developed particular vocal production techniques that they believe capture the sound of Chaoxianzu: the cultural and stylistic ambiguity of the sound itself becomes the marker of their identity (chapter 6). Meanwhile, some musicians, such as composers in the Yanbian Song and Dance Troupe and Yanji Chaoxianzu Arts Troupe, demonstrate the heterogeneity of Chaoxianzu music to which individual musicians contribute, each with their own musical training and accordingly different choices of musical signs that convey Chaoxianzu identity (chapter 5). Stylistic and compositional variables in Chaoxianzu music are closely related not only to individual musicians' imagination of a Korean sound but also the underpinning ideologies of the different performing arts organizations with which Chaoxianzu composers are affiliated. Thus, Chaoxianzu compositions in post–Cultural Revolution China reaffirm that ethnic music is not the uniform representation of a homogeneous group but rather the

result of highly individualized interpretations and expressions of ethnicity (chapters 5). While this diversity flows from the musicians' relative freedom since the 1980s, we are simultaneously confronted with the creation of arts that are no longer rooted in common semantic references to Chaoxianzu or Korean ethnicity. My examination of Chaoxianzu musicians reveals that the musical identity of Chaoxianzu is also characterized by ambiguity, in that no one can provide a neat summary or description of it. It must be defined in multiple ways.

While a massive return migration of Chaoxianzu to South Korea was primarily driven by economic issues, a number of Chaoxianzu musicians visited South Korea with an interest in the traditional Korean music preserved in South Korea. The most recent discussion on Chaoxianzu music has been shifted in context to South Korea, to where more than five hundred thousand Chaoxianzu have moved over the last twenty years. Chaoxianzu musicians not only reshape who they are as diasporic and return migrant musicians in South Korea but also contribute to the contemporary musical landscape of the hegemonic group that views and treats them unequally (chapter 7).

This book's account of Chaoxianzu music has also aimed to show how diasporic Koreans in China have been affected by and reacted against old and recent social relationships that they have shaped and become entangled with, leading to the construction of today's unique Chaoxianzu identity. Geopolitically, historically, culturally, and ethnically speaking, Yanbian functions as a borderland. It has been a place of ambiguity located between China and Korea, and this ambiguity had facilitated the movement of Koreans into China and then their reconnection to their ancestral homelands, whether that is North or South Korea. Historians Adelman and Aron (1999), in their discussion of pre-nineteenth century frontier regions in America, instead describe a borderland where geographic, political, and cultural borders were not clearly defined and where native Indians and mestizos exploited their privilege in trading and negotiating with their European imperial rivals by playing one outside power off against another (814–815). Although Koreans were not indigenous to Yanbian, imperial power struggles ironically transformed the region into a politically ambiguous space where Koreans could enjoy relative freedom from Japan's colonial rule and avoid being caught between the poles of China and Japan. Perhaps, such a locational merit enabled a sizable number of Korean migrants to continue to reside in Yanbian after the peninsula was liberated from Japan, although that decision eventually cut them off from contact with South Korea for about three decades during the period of the Cold War. The mood of establishing diplomatic relations between the PRC and South Korea gradually allowed South Koreans to visit Yanbian as well as the rest of China from the late 1980s. Some South Koreans who had been separated from their relatives in North Korea before 1953 used Yanbian as a route into North Korea to search for

their family, helped by Chaoxianzu who had access to North Korea. In this region, Yanbian has served as a liminal zone where two ideologically and politically separate Koreas can meet. As much in the early twentieth century as today, Yanbian's border status makes it a place of endless possibilities—good or bad—where unusual, extraordinary, and new creation can take place. As James Clifford (1997) eloquently states, "When borders gain a paradoxical centrality, margins, edges, and lines of communication emerge as complex maps and histories," and this complexity results from *contacts* and *new relations* that make up "processes of displacement" (7). What one expects or might view as the "local" is already "translocal," constituted "with historical contact, with entanglement at intersecting regional, national, and transnational levels" (7).

Beginning in the mid-1990s, many Chaoxianzu families have experienced unexpected visits from their North Korean relatives who crossed the Sino-Korean border in search of financial and material support from their Chaoxianzu families or to begin their route of migration to liberal states such as South Korea. By passing and crossing Yanbian, some North Koreans become exiles while others return to North Korea with donations from their Chaoxianzu families. Not only do others shift and/or transcend social and political borders through Yanbian, but Chaoxianzu themselves also move in and out of their social borders. Each year, the Yanbian Korean Autonomous Prefecture loses population to the large industrial cities of China and to foreign countries including South Korea, whereas increasing numbers of Han Chinese residents in Yanbian weaken the justification of Yanbian continuing to be the autonomous region of the Korean minority nationality.

While Chaoxianzu have had the right to foster their own education system from preschool to university in Yanbian, a growing number of Chaoxianzu parents have been inclined to send their children to Chinese schools these days (*hanjok hakkyo; hanzu xuexiao*), hoping that their children can be linguistically and academically competent with Han Chinese. These younger-generation Koreans are more at home in Chinese than Korean while being influenced by multiple cultural hegemonies flown from inland China and South Korea. Although such a social transformation in Yanbian is not so different from elsewhere in the world, the geopolitical, ethnic, and cultural complexity observed in Yanbian today points not only to how the boundary between local and translocal has been blurred and crisscrossed by ever busier social traffics and contacts but also to how it forecasts new local creation out of innate complexity and enabled translocality.

After all, numerous musical activities described in this book, and that have striven to gain significance as Chaoxianzu sound cultures, can only make sense when viewed together with social, cultural, and geopolitical ubiquities that have conditioned and constituted the lives of Koreans in China. This study on

Chaoxianzu music, much of which is centered in Yanbian, a creative border-land, illustrate how the cultural politics of diaspora led to the diversification of Koreanness along with the shifting and merging ideological and political boundaries in Northeast Asia. It confirms that ethnic identity is never homogeneous but is instead a multiple and hybrid construction, permeable and fluid, constantly written and rewritten by active social agents expressing who they are and what they want to be. There is no single nation or state but rather people who demarcate and express their sense of belonging through imagining who they are and writing and rewriting their relations with states and nations.

NOTES

Introduction

1. For a discussion of voluntary and forced migration, see Kunz (1973) and Reyes (1986).

Chapter 1: China's Northeastern Border and Korean Migration to China

1. According to the statistics presented in Lee Kwang Kyu's *Overseas Koreans* (2000, 3), approximately 5.5 million Koreans live outside the Korean Peninsula. Of these, 1,926,017 were recorded as living in China, 1,661,032 in the United States, and 659,323 in Japan. Although the 2018 statistics on overseas Koreans reported by the South Korean Ministry of Foreign Affairs informed that the number of Koreans in the United States exceeded that of China by 85,596, until 2017 China had always been the country with the largest number of Koreans residing. See "Chaeoedongp'o chŏngŭi mit hyŏnhwang" [The Definition and Current Status of Overseas Koreans], December 2018, Ministry of Foreign Affairs, accessed 16 November 2020, http://www.mofa.go.kr/www/wpge/m_21507/contents.do. These Ministry of Foreign Affairs statistics do not distinguish Chaoxianzu from the overall numbers of Koreans in China. The 2010 population census of the People's Republic of China did count Chaoxianzu in particular, at 1,764,882. See "Tabulation on the 2010 Population Census of the People's Republic of China," National Bureau of Statistics of People's Republic of China, 29 April 2011, http://www.stats.gov.cn/tjsj/pcsj/rkpc/6rp/indexch.htm. Based on the census statistics, the size of the Chaoxianzu population has not been decreasing dramatically even though it is known that many have left China since the 1990s (and continue to do so today).

2. More than four hundred thousand South Koreans are estimated to have moved to China since the start of the PRC's industrial boom. As of 2011, between four and five thousand North Koreans were also living in the PRC with legal resident visas, while somewhere between twenty thousand and four hundred thousand North Korean border crossers were presumed to reside illegally in China. For further information on the status of Koreans in China, see Chang Yoonok (2006, 14).

3. In approximating the demographics of Koreans in China, North Korean border crossers are excluded due to uncertainty around their numbers and political affiliations.

4. Kwak (2013, 237) reports Yanbian's size as 42,700 km².

5. According to Chinese government census statistics, the forty-four townships consisted of nineteen in Heilongjiang, eleven in Jilin, thirteen in Liaoning, and one in Inner

Mongolia. Kwak (2013, 237) reports Chaoxianzu villages in Northeast China as numbering 491 in Heilongjiang, 273 in Jilin, and 144 in Liaoning, all together about nine hundred. Kwak's figures on Korean concentrations outside Yanbian, based on the 1990 statistics, differ from those of other scholars such as Olivier (1993, 188–192) and Pease (2002, 64), who list thirty-five Korean autonomous townships and 520 Korean autonomous villages.

6. See KOSIS data provided by the Bureau of Statistics in South Korea in its "2018yŏn iminja ch'eryusilt'ae mit koyongjosa kyŏlgwa" [2018 Statistics of Foreign Immigrants and Their Employment Status in South Korea], 18 December 2018, http://www.kostat.go.kr/portal /korea/kor_nw/1/1/index.board?bmode=read&aSeq=372125.

Chapter 2: Korean Music in China

1. The first modern Korean school established in Yanbian was Sŏjŏnsŏsuk School in Longjing. It was established in 1906 by Yi Sangsŏl, a member of the Korean royal family. Many more Korean schools were subsequently established in Northeast China. In Yanbian alone, 191 Korean schools were recorded in 1926, and 211 in 1928. All were private schools founded by Korean immigrants, expatriate intellectuals, or religious leaders (T. Kim 1992, 4).

2. *Nongak* features Korean percussion and melodic instruments. The main percussion instruments are *changgo* (hourglass drum, also called *changgu*), *puk* (barrel drum), *sogo* (small frame drum with handle), *ching* (large gong), and *kkwanggwari* (small gong). On these are played a series of folk rhythms, accompanied by one or two melodic instruments, such as *swaenap* (double-reed conical oboe; also called *t'aep'yŏngso*) or *p'iri* (double-reed cylindrical oboe). Today, many South Korean as well as international scholars in Korean music prefer to refer to this ensemble of predominantly percussion instruments as *p'ungmul* instead of *nongak*. Nevertheless, in this book the term *nongak* is kept since that name is mostly used by Chaoxianzu as well as North Korean scholars in their literature, and in the context of Chaoxianzu music, this music has been strongly associated with Korean peasantry and agrarian identity.

3. Also known as "Sin'gosan t'aryŏng" [Song of Sin'go Mountain].

4. Xinjing was the capital of Manchukuo and coincides with present-day Changchun in Jilin, Northeast China. See Chaoxianzu Music Organization (2005, 26).

5. For native Korean scholars' views and discourses on *sinminyo*, see related discussions in Hilary Finchum-Sung (2006). Also, Son Min Jung (2006) provides a brief historical anecdote on the beginnings of Korean popular music in her discussion of *t'ŭrot'ŭ* or *ppongtchak* (the oldest style of Korean popular music), often undifferentiated from early twentieth-century *yuhaengga*, a term that at the time covered somewhat broad musical terrain and was not limited to one particular style of music.

6. In 1928 there were 621 schools in Manchuria with 29,264 Korean students enrolled. In his book, Lee Chae-Jin (1986, 35–36) lists seven types of schools attended by Korean students.

7. Koreans are seen as the only ethnic minority in China to exceed the Han majority in terms of overall achievement in education and completion of college. For a more comprehensive view of the history of Korean education and educational systems, see C.-J. Lee (1986).

8. In the second half of the twentieth century, this function shifted to Yanji. Today Longjing is one of several autonomous cities in the Yanbian Korean Autonomous Prefecture.

9. Interviews with Kim Chin, 18 March 2005, and An Kungmin, 23 June 2005.

10. Statistical discrepancies are observed in Korean demographic figures both in terms of the number in China as well as the number that returned to Korea around 1945. According to Lee Hun, the Chaoxianzu population reached 2,163,115 by 1945; with the liberation around 700,000 returned to Korea, with 1.5 million remaining in the Northeast and later becoming Chinese citizens (see H. Lee 2005, 11). Although sizable differences are found in estimates of these figures, a number of sources agree that about 1.5 million Koreans remained in China.

11. The Lu Xun Academy of the Arts was established in Yan'an in 1938. The school consisted of four departments: literature, theater, music, and art. It produced over eight hundred graduates who completed one- or two-year programs during the war against Japan (Lufkin 2016, 144).

12. See chapter 3 for further details regarding the founding of the Yanbian Korean Autonomous Prefecture and the designation process of Koreans as a PRC minority nationality.

13. Pease (2002, 53) refers to this collection as the Folksong Edition of the Korean Folk Arts Material Collection.

14. Most traditional Korean rhythmic cycles are composed of triple or compound triple meter. Examples of such rhythmic cycles are *chinyangjo, chungmori, chungjungmori, chajinmori, kukkŏri, semach'i, t'aryŏng,* and *manjangdan.*

15. *Ch'angguk* is a genre of musical theater that emerged in the early twentieth century. It is considered as a more elaborate and expanded setting of traditional *p'ansori* in terms of scale of stage production and includes a larger number of performers, more theatrical props, and elaborated instrumentation.

16. "A Brief Overview of China's Cultural Revolution," *Encyclopaedia Britannica,* accessed 11 July 2019, https://www.britannica.com/story/chinas-cultural-revolution.

17. The model operas were rooted in the Beijing opera tradition and were revolutionary in content. Some of them incorporated Western orchestral instruments and dance styles. They were *The Legend of the Red Lantern, Shajiabang, Taking Tiger Mountain by Strategy, Raid on the White Tiger Regiment, Eulogy to the Dragon River,* and *On the Dock;* the two ballets were *Red Detachment of Women* and *The White-Haired Girl.*

18. Lin Biao was a Chinese general who was pivotal in the Communist victory in the Chinese Civil War, especially in Northeast China, and whose power in the 1960s and through the initial stage of the Cultural Revolution was second only to that of Chairman Mao. He died suddenly in 1971 in controversial circumstances.

19. Interview with An Kungmin, 23 June 2005.

20. If those Chaoxianzu who have been naturalized as South Koreans and who are illegal migrants are included in the figures, the total Chaoxianzu population in South Korea is 700,000 or more. See "Kungnae chosŏnjok 80manmyŏng . . . ibangin anin ibangin" [800,000 Chaoxianzu residents in South Korea . . . not foreigners but foreigners], *Hankuk ilbo* [Korea Daily News], 19 December 2015, https://www.hankookilbo.com/News/Read /201512190423165911.

21. In terms of volume of material, more Chaoxianzu traditional music was collected than what appeared in the anthology. The Chaoxianzu Music Organization (2005, 303–309) reported that according to the records of the local committee, about 1,500 *minyo,* 100 instrumental pieces, 150 theatrical pieces, and 15 instruments were collected in all.

22. Cho Sunhŭi later published a series of *kayagŭm* transcriptions of *sanjo* by Kim Ch'angjo, An Kiok, Yu Tonghyŏk, Ch'oe Oksam, Chŏng Namhŭi, and Kim Kwangjun for her students (see chapter 4).

23. Interview with Kim Sŏngsam, 28 June 2005.

24. Interviews with Hwang Ch'angju, 18 June 2005, and Kim Kyŏngae, 13 July 2005.

25. In 2017 these radio and television stations were merged to become Yanbian Radio TV Station (Yŏnbyŏn najio TV pangsongguk), although YBTV continues to be used as its acronym.

Chapter 3: The Construction of Chaoxianzu Musical Identity

1. Determining what year the Yanbian Song and Dance Troupe was founded can be confusing. The official date of foundation is 1953 (Um 2013, 50), yet performances were documented going back as far as 1949, the year the PRC was founded. The discrepancy may be due to the different names used to refer to what was essentially the same group. For example, the organization that preceded the Yanbian Song and Dance Troupe (Yŏnbyŏn kamudan) was the Yanbian Culture and Arts Work Team (Yŏnbyŏn mun'gongdan), into which various Korean performing arts groups in China were merged as Yanbian became the hub of Korean culture and was designated the Korean Autonomous Prefecture.

2. Interview with An Kungmin, 23 June 2005.

3. Interview with Kim Chin, 18 March 2005.

4. Among China's many nationalities, Chaoxianzu have demonstrated high levels of achievement in education (C.-J. Lee 1986; Gladney 1998). The first decade after the founding of the PRC was a golden period for minority nationality education, and in Yanbian, quite a few Korean schools were established at the primary and secondary levels. By 1956, out of forty secondary schools in Yanbian, thirty were Korean and two were mixed Korean-Han (C.-J. Lee 1986, 71). The Northeast Korean People's University was established in April 1949, even before the founding of the PRC. It was the first institution of higher education established by and for a minority nationality in China. The university was later renamed Yanbian University (Yŏnbyŏn Taehak; Yanbian Daxue). In its first year, 490 students enrolled in classes in the arts, science, medicine, agronomy, and engineering (C.-J. Lee 1986, 61). All instruction was in Korean.

5. The institutions where Chaoxianzu youths studied include the Central Conservatory of Music (Chungang ŭmak hagwŏn; Zhongyang yinyue xueyuan), Central University of Nationalities (Chungang minjok hagwŏn; Zhongyang minzu daxue), Shanghai Conservatory of Music (Sanghae ŭmak hagwŏn; Shanghai yinyue xueyuan), Shenyang Conservatory of Music (Simyang ŭmak hagwŏn; Shenyang yinyue xueyuan), Jilin Arts School (Killim ŭmak hakkyo; Jilin yinyue xuexiao), Northeast Normal University (Tongbuk sabŏm taehak; Dongbei shifan daxue), and Harbin Normal University (Haŏlbin sabŏm taehak; Harbin shifan daxue), as well as North Korea's Ch'oe Sŭnghŭi Dance Institute (Ch'oe sŭnghŭi muyong yŏnguso) and P'yŏngyang College of Music and Dance (P'yŏngyang ŭmak muyong taehak) (T. Kim 1992, 13).

6. The number of *Yŏngsan hoesang* suits is cited differently by different scholars and literature in Korean music. According to Kim Hee-sun, it ranges from five to fifteen pieces (2007).

7. Interview with Kim Chin, 18 March 2005.

8. It is hard to guess whether the extra string was originally added to the lower or higher edge by comparing today's twelve-string and thirteen-string *kayagŭm* since Chaoxianzu tuning has also deviated from traditional practice. Interview with An Kungmin, 23 June 2005.

9. Like most other traditional Korean instruments whose sizes vary according to whether they are used for *minsogak* or *chŏngak,* for *chŏttae* the *minsogak* version is the shorter one.

10. *Nonghyŏn* refers to vibrato on Korean stringed instruments; *yosŏng* is the equivalent for wind instruments.

Chapter 4: The Chaoxianzu *Kayagŭm*

1. Interview with Kim Chin, 18 March 2005. All personal recollections and quotations in the following passages come from this interview.

2. There are some discrepancies in recollections of this performance. While Kim Chin argues that the composition was a *kayagŭm* concerto and that he was a soloist at the performance, An Kungmin and others state that it was an orchestra-only arrangement, with at least fifty Chaoxianzu musicians on stage that day.

3. According to Hwang et al. (2002), Kim Chin's 1957 *kayagŭm* transcriptions of Kim Ch'angjo's and An Kiok's *sanjo,* as well as two *kayagŭm sanjo* collections published by Cho Sunhŭi (1983) and an anonymous author (1987), contain *chinyangjo.*

4. As pointed out earlier, the emphasis and practice of personalization of *sanjo* music in South Korea has been far less than that in traditional Korea.

5. Personal communication with Lee Byong Won, 1 October 2005.

6. Interview with Cho Sunhŭi, 22 June 2005. All personal recollections and quotations in the following passages come from this interview.

7. Kim Chin's *kayagŭm* books, which I was able to look at in Yanbian, left the "Chinyangjo" movement out from An Kiok's and Kim Ch'angjo's *sanjo.*

8. Interview with Kim Sŏngsam, 1 June 2005.

9. Ibid.

10. Interview with Kim Sŏngsam, 28 June 2005.

11. Ibid.

12. Interview with Kim Sŏngsam, 20 May 2005.

13. Ibid.

Chapter 5: Musical Signs and Essentializing Chaoxianzuness

1. The term "strategic essentialism" was coined by Gayatri Chakravorty Spivak, a postcolonial feminist philosopher and literary theorist who discussed it in her explanation of essentialist positions taken by postcolonial and subaltern agents in their expression and construction of identity. For more on this, see Spivak (1993).

2. These were the Antu Arts Troupe (1957), Changbai Korean Autonomous District Song and Dance Troupe (1958), Heilongjiang Mudanjiang Korean Song and Dance Troupe (1981), Helong Arts Troupe (1957), Hunchun Arts Troupe, Longjing Arts Troupe (1951), Tumen Arts Troupe (1970), Wangqing Arts Troupe, Yanbian Radio and Television Broadcasting Arts Troupe (1978), Yanbian Song and Dance Troupe (established in 1947 as the Yanbian Culture and Arts Work Team), Yanbian University [Yanbian Arts School] Arts Troupe (1957), and Yanji Chaoxianzu Arts Troupe (1981). More than half of these groups are now defunct; only relatively larger organizations under Yanbian, Yanji, and Changbai government sponsorship continue to exist (H. Lee 2005, 91).

3. Interview with An Kungmin, 23 June 2005; interview with Pak Sesŏng, 17 June 2005.

4. The section titles in the composer's own manuscript and those found in published versions of it, such as *Jinlinsheng wushinian wenyi zuopinxuan, 1949–1999,* do not agree.

5. Interview with An Kungmin, 23 June 2005. All personal recollections and quotations in the following passages come from this interview.

6. "Naŭi saldŏn kohyang ŭn" [My Hometown Where I Lived] is the opening phrase of a well-known Korean children's song, "Kohyang ŭi pom" [Hometown Spring]. This song was composed by Hong Nanp'a with text by Yi Wŏnsu. Since its introduction in 1926, it has become one of the most widely known songs among Koreans.

7. Interview with Pak Sesŏng, 17 June 2005. All personal recollections and quotations in the following passages come from this interview.

8. Perhaps the "ethnic traditions," "ethnic music," or "traditional music" of Chaoxianzu must also be distinguished from the "tradition" or "traditional music" of other diasporic Korean groups or from those practiced in the home country, even as Chaoxianzu traditions are seen as specific signs that stand for "Korean tradition" for people in Yanbian, and more broadly in China.

9. Interview with Kim Sunhwa, 25 June 2005.

10. The instrument is North Korea's representative zither invented in the 1970s by combining the mechanism of the *yanggŭm* (hammered dulcimer) with *kayagŭm* playing techniques.

11. Interview with An Kyerin, 20 June 2005. All personal recollections and quotations in the following passages come from this interview.

12. Hundred Chicken Feast (百鸡宴) is particularly known as an accompanying ritual for the Chinese New Year celebration practiced in Zhanjiang, a prefecture-level city, located at the southwestern end of Guangdong Province, People's Republic of China. See "Baijiyan" [Hundred Chicken Feast], Baidu Baike [Baidu Encyclopedia], accessed 20 November 2020, https://baike.baidu.com/item/%E7%99%BE%E9%B8%A1%E5%AE%B4/71980.

13. *Salp'uri* is a Korean folk/traditional rhythm used in shamanic ritual music in the southeastern provinces of Korea.

14. Interview with Hwang Ch'angju, 21 June 2005. All personal recollections and quotations in the following passages come from this interview. Here, *sanjo* can be understood as a reference to traditional Korean music in general.

15. A contrasting section after C, section d, is labeled in lowercase to reflect its short duration.

16. *Samullori*—also spelled as *samul nori*—is a neotraditional percussion style invented in 1978 in South Korea. It has been considered as a successful modern adaptation of traditional farmers' band music. The ensemble consists of four instruments: *puk, changgo, kkwaenggwari,* and *ching.*

Chapter 6: Chaoxianzu Vocal Music

1. Interview with Chŏn Hwaja, 3 July 2005. All personal recollections and quotations in the following passages come from this interview.

2. *Naver Dictionary,* s.v. "*kasŏng,*" accessed 15 August 2017, http://krdic.naver.com/detail.nhn?docid=253900.

3. Interview with Kim Sunhŭi, 16 June 2005; my translation.

4. Interview with Pak Ch'unhŭi, 17 June 2005; interview with Kim Sunhŭi.

5. http://www.iybtv.com, accessed 17 August 2017.

6. The Korean word "*t'ŭrot'ŭ*" (trot) is derived from the English word "foxtrot," an American dance style. It was originally used as a general term to describe Korean popular music in duple meter; it has become the name of a particular genre over time.

7. Not to be confused with the Chaoxianzu *kayagŭm* musician Kim Sŏngsam, extensively discussed earlier in this book. To differentiate them, I refer to the singer as *kasu* or singer Kim Sŏngsam.

8. *Palladŭ,* another Korean popular music genre, features lyrical songs with themes such as love, longing, nostalgia, and separation, often slow to moderate in tempo.

9. All song translations are my own.

10. Interview with Lim Pongho, 23 June 2005.
11. Interview with Kim Hun, 7 June 2005.

Chapter 7: Returning to a Home Never Lived In?

1. "Return migrants" and "return migration" are terms adopted from Takeyuki Tsuda's introduction to his edited volume *Diasporic Homecomings: Ethnic Return Migration in Comparative Perspective*, in which he defines return migrants as "later-generation descendants of diasporic peoples who 'return' to their countries of ancestral origin after living outside their ethnic homelands for generations" (2009a, 1).

2. The closest translation of *chŏnt'ong ŭmak* is "traditional music." The term embraces a range of sounds and practices that can be related to an "old," "past," or "traditional" identity of Korean music. In South Korea, *chŏnt'ong ŭmak* also goes by other names, such as *kugak* (or *gugak*), literally meaning "national music," and *uri sori,* literally "our sound," terms that have been used interchangeably. While in South Korea traditional music has been a marker of national identity, as the name *kugak* implies, in North Korea there has been little emphasis on *chŏnt'ong* (tradition) as a marker of national music or even as a concept. Instead, *chuch'e* (self-reliance) music has come to represent the unique cultural identity of North Korea.

3. "Kyŏnggi Arirang" is also known as "Ponjo Arirang." Numerous versions of "Arirang" are found in Korea and its overseas communities. A version of "Ponjo Arirang" was featured in director Na Un'gyu's famous feature film *Arirang,* released in 1926. The film depicts a Korean man, Ch'oe Yŏngjin, who becomes mentally unstable after participating in the historic protest against the Japanese colonial government on 1 March 1919. On the back of the film's enormous success, the "Kyŏnggi/Ponjo Arirang" tune shot to popularity in Korea and neighboring countries (Maliangkay 2002, 228). For Koreans, "Arirang" acted as a sonic metaphor for historic Korea and evoked national sentiment against Japanese colonialism. The song has remained popular over time; both North and South Korea as well as the Korean diasporas have used it as a sonic emblem representing Korea.

4. The few works available in English include those of Rowan Pease (2002, 2006, 2013, 2015, 2016), Haekyung Um (2004b, 2013), and Sunhee Koo (2007, 2008, 2010, 2011). South Korean scholar Chun In Pyong (Chŏn Inp'yŏng) published *Chaechung kyop'o ŭi muhyŏng munhwajae* [Intangible Cultural Properties of the Koreans in China] (2003), while South Korean *kayagŭm* player Yang Sŭnghŭi introduced Chaoxianzu *kayagŭm* music in her monograph (with coauthor Pak Ch'ŏl) dealing with Kim Ch'angjo's *kayagŭm sanjo* (2000) and in her study of written documents on Kim (2001).

5. See "Act on the Immigration and Legal Status of Overseas Koreans," Korea Law Translation Center, 29 May 2016, http://elaw.klri.re.kr/kor_service/lawView.do?hseq=38886 &lang=ENG.

6. Although the school uses "Pusan University" as its English name, the South Korean government, following its adoption of the Revised Romanization system in 2000, changed the official spelling of Pusan, the capital city of South Kyŏngsang Province, to Busan.

7. "Gayastra" (Kayasŭt'ŭra) is a portmanteau, combining the first two syllables of "*gayageum*" (*kayagŭm*) and the last syllable of "orchestra."

8. Instead of the traditional twelve-string pentatonic *kayagŭm,* Gayastra musicians use the twenty-five-string heptatonic version.

9. Interview with Pak Wich'ŏl, 21 June 2011. All personal recollections and quotations in the following passages come from this interview.

10. The numbers of *kayagŭm* strings vary between the states—North Korea, China, and South Korea—where the instrument is used. All versions having twenty-one, twenty-three, or twenty-five strings were built as heptatonic instruments and involved the same types of changes to the traditional twelve-string *kayagŭm*.

11. Interview with Kim Kyeok, 29 June 2011. All of Kim's personal recollections and quotations in the following passages come from this interview.

12. Interview with Chun In Pyong, 28 June 2011.

13. "Chaoxianzu Singer Ŭn Hŭi Ji [Kim Ŭnhŭi]," *Jilin Newspaper,* 27 July 2011, http://www.jlcxwb.com.cn/sports/content/2011-07/26/content_59279.htm.

GLOSSARY

THIS glossary contains terminology from the text related to Chaoxianzu and their music in Korean and corresponding Chinese characters, and pinyin where applicable. Included are (1) general terminology; (2) musical terminology; and (3) place-names. Terms are listed in alphabetical order in the language in which they appear in the text.

General Terminology

In the first column, romanized Chinese words are distinguished from Korean ones with (C). Elsewhere romanized Korean words are supplemented with *hangŭl*, Chinese characters, and pinyin when necessary; English terms are supplemented with *hangŭl*, Korean romanization, and pinyin.

Terms	Hangŭl (Chinese)	Korean—MR	Pinyin	Meaning
Anti-Rightist Movement	반우파 운동 (反右派運動; 反右運動)	*Panup'a undong*	*Fanyou yundong*	Chinese political campaign in 1957–1958 resulting in a purge of dissidents
Chaoxian (C)	조선 (朝鮮)	*Chosŏn*		Korea's last dynasty (1392–1910)
Chaoxianzu (C)	조선족 (朝鮮族)	*Chosŏnjok*		A contraction of *Chaoxian minzu*; the official designation for the Korean minority nationality in China
Chinese Civil War				Nationalist-Communist War (1927–1950)
Chinese People's Political Consultative Conference (CPPCC)	중국인민정치 협상회의 (中國人民政治協商會議)	*Chungguk inmin chŏngch'i hyŏpsang hoeŭi*	*Zhōngguo renmín zhengzhi xieshang huiyi*	A consultative body whose members represent various social groups
Chosŏn	조선	*Chosŏn*		See Chaoxian
Chosŏnjok	조선족	*Chosŏnjok*		See Chaoxianzu
Chosŏn ŭiyonggun	조선 의용군 (朝鮮義勇軍)		*Chaoxian yiyongjun*	Korean volunteer army or militia

Terms	Hangŭl (Chinese)	Korean—MR	Pinyin	Meaning
chuch'e sasang	주체사상 (主體思想)			Self-reliance doctrine or ideology; Kim Ilsŏng's slogan and philosophy of independence and self-sufficiency, which, as official ideology, had a great impact on the shape of North Korean culture and arts since the 1960s
Culture and Arts Work Team	문공단 (文工團)	*mun'gongdan*	*wengongtuan*	Military unit specializing in performing arts during the period of the Communist Revolution in China before 1949
Fengjin (C)	봉금 (封禁)	Ponggŭm		Qing dynasty policy that prohibited immigration to the sacred land of the Qing dynasty ancestors
Great Leap Forward Movement	대약진 운동 (大躍進運動)	Taeyakchin undong	Dayuejin yundong	Economic modernization movement initiated by Mao and conducted by the CCP, 1958–1962
Hundred Flowers Campaign	백화운동 (百花運動)	Paekhwa undong	Baihua yundong	Period in the CCP between 1956 and 1957 when people were encouraged to come up with a variety of solutions and ideas to solve current problems; its slogan was "Let a hundred flowers bloom, let a hundred schools of thought contend"
Intangible Cultural Asset System	무형문화재법 (重要無形文化財法)	Muhyŏng munhwajaebŏp		South Korean government program to protect traditional arts and culture
minjian (C)	민간 (民間)	*mingan*		Folk; people
minzu (C)	민족 (民族)	*minjok*		Nation; nationality

General Terminology (*continued*)

Terms	Hangŭl (Chinese)	Korean—MR	Pinyin	Meaning
minzu gongzuo (C)	민족공작 (民族工作)	*minjok kongjak*		A large-scale survey and research project on Chinese minority cultures that was carried out all over China as a major government initiative
National People's Congress, the Legislature (NPC)	중국 인민 대표 대회 (中华人民共和国全国人民代表大会)	Chunghwa inmin kongwaguk inmin taep'yo taehoe	Zhonghua renmin gongheguo renmin daibiao dahui	The national legislature of the People's Republic of China; the highest state body in the PRC, where minorities and Han are represented by a proportional number of deputies; a unicameral legislature with the power to legislate, oversee the operations of the government, and elect the major officers of the state
propaganda team	선전대	*sŏnjŏndae*		Teams established under the Korean militia in China that fought in the Chinese Civil War from 1938 to the end of the Korean War in 1953
zizhiqu (C)	자치구	chach'igu		Minority nationality autonomous region; equivalent to a province
zizhixian (C)	자치현	chach'ihyŏn		Minority nationality autonomous county
zizhixiang (C)	자치향	chach'ihyang		Minority nationality autonomous village
zizhizhou (C)	자치주	chach'iju		Minority nationality autonomous prefecture

Musical Terminology

Terms	Hangŭl	Pinyin	Meaning
aak	아악	yayue	"Elegant music"; court ritual music
ch'angdam	창담	changtan	A Chaoxianzu sung narrative art form
changdan	장단		Rhythmic cycles; examples of traditional Korean rhythms include *chinyangjo, chungmori, chungjungmori, chajinmori, hwimori, ŏnmori, kukkŏri, semach'i, t'aryŏng, manjangdan*
ch'angga	창가	changge	Song or school song that emerged in Korea at the start of the twentieth century, usually with a didactic message
changgo or changgu	장고/장구		Hourglass-shaped drum
ch'anggŭk	창극		Modern and elaborated form of *p'ansori*
changswaenap	장쇄납		Conical oboe; long version of *swaenap*
chapka	잡가		Literally means "miscellaneous songs"; traditional Korean folk songs sung by professional musicians rather than amateur or folk artists
ching	징		Large gong
chinsŏng	진성		True and natural voice
chŏngak	정악		Music of the aristocracy or literary class
chŏnt'ong	전통		Old tradition
Chosŏnjok kayo or Chosŏnjok taejung ŭmak	조선족 가요		Chaoxianzu songs composed by Chaoxianzu composers; distinguished from traditional Korean folk songs or popular songs produced in Korea; see *yŏnbyŏn kayo* or *yŏnbyŏn norae*
chŏttae	젓대		See *taegŭm*

Musical Terminology (*continued*)

Terms	Hangŭl	Pinyin	Meaning
chuch'e ch'angbŏp	주체창법		Post-1960s North Korean national voice or singing style
chuch'e ŭmak	주체음악		Post-1960s North Korean national music
chunggŭm	중금		Alto *taegŭm;* see *taegŭm*
ch'wijuak	취주악		Marching band music
dizi (C)			Chinese bamboo transverse flute
gangtai pop (C)			Chinese popular music produced in Hong Kong and Taiwan
geming gequ (C)	혁명가요		Revolutionary song
guzheng (C)			Chinese twenty-one-string zither
haegŭm	해금		Traditionally, a two-string spike fiddle with silk strings; Chaoxianzu musicians use a four-string version; see also *illamgŭm* and *so-haegŭm*
han	한		Korean ethos; resentment, bitterness, unresolved anger
hanbok	한복		Korean traditional dress
heterophony			Multiple lines of sound moving simultaneously while rendering one central melody
honsŏng ch'angbŏp	혼성창법		Chaoxianzu vocal style produced by alternating between head voice (*kasŏng*) and chest/throat voice (*chinsŏng*)
hyŏndaesŏng	현대성		Modernity
illamgŭm	일남금		Chaoxianzu four-string version of the *haegŭm;* instrument body modeled after the head of the *kayagŭm;* also called *yŏnbyŏngŭm*
jiangnan sizhu (C)			Silk and bamboo ensemble from south of the Yangzi River
kagok	가곡		Art songs of vernacular origin and of Western Classical music
kasŏng	가성		Artificial or falsetto voice

Musical Terminology (*continued*)

Terms	Hangŭl	Pinyin	Meaning
kayagŭm	가야금		Originally twelve-string zither; modern versions are found with twenty-one to twenty-five strings
kkwaenggwari	꽹과리		Small gong
kŏmun'go	거문고		Six-string zither plucked with a bamboo stick
koto			Thirteen-string Japanese zither
kugak	국악		Traditional Korean or national music of South Korea
kukkŏri	굿거리		Korean rhythm or rhythmic cycle
kun'ga	군가	*junge*	Army song
kuyŏndan	구연단		Narrative arts company
kwangdae	광대		Professional performing artists in traditional Korea
kwŏnbŏn	권번		School for Korean female entertainers
kyemong kayo	계몽가요		Songs for enlightenment
Kyŏnggi [Gyeonggi] minyo	경기민요		Folk song [style] from the central part of Korea
mingan yein	민간예인	*minjian yiren*	Folk artists
minjok sŏngak	민족성악	*minzu shengyue*	Ethnic/national voice
minjok ŭmak	민족음악	*minzu yinyue*	Ethnic/national music
minsogak	민속악		Folk music
minsŏng	민성	*minsheng*	Ethnic voice
minyo	민요	*minyao*	Traditional folk songs: *t'osok* or *hyangt'o minyo* (styles and repertoire are specific to a locality); *t'ongsok minyo* (popular folk songs sung across regions); *sinminyo* (newly introduced or commercial folk songs); and *chŏnt'ong minyo* (traditional folk songs)

Musical Terminology (*continued*)

Terms	Hangŭl	Pinyin	Meaning
model opera		*yang-banxi*	One of eight model works officially sanctioned during the Cultural Revolution, including six operas (one an operatic symphony) and two ballets
modŭmbuk	모듬북		A set of single-headed drums; recently invented in South Korea
monophony			Musical texture resulting from singing/playing in unison
musok ŭmak	무속음악		Korean shamanic music
namdo sori/namdo minyo	남도소리		Folk song [style] of southeastern Korea
nongak	농악		Korean farmers' band music
nongbuga	농부가		Farmers' song; Korean folk song
nonghyŏn	농현		Vibrato
norae yŏkkŭm	노래엮음		Song medley
ongryugŭm	옥류금		North Korean zither invented in the 1970s; now the most representative national instrument of North Korea
ŏrok kayo	어록가요		Quotation songs, especially those using Chairman Mao's quotations
p'ansori	판소리		Traditional sung drama with *puk* accompaniment
pipa (C)			China's four-string pear-shaped lute
p'iri	피리		Double-reed bamboo pipe; Chaoxianzu *p'iri* come in three different sizes—soprano, alto, bass—with a metal key attachment
puk	북		Barrel drum
pukhan'gŭm	북한금		See *so-haegŭm*
pukpyŏngch'ang	북병창		Chaoxianzu song narrative with *puk* accompaniment
p'yŏnggo yŏkkŭm	평고엮음		Song medley self-accompanied on a small hand drum

Musical Terminology (*continued*)

Terms	Hangŭl	Pinyin	Meaning
salp'uri	살풀이		Korean traditional rhythm
samullori/samul nori	사물놀이		Neotraditional percussion ensemble that arose in 1978 in South Korea, composed of four instruments: *puk, changgo, kkwaenggwari,* and *ching*
sanjo	산조		Solo instrumental music tradition
sigimsae	시김새		Bending or gliding notes or ornamenting notes in Korean traditional music
sijo	시조		A form of recitation of classical poetry
sinminyo	신민요		New Korean folk song introduced during the Japanese colonial period
sŏdo sori/sŏdo minyo	서도소리		Folk songs from northwestern Korea
sogŭm	소금		The smallest and highest-pitched bamboo transverse flute; see *taegŭm (chŏttae)*
so-haegŭm	소해금		Lit., small *haegŭm;* North Korean–invented spike fiddles, in four different sizes; *so-haegŭm* has the highest pitch range among the four; also known as *pukhan'gŭm*
sŏjŏng kayo	서정가요		Lyrical songs
swaenap	쇄납		Conical oboe; double-reed instrument; also called the *nallari* or *t'aep'yŏngso*
taegŭm	대금		Traditionally a bamboo transverse flute with a membrane; the Chaoxianzu version is made of hardwood in various sizes, with metal keys attached and no membrane
tan'ga	단가		Short song; also, prelude to *p'ansori*

Terms	Hangŭl	Pinyin	Meaning
tanso	단소		Short bamboo end-blown flute; the Chaoxianzu *tanso* has a metal key pad attached
t'aryŏng	타령		A form of folk song
tongsu yinyue (C)			Government-sanctioned Chinese popular music that emerged in the PRC in the 1980s
tongyo	동요		Children's songs
t'ungso	퉁소	*dongxiao*	Long vertical bamboo flute; longer than *tanso*
t'ŭrot'ŭ	트로트		A genre of Korean popular music characterized by an old-fashioned sound reminiscent of the early twentieth century songs
Yanbian color			Hybridity in Chaoxianzu music
Yanbian songs		*Yanbian geyao*	See *Yŏnbyŏn kayo*
yanggak	양악		Western music or music imported from the West
yanggŭm	양금		Korean name for hammered dulcimer
yangqin (C)			Chinese name for hammered dulcimer
Yŏnbyŏn ch'angdam	연변창담	*Yanbian changtan*	Chaoxianzu narrative art form
yŏnbyŏngŭm	연변금		See *illamgŭm*
Yŏnbyŏn kayo or *Yŏnbyŏn norae*	연변가요/ 연변노래		Chaoxianzu songs
Yŏnbyŏn saekch'ae or *saekkal*	연변색채/ 연변색깔		Yanbian color
Yŏngsan hoesang	영산회상		Suite of five to fifteen short pieces in the Korean *chŏngak* tradition
yuhaengga		*liuxingge*	Early twentieth-century popular song

Place-Names

Geographical references are listed in alphabetical order. Place-names appear primarily in the languages of the country in which they are located. Places in China are transcribed in pinyin followed by Chinese characters, *hangŭl*, and the McCune-Reischauer transcription and the 2000 Revised Romanization of Korean, whereas places in North and South Korea are given based on the McCune-Reischauer transcription followed by Chinese characters, *hangŭl*, and the 2000 Revised Romanization. A letter in parentheses indicates the country where the place is found (C = China and K = Korea). Brackets are used for additional clarification.

Place	Characters	Hangeul	Romanization of Korean
Antu (C)	安圖	안도	Ando
Beijing (C)	北京	북경	Pukkyŏng; Bukgyeong
Changbaishan [mountain] (C)	長白山	장백산	Changbaeksan; Jangbaeksan
Changbaixian (C)	長白縣	장백현	Changbaekhyŏn; Jangbaekhyeon
Changchun (C)	長春	장춘	Changch'un; Jang-chun
Chŏllado (K)	全羅道	전라도	Jeollado
Ch'ungch'ŏngdo (K)	忠淸道	충청도	Chungcheongdo
Dongbei [Northeast China] (C)	東北	동북	Tongbuk; Dongbuk
Hamgyŏngdo (K)	咸鏡道	함경도	Hamgyeongdo
Heilongjiang (C)	黑龍江	흑룡강	Hŭngnyonggang; Heukryonggang
Helong (C)	和龍	화룡	Hwaryong
Hunchun (C)	琿春	훈춘	Hunch'un; Hunchun
Inchŏn (K)	仁川	인천	Incheon
Jiandao [an area in Northeast China] (C)	間島	간도	Kando; Gando
Jilin (C)	吉林	길림	Killim; Gillim
Kangwŏndo (K)	江原道	강원도	Gangwondo
Kyŏnggido (K)	京畿道	경기도	Gyeonggido
Kyŏngsangdo (K)	慶常道	경상도	Gyeongsangdo
Liaoning (C)	遙寧	요녕	Yonyŏng; Yonyeong

Place-Names (*continued*)

Place	Characters	Hangeul	Romanization of Korean
Longjing (C)	龍井	용정	Yongjŏng; Yongjeong
Mudanjiang (C)	牧丹江	목단강	Moktan'gang; Mokdangang
Paektusan [mountain] (K)	白頭山	백두산	Baekdusan
P'yŏngando (K)	平安道	평안도	Pyeongando
P'yŏngyang (K)	平襄	평양	Pyeongyang
Shenyang (C)	沈陽	심양	Simyang
Sŏngnam (K)	城南	성남	Seongnam
Tumen (C)	圖們	도문	Tomun; Domun
Wangqing (C)	王淸	왕청	Wangch'ŏng; Wangcheong
Xincun (C)	新村	신촌	Sinch'on; Sinchon
Xinjing (C) [old name for Changchun]	新京	신경	Sin'gyŏng; Singyeong
Yan'an (C) [Yenan]	延安	연안	Yŏnan; Yeonan
Yanbian (C)	延邊	연변	Yŏnbyŏn: Yeonbyeon
Yanbian Korean Autonomous Prefecture (C)	延邊朝鮮族自治州	연변 조선족 자치주	Yŏnbyŏn chosŏnjok chach'iju; Yeonbyeon joseonjok jachiju
Yanji (C)	延吉	연길	Yŏngil; Yeongil

REFERENCES

General

Adelman, Jeremy, and Stephen Aron. 1999. "From Borderlands to Borders: Empires, Nation-States, and the Peoples in between in North American History." *American Historical Review* 104 (2): 814–841.

Anderson, Benedict. 1983. *Imagined Communities: Reflections on the Origin and Spread of Nationalism*. London: Verso.

Ang, Ien. 2003. "Together-in-Difference: Beyond Diaspora, into Hybridity." *Asian Studies Review* 27 (2): 141–154.

Arirang Nang-Nang. 2005. Liner notes to *Arirang Nang-Nang* [CD]. Yongin: Synnara Music NSC-143.

Atkins, E. Taylor. 2007. "The Dual Career of 'Arirang': The Korean Resistance Anthem That Became a Japanese Pop Hit." *Journal of Asian Studies* 66 (3): 645–687.

Baily, John. 2005. "So Near, So Far: Kabul's Music in Exile." *Ethnomusicology Forum* 14 (2): 213–233.

Bakhtin, M. M. 1981. *The Dialogic Imagination: Four Essays*. Edited by Michael Holquist. Translated by Caryl Emerson and Michael Holquist. Austin: University of Texas Press.

Baranovitch, Nimrod. 2001. "Between Alterity and Identity: New Voices of Minority People in China." *Modern China* 27 (3): 359–401.

———. 2003. *China's New Voices: Popular Music, Ethnicity, Gender, and Politics, 1978–1997*. Berkeley: University of California Press.

Barth, Fredrik. 1969. *Ethnic Groups and Boundaries: The Social Organization of Culture Difference*. London: Little, Brown.

Cathcart, Adam. 2010. "Nationalism and Ethnic Identity in the Sino-Korean Border Region of Yanbian, 1945–1950." *Korean Studies* 34: 25–53.

Ch'a, Sunbok. 2004. "Naega mannan chosŏnjok yesulga" [Chaoxianzu Artist Whom I Met]. *Yesul segye* [Arts World], May/June, 49–57.

Chang, Chinsŏk. 2009. "Chungguk chosŏnjok kiak ŭmak ch'angjak koch'al" [Study on the Development of Chaoxianzu Instrumental Music in China]. *Han'guk chŏnt'ong ŭmakhak* [Journal of the Society for Korean Traditional Musicology] 10: 239–248.

Chang, Yoonok [Chang, Yunok]. 2006. "North Korean Refugees in China: Evidence from a Survey." In *The North Korean Refugee Crisis: Human Rights and International Response*, edited by Stephan Haggard and Marcus Noland, 14–32. Washington, DC: U.S. Committee for Human Rights in North Korea.

Chaoxianzu Music Organization, ed. 2005. *20segi chungguk chosŏnjok ŭmak munhwa* [The Music Culture of the Korean Chinese in the Twentieth Century]. Beijing: Minjok ch'ulp'ansa [Nationality Publishing Company].

China Map Publication Company. 2005. *Jilinsheng dituce* [A Map of Jilin Province]. Beijing: China Map Publication Company.

Cho, Sunhŭi. 2000. "23hyŏn 7ŭmgye kayagŭm ŭi ch'angjak" [The Invention of Twenty-Three-String Heptatonic Kayagŭm]. *Yesul segye* [Arts World], September/October, 37–39.

Cho, Yumi. 2002. "Chunggungnae chosŏnjok kayagŭm ŭmak ŭi hyŏnhwang" [The State of Chaoxianzu Kayagŭm Music in China]. *Han'guk ŭmbanhak* [Korean Discography] 12: 89–99.

Ch'oe, P'ilsuk. 2014. "Sangai esŏ peijing kkaji tongnipt'ujaeng ŭi yŏjŏng" [From Shanghai to Beijing: Tracing the Korean Independence Movement in China]. In *Chungguk taeryugesŏ purŭnŭn t'aihangsan arirang* [Singing Arirang in Taihangshan, China], edited by Hanjung hangil yŏksa t'ambangdan [South Korean tribunal team investigating anti-Japanese movements in China], 161–188. Seoul: China House.

Ch'oe, Sanghwa. 2011. Program notes for *Hana toenŭn kyŏre ŭi ŭmak* [Unifying Korean National Music]. Sŏngnam (Seongnam) Arts Center Concert Hall, 23 June.

Chŏn, Hwaja. 1998. "Minjok sŏngak kwa sori hullyŏn" [Chaoxianzu Voice and Vocal Training]. *Yesul segye* [Arts World], September/October, 38–40.

———. 1999. "Uri chŏnt'ong minyo ŭi ŏje wa onŭl" [The Past and Present State of Our Traditional Music]. *Yesul segye* [Arts World], March/April, 30–32.

Chŏng, Howŏn. 2018. "Yŏnbyŏn chosŏnjok chach'iju in'gu" [The Demography of Yanbian Korean Autonomous Prefecture]. *Yŏnbyŏn ilbo* [Yanbian Daily], 9 May. http://www.iybrb.com/com/content/2018-05/09/55_307584.html#.

Chŏng, Wŏnsik. 2014. "Chosŏn ŭiyongdae [Chosŏn ŭiyonggun] wa taejangjŏng" [Great Journey with the Korean Militia in China]. In *Chungguk taeryugesŏ purŭnŭn t'aihangsan arirang* [Singing Arirang in Taihangshan, China], edited by Hanjung hangil yŏksa t'ambangdan [South Korean tribunal team investigating anti-Japanese movements in China], 102–160. Seoul: China House.

Chun, In Pyong [Chŏn, Inp'yŏng]. 2000/2001. *Saeroun han'guk ŭmaksa* [New Historicization of Korean Music]. Seoul: Hyŏndae ch'ulp'ansa [Hyŏndae Publishing Company].

———. 2003. "Chŏnt'ong ŭmak ŭi chŏnsŭng yangsang" [Transmission of Traditional Korean Music]. In *Chaejung kyop'o ŭi muhyŏng munhwajae* [Intangible Cultural Properties of Koreans in China], 1–48. Seoul: Kungnip munhwajae yŏn'guso [National Research Institute of Cultural Properties].

Clifford, James. 1997. *Routes: Travel and Translation in the Late Twentieth Century*. Cambridge, MA: Harvard University Press.

Cohen, Robin. 1997. "Diasporas, the Nation-State, and Globalisation." In *Global History and Migration*, edited by Wang Gungwu, 117–143. Boulder, CO: Westview.

D'Evelyn, Charlotte. 2014. "Driving Change, Sparking Debate: Chi Bulag and the *Morin Huur* in Inner Mongolia, China." *Yearbook for Traditional Music* 46: 89–113.

Donnan, Hastings, and Thomas M. Wilson. 1999. *Borders: Frontiers of Identity, Nation and State.* Oxford: Berg.

Duara, Prasenjit. 2003. *Sovereignty and Authenticity: Manchukuo and the East Asian Modern.* Lanham, MD: Rowman & Littlefield.

Eisenstadt, S. N. 2000. "Multiple Modernities." *Daedalus* 129 (1): 1–29.

Eriksen, Thomas Hylland. 2002. *Ethnicity and Nationalism.* 2nd ed. London: Pluto Press.

Erikson, Erik H. 1963. *Childhood and Society.* 2nd ed. New York: Norton.

———. 1968. *Identity: Youth and Crisis.* New York: Norton.

Felski, Rita. 1997. "The Doxa of Difference." *Signs* 23 (1): 1–21.

Finchum-Sung, Hilary. 2006. "New Folksongs: Sinminyo of the 1930s." In *Korean Pop Music: Riding the Wave,* edited by Keith Howard, 10–20. Folkestone, UK: Global Oriental.

Gladney, Dru C. 1998. *Ethnic Identity in China: The Making of a Muslim Minority Nationality.* Fort Worth, TX: Harcourt Brace College Publishers.

Greenfeld, Liah. 1992. *Nationalism: Five Roads to Modernity.* Cambridge, MA: Harvard University Press.

Hall, Stuart. 1980. "Encoding/Decoding." In *Culture, Media, Language,* edited by Stuart Hall, Dorothy Hobson, Andrew Lowe, and Paul Willis, 128–139. London: Hutchinson.

———. 1994. "Cultural Identity and Diaspora." In *Colonial Discourse and Post-Colonial Theory: A Reader,* edited by Patrick Williams and Laura Chrisman, 227–237. London: Harvester Wheatsheaf.

Han, Enze. 2013. *Contestation and Adaptation: The Politics of National Identity in China.* New York: Oxford University Press.

Han, Kuo-Huang, and Judith Gray. 1979. "The Modern Chinese Orchestra." *Asian Music* 11 (1): 1–43.

Han, Sangil. 2011. Program notes for *Hana toenŭn kyŏre ŭi ŭmak* [Unifying Korean National Music]. Sŏngnam Arts Center Concert Hall, 23 June.

Han, Sangu. 1989. *Pukhan ŭmak ŭi silsang kwa hŏsang* [The True and the False of North Korean Music]. Seoul: Sinwŏn Munhwasa.

Harrell, Stevan. 1995. "Introduction: Civilizing Projects and the Reaction to Them." In *Cultural Encounters on China's Ethnic Frontiers,* edited by Stevan Harrell, 3–36. Seattle: University of Washington Press..

———. 2001. *Ways of Being Ethnic in Southwest China.* Seattle: University of Washington Press

Hobsbawm, Eric, and Terence Ranger, ed. 1983. *The Invention of Tradition.* Cambridge: Cambridge University Press.

Howard, Keith, Chaesuk Lee, and Nicolas Casswell. 2008. *Korean Kayagŭm Sanjo: A Traditional Instrumental Genre.* London: Ashgate.

Hwang, Byungki. 1985. "Some Notes on Korean Music and Aspects of Its Aesthetics." *World of Music* 27 (2): 32–48.

Hwang, Chunyŏn, Sin Taechŏl, Kwon Tohŭi, and Sŏng Kiryŏn. 2002. *Pukhan ŭi chŏnt'ong ŭmak* [Traditional Music of North Korea]. Seoul: Seoul National University Press.

Iwabuchi, Koichi. 2002. *Recentering Globalization: Popular Culture and Japanese Transnationalism.* Durham, NC: Duke University Press.

Jones, Stephen. 2003. "Reading Between the Lines: Reflections on the *Massive Anthology of Folk Music of the Chinese Peoples.*" *Ethnomusicology* 47 (3): 287–337.

Killick, Andrew. 2017. "Traditional Music and the Work Concept: The *Kayagŭm Sanjo* of Hwang Byungki." *Yearbook for Traditional Music* 49: 1–25.

Kim, Hee-sun. 2007. "Pungnyu: Classical Instrumental Music." In *Music of Korea*, Korean Musicology Series 1, edited by Byong Won Lee and Yong-Shik Lee, 49–63. Seoul: National Center for Korean Traditional Performing Arts.

———. 2009. "Music of Sanjo." In *Sanjo*, Korean Musicology Series 3, edited by Yong-Shik Lee, 13–43. Seoul: National Center for Korean Traditional Performing Arts.

Kim, Illyun. 2009. Liner notes for *Beautiful Departure: The Present* [CD]. Seoul: Loen Entertainment.

Kim, Indŏk. 2012. "P'yŏngsaeng maŭmŭro kŭmhyŏn ŭl ttŭnnŭnda" [Lifetime Performance of Plucking a Korean Zither]. *Yŏnbyŏn ilbo* [Yanbian Daily], 2 July. http://m.iybrb.com/news-v/as[x?od=18452&t=1.

Kim, Namho. 2010. *Chungguk chosŏnjok chŏnt'ongŭmak—taejungŭmangnon* [Survey on Korean Chinese Music Traditions—on Popular Music]. Seoul: Minsogwŏn.

Kim, Sŏngsam. 2000. "Chungguk chosŏnjok akki kaehyŏg e taehan koch'al" [Survey of Chaoxianzu Instrument Modification]. *Yesul segye* [Arts World], March/April, 42–47.

Kim, Tŏkkyun, ed. 1992. *Chungguk chosŏn minjok yesul kyoyuksa* [Historical Survey on Korean Minority Nationality Education in the Arts]. Longjing: Tongbuk chosŏnminjok kyoyuk ch'ulp'ansa [Northeastern Korean Minority Nationality Education Press].

———, ed. 1997. *Yŏnbyŏn yesul hakkyo kansa* [Concise History of Yanbian Arts School]. Longjing: Tongbuk chosŏnminjok kyoyuk ch'ulp'ansa [Northeastern Korean Minority Nationality Education Press].

Kim, Tŏkkyun, and Kim Tŭkchŏn, eds. 1998. *Chosŏn minjok ŭmakka sajŏn* [Dictionary of Korean Musicians]. Yanji: Yŏnbyŏn taehak ch'ulp'ansa [Yanbian University Press].

Kim, Yep'ung. 2004. "Chosŏnjok minyo ŭi chŏnsŭng kwa pyŏnhyŏng e taehan ŭmak chŏk yŏn'gu" [A Study of Transmission and Change in Korean Chinese Folk Songs]. PhD diss., Academy of Korean Studies.

Kim, Yongbŏm. 2012. *Chungguk muhyŏng munhwa yusan chedo pyŏnhwa e taehan chŏngch'aek chŏk taeŭngbangan yŏn'gu* [Study and Prospectus on the Changing Policy of the PRC's Intangible Cultural Heritage Law]. Seoul: Korea Culture and Tourism Institute.

Ko, Yŏnggil. 2003. *Algi swiun uri minjok yŏksa* [An Easy Understanding of Our People and History]. Beijing: Minjok ch'ulp'ansa [Nationality Publishing Company].

Koo, Sunhee [Ku, Sŏnhŭi]. 2007. "Sound of the Border: Music, Identity, and Politics of the Korean Minority Nationality in the People's Republic of China." PhD diss., University of Hawai'i at Mānoa.

———. 2008. "Selective Identity: Korean Minority Composers and the Performance of Ethnicity in the People's Republic of China." *Asian Musicology* 12: 7–48.

———. 2010. "Inventing Ethnic Music: Vocal Music of the Korean Ethnic Minority in the People's Republic of China." *Asian Musicology* 16: 5–42.

—————. 2011. "Why Art Music in a Socialist State? Status and Adaptation of Sanjo in Yanbian Korean Autonomous Prefecture in the People's Republic of China." In *Perspectives on Korean Music*, vol. 2, edited by R. Anderson Sutton, 67-85. Seoul: Ministry of Culture, Sports, and Tourism.

Koo, Sunhee, and Sang-Yeon Sung. 2016. "Asia and Beyond: The Circulation and Reception of Korean Popular Music Outside of Korea." In *Made in Korea: Studies in Korean Popular Music*, edited by Hyunjoon Shin and Seung-Ah Lee, 203-214. London: Routledge.

KOSIS (Korean Statistical Information Service). 2018. *2018yŏn iminja ch'eryusilt'ae mit koyongjosa kyŏlgwa* [2018 Statistics of Foreign Immigrants and Their Employment Status in South Korea], 18 December 2018, http://www.kostat.go.kr/portal/korea /kor_nw/1/1/index.board?bmode=read&aSeq=372125.

Kunz, Egon F. 1973. "The Refugee in Flight: Kinetic Models and Forms of Displacement." *International Migration Review* 7 (2): 125–146.

Kwak, Sŭngji. 2013. *Chosŏnjok, kŭdŭrŭn nuguin'ga* [Chaoxianzu, Who Are They?]. Koyangsi (Goyangsi), South Korea: In'gansarang.

Lau, Frederick. 1995/1996. "Individuality and Political Discourse in Solo *Dizi* Compositions." *Asian Music* 27 (1): 133–152.

—————. 2001. "Performing Identity: Musical Expression of Thai-Chinese in Contemporary Bangkok." *SOJOURN* 16 (1): 38–69.

—————. 2007. *Music in China: Experiencing Music, Expressing Culture*. London: Oxford University Press.

Lee, Bo-Hyeong [Lee, Bo-hyung or Yi, Pohyŏng]. 1972. *Kayagŭm Sanjo*. Seoul: Munhwajae kwalliguk [Cultural Heritage Administration].

—————. 2009. "Social History of Sanjo." In *Sanjo*, Korean Musicology Series 3, edited by Yong-Shik Lee, 3–12. Seoul: National Center for Korean Traditional Performing Arts.

Lee, Byong Won [Yi, Pyŏngwŏn]. 1988a. "Musical Identity and Acculturation in the Yanbian Korean Autonomous Region of the People's Republic of China: An Overview." Paper presented at the Fifth International Conference on Korean Studies, Sŏngnam (Seongnam), Republic of Korea.

—————. 1988b. "Theory and Practice of the *Chuch'e* (Self-Reliance) Ideology on Music in the Democratic People's Republic of Korea." Paper presented at the Thirty-Third Annual Meeting of Society for Ethnomusicology, Tempe, Arizona.

—————. 1997. *Styles and Esthetics in Korean Traditional Music*. Seoul: National Center for Korean Traditional Performing Arts.

Lee, Chae-Jin [Yi, Ch'aejin]. 1986. *China's Korean Minority: The Politics of Ethnic Education*. Boulder, CO: Westview.

Lee, Hun [Yi, Hun]. 2005. "Chungguk chosŏnjok kongyŏn tanch'e e kwanhan ŭmak sahoesa chŏk yŏn'gu" [History of Music Sociology of a Korean-Chinese Public Performance Troupe]. PhD diss., Seoul National University.

—————. 2006. *Chungguk chosŏnjok kongyŏn tanch'e e kwanhan ŭmak sahoesa chŏk yŏn'gu* [History of Music Sociology of a Korean-Chinese Public Performance Troupe]. Yanji: Yŏnbyŏn inmin ch'ulp'ansa [Yanbian People's Press].

Lee, Kwang Kyu [Yi, Kwangkyu]. 2000. *Overseas Koreans*. Seoul: Chimmundang Publishing Company.

Litzinger, Ralph A. 2000. *Other Chinas: The Yao and the Politics of National Belonging.* Durham, NC: Duke University Press.

Lufkin, Felicity. 2016. *Folk Art and Modern Culture in Republican China.* Lanham, MD: Lexington Books.

Maliangkay, Roald. 2002. "The Revival of Folksongs in South Korea: The Case of *Tondollari.*" *Asian Folklore Studies* 61 (2): 223–245.

Manuel, Peter. 1988. "China." In *Popular Musics of the Non-Western World: An Introductory Survey,* 221–235. New York: Oxford University Press.

Mao, Zedong [Tse-Tung]. 1966 [1940]. "On New Democracy." In *Selected Works of Mao Tse-Tung,* vol. 2, 339–384. Beijing: Foreign Languages Press.

———. 1967 [1942]. "Talks at the Yenan [Yan'an] Forum on Literature and Art (May 1942)." In *Selected Readings from the Works of Mao Tse-Tung,* vol. 3, 204–233. Beijing: Foreign Languages Press.

Moskowitz, Marc L. 2010. *Cries of Joy, Songs of Sorrow: Chinese Pop Music and Its Cultural Connotations.* Honolulu: University of Hawai'i Press.

Nam, Hŭich'ŏl. 2016. "Chungguk hyŏngmyŏngŭmak ŭi sŏn'guja ch'oe ŭmp'a e taehayŏ" [Ch'oe Ŭmp'a, a Leader of Chinese Revolutionary Music]. *Ŭmakhak* [Journal of Musicology] 31: 93–124.

Negus, Keith. 1996. *Popular Music in Theory: An Introduction.* Middletown, CT: Wesleyan University Press.

Olivier, Bernard Vincent. 1993. *The Implementation of China's Nationality Policy in the Northeastern Provinces.* San Francisco: Mellen Research University Press.

Ong, Aihwa. 1996. "Cultural Citizenship as Subject-Making: Immigrants Negotiate Racial and Cultural Boundaries in the United States [and Comments and Reply]." *Current Anthropology* 37 (5): 737–762.

Ortner, Sherry B. 1984. "Theory in Anthropology since the Sixties." *Comparative Studies in Society and History* 26 (1): 126–166.

———. 2006. *Anthropology and Social Theory: Culture, Power, and the Acting Subject.* Durham, NC: Duke University Press.

Park, Chan E [Pak, Ch'anŭng]. 2003. *Voices from the Straw Mat: Toward an Ethnography of Korean Story Singing.* Honolulu: University of Hawai'i Press and Center for Korean Studies.

Park, Jung-Sun [Pak, Chŏngsŏn], and Paul Y. Chang. 2005. "Contention in the Construction of a Global Korean Community: The Case of the Overseas Korean Act." *Journal of Korean Studies* 10 (1): 1–27.

Pease, Rowan. 2002. "Yanbian Songs: Musical Expressions of Identity amongst Chinese Koreans." PhD diss., University of London.

———. 2006. "Healthy, National and Up-to-Date: Pop Music in the Yanbian Korean Autonomous Prefecture, China." In *Korean Pop Music: Riding the Wave,* edited by Keith Howard, 137–153. Folkestone, UK: Global Oriental.

———. 2013. "Broken Voices: Ethnic Singing and Gender." In *Gender in Chinese Music,* edited by Rachel Harris, Rowan Pease, and Shzr Ee Tan, 181–200. Rochester, NY: University of Rochester Press.

———. 2015. "'Asŭrang' (Dance Music): Buzz, Modernity, and Tradition in China." In *Pieces of the Musical World: Sounds and Cultures,* edited by Rachel Harris and Rowan Pease, 81–97. New York: Routledge.

———. 2016. "The Dragon River Reaches the Borders: The Rehabilitation of Ethnic Music in a Model Opera." In *Listening to China's Cultural Revolution: Music, Politics, and Cultural Continuities*, edited by Paul Clark, Laikwan Pang, and Tsan-Huang Tsai, 167–186. New York: Palgrave Macmillan.

Perris, Arnold. 1983. "Music as Propaganda: Art at the Command of Doctrine in the People's Republic of China." *Ethnomusicology* 27 (1): 1–28.

Quayson, Ato. 2003. *Calibrations: Reading for the Social.* Minneapolis: University of Minnesota Press.

Ramnarine, Tina K. 2007. "Musical Performance in the Diaspora: Introduction." *Ethnomusicology Forum* 16 (1): 1–17.

Reischauer, Edwin O., ed./trans. 1955. *Ennin's Diary: The Record of a Pilgrimage to China in Search of the Law.* New York: Ronald Press.

Reyes, Adelaida. 1986. "Tradition in the Guise of Innovation: Music among a Refugee Population." *Yearbook for Traditional Music* 18: 91–101.

———. 1989. "Music and Tradition: From Native to Adopted Land through the Refugee Experience." *Yearbook for Traditional Music* 21: 25–35.

———. 1999a. "From Urban Area to Refugee Camp: How One Thing Leads to Another." *Ethnomusicology* 43 (2): 201–220.

———. 1999b. *Songs of the Caged, Songs of the Free: Music and the Vietnamese Refugee Experience.* Philadelphia: Temple University Press.

———. 2014. "Identity Construction in the Context of Migration." *Il Saggiatore Musicale* 21 (1): 105–121.

Rice, Timothy. 2003. "Time, Place, and Metaphor in Musical Experience and Ethnography." *Ethnomusicology* 47 (2): 151–179.

———. 2007. "Reflections on Music and Identity in Ethnomusicology." *Muzikologija/Musicology* (Journal of the Serbian Academy of Sciences and Arts) 7: 17–38.

Rosaldo, Renato. 1993. *Culture and Truth: The Remaking of Social Analysis.* Boston: Beacon Press.

Russell, Mark J. 2008. *Pop Goes Korea: Behind the Revolution in Movies, Music, and Internet Culture.* Berkeley, CA: Stone Bridge.

Safran, William. 1991. "Diaspora in Modern Societies: Myths of Homeland and Return." *Diaspora* 1 (1): 83–99.

Sasse, Werner. 1991. "*Minjung* Theology and Culture." *Papers of the British Association for Korean Studies* 1: 29–43.

Schein, Louisa. 2000. *Minority Rules: The Miao and the Feminine in China's Cultural Politics.* Durham, NC: Duke University Press.

Seol, Dong-Hoon, and John D. Skrentny. 2009. "Ethnic Return Migration and Hierarchical Nationhood: Korean Chinese Foreign Workers in South Korea." *Ethnicities* 9 (2): 147–174.

Shuker, Roy. 2005. *Popular Music: The Key Concepts.* 2nd ed. Milton Park, UK: Routledge.

Sin, Ch'unho. 2011. "Simyang k'oria t'aun sŏt'ap kwa han'gungmunhwa" [Korean Culture and Xita Street in Shenyang Korea Town]. *Chaeoehanin yŏn'gu* [Journal of Overseas Koreans] 24: 173–233.

Sin, Kwangho. 2012. "Chungguk chosŏnjok kayagŭmyesul ŭi hyŏngsŏng kwa palchŏn" [The Formation and Development of Chaoxianzu Kayagŭm Music]. *Yŏksa minsokhak* [Journal of History and Folklore] 43: 299–323.

——. 2016a. "Chungguk chosŏnjok minjok sŏngagyesul ŭi hyŏngsŏng kwa palchŏn" [The Formation and Development of Chaoxianzu Vocal Music in China]. *Han'gukhak yŏn'gu* [Korean Studies Journal] 42: 315–341.

——. 2016b. "Kayagŭm sanjo ŭi chungguk chŏnp'a wa chŏnsŭng" [Dislocation and Transmission of Kayagŭm Sanjo in China]. *Kugakkyoyuk* [Journal of the Society for Korean Music Educators—SKME] 42: 133–147.

Sin, Okpun. 2012. *Yŏnbyŏn sŏngak ŭi sŏngŭm yŏn'gu* [Study of the Sound of the Yanbian Voice]. Seoul: Ch'aeryun Publishing Company.

Son, Min Jung [Son, Minjŏng]. 2006. "Highway Songs in South Korea." In *Korean Pop Music: Riding the Wave*, edited by Keith Howard, 72–81. Folkestone, UK: Global Oriental.

Song, Changzoo [Song, Ch'angju]. 2009. "Brothers Only in Name: The Alienation and Identity Transformation of Korean Chinese Return Migrants in South Korea." In *Diasporic Homecomings: Ethnic Return Migration in Comparative Perspective*, edited by Takeyuki Tsuda, 281–304. Stanford, CA: Stanford University Press.

——. 2019. "Joseonjok and Goryeo Saram Ethnic Return Migrants in South Korea: Hierarchy among Co-ethnics and Ethnonational Identity." In *Diasporic Returns to the Ethnic Homeland: The Korean Diaspora in Comparative Perspective*, edited by Takeyuki Tsuda and Changzoo Song, 57–77. London: Palgrave Macmillan.

Spivak, Gayatri Chakravorty. 1993. "In a Word: Interview." In *Outside in the Teaching Machine*, 1–23. London: Routledge.

Stokes, Martin, ed. 1994. *Ethnicity, Identity and Music: The Musical Construction of Place*. Oxford: Berg.

Sutton, R. Anderson. 2010. "Where's the Improvisation? Reflections on Javanese *Gamelan* and Korean *Sanjo*." In *Perspectives on Korean Music*, vol. 1, edited by R. Anderson Sutton, 155–174. Seoul: Ministry of Culture, Sports, and Tourism.

Tölölyan, Khachig. 1991. "The Nation-State and Its Others: In Lieu of a Preface." *Diaspora* 1 (1): 3–7.

Tsuda, Takeyuki. 2009a. "Introduction: Diasporic Return and Migration Studies." In *Diasporic Homecomings: Ethnic Return Migration in Comparative Perspective*, edited by Takeyuki Tsuda, 1–18. Stanford, CA: Stanford University Press.

——. 2009b. "Why Does the Diaspora Return Home? The Causes of Ethnic Return Migration." In *Diasporic Homecomings: Ethnic Return Migration in Comparative Perspective*, edited by Takeyuki Tsuda, 21–43. Stanford, CA: Stanford University Press.

——. 2019. "Korean Diasporic Returns." In *Diasporic Returns to the Ethnic Homeland: The Korean Diaspora in Comparative Perspective*, edited by Takeyuki Tsuda and Changzoo Song, 3–16. London: Palgrave Macmillan.

Turino, Thomas. 1999. "Signs of Imagination, Identity, and Experience: A Peircian Semiotic Theory for Music." *Ethnomusicology* 43 (2): 221–255.

——. 2008. *Music as Social Life: The Politics of Participation*. Chicago: University of Chicago Press.

Um, Haekyung [Ŭm Hyegyŏng]. 2004a. "Introduction: Understanding Diaspora, Identity and Performance." In *Diasporas and Interculturalism in Asian Performing Arts: Translating Traditions*, edited by Hae-kyung Um [Haekyung Um], 1–13. London: Routledge.

——. 2004b. "Community, Identity and Performing Arts: The Korean Diaspora in the Former Soviet Union and China." In *Diasporas and Interculturalism in Asian*

Performing Arts: Translating Traditions, edited by Hae-kyung Um [Haekyung Um], 43–60. London: Routledge.

———. 2013. *Korean Musical Drama: P'ansori and the Making of Tradition in Modernity*. New York: Routledge.

Van Hear, Nicholas. 1998. *New Diasporas: The Mass Exodus, Dispersal and Regrouping of Migrant Communities*. London: University College London Press.

Waterman, Christopher Alan. 1991. "*Jùjú* History: Toward a Theory of Sociomusical Practice." In *Ethnomusicology and Modern Music History*, edited by Stephen Blum, Philip V. Bohlman, and Daniel M. Neuman, 49–67. Urbana: University of Illinois Press.

Williams, Raymond. 1977. *Marxism and Literature*. Oxford: Oxford University Press.

Willoughby, Heather. 2000. "The Sound of Han: P'ansori, Timbre and a Korean Ethos of Pain and Suffering." *Yearbook for Traditional Music* 32: 17–30.

Wong, Chuen-Fung. 2012. "Reinventing the Central Asian Rawap in Modern China: Musical Stereotypes, Minority Modernity, and Uyghur Instrumental Music." *Asian Music* 43 (1): 34–63.

Wong, Isabel K. F. 1991. "From Reaction to Synthesis: Chinese Musicology in the Twentieth Century." In *Comparative Musicology and Anthropology of Music: Essays on the History of Ethnomusicology*, edited by Bruno Nettl and Philip V. Bohlman, 37–55. Chicago: University of Chicago Press.

Yang, Sŭnghŭi. 2001. "Kim Ch'angjo e kwanhan nambukhan charyo mit munhŏn koch'al-e-ŭihan kojŭng" [The Study of Kim Chang-jo Using Documents and Literature Found in North and South Korea]. In *Sanjo yŏn'gu* [A Study of Sanjo], 54–143. Chŏnnam (Jeonnam), Yŏngam-kun (Yeongam-gun): Kayagŭm Sanjo Preservation Committee.

Yang, Sŭnghŭi, and Pak Ch'ŏl, ed. 2000. *Kayagŭm sanjo ŭi ch'angsija aksŏng Kim Ch'angjo sŏnsaeng* [The Originator of Kayagŭm Sanjo, Aksŏng Kim Chang-jo]. Chŏnnam (Jeonnam), Yŏngam-kun (Yeongam-gun): Yŏngam Cultural Center.

Yano, Christine R. 2002. *Tears of Longing: Nostalgia and the Nation in Japanese Popular Song*. Cambridge, MA: Harvard University Press.

Ye, Yŏngjun. 2014. "Inminhaebanggun'ga chiŭn chŏngyulsŏng . . . chungguk, t'ansaeng 100yŏn chaejomyŏng" [Commemorating the 100th Birthday of Chŏng Yulsŏng, the Composer of the Anthem of the Chinese People's Liberation Army]. *Chungang ilbo* [Chungang Daily News], 9 August. https://news.joins.com/article/15486977#none.

Yoshihara, Mari. 2007. *Musicians from a Different Shore: Asians and Asian Americans in Classical Music*. Philadelphia: Temple University Press.

Yu, Myŏngi. 1999. "Chosŏnjok ŭi haeoe ch'wiŏp kwa sahoe munhwajŏk pyŏnhwa" [Overseas Employment of Korean Chinese and Sociocultural Changes]. In *31hoe han'guk munhwaillyuhakhoe haksultaehoe palp'yo nonmunjip* [The Thirty-First Korean Cultural Anthropology Conference Proceedings]. Seoul: Korean Cultural Anthropology Association.

Audiovisual Recordings

Arirang nang-nang. 2005. *Arirang nang-nang*. Synnara Music, NSC-143, compact disc.

Chungang kayasŭt'ŭra. 2009. *Chungang kayasŭt'ŭra che 1 chip—Arŭmdaun ch'ulbal* [Chung-Ang Gayastra, vol. 1—Beautiful Departure]. Loen Entertainment, L100003780, compact disc.

Hwang Yŏngae. 2004. *Changbaek ŭi p'okp'osu ya* [Waterfall of Changbai Mountain], published by Jilin Nationality Audio-Visual Publishing Company, ISBN 7-88356-095-6, video compact disc.

KBS Orchestra, Hong Hŭijin, Kim Chongdŏk, et al. 1999. *Pukhan arirang* [North Korean Arirang]. Synnara Music, NSSRCD-011, compact disc.

Kim Sŏngsam. n.d. *Kimsŏngsam koltŭn hitt'ŭsong* [Kim Sŏngsam Golden Hit Song]. Jilin Nationality Audio-Visual Publishing Company, ISRC CN-D08-02-305-00/V.J6, video compact disc.

Muk Kyewŏl, An Pich'wi, Yi Ŭnju, Ko Paekhwa, Yi Suk, Kim Kŭmsuk, and Kim Hyeran. 2000. *Seven Great Artists Singing Kyŏnggi Folk Songs*, published by Silla Music, SUC-1766, compact disc.

Pak Ch'unhŭi. 2002. *Pak ch'unhŭi noraet'ŭkchip* [Piao Chunji Special Collection]. Jilin Nationality Audio-Visual Publishing Company, ISRC CN-D08-02-036-00/V.J6, video compact disc.

Yeppŭn sonyŏdŭl. 2002. *Yeppŭn sonyŏdŭl* [Pretty Girls]. Jilin Nationality Audio-Visual Publishing Company, ISRC CN-D08-02-304-00/V.J6, video compact disc.

INDEX

Page numbers in **boldface** type refer to illustrations.

migration history of, 19–26; minority nationality policies and, 3, 27, 52, 55–58, 70–79; population statistics of, 19, **25**, 29–32, 69, 183nn1–3, 185n10, 185n20; relations with North Korea vs. South Korea, 157–161, 163; as return migrants, 1–2, 18, 161–163, 172, 173, 189n1; as term, 1

Chaoxianzu music, 2–5, 33–34, 69–70, 177–181; as communist propaganda, 45–51, 59, 66; diasporic agency and, 15–16; folk songs, overview, 36–39, 62–63; instrumental folk music, overview, 39–40; instrument development and manufacturing, 64–65, 79–90; mass media and, 6–7, 17, 37, 50, 52, 67, 114, 146–149; musical signs and cultural identity, 113–115; political reform and, 62–68; popular music, overview, 6, 35, 40–42, 66–68, 137, 184n5, **200**; post-1949, 52–56; pre-1949, 34–36; research strategy on, 5–8; Western music, overview, 42–45, 54. *See also* Chaoxianzu; Chaoxianzu vocal music; *names of specific instruments*

Chaoxianzu Music Organization, 39, 40, 58, 87, 185n21

Chaoxianzu vocal music, 136–137; by Chŏn Hwaja, 60, 64, 139–143, 144; construction and development of, 137–139; *hallyu*, 152–156; by Kang Sinja, 64, 143–146; by Kim Sŏngsam, 149–150, 151, 152, 188n7 (ch. 6); mass media and, 146–149; by Pak Ch'unhŭi, 65, 149; *Yeppŭnidŭl* [Pretty Girls] album, 150–152. *See also* Chaoxianzu music

chapka, 35, 38, **195**

children's musical education, 76–77

Chi Mansu, 53, 77

China, **20**; Age of Reform, 62–68; Cultural Revolution, 56–62; dynastic history of, 22–23, 43; establishment of PRC, 1, 3, 19; establishment of Republic of, 43; geography of, **20**, 21,

183n4; Kando/Jiandao Convention, 23–24; Korean migration history and, 1–2, 19–26, 161–163, 172, 173, 189n1; population statistics of, 19, **25**, 183nn1–3, 185n10, 185n20. *See also* Han Chinese (ethnic majority)

Chinese Civil War, 19, 28, 46–47, **192**

Chinese Communist Party (CCP), 19; civil war of, 46–47, **192**; Korean alliance with, 46–48; Lin Biao and, 59, 185n18; minority nationality cultural project by, 4, 36, 52–56, 70–79; minority nationality policies of, 3, 27–29, 55–58. *See also* China; Great Leap Forward Movement; Mao Zedong

Chinese Communist Revolution, 19, 51, 71, **193**

Chinese Cultural Revolution, 56–62

Chinese Music Organization, 58. *See also* Chaoxianzu Music Organization

Chinese Nationalist Party, 27, 46

Chinese New Year celebrations, 5, 147, 188n12

Chinese People's Liberation Army, 19, 47, 49

Chinese People's Political Consultative Conference (CPPCC), 69, **192**

Chinese Soviet Republic, 27

ching, 184n2, 188n16, **195**

chinsŏng, 139–140, 144, **195, 196**

chinyangjo, 96–97, 185n14, 187n3 (ch. 4), **195**

Cho Chongju, 138

Ch'oe Ch'anggyu, 117

Ch'oe Oksam, 97, 185n22

Ch'oe Sammyŏng, 72, 74, 75, 78, 117

Ch'oe Sangwa, 159

Ch'oe Ŭmp'a, 49

chŏngak, 35, 39, 78, 88, 139, 186n9, **195**

Chŏng Chinok, 54, 74–75

Chŏng Chun'gap, 59–60, 64–65

Chŏng Namhŭi, 185n22

"Ch'ŏngnyŏn haengjin'gok" [Youth March], 48

Chŏng Yulsŏng, 49

ABOUT THE AUTHOR

Sunhee Koo is senior lecturer in ethnomusicology in the School of Social Sciences at the University of Auckland, New Zealand. She specializes in East Asian performing arts, through which she examines the construction and negotiation of identities. Based on her ethnographic research on diasporic Koreans in China, Korea, and Japan, she has published a number of articles in prestigious journals including the *Journal of Asian Studies*, *Korean Studies*, *Asian Music*, and the *Yearbook for Traditional Music*. In her work, she demonstrates how expressive arts such as music and dance manifest various collisions and convergences of cultures and peoples in late modernity.

**MUSIC AND
PERFORMING
ARTS** OF ASIA
AND THE PACIFIC